DEVELOPING MISSION

A volume in the series

The United States in the World

founded by Mark Philip Bradley and Paul A. Kramer

edited by Benjamin Coates, Emily Conroy-Krutz, Paul A. Kramer, and Judy Tzu-Chun Wu

A list of titles in this series is available at cornellpress.cornell.edu.

DEVELOPING MISSION

Photography, Filmmaking, and American Missionaries in Modern China

Joseph W. Ho

Cornell University Press
Ithaca and London

First published 2021 by Cornell University Press

Library of Congress Cataloging-in-Publication Data

Names: Ho, Joseph W., 1987– author.
Title: Developing mission : photography, filmmaking, and American missionaries in modern China / Joseph W. Ho.
Description: Ithaca [New York] : Cornell University Press, 2021. | Series: The United States in the world | Includes bibliographical references and index.
Identifiers: LCCN 2021007660 (print) | LCCN 2021007661 (ebook) | ISBN 9781501760945 (hardcover) | ISBN 9781501761850 (paperback) | ISBN 9781501760952 (pdf) | ISBN 9781501760969 (epub)
Subjects: LCSH: Missions, American—China—History—20th century. | Vernacular photography—China—History—20th century. | Photography—Social aspects—China—History—20th century. | Photography—China—History—20th century. | Amateur films—China—History—20th century. | Christianity—China—20th century.
Classification: LCC BV3415.2 .H625 2021 (print) | LCC BV3415.2 (ebook) | DDC 266/.023730510904—dc23
LC record available at https://lccn.loc.gov/2021007660
LC ebook record available at https://lccn.loc.gov/2021007661

For Jing, Jane, and James

For my parents, Jimmy and Patricia

And in memory of Liu Ju, Sophie Henke, Cecile Lewis Bagwell, Clara Bickford Heer, Lois Henke Pearson, and Anne Lockwood Romasco—let light perpetual shine upon them

We believe in one God, the Father Almighty, Maker of heaven and earth, and of all things visible and invisible.

—Nicene Creed

All photographs are memento mori.

—Susan Sontag

Contents

x *Contents*

Note to the Reader

The *Developing Mission* companion website (https://doi.org/10.7302/1259) is hosted by the University of Michigan and contains a wide range of rare primary sources—including color slides, film clips, and other digitized visual and textual materials—to supplement the book. These were assembled by the author over several years of international research and have not been available to the general public until now.

Unless otherwise noted, all referenced materials from the Li/Liu Family Collection, the Scovel Family Collection, the Winfield-Sullivan Family Collection, and the Angus Family Collection remain in these respective families' private possession. As of this writing, the Henke Family Collection is being prepared for preservation at the University of Michigan Asia Library.

Hanyu pinyin romanization is generally used throughout this book. However, when possible, the text retains missionary phoneticizations or Wade-Giles romanizations of key terms. This is to remain faithful to original sources for which Chinese characters are not separately available. A glossary of selected Chinese terms is provided for further reference.

Abbreviations

HFC Henke Family Collection, University of Michigan Library, Ann Arbor

JARC Jesuit Archives and Research Center, St. Louis, Missouri

LFP Lewis Family Papers, Bentley Historical Library, University of Michigan, Ann Arbor

PCC Passionist China Collection, Passionist Historical Archives Collection, McHugh Special Collections, the University of Scranton, Pennsylvania (physical collection); the Ricci Institute for Chinese-Western Cultural History at the University of San Francisco, California (digital collection)

SFC Scovel Family Collection

WSFC Winfield-Sullivan Family Collection

DEVELOPING MISSION

Introduction

All Things Visible and Invisible

On a curving side street near Wuhan University's tree-lined campus in central China stands a nondescript apartment building. Like many others nearby, it houses university faculty and graduate students. It is a fairly quiet neighborhood. Few vehicles pass this place, a small comfort to the elderly woman residing on the second floor, in a room facing away from the street and toward the tall, cicada-inhabited trees covering the rolling hills. It is here that the former nurse, Liu Ju, spends most of her days. The room's furnishings are simple but life-sustaining. A second bed near the open window, spread with neatly folded sheets, awaits sleepless nights spent by Liu's son, daughter, and caretaker. A dented, well-used oxygen tank stands nearby, while a small television on a dresser table broadcasts dramas and news programs from China Central Television punctuated by frequent commercials. Liu, ninety-four, sleeps for long hours during the day, physically frail and struggling to retain memory through the increasing haze of dementia.

A few things in the room represent Liu's religious identity as well as her past. A pocket-sized Bible sits on a nightstand, its gilt-edged pages worn by perusal. Liu, a Protestant Christian, still reads it whenever possible. Stored in a wooden drawer underneath the bed is an old folding camera, a German-made Kodak Vollenda 620 from the mid-1930s. Age and time have

weathered it. Its leather bellows have long since succumbed to Wuhan's heat and humidity, and its lens and shutter assembly are missing. These, however, are not signs of misuse. The camera was owned by Liu's husband, Li Qing-hai, and like the Bible on the nightstand, it displays signs of both extensive use and personal care. When the Kodak's folding metal viewfinder snapped off, Li, a Cornell-educated professor of surveying at the Wuhan Institute of Surveying and Cartography, handcrafted a cardboard peep sight to extend the camera's use. Beside the camera are several photograph albums. Two of them are older than the rest, their covers worn from age and repeated handling, containing black-and-white prints dating back to Liu Ju's youth.

One of these photographs, made in 1948, shows her as a thirty-one-year-old standing in front of a brick house, next to two foreigners, a man and a woman dressed in neat clothing. The woman next to Liu wears a Chinese-style silk jacket.[1] It is clearly a special occasion. Liu stands intimately close to the woman in the image, leaning ever so slightly against her as they smile warmly. In another photograph pasted next to the first in the album, Liu has disappeared, leaving only the man and woman standing together, smiling as before. No captions indicate their identity or the occasion for the pictures. The silence is, perhaps, metaphorical. With the camera and photographs stored away under Liu's bed, they seem to hold importance for her alone, as fading traces of a distant past.[2]

Seven thousand miles east of Liu's apartment, a house stands on a steep rise overlooking both the Los Angeles basin and the Pacific Ocean. When the haze lifts on a hot day, it is possible to look east to see the sprawling city in miniature in the valley below, and west to the peaks of Santa Catalina Island rising out of the sea—a dramatic backdrop for ships passing along the coast. Another woman in the later years of her life resided on this seaward side of the house. Standing in her room with the window open and seeing the sun-light brightening the cresting waves below, it is not difficult to imagine the elderly Jessie Mae Henke, also a former nurse, remembering and reimagin-ing the China of her past. Her memories, like Liu's were aided by images, a collection of black-and-white prints she and her physician husband, Harold Eugene Henke, made over half a century prior. The couple had films as well, various 16 mm black-and-white and Kodachrome reels that passed through a now long-unused spring-wound Cine-Kodak Model B movie camera stored in an adjoining study. Although in better physical shape than its lensless still counterpart in Wuhan, the Henkes' Cine-Kodak nonetheless bears the marks of heavy use: missing leatherette, metal parts covered with a brown-ish patina, and layers of haze in the 25 mm f/1.9 Kodak Anastigmat lens.[3]

Stored in a box nearby is a large album that Jessie Mae assembled after her return from China. It is a hefty volume bound in faded blue cloth and emblazoned with the words *"Chicago Tribune* Scrap Book: The World's Greatest Newspaper."* The album, its heavy yellowed pages held together by two large, slightly rusted screws, is an American Protestant missionary's visual assemblage.[4] One of the persons inhabiting the album sits together with her fellow Chinese nursing students in a small square photographic print midway through the volume, a group photograph made by a missionary's Rolleiflex camera in the city of Shunde in North China.[5] The only caption here, written by Jessie Mae shortly after the photograph was pasted into the album, simply states: "Student Nurses." But a closer look reveals something else about the image. The woman staring stoically into the camera's lens, sitting at the far left of the first row of students with their cotton uniforms and stiff white caps, is none other than Liu Ju. She was then a twenty-year-old who enrolled in the nursing school in the fall of 1937, having fled the Japanese military invasion that swept through her hometown of Shijiazhuang that summer.[6]

Nearly three-quarters of a century later, Liu sat on her bed in her apartment with the window open, looking at her own albums. The humming

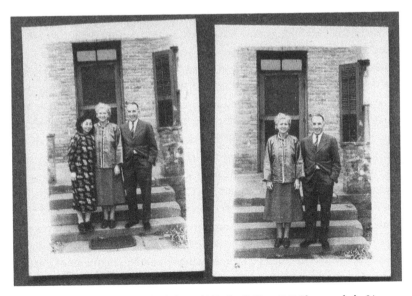

Figure I.1. Liu Ju, Jessie Mae Henke, and Harold Henke, Beijing, 1948. Photographs by Li Qinghai. Li/Liu Family Collection, Wuhan, China.

cicadas crescendoed outside. Her son paced back and forth at the far end of the room, deep in thought, and her daughter sat on a stool next to the bed, waiting for her to respond. Liu lifted a finger to point at the photograph with her and the two foreigners. Her husband made the image during their 1948 wedding reception in Beijing, held in the house of the couple smiling at the camera. She paused, remembering, and looked up. "Mrs. Henke, Dr. Henke," she said, "they were like my family."[7]

Views

As I sat in that room, looking back at Liu and the Henkes in the photographs, I struggled to make sense of the historical trajectories and visual frames that I was encountering. Liu's reference to "family" was an apt one. She was a member of a global spiritual community, a person whose identity was defined not only by her individual religious beliefs but also by her past and present associations with Christian institutions. This identity, in a highly personal as well as historical way, was embodied in familial images—images of family (her own and that of religious and cultural community) that were part of a family of images, an assemblage of experiences, imaginations, and visual practices.

But like faint memories of long-lost relationships, this history of once-visible peoples and things now resides in comparative invisibility, overshadowed by grander historical scales and ever-shifting distances of time and space. An old hymn, well known to Chinese Christians and missionaries at the time the albums were assembled, offers a poetic rendering: "Time, like an ever-rolling stream / bears all its sons away / they fly, forgotten, as a dream / dies at the opening day."[8] Liu Ju and Jessie Mae Henke's images are now located on opposite sides of the Pacific. Nearly all the individuals depicted in them are no longer living; the communities with which they were once familiar no longer exist in the same identifiable forms. The cameras are stored underneath a bed in present-day China, displayed on a dusty shelf in Los Angeles, or, more often, lost or otherwise divorced from their historical contexts. This is the paradoxical fate of photographic equipment, responsible for and yet almost always invisible in the visual materials it produces. These experiences and objects represent the remaining fragments of images, image-making, and the Sino-US interactions that bound them together.

These interactions took place within a global community of foreign and Chinese Christians. It was mutually constructed, shaped by the convergence

of disparate histories—those of missionaries, of the Chinese who engaged with them (sometimes as converts, sometimes not), and of various groups and institutions to which they were connected. Christian networks within and beyond China facilitated these links, serving as communication channels among participants. American and Chinese communities created, translated, and received materials that represented diverse identities, in which experiences and exchanges were informed by transnational religious identification.[9] This religious-cultural space of the combined missionary enterprise and Chinese Christian community was forged, made visible, and then rendered unseen in multiple registers. Being existentially mobile, the missionary enterprise encompassed evolving religious imaginations and engagements with secular contexts, as well as the movement of participants between spiritual and physical worlds.

This evolution included a spectrum of ideological approaches. Views from the 1880s and 1890s, as Carol Chin describes, were rooted in "beneficent imperial[ism]," in which missionaries, "secure in the superiority of their Americanness and the magnanimity of their Christianity . . . did not pause to consider the possibility that Chinese culture might have some value or that China might have something to teach them."[10] Their twentieth-century successors—including all of the people described in this book—not only found much in China from which to learn but also saw their lives and ways of seeing profoundly transformed by experiences in which they were not the prime movers. As David Hollinger and Lian Xi point out, missionaries from the 1920s through the 1950s acted as locally embedded collaborators (and evangelists of progressive ideals in and beyond China) as opposed to smug purveyors of ideological imposition.[11] Beyond unidirectional cultural imperialism, growing numbers of missionaries across the twentieth century held mutable views on global citizenship, reform and religion, and cross-cultural encounters in Sino-US contexts. Seeing missionary experience as chronologically contingent and ideologically diverse illuminates lived realities for missionaries and Chinese Christians that fell between the opposing poles of conservative and liberal perspectives.[12] Missionary images function not only as windows but also as mirrors. They, too, are products of these evolutions and tensions. As mediatory visual artifacts, they fully reflect the multiple experiences from which they came. To trace this relationship, let us begin by considering the various contexts that framed these visions.

Beginning in the mid-nineteenth century and peaking in the twentieth, thousands of American Protestant and Catholic missionaries traveled to

and resided in China.[13] The individual projects that they undertook, though broadly motivated by Christian spiritual calling and the impetus of religious conversion, varied widely in practice.[14] Humanitarian projects combined with evangelistic ideals drove the parallel growth of churches and religious fellowships as well as medical and educational institutions. In the process of putting Christian service into practice, all missionaries developed complex relationships with the Chinese people and state. They wrestled with questions of identity (cultural, religious, and national) that roughly coalesced around popular movements such as the Boxer Uprising of 1900, the 1911 Revolution, the May Fourth Movement of 1919, and the Anti-Christian Movement of the 1920s.[15] With the violent upheavals of the long Chinese Civil War (1927–1949) and the Second Sino-Japanese War (1937–1945) in the Republic of China, many missionaries shifted their religious projects to provide humanitarian responses to domestic conflict and foreign invasion.[16] After Japan's surrender in 1945, missionaries who returned to their churches, hospitals, and schools across the country quickly found themselves swept up in the renewed civil war between Communist and Nationalist forces. This ultimately ended in radical regime change—the foundation of the People's Republic of China (PRC) and the Nationalist government's retreat to Taiwan—and the official cessation of foreign missions in mainland China, establishing contested relationships between organized religion and Chinese state power that exist to this day.[17]

At various moments in this first half of the twentieth century, Americans as well as Chinese were caught up in chaotic uncertainties that included widespread suffering and contestations over national identity, spiritual belonging, and political allegiances.[18] During the dramatic historical changes that took place around them, American missionaries interacted with both Chinese and other foreigners in various contexts. They became acquainted with friends, colleagues, and opponents, struggling with indigenous and foreign pressures. Many in Protestant denominations raised families, giving rise to (or joining existing) lineages of missionaries, diplomats, and intellectuals with unique connections to Asia, the United States, and the world.[19] All developed some knowledge of Chinese language and culture, gained through basic language training followed by long periods of daily experience in the field.[20] And many missionaries carried cameras. The images they produced, the meanings these images contained, and the visual practices used to produce them were as historically mobile as those behind and before the lens. Likewise, connections between camera and missionary were not fixed in any one particular time and place.

Photography by foreign missionaries in China dates back to the early 1850s, when Fr. Claude Gotteland, SJ, began producing daguerreotypes at the French Catholic mission in Shanghai, part of an educational and scientific mission inaugurated in 1842, a mere three years after this world-changing visual technology was made public in France.[21] Gotteland made his own photographs, but in major Chinese cities and treaty ports the process was soon largely taken over by studios run by Chinese and foreign professionals.[22] Although Gotteland was not alone in his early photographic work, wide-ranging vernacular imaging (by which I mean nonprofessional or amateur practices) by missionaries and other foreigners in China did not take off until later in the nineteenth century, bolstered by developments in popular imaging technologies and international commercial empires, spearheaded in part by US companies like Eastman Kodak.[23] With the commercialization of dry plates, flexible rollfilm, and mass-produced cameras, many late nineteenth- and early twentieth-century American missionaries carried increasingly lighter, more user-friendly consumer cameras to China, and the production and circulation of images grew exponentially. Intrepid others continued to employ bulky large-format cameras (derived from immobile nineteenth-century studio cameras) to produce finely detailed photographs on glass plates or sheet film.[24] In a shift paralleling the rise of modern documentary photography, their successors of the interwar, wartime, and postwar eras employed far smaller medium-format and 35 mm (then called "miniature") cameras, allowing for advanced image-making possibilities on portable, high-capacity rollfilm. As motion-picture technology became more economical and widespread in the late 1920s, missionaries created narrative films with amateur movie cameras.[25] The resulting images, still or moving, were often produced with widely varying degrees of technological expertise under difficult physical conditions across China.

Missionary photographs and films had multifaceted existences. Prints were kept in family albums, shared with other people, or reproduced in religious and secular publications. Still and moving images alike were used as illustrations for sermons, lectures, and presentations on both sides of the Pacific. Personal photographs taken by missionaries served as mementos of their relationships with friends and colleagues. Preserved in ubiquitous albums, scrapbooks, and slide-projector trays, these images re-enact lived experiences through multisensory visual and material display.[26] In a number of cases, missionaries' visual practices developed in parallel with those of Chinese nationals whose work or religious beliefs brought them into direct contact with missionaries.[27]

Missionary images were widely employed in fundraising efforts across American and Chinese communities, reflecting long-term trends in Christian media around the world.[28] Views of evangelistic and humanitarian success alternated with depictions of needs and difficulties, generally intended to elicit spiritual, emotional, and financial responses from audiences. Although quantifying all the ways in which viewers received such images and engaged in material contributions is beyond the scope of this book, episodes in which images were deployed in mission conferences, church magazines, and private support networks appear across the pages to come. But the complicated existences of missionary images did not always begin or end with transactional appeals. Rather, visual practices fundamentally reshaped vision and experience in ways that did not match carefully crafted institutional self-promotion, disrupting or even departing from it. After all, these images turned out to be as much about their makers as they were about China, and as much about future perceptions as about present realities.

Cameras, photographs, and films mediated missionary and Chinese Christian experiences on the ground. In documenting modern China and their presence in it, American missionaries developed a visual modernity, produced by modern visual technologies, that framed religious and cultural in-betweenness across both missionary and Chinese Christian groups. The image-making at the heart of this book thus had multiple purposes that evolved in response to changing historical contexts and expressions. At times, photography and filmmaking organized visions, framed cross-cultural encounters, and shaped perceptions of place and purpose in the world. In conditions of conflict, they became documentary representations of violent events (and, in the cameras of some missionaries, explicitly partisan). These representations were born of intersections between visual expertise, political realignments, and wartime contingencies. Subsequently, with the missionary enterprise's collapse in the early PRC, they became visual traces, fragments of once-visible, now-remembered experiences that no longer fit into post-1949 Chinese national identity or the Christian community. Already mutable in meaning, such images entered obscurity with the disappearance of the historical contexts for (and in) which they were made.

These photographs do not neatly coincide with historical studies of this period. One prevailing idea is that modern imaging has been primarily employed in the cause of secular, imperialistic surveillance or "social dislocation," as Emily Rosenberg and Laura Wexler note.[29] Histories of empire after the cultural turn rightly give serious attention to photography's and filmmaking's disruptive impacts in colonial and imperial contexts. At the same

time, most of these studies favor photographers affiliated with commercial or secular institutions, while neglecting missionaries and their body of visual work. Moreover, many cultural histories of imperialism have largely conflated missionary activities with hegemonic power, sometimes reducing missionaries to one-dimensional colonial agents while glossing over their working ideologies and complex (or even constructive) experiences with indigenous groups.[30] Although newer scholarship provides critical responses to these longstanding erasures, the wide-ranging historical specificities of missionary imaging in East Asia remain difficult to ascertain.

The broad conflation of missionary visual practices with those of secular groups flattens critical differences in those practices and missionaries' perspectives. Furthermore, it makes irrelevant nuances in cross-cultural encounters, alignments in ideology, and personal relationships related to community and belief—such as those experienced by Liu and Henke—as well as activities that run against the grain of hegemonic power. These include missionary alliances with anti-imperial and antiwar movements (permutations of "Christian internationalism" described by Michael G. Thompson), the development of self-supporting indigenous religious communities, and the ideological "conversion of missionaries" (that Lian Xi examines) from agents of empire to religious participants in cross-cultural encounters and world-making projects.[31] In terms of connections between media, the missionary enterprise, and home audiences, many of these experiences echoed the late nineteenth- and early twentieth-century development of American Christian humanitarianism across international contexts—bolstered by print culture—explored by Heather Curtis.[32] Although some missionaries were aligned with imperial power and employed visual practices to reinforce it, the goal of this book is to expand the connections between imaging and identity beyond such approaches. Just as missionaries debated and developed increasingly progressive cultural and religious sensitivities over the nineteenth and twentieth centuries, so too did their imaging practices incorporate self-reflexive relations to imaged subjects and global Christianity. On the one hand, these changing visual practices reflect what Ann Stoler refers to as "epistemic anxieties," the missionaries' grappling with uncertainties about what they knew or did not know individually and communally.[33] On the other hand, photography and filmmaking reflected missionaries' complicated identities in China, living in and among nations and peoples, imperial powers, religious institutions, and local communities.[34]

In illuminating this in-betweenness, this book aims to bridge historical scholarship on Sino-US encounters, modern China, and visual practices in

East Asia. Almost no histories of American missionary activity in China (and in other places in East Asia during the nineteenth and twentieth centuries) examine the role of widespread photographic practices in missionary and Chinese experience. Even studies that place strong emphasis on cross-cultural encounters in the missionary enterprise make no mention of visual practices by missionaries, though as this book shows, such practices were widespread.[35] Likewise, pioneering studies on the history of photography in China, though touching on the foreign missionary presence and highlighting specific missionary-photographers, remain silent on photography and filmmaking by missionaries as a specific cultural phenomenon. Such studies prioritize a formal, art-historical view of foreign visual practices, neglecting to examine missionary imaging's vernacular qualities or its trajectories beyond the mid-to-late nineteenth century.[36] Finally, current histories of modern photography in East Asia, though concerned with the local development of visual practices and discourses (photography by Chinese individuals or, more broadly, Chinese photography), simply do not include missionaries in the conversation.[37] Although this absence stems from missionaries' status as foreigners, their embedded presence and imaging practices in Chinese environments were no less relevant to visual perceptions of modern China. In other words, their visual practices are simply lost in the critical mix, with the images and image-makers perceived as too foreign or too far removed from indigenous experience, or as myopically imperialist, antimodern, or religiously biased. As this book shows, the reality was far more complex.

Similar gaps exist in scholarly uses of missionary images. When reproduced in texts on modern Chinese history or Sino-US contacts, these sources are seldom explicitly investigated as visual products (as opposed to flat representations) of missionary and Chinese Christian experience. They largely appear as illustrations, lacking discussions about production and processes, circulation, or image authorship and interpretation.[38] Scholarship on modern China and US history in a global context has thus overlooked significant transnational visual experiences, as well as effectively ignoring the existence of a major group of people who collectively visualized China from specifically embedded perspectives during the twentieth century. American missionary imaging in changing Chinese historical landscapes represented visual narratives hidden in plain sight, ranging from peacetime perspectives on community building and nation building to representations of war and political upheaval. The massive numbers of existing images and their equally numerous historical meanings are too significant to be put aside as unexamined secondary sources.

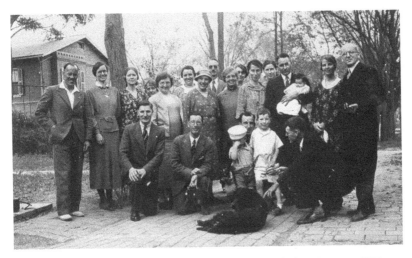

Figure I.2. Presbyterian mission meeting group photograph, North China, June 1936. HFC.

A single photograph from the Henkes' scrapbook album demonstrates how these visual practices appear—and yet, are easily missed. In June 1936, on an overcast day in Hebei, North China, a small group of American Presbyterian missionaries gathered for a photograph. In the image, some individuals smile, while a few others stand with serious looks, and a Labrador dog curls up at the feet of the group. All are aware of the photographer, whose presence behind the camera—visible to the subjects but not to the viewers—makes this photograph possible.

A closer look at the image reveals something else: the presence of visual technologies. A rectangular camera case, its leather strap looped lazily on the ground, sits at the right side of the frame. A spectacled man at the center of the group casually dangles a compact 8 mm or 16 mm movie camera from its carrying handle, while the person next to him cradles a folding camera, its small waist-level viewfinder reflecting a tiny bright spot of open sky. Finally, a man standing on the group's right holds a twin-lens reflex camera upside down, its viewing hood open and pointing downward. This display of cameras and image-making potential is easily missed by most viewers not specifically looking for traces of photographic technology. This image is but one window onto the multifaceted existences of missionary visual practices, and it is far from alone. It references countless other images in the rolls of film that passed through the cameras in the hands of the missionaries pictured, and myriads more across China before and after this moment.

Archives across the United States hold hundreds of thousands of images made in China by missionaries during the nineteenth and twentieth centuries, a fraction of greater quantities likely extant in North America, Europe, and East Asia. Although an increasing number of these collections have been digitized (giving the images new afterlives wholly unimagined by their historical subjects and creators) many more, for reasons of funding, institutional contingencies, and private ownership, remain inaccessible to wider publics.[39] As one historian of Chinese photography notes: "Missionary archives contain much of photographic interest, but the sheer volume of material can deter any but the most determined of photo-historians. Transcriptions and digitisation . . . are necessary before such material can be more widely disseminated. This requires time and funds. The [i]nternet is powerless in this area."[40] Although growing numbers of online collections such as the University of Southern California's International Mission Photography Archive and Duke University Library's Sidney D. Gamble Photographs Collection have alleviated the situation described in the quote, far more visual materials remain unexamined and undigitized in other archives.[41] Family collections are a potential-laden unknown quantity, but only if consistently cared for by possessors and discovered by researchers with the good fortune to make the necessary contacts. One wonders how many materials were stripped of their historical contexts by the changing interests (or personal fates) of their caretakers, and relegated to internet resale sites, flea markets and antique stores, or even landfills. Missionary filmmaking in China, explored for the first time in this book, is even more underrepresented in the historical record than its photographic counterpart because of far greater difficulties associated with storing and sharing film materials. Thus, an underlying goal of this book is to advance the recovery of these materials by examining their meanings and raising questions about their afterlives, preservation and accessibility, and future exploration by scholars and others.

Lenses

Missionaries convert—or aim to convert—others. So do photographs and films. Missionary images, therefore, embody overlapping forms of religious and visual conversion. For the purposes of this book, conversion (defined broadly) and media go hand in hand. Building on the popular scholarly phrase "the medium is the message," we may well see the history that this book uncovers as messages in and of visual mediation.[42]

To make sense of these tangled conversions, we must take a closer look at the lenses, figurative and literal, that framed them. Imagine for a moment that you are an American Presbyterian educational missionary in central China around 1927. It is Easter Sunday, and the morning's festive church service has just concluded. To mark the occasion, you decide to photograph your fellow Chinese and American evangelists. Speaking in a mix of English and Mandarin, you direct a group of chatting colleagues to stand together next to the church gate. You unfold a compact Kodak Autographic camera while guessing the focusing distance between you and the group (is it fifteen feet or ten?) and the right exposure. Clouds have obscured the sun, so 1/25th of a second on the shutter and an aperture of f/6.3 will have to do. So near the minimum hand-held shutter speed, you must hold the camera steady, taking care not to blur the photograph. After setting these values, you push a knob to tension the shutter's mainspring and look down—bowing almost— into a tiny reflex finder next to the lens at waist level. Everyone appears as miniature figures in the glass rectangle, inverted right to left. As you signal your readiness to make the photograph, smiles disappear and slouched bodies stand upright. In one stroke, you gently squeeze the shutter release and the camera clicks softly. The moment is over.

Whether they knew it or not, the missionary and everyone in front of the camera participated in creating a specific kind of image: an indexical photograph. Indexicality is the inherent ability of photographic and filmic images to represent some form of reality that existed at a specific moment in time, albeit a limited (framed) and manipulated one. As semiotician Roland Barthes puts it, "In Photography I can never deny that *the thing has been there*. There is a superimposition here: of reality and of the past. . . . What I intentionalize in a photograph . . . is Reference, which is the founding order of Photography. The name of Photograph's *noeme* will therefore be: 'That-has-been' . . . what I see has been there, in this place which extends between infinity and the subject . . . it has been here and yet immediately separated; it has been absolutely, irrefutably present, and yet already deferred."[43] With the click of a shutter or the running of a movie camera, the photographers and subjects as well as time and space instantaneously entered a visual process that ended in the production of a print, slide, or length of movie film to be viewed. These materials engaged viewer perceptions—always reminding them of the has-been moment before the lens—while embodying what Barthes describes as the *punctum*: a "wounding" or "attractive" element in images that varies from viewer to viewer, but is always linked to personal imagination.[44] Like disparate rays of light gathered by a lens and then

projected on a surface, so too did images create and then disseminate multiple interpretations of reality, with each sliver of visual meaning reaching or "pricking" viewers differently, as Barthes notes.

Let us return to the imagined example above. In the basement of your mission residence, you develop your roll of film containing the photograph of the evangelists, print it and other images, and soon mail them with a letter to family in faraway Illinois. What do they see in this image? Not the photographer or the camera, of course. But they see other things: Chinese and American individuals differentiated by race and gender, perhaps wearing similar clothing, perhaps not. They glimpse some of the church architecture behind the group, or at least a portion of the environment visible to the camera. They might see clutched Bibles and various facial expressions. And they begin to question, converse, and imagine. Who are these people? That was the missionary who spoke here last Christmas. Is that the hospital? It's the school—see, she wrote it on the back of the picture. There are warlords in that part of China, aren't there? Let us pray for her—no, for all of them.

In this imagined discussion on receiving an image, perhaps much like any number of conversations that took place in US homes and churches, the photograph animates visual perceptions. In looking, viewers likely consider topics ranging from personal relationships to national political contexts, from the banal (facial expressions) to the spiritual (prayers for safety). The image might spark a direct reply, contributing to a communication loop between the photographer and the recipients of her images. Perhaps the Illinois family members write back to their missionary relative requesting more details, maybe including photographs of their own in a visual exchange. Or possibly the album is accompanied by a private letter or mission report requesting funds for specific uses in China. Regardless of intent and application, it is undeniable that such images transmitted knowledge. In small but personally significant ways, viewers encountered fragments of China, even if the greater Chinese nation and its people lay beyond the edges of the image frame.

Above all, these viewers would not have seen or interpreted an image in the same way as one in a secular setting—a magazine or news publication, for example. Their perceptions were fundamentally religious and inherently transnational; the kingdom of God was their imagined community.[45] This ideological association would have been shared by the photographer and the subjects of the photograph, and they all knew it in some way. Their personal identities were characterized by the imagining and association of shared religious ideologies across multiple places and

times, a multidimensionality that underlay the perceptions of American missionaries in China as well as those of Chinese converts and colleagues. After all, the ways in which missionaries perceived their presence in China, for both religious or humanitarian projects, were mediated by Christian worldviews, whether Protestant or Catholic. Likewise, Chinese Christian participants saw themselves as part of shared frameworks of belief that shaped their spiritual and sociocultural identities. At least for the maker and subjects of this image (and to a lesser but still significant extent, their viewers "at home" in the United States or China), their religious identification went beyond being only American or Chinese.[46]

Furthermore, these emerging modernities were advanced by intersecting developments in American religious missions and Chinese nation building. Technological influences and generational changes in missions from the 1920s through the 1940s profoundly transformed contacts between the United States and China, with missionaries negotiating faiths in God and modern technology in close conversation (or competition) with ideas about indigenous community building and national salvation promoted by Chinese groups, secular and religious. These encounters were exhibited in visual practices and paralleled by evolving media forms (radio, cinema, and print culture) and cross-cultural identities in medical, educational, and theological contexts. In constructing these new ways of seeing, the American missionary enterprise self-consciously attempted to differentiate itself from earlier forms of missions and imperial power by prioritizing collaboration under the aegis of global citizenship. These worldviews colored missionary images.

Missionary visual materials were thus permeated with personal, institutional, and divine meanings that transcended national and cultural boundaries. As Thomas Tweed writes, "Religious flows—and the traces they leave—move through time and space. They are horizontal, vertical, and transversal movements. . . . [They also] move across varied 'glocalities,' simultaneously local and global spaces, as for example when missionaries carry their faith from one land to another."[47] Image-makers, subjects, and viewers were all implicated in the ways in which Christianity, in China or the United States, left such traces in time and space. This inverts Walter Benjamin's classic argument on the processes of "mechanical reproduction" erasing or destroying the organic or nonmechanical "aura" of a visualized object, person, or scene.[48] In this instance, vernacular visual practices imbued images with forms of "aura" particular to the religious enterprises and imaginations involved.

At the same time, the visual culture in which missionaries and Chinese associates participated was built on the global spread of modern visual technologies. This was made possible by shared image-making knowledge and commercial networks, with international photographic commodities and ways of seeing overlapping with the missionary enterprise. Missionaries crossed the Pacific with European- and US-made consumer cameras of varying quality, loaded them with Kodak (US), Ilford (UK), or Agfa (German) film, and used them in both East Asian and American environments. Chinese transportation, commercial institutions, and communication networks enabled missionaries to receive and send photographic materials and equipment internationally. Professional Chinese photographers visited mission compounds, schools, churches, and hospitals to make images for purchase. Missionaries, in turn, visited local studios for film development, formal portraits, and passport images. Missionaries and Chinese Christians, particularly those with cosmopolitan contacts or backgrounds, consumed visual media ranging from US magazines and movies to pictorial religious posters and secular illustrated publications produced in China. These technologies and tropes shaped how missionaries interacted with and visualized China, encompassing the specific ways in which mobile cameras were used on the ground as well as the wider reception of images.

Bearing in mind actor-network-theory and the work of Bruno Latour, this is not simply a book about people who made images—privileging either the people or the images. Rather, it follows the construction of visual knowledge as dependent on both human and nonhuman actors, as well as on the ways they influenced each other. As Latour notes, "In addition to 'determining' and serving as a 'backdrop for human action,' things might authorize, allow, afford, encourage, permit, suggest, influence, block, render possible, forbid, and so on."[49] By considering the agency of things in this manner, this book exposes moments in which objects shaped human experience. This occurred in immediate, mundane ways (the technical aspects of a specific camera design or characteristics of a film emulsion leading photographers to think and act in certain ways, for example) and in broader influences across time and social contexts (with images-as-objects encountering various audiences). Although it is impossible to trace all of these interactions, this book aims to make visible moments in which photographic objects acted as agents and to demonstrate how cameras, lenses, film, darkroom apparatus, visual reproduction, and communications technologies appeared, imparted actions, and disappeared in relation to historical experience.[50] The cultures within which these objects existed—multiple layers of visual production,

circulation, and reception within the missionary enterprise—therefore comprise, in the words of Jonathan Crary, "points of intersection where philosophical, scientific, and aesthetic discourses overlap with mechanical techniques, institutional requirements, and socioeconomic forces . . . embedded in a much larger assemblage of events and powers."[51]

This visual culture and its products thus cannot be divorced from materiality, with the intersection of objects, human actors, and the "assemblage of events and powers" mirrored by physical assemblages of images. The hypothetical photograph mailed from central China to Illinois might have been received and handled as a single black-and-white print, turned over and back to read any handwritten inscriptions, and then joined with others in a photograph album (with verso captions hidden, sometimes permanently, with a splash of glue on paper). As with Jessie Mae Henke's *Chicago Tribune* scrapbook and Liu Ju's albums, referenced earlier, these collections often contained a mix of personal, religious, ethnographic, and documentary images. As Elizabeth Edwards and Janice Hart note, albums "narrativise photographs . . . their materiality dictates the embodied conditions of viewing, literally performing the images in certain ways."[52] Liu's and Henke's albums lend themselves to tactile engagement, performing relationality through display. To access the images within, the viewer needs to heft the album onto a table or some other support, grasping the cover and turning over heavy, mildewed pages. Seeing and handling the photographs in this way physically links the viewer to an imagined sense of past time. When touching dog-eared page corners, noticing creases or smudges where viewers' fingers traced details on photograph surfaces, or even catching the slightly mildewed scent of the cardboard, the viewer easily imagines himself or herself in the place of past viewers—and their relations to image-makers and subjects.[53] Viewings took place in living rooms, on desks and kitchen tables, and across institutional settings over time, involving individuals and groups in performances scripted by visual artifacts.[54]

Although photographs and films produced by missionaries began their lives in local spaces and specific historical contexts, they almost never stayed put in place or in meaning. As "materialized memory traces" (as W. J. T. Mitchell termed them), visual materials moved through the missionary enterprise—and then escaped it.[55] The recipients of these images came to include those far beyond families, friends, and churches. Missionary images, first intended to represent specific religious and cultural experiences, came to embody cross-cultural identities, wartime traumas, and shifts in regional, national, and global modernities. Although some languished (and continue

to do so) in obscurity, others entered international media because their creators' and subjects' experiences converged with major historical events. With missionary involvements in American society, viewers and image-interpreters came to include US and Chinese publics, military personnel, politicians and religious leaders (including those who never set foot in China or the United States), and multiple generations of scholars. Each saw different meanings in the images, according to the historical contexts in which they encountered them.

These trajectories of representation and interpretation had limits. The missionary enterprise certainly had a deep and lasting gender bias in, reflected in social and institutional norms, with both American and Chinese men having disproportionate access to advanced medical, theological, and professional training.[56] Although most visible in the Protestant missionary enterprise of the nineteenth and early twentieth centuries, the specter of the "gospel of gentility" (forms of Christian domesticity promoted by female missionaries in late imperial China) never fully vanished. Likewise, the belief in masculine expertise persisted in both progressive or conservative groups.[57] In some ways, the missionary deployment of photographic technology echoed the persistence of homosocial visual cultures around the world, in which men constructed and asserted technocratic dominance through camera use.[58] Nevertheless, Christianity in modern China and Sino-US contexts encompassed new forms of agency for Chinese and American women, sometimes breaking barriers they persistently faced in their home countries. These new forms of agency included medical practice, organizational administration and higher education, and radically expanded roles in religious leadership—the latter at a time when women were almost entirely barred from US pulpits.[59] Female missionaries and Chinese "Bible women" (a general term for female evangelists) made up a majority of participants in Protestant denominations, and Catholic religious women, foreign and indigenous, exercised similarly transformative influence on their communities and institutions.[60] Publicly and privately, women across Chinese Christian and missionary contexts resisted abiding gender norms.

Similarly, women were crucial to the large processes of image-making, including and beyond camera operation.[61] Far from silent subjects or passive bystanders, they served as vital interlocutors, contextualizing images and image-making (both their own and those of men). They influenced the ways in which visual materials were created, circulated, and seen. Jessie Mae Henke, for example, clearly shared cameras with Harold Henke. His

presence in certain films and her conspicuous absence indicate that she was as involved behind the lens as he was, especially in films of women's community activities to which she had special access. She certainly wrote more about image-making than Harold did. Jessie Mae's private letters carefully document specific contexts for photographs and films, with comments on subjects ranging from the challenges of visual production to the circulation of images. Jessie Mae's spoken narration—accompanying the films that she and Harold produced in China—literally gave voice to the films, and when recorded later in her life, crucially preserved the personal tenor and presentation modes of missionary films in ways that documents could not capture. Indeed, these recordings are the only direct remnant of movie presentations as experienced by historical audiences. Without her observations in various media forms spanning over a half-century, it would be challenging, if not impossible, to reconstruct the lives and afterlives of these images.

Equally crucial contributions are found in Liu Ju's oral history, the writings of Myra Scovel and Roberta Lewis, and the experiences of many other women whose lives intersect with this book. Read against the grain, their narratives allow us to better understand how image-making and visual imaginations crossed gender divides, being built on collaborations between women, men, and their communities. They show us that male lenses and gazes alone did not build the missionary enterprise. By asserting multiple identities (professional, personal, religious, and cultural) in images, participating in creative processes in and beyond camera use, and documenting the contexts through which visual materials passed, these women—among many others—were vital to the construction of this visual culture. Their stories, collected in fragments here, and those yet to be written are equal parts reminder and challenge that these images contain many additional experiences and ways of seeing to be explored.

Returning once more to the hypothetical photograph of the Easter service, we find that decades have now passed since its creation in China and first journey across the Pacific. It and its family album are now preserved in an institutional archive, where a staff member has digitized the collection and enabled public access. Researchers looking at the image would draw different conclusions about it. A historian examining the political agency of modern women in Sino-US cultural encounters might read it as a representation of these contested relationships.[62] Another, working on gendered expressions of American cultural imperialism, would see it a slightly different way, whereas a scholar of modern Chinese history (knowing that the

photograph was made around the time when the 1926–1928 Northern Expedition overtook the missionary's city) would interpret the image in a broader context of antiforeign nationalism.[63] A theologian, studying the grassroots development of Chinese Christianity, might connect the image to the complexities of religious indigenization.[64] A member of the Chinese church founded by the missionary's organization might order a reproduction for a photo book commemorating the hundredth anniversary of his religious community, recovering a part of its pre-1949 history. His online request might be evaluated hours before a Shanghai-based editor of "old photos" (*lao zhaopian*) sent hers, hoping to include the image in a glossy coffee-table volume for a popular market in China.[65] And before all this, another visitor to the archive might have requested to see the album in person. Opening it to the right page, she would have gazed at it while saying to a friend, "She was my great-grandmother." Although no single one of these many interpretations could stand in for all the meanings surrounding the photograph, they would nonetheless be animated by it, engaging viewers whom the photographer and her colleagues could never have imagined on that Easter Sunday. Viewers of such images now include you, the reader of this book.

Images of and by transnational individuals and communities are thus imbued with multiple experiences of global modernity, Christianity in China, and Sino-US encounters. They are mirrors that reflect and lenses that refract their subjects' and makers' diverse identities, visualizing layered experiences alongside imaginations of "the image and reality of faraway places and times," as described by J. Lorand Matory.[66] Visual conversions, like those across religious and cultural spheres, radically shaped interactions between subjects and image-makers, image-makers and viewers. As historical shifts took place in and around the Christian enterprise in modern China, visual practices and meanings changed alongside them. This book thus illuminates frames within frames—in viewing and sharing, interpreting and imagining.

Frames

I begin *in medias res*, with first encounters with China, seen through the viewfinder. What did it mean for uninitiated American missionaries to imagine acculturation while producing photographs in their new land of adoption? The first chapter, "New Lives, New Optics," traces the experiences of Presbyterian medical missionary families as they arrived in North China and East China in the 1920s and early 1930s, mapping their formative photographic

experiences onto modern cross-cultural perceptions. New technologies and imaging trends in and beyond China directly shaped missionary ways of seeing. Consumer photography and international markets enabled wider accessibility to photographic resources across East Asia. Small, mobile cameras enabled (and promoted) close interactions with local environments. Supporting groups in the United States desired images that represented religious, educational, and medical projects in the mission field. The merging of these conditions gave rise to missionary identities as uniquely embedded cultural mediators and modern visual producers.

As Americans expanded their mission work, they found that photographic images could work as assertions of faith and a common language among believers. The second chapter, "Converting Visions," looks at media technologies and visual practices across the 1920s that connected Chinese Catholic communities in isolated West Hunan to US congregations in West Hoboken, New Jersey. Using colorful examples from the Passionist order, it shows how Catholic missionary-photographers wrestled with environmental contingencies, tensions with Protestants and better-established Catholic orders, misinterpretation of their images by US editors, and visualizations of martyrdom as media events in warlord-era Central China.

In 1931, a New York congregation purchased a cutting-edge Cine-Kodak 16 mm movie camera and shipped it to a Presbyterian mission compound in North China. The odyssey of this device frames a ground-level history of missionary-produced films in East Asia from the early twentieth century onward, as well as of transnational cinematic imaginations—both secular and religious—that shaped the life of the camera and its visual products. The third chapter, "The Movie Camera and the Mission," follows the use of the Cine-Kodak in constructing cosmopolitan images of global missionary contact in the 1930s, as its owners produced films in interwar China for US audiences and footage in the Depression-era Midwest for Chinese viewers. It uncovers experimental film production by a medical missionary family and resulting translations of local space, temporality, and Chinese Protestant identities on film.

The fourth and fifth chapters expand on the ways in which missionary visual practices overlapped with war and revolution in China. These chapters track the shifting production and uses of American missionary images as the nation was beset by the Second Sino-Japanese War (1937–1945) and the renewed Chinese Civil War. The late 1930s and the 1940s were characterized by severe disruptions of missionary activities that prefigured the ultimate end of the foreign missionary enterprise after 1949. Missionaries reacted to

the Japanese invasion by filming military atrocities, aiding the Chinese war effort with visual expertise, and hiding photographs and films between the walls of their mission residences for future recovery. The fourth chapter, "Chaos in Three Frames," looks at missionary visual practices as documentary imaging in times of conflict. It illuminates previously unexplored overlaps between missionary-produced images and the Nanjing Massacre, the Nationalists' formation of Free China, and the Japanese military occupation. Fragmentary images and experiences reflected violence, contingencies, and political polarization. Missionary images dramatically left their prewar existences and entered wartime histories.

As mission institutions collapsed in the early years of the PRC, visual materials became symbols of loss, nostalgia, and imagined futures for American missions and Chinese Christian communities. To trace the nostalgic deployment of missionary images, the fifth chapter, "Memento Mori," explores the contrasting perspectives of two California Province Jesuit filmmakers (one a visitor from the United States, the other a local member of the Yangzhou mission) shooting two feature-length color films with sound narration as their order's centuries-long missions in mainland China crumbled. In parallel with these perspectives, I return to Protestant families and Chinese associates as they produced their final images during the regime change, expulsion of missionary communities, and lowering of the Bamboo Curtain in the early Cold War realignments of 1948–1952.

The book concludes by exploring the later twentieth-century afterlives of missionary photographs and films, looking at their shifting historical existences after the end of the mission enterprise in China. These images vanished, resurfaced, and were reimagined in the vagaries of the global Cold War, the Cultural Revolution, and US engagements with China after the Mao era. This seventy-year period contains episodes of material loss and recovery (alongside changing popular views of American contacts with modern China) and ends with the new circulation of missionary images in a digital world, their increasing visibility in present-day Sino-US cultural and religious relations, and their twenty-first century return to the Chinese communities of their creation. These trajectories are framed by personal encounters with the images and the people behind and within them. At times, these encounters take the form of surprising chance discoveries in archival settings—the recovery of the two aforementioned Jesuit films, for example, occurred in a repository kitchenette used as overflow storage. Others take place in private homes and unexpected storage spaces, accompanied by

the colleagues, children, and grandchildren of named individuals, some of whom lived through the same times with different age perspectives. In this light, I now briefly jump to the end of the book: the momentary bridging of a single photograph, a single life, and an afterlife.

The interview with Liu Ju was mentally and physically draining, as much or more so for her than it was for me and her children in the room. But in a burst of sudden clarity as we concluded our conversation, Liu took my hand and said that I ought to visit again. I gave her a small basket of fresh fruit as a gift. Next time, she said with a smile, we would have a meal together—noodles, perhaps—and talk further. Her son handed me her two precious albums. I was to take them back to my temporary residence in Wuhan and make reference photographs of them before I left China for the United States. This material would be for research as well as the family's use, we had agreed. I walked out of the apartment carrying the albums in a thin plastic bag, an improvised protection against the rain now cutting through the spring heat. On reaching the bottom of the stairs, I began to cry.

A few months after the meeting, I was in California making similar photographic copies of the Henkes' scrapbook. It was then that I came across the photograph, made by Jessie Mae and Harold's medical missionary colleague in China, Ralph Charles Lewis, depicting Liu and her nursing colleagues at Shunde shortly after the Japanese invasion of 1937. Because I had not seen any images like it in Liu's albums, I made a digital copy and emailed it to her son, Li Weilai, who printed it for his mother to see.[67] Sixteen days later, he sent another message:

> I am sorry to tell you that my mother Liu Ju passed away at 03:10 pm, on last Sunday, August 21, 2011. She expired in peace at home, after lunch, but her life quality had been not good since 2009, [due to] asthma, diminished mental state and shingles.
>
> She had lived in this world for 94 years 2 months and 23 days, and she was a very good mother of us. We now finished her burial, and still feel sad. She [was born] in a Christian family, now she was called to be with the Lord. Fortunately, she saw the photo took in 1937 in [Shunde] when she was 20 that [you] sent me, and she still remembered almost all names of her classmates.[68]

Not long afterward, Weilai emailed me a photograph of his mother's room shortly after she had passed away. At Liu's bedside lay an enlarged, framed

copy of the group photograph that Ralph Lewis made, Harold Henke and Jessie Mae collected in their scrapbook, and I sent to her, not knowing what she would make of it. It was an image within an image, encompassing a lost era, relationships and encounters, and a life now past, but undoubtedly well lived. It is with this ending, this looking back, that we now turn to the stories and visions of "all things visible and invisible."[69]

Chapter 1

New Lives, New Optics

Missionary Modernity and Visual Practices in Interwar Republican China

Pedestrians and vehicles pass quickly through the junction of South Xinhua Road and Xinxi Street in the city of Xingtai, some 280 miles south of Beijing. The area is largely residential, populated by drab apartment blocks standing a modest five to seven stories high. Turning the northwest corner onto Xinxi Street and entering through a tall metal gate, a courtyard appears and the traffic noise fades. This yard is bounded on one side by a two-story concrete meeting hall and on the other side by a church with a squat bell tower. In comparison to the apartments that crowd it on all sides, the church, with its stained-glass windows and dark gray brick walls, looks as though it does not belong on this street, in this unassuming city.

It is not the only structure that appears out of place. A few hundred feet behind the church, the enthusiastically named Great Wall Gourmet Restaurant shares a large parking lot with the Xingtai Military Guesthouse. The restaurant is housed in a two-story structure of distinctly early twentieth-century Western design. The entrance is framed by adjoining verandas, most sealed by glass windows or bricked up completely. Whereas the part of the building facing the parking lot is covered in glossy tan tiling, the unmodified rear exposes older hand-laid brickwork, much of it the same shade of ashen gray as the nearby church. Behind the guesthouse, at the right-angle

turn in an L-shaped alleyway, is a gabled house of upright-and-wing con-
struction, closely resembling those found in the rural US Midwest from the
mid-nineteenth through the early twentieth centuries.[1] Like the church, the
house is hidden away behind an apartment building and a concrete wall; the
latter fences in a small exercise yard in front of the gabled façade. With its
exterior brick walls painted a bright yellow, the house is a currently a meet-
ing place for veterans of the People's Liberation Army (PLA).[2] When the
front door is open, the blare of a television echoes from the inside, filling the
otherwise silent yard with music and disembodied voices.

Down the alleyway past a long stretch of apartments on both sides, an
abandoned two-story building fills the view, built with the same brick as the
house and the restaurant and also clearly of early twentieth-century design.
This imposing structure looks as if it had suddenly fallen from a faraway
time and place to block the alleyway. Despite its incongruous state, Xing-
tai's builders left it to decay *in situ*. The building's ungainly size allows only
passersby on foot or bicycles to skirt it, and then only with difficulty. Their
indifference is visible in a halo of everyday detritus around the structure:
cigarette butts, broken beer bottles, and discarded ads mixed with North
China's pervasive grayish-yellow dust. Whereas the first-story windows are
covered with thick metal bars, now laden with rust, the ones on the second
story are fully open to the elements. The rear wall, perhaps because of such
exposure, has partially collapsed. A peek through a jagged hole in the front
door reveals a hallway stuffed with discarded cardboard boxes and packing
material. An aged political phrase painted on the front façade, its oversized
blue-black characters now nearly invisible, heightens the building's mystery.
When one looks at it from the far end of the alleyway, it is barely possible to
make out the Mao-era slogan: "seek truth from facts" (*shi shi qiu shi*).[3]

Another kind of fact seeking is taking place back in the church courtyard.
A series of display cabinets have been installed facing the sanctuary entrance,
placed in such a way that people can easily see them as they exit and enter the
building. Their horizontal layout mirrors congregants' physical movement
as they walk down the steps from the entrance and to the right of the church
to leave the courtyard. However, instead of typical announcements, the cabi-
nets are filled with enlarged black-and-white photographs, many printed on
copy paper with a consumer inkjet printer. Every Sunday morning, when
the congregation streams outside after the service, they literally come face
to face with visual reminders of the community's past. This past is at once
familiar and foreign. The black-and-white photographs mostly depict groups

Figure 1.1. Display case in church courtyard with historical photographs, Xingtai Grace Christian Church, June 8, 2011. Photograph by the author.

of Chinese people, women and men, gathered together with Caucasian individuals. After all, what is now the Xingtai Grace Christian Church (Xingtai jidujiao huai'en tang) was once the chapel for a mission station operated by the Presbyterian Church in the United States of America between 1903 and approximately 1947.[4] During this time, the city was called Shunde or Shundefu, a name that predated the Republican era but persisted through it.[5]

Although the city's name and physical landscape have radically changed since 1947, traces of the former Presbyterian mission remain hidden in plain sight. The four buildings previously mentioned, now repurposed or abandoned apart from the church, are the last structures remaining from the Republican-era mission compound. The brick-and-stone church was one of the first buildings on the site, appearing in documents from 1903.[6] Guests at the Great Wall Gourmet restaurant now dine in spaces formerly occupied by the wards of the Hugh O'Neill Memorial Hospital for Men, the upright-and-wing PLA clubhouse was a missionary family residence, and the abandoned building between the apartments originally housed the Presbyterian Girls' Boarding School, built in 1915.[7] These structures and others that no longer exist were designed by US architects, built with Chinese labor, funded by benefactors in China and the United States, and

staffed by American missionaries and Chinese Protestants.[8] They are the architectural remnants of transnational contact.

In Xingtai today, this connection still exists in the memories of a few nonagenarian church members—most of whom were children when the mission was active in the 1920s and 1930s—and the documents and photographs in the display cabinets, a local history project spearheaded by the church's current minister, the Rev. Wang Ye, and other members of the congregation.[9] With the rapid urban development underway in the city, it is difficult to predict how much longer these physical traces of the missionary enterprise and the church's early history will be visible. One enterprising contractor, property transaction, or ambitious public-works project may be all that is necessary to permanently remove the remaining mission buildings, which have stood for over a century. In this changing environment, the developments of China today are quickly and quietly sweeping away a radically different modern world from China's past.

This former world encompassed missionary modernity in Republican China. It also encompassed images and cameras, leaving behind visual and material traces extending beyond the boundaries of the church courtyard, the city, and the geographic space of East Asia. Most of the photographs displayed in the metal cabinets represent small fragments of larger visual collections produced by American missionaries who lived, worked, and worshiped in the mission compound in Shunde in the 1920s and 1930s. Some of these people, their faces and bodies rendered in the reprinted black-and-white images, now look back at present-day viewers passing through the courtyard, a space that the photographed figures once inhabited. The few remaining buildings from the subjects' time also appear in some of the photographs, then newer and with different intended purposes. The missionaries' presence remains in the present-day space in disembodied and incompletely contextualized visual form, surrounded by reappropriated fragments of their former communal spaces, a striking example of the Barthesian "has been."[10] The missionaries' larger body of photographic work, from which individual images were drawn for display at Xingtai, now resides in closets, garages, and institutional archives in the United States, far from the places and times of their creation. These visual collections include private materials inaccessible to anyone but the people to whom they currently belong (who often regard them as "family photos" or "old pictures of China"). The scattered nature of these collections masks the multiple historical contexts that enabled their production. To best understand the experiences and optics behind the images—and the vagaries of time that

caused these materials to vanish from broader view—we must first look at the historical convergences that brought them into being.

Worldviews and Viewfinders

The missionary modernity of the 1920s and 1930s was a worldview that existed between the larger histories of US presence in East Asia and competing national identities in Republican China. It was not the secular political identity envisioned by Nationalist and Communist leaders or the cosmopolitanism seen in the wealth and glamour of urban Shanghai.[11] Nor was it the pursuit of national moral regeneration promoted by the Nationalist New Life Movement, though some Chinese Christians and missionaries viewed Chiang Kai-shek and Soong Mei-ling, professing Methodists, as emblems of Christian nationalism in China.[12] Rather, missionary modernity was a way of thinking and believing grounded in a modern Christian view of a cross-cultural world, distinct from older worldviews that gave preference to religious conversion of "heathen" peoples while riding roughshod over issues of cultural difference and indigenous cooperation.[13] In practice, it was a way of deploying modern medical and educational methods in parallel with religious conversion and Christian world making.

Missionary modernity was shaped in part by clashes over missionary practice and identity abroad. Protestant missionaries embarking on work in interwar China did so against a background of doctrinal battles fought by US church leaders in the Fundamentalist-Modernist Controversy, with both sides often using missions abroad as testing grounds and targets for their critiques.[14] With fundamentalists arguing for adherence to conservative Protestant beliefs with evangelistic priorities ("saving souls") and the modernists prioritizing progressive humanitarianism ("meeting needs") with liberal theologies, missionaries were caught in "a classic 'no-win situation,'" entangled between contradictory, often intrusive external viewpoints.[15] Despite divides along conservative-liberal lines, expressed in hierarchical clashes and public defections of prominent theologians and missionaries, in practice, most participants in the missionary enterprise held to complementary articulations of Christian belief and outreach. Religious evangelism and charitable activities were often inextricably intertwined and physically coexistent, as in the cases of missionary schools and hospitals that occupied the same grounds as churches and seminaries.[16] The nature of modern missions as embodying service to both God and man was the ideological common ground for

the vast majority of American missionaries in interwar China, who in many cases chafed under conservative and liberal criticism from church leadership abroad.

This essential in-betweenness was well represented by a 1929 article in the *Chinese Recorder*, a Protestant missionary magazine published in Shanghai. Entitled "Modern Significance of the Missionary," the article contrasted modern missionaries against their "primitive predecessors," claiming, "Primitive missionaries worked always and only under one government. . . . The modern missionary is under all kinds of governments and works as a political alien . . . not only a herald of the kingdom of God but [also] a demonstrator of a citizenship higher than any from which he comes or to which he goes. . . . Modern missionaries [are] . . . not only the sharers of a religious experience but the agents, also, of international Christian sharing and colleagues with the Chinese Christians in a search for a new and wider culture . . . permeated by the spirit of Christ."[17] At the core of this "international Christian sharing" was the reconfiguration of missionaries' identity as embedded mediators, working in collaboration with (or secondary to) Chinese Christians to build modern religious community.[18] Instead of prior approaches that privileged a hierarchical, disengaged position in regard to the Chinese population, the modern missionary could not "be thought of only as one who induces a few to accept his message and then passe[d] on elsewhere . . . [he was] the medium of this permanent interchange of Christian fellowship and resources and a permanent essential of the modern demonstration that Christianity [set] up enduring international relationships."[19] Although this was perhaps too much of a "hard saying" for conservative ears, it expressed not only the challenging new realities for missions but also the nature of the images these communities produced. In their visual meanings and the experiences they represented, they too were a medium of permanent interchange.[20]

Of course, the historical shifts in and around Christian missions in 1920s and 1930s China were just as physical as they were ideological. American missionaries experienced local conflicts between the military forces of regional warlords, Nationalists, and Communists in the years leading up to the Japanese invasion of North China that sparked the Second Sino-Japanese War. Shunde, for example, as one of the towns along the north-south Jinghan Railway line running between Beijing and Hankou in Central China, was at various points occupied or in territories nominally controlled by each of these forces.[21] In regional conflicts, missionaries often occupied the same spaces as other foreigners and Chinese nationals (often also foreign-educated)

involved in secular modernization projects. At times, their paths crossed with civil engineers working on railways and bridges, educational reformers and academics, government and military officials, and medical personnel not directly affiliated with church-sponsored organizations.[22] Such encounters in the interwar social and political milieu—combined with the desire to engage with the local environment or otherwise work around its contingencies—pushed missionaries to see themselves, the Chinese people, and shifting political powers as part of a new, modern landscape in which they were collectively bound.[23] These evolving identities gave rise to new forms of expression and imagination broadly driven by changes in the spaces that missionaries inhabited.

The interwar period was a time of increased regional mobility and communication, in part because of infrastructure stabilization across China during the Nanjing Decade, a period of relative political centralization, economic growth, and urban development spearheaded by the Nationalist government.[24] Between domestic conflicts and through the beginning of the Second Sino-Japanese War, missionaries benefited from relatively reliable national transportation and goods-exchange systems. They used national railways to travel to and from cities with greater speed and efficiency.[25] Medical supplies, evangelistic and educational materials, and personal goods—not to mention film, camera equipment, and developing chemicals—used by mission stations in the interior flowed along the same transportation lines from commercial markets on the eastern coast. Newspapers, magazines, and other English and Chinese print media accompanied these shipments.[26] The Chinese postal system carried missionaries' correspondence, publications, and visual materials through its national networks; textual and visual information crisscrossed the country and over the Pacific to international and US mail routes.[27] Photographs, particularly small prints and negatives, lent themselves well to sharing and mailing, as did compact reels of movie film. Attached to letters and albums or stuffed into packages, missionary images made the journey across China and the world.

In tandem, contemporary missionary journals featured images in prominent ways. Alongside extensive textual discourse (covering topics ranging from theological and political debates to architectural and medical practices), many issues of the *Chinese Recorder* contained a glossy illustrated frontispiece and a photographic insert midway through, featuring images contributed by missionaries and other photographers from various parts of China and East Asia.[28] In 1937, for example—the year of the Japanese invasion—the *Recorder* contained images from contributors in Shanghai,

Ikonette
No. 504/12

A New Introduction to Zeiss Ikon Roll-film Cameras

$2\frac{1}{2} \times 1\frac{5}{8}''$. Weight 11 oz.

Zeiss Ikon cameras have gained the first place in the sales record of photographic goods in China. It is due to their high craftsmanship and satisfactory service. This charming Vest Pocket Camera is a new model for amateurs, designed by Zeiss Ikon experts, having all the merits of Zeiss Ikon instruments, but sold at a low possible price accessible even to the modest purse. Its body is made from light metal, covered with grained leatherette, equipped with a rigid front, the focusing of which is made by one single movement either on 6 feet or infinity. The shutter, which is made by the celebrated Compur shutter makers, can be regulated for time and instantaneous exposures. The Frontar lens works from F/9 with stops at F/12 and F/25. It is moreover marked by its easy loading of films in daylights and pictures taken with this small camera can be successfully enlarged afterwards.

Price, $ 14 each

Sub-agents

The Commercial Press, Limited.
Shanghai

D—196

Figure 1.2. Zeiss Ikonette camera advertisement, *Chinese Recorder* 60, no. 5 (May 1929): xvii.

Beijing, Nanjing, and various locations in Suzhou, Hunan, Shandong, Sichuan, and Guangdong.[29] The *Recorder* was mailed to subscribers across the country and abroad, such that these images were widely seen by readers strongly invested in tracking developments in the missionary enterprise.[30] In addition to images, the interwar *Recorder* often featured advertisements for German and American photographic equipment, marketing to an audience that was increasingly interested in modern technologies. Alongside promotional material for Chinese-language manuals and US household products as varied as Bakerite kitchen ingredients and the suspiciously titled Valentine's Meat-Juice (a nutritional supplement for children), readers of the *Recorder* encountered ads for consumer cameras, movie projectors, and film aimed specifically at missionaries on a tight budget.[31]

There was a good reason for this marketing strategy. Like middle- and upper-middle-class US consumers, as well as their counterparts in the Chinese elite, missionaries were drawn to devices representative of modern experience.[32] This interest was perhaps accentuated by their periods of isolation from Chinese urban centers where such technology was more commonplace. As Harry Lewis, the son of a medical missionary at Shunde noted, "The missionaries were very interested in gadgets" (a sentiment echoed by other unrelated missionary children who had lived across China).[33] One of the "gadgets" that Lewis's father, Dr. Ralph C. Lewis, was particularly fond of was a portable Victor phonograph, purchased with funds from Calvary Presbyterian Church in San Francisco before the family left for China in 1933. Ralph Lewis, whose photography is discussed below, mentioned the phonograph multiple times in letters written to family and supporters in the United States after arriving in China. One such letter, written to Calvary Church's congregation a few months after arrival, read: "The phonograph that we purchased just before we sailed with some of the money that the church gave us is surely giving us a great deal of pleasure. It is a very fine instrument and it makes us feel that the person or orchestra is right in the room with us. In the years to come it will help us to keep up our spirits a great deal. . . . Our phonograph is a constant reminder of Calvary Church and we just want to thank you again."[34]

At times, "keep[ing] up spirits" with the phonograph meant that some missionaries (particularly younger ones well versed in contemporary popular culture) privately took part in secular leisure activities like dancing that were often frowned on by older, more conservative colleagues. Jim and Carl Scovel, the two eldest sons of Myra and Frederick Scovel, a Presbyterian medical missionary couple in Shandong, remembered their parents as

"excellent dancers." They would at times "post Jim at the back door and [Carl] at the front door [of the mission house], roll up the rug in the living room, put on . . . dance records . . . and dance—and [the sons'] point was to warn them if another missionary was coming!"[35] For those missionaries funded by more affluent US churches managing to weather the Depression, radios joined phonographs in mission-station homes, mirroring US experiences with this medium.[36] In addition to national and foreign radio broadcasts, Christians in China tuning in after December 1935 would also have picked up hymns and sermons transmitted "free from advertising" by the North China Christian Broadcasting Station.[37] Toward the end of the 1920s, motion-picture technology became more affordable; by the mid-1930s, consumer movie projectors appeared in missions across China for entertainment and educational purposes. Modern missionaries were thus simultaneously converts to and evangelists of modern technologies, with links between mediatory identities, foreignness and belonging in a changing China, and connections to the United States setting the stage for these experiences. Furthermore, to be an embedded participant or agent of permanent interchange meant seeing oneself and making oneself seen in media that reflected these characteristics.

Missionary visual practices of the period were influenced by global developments in imaging technologies and photographic ways of seeing. From approximately 1924 to 1934 the marketing and use of miniature cameras expanded. This movement was dominated first by German commercial exports such as the Leica and Rolleiflex and then by more economical American products.[38] These cameras offered much smaller film sizes than their predecessors, sometimes measured in terms of millimeters (e.g., 35 mm) rather than centimeters or inches, and deemed "miniature" in comparison to the larger film formats then commonplace.[39] This allowed for a higher number of photographic frames per roll, cutting costs for Depression-era photographers seeking to reduce financial outlays.[40] Moreover, advertisements touted miniature camera users' ability to produce—with greater mobility and economy—photographic enlargements potentially rivaling those of much larger cameras.[41] This was only partially true, as contemporary manuals also described the challenges of obtaining acceptable enlargements from small negatives. Doing so required precise control over the image-making process, beginning with high-quality equipment to ensure sharp negatives to work with.[42]

Although not all missionaries used or could afford advanced miniature cameras, parallel innovations in film chemistry allowed photographers with

consumer equipment to access wider imaging capabilities. The creation of films that were more sensitive to all bands of the color spectrum—which technical literature dubbed "panchromatic" films in comparison to the earlier "orthochromatic" emulsions—spearheaded increasing light sensitivity.[43] By the early 1930s, a missionary-photographer could load his or her camera with these emulsions, even if it did not have a high-end (and prohibitively expensive) large-aperture lens, and create usable photographs in dimmer lighting conditions.[44] In stronger daylight, the photographer could select faster shutter speeds, capable of freezing subject motion with far less or no blur while holding the camera by hand. More usably sharp images were thus possible, even under adverse conditions. This was particularly important for missionary-photographers, who, like their contemporaries in travel or documentary imaging, often could not readily retake photographs after the moment had passed or the image-maker or subject had moved on. Advertisements in the *Chinese Recorder* played to these anxieties when marketing to missionary readers, with Shanghai's Eastman Kodak branch touting the advantages of more sensitive film, couched in breathless arguments for increasing mobility and speed.[45]

These technological developments all translated into distinctly mobile visual practices that were more rapid and less obtrusive than those of previous eras and that simultaneously gave rise to new genres of photo-reportage. Although generally excluded from professional image-making categories because of their amateur status, interwar missionary-photographers nonetheless benefited from the similar technologies used by professionals and absorbed documentary images via globally circulated pictorial magazines or other print media. In practice, interwar missionary-photographers could carry a lightweight camera with them and deploy it quickly when needed. Sensitive film freed them from setting up a tripod, a practice that often drew public attention to the highly conspicuous imaging apparatus and its user.[46] Optical aids such as rangefinder and reflex systems shortened the time needed to focus and frame an image, particularly while making photographs on the move. Photographers using small reflex cameras like the Rolleiflex also benefited from an additional technical characteristic. Unlike most large-format cameras and many 35 mm cameras, which required looking straight through the camera viewfinder *at* the scene to be photographed, the reflex viewfinder design required that the photographer bend forward at a right angle to look *down* at the focusing screen. The photographer would have appeared to be bowing to the subject of his or her image, simultaneously presenting a nonthreatening physical profile and avoiding a direct gaze.[47] These

viewfinders and the worldviews of missionaries behind them combined to create specifically modern visualizations of China.

All these factors contributed to the camera's unique roles in shaping and representing distinct forms of missionary experience on the ground. As missionaries explored Chinese environments for the first time, their photography merged mobility and visual curiosity, influencing the ways in which cultural encounter and acclimation were carried out. With cameras in hand and language-school lessons in mind, image-makers engaged in spatial, linguistic, and cultural navigation mediated by the act of image-making. The resulting photographs then entered networks of circulation, connecting makers to US communities left behind. Photographers' ties to the United States and desire to maintain links with faraway families and friends (especially as foreigners in a new land) encouraged the making and sending of images as mementos, sharing sights of China that complemented and often expanded beyond standard textual correspondence. As missionaries moved beyond acclimation and language training and took up their specific mission projects, their visual practices evolved in form and function. Entry into China at large gave way to entry into their work, with images visually transmitting knowledge and results on an institutional level. Although missionaries began by using the camera in a straightforward way as an exploratory tool—much as nonmissionary visitors to China did—this gave way to visualizing growing embeddedness, as missionaries envisioned what it meant to be aligned with Chinese Christian groups in faith and practice, as partners in (and members of) a global religious community.

Imaging Cross-Cultural Encounters

On a Sunday afternoon, Harold Henke sat down at his desk and loaded a piece of paper into the typewriter sitting in front of him. A few turns of the advance knob brought the page under the roller into position, revealing the neatly preprinted letterhead at the upper left margin: "NORTH CHINA UNION LANGUAGE SCHOOL—PEKING, CHINA."[48] Anticipating the letter's lengthiness, Henke wasted no space. His keystrokes embedded the date in the paper immediately below "CHINA" in the letterhead. It was October 23, 1927, and the doctor was writing from a room assigned to him and his wife Jessie Mae in the school's dormitory, located on Hatamen Street in Beijing.[49] It was only the couple's third week in China, and they found it prudent to draft a letter to friends and family in the United States awaiting details of

their experiences abroad. Included with the letter were photographs produced by the Henkes during their transpacific journey and in their first days in China. Like the typewriter and its mechanical structuring of text, these images and the photographic activities that produced them structured the missionaries' new encounters with foreignness.

In writing, Harold Henke described the "dandy trip across the Pacific" on the SS *President Pierce* with another Presbyterian missionary, a "Dr. Turner, who with his wife and 3 months [*sic*] old baby" was "studying the [Chinese] language here" with the Henkes. He also detailed brief touristic jaunts in Japan as they transferred to a coastal steamer, the *Chozo Maru*, carrying them from Kobe to Tianjin.[50] Most notably, the account of traveling from the United States to China was formed not only by what the Henkes did but also by what they *saw*. In fact, a number of the descriptions combine images and imagination in a strikingly vivid manner, as in Harold's account of travel across the Inland Sea of Japan: "[Seeing] more fish of all shapes, sizes, color, and amounts than ever before . . . [the sea] quite beautiful all the way along, smooth as glass, and flanked by high mountainous shapes in every nook of which was a little village."[51] Although the letter makes no mention of photography, the clear nods to visuality indicate that Harold recalled specific instances in which sight made an impression on him, much like a photographer recalling striking image-taking moments. Eight photographs of the voyage survive in an album that the Henkes assembled sometime during their first year in China. Two of these black-and-white prints, depicting "a fishing junk sailing at full speed" and an island in the Inland Sea, strongly support the possibility that the act of photography imprinted certain images in Henke's imagination.[52]

These links between image and imagination entered the letter as Harold shared "our first view of China" with readers in the United States. His emphasis on visual cues is almost palpable as the third paragraph begins:

Sunday morning October 2nd we awoake [*sic*] to our first view of China, the bay, harbor, and shore at [Tanggu]. There the view is one of a low, flat, barren coast line with piles everywhere of the brown salt and the windmills and necessary apparatus for pumping the sea water into the drying vats. . . . We entered the mouth of the Haiho river and steamed slowly up it 6 miles to land at Tangu [*sic*]. The shore of the river was dotted with frequent fishing villages made of low, mud houses built tight together in regular formation. Fishing boats of every size and shape, nets, barges . . . and Chinese were everywhere.[53]

The typo in the first sentence is telling. The letter shows that Henke first typed "we awake," as if reliving the experience, and then retyped a bold "o" over the "a" to shift from present to past tense. This instantaneous quality merges with visual cues drawn from focused observations of the new environment, heightened by anticipation and amazement. The description almost identically mirrors the first two photographs that the Henkes took in China, which survive as 3.25" x 4.25" black-and-white prints depicting the "shore of the river" mentioned in the letter and the port of Tanggu as their ship docks at the wharf.[54] Given the specificity of the letter description, it is easy to imagine the couple recalling not only what they saw as intent observers on board the docking ship but also more specifically what was framed in their folding camera's viewfinder in the moments before and after releasing the shutter.[55] Harold and Jessie Mae Henke's first encounter with China was thus shaped by photographically mediated vision.

The importance of the occasion was evidently great enough for the two photographs to be later reprinted repeatedly, appearing together no fewer than three times in albums and loose folders in the existing family collection. These prints represent an elevation of the moment through photography while also making concrete the ability to see as an emotional climax. After all, images shape and are shaped by complex feelings—in this case, anxiety, uncertainty, and a fear of the unseen. Although Jessie Mae recounted the trip as "enjoyable" (she and her husband were reportedly "the youngest first class passengers" and "won most of the tournaments in deck games"), it is clear that at one point while underway, the Henkes were suddenly unsure of where they would land in China.[56] During the voyage from Seattle to Japan, "a cablegram, received enroute [*sic*]," informed the couple that the Presbyterian Board of Foreign Missions in New York had changed their original mission posting from "Yueng [*sic*] Kong, South China" to "Shuntehfu, North China," a difference of several thousand miles. Moreover, the message contained "instructions to get off in Japan, transfer to a small Japanese liner, cross the Inland [S]ea to the port of Tangku, thence by rail to Tientsin and Peking," no small task for two Americans with no formal training in Asian languages.[57] The drastic change in travel arrangements, determined by a single wireless transmission from a now-distant mission organization, likely unsettled the Henkes. Because of this, seeing their disembarkation port for the first time on the morning of October 2, 1927—over a month after they had left the United States—may well have provided a sense of relief.

The caption on the back of the second photograph, in Jessie Mae's handwriting, reads quite simply, "The wharf where we landed at Tangku, China . . .

October 2, 1927."[58] The photograph itself depicts a striking immediacy; the ship is a few hundred yards away from shore, but the figures watching the vessel approach are clearly visible in an enlargement of the negative. The image represents a microcosm of the world that the Henkes were about to enter. Six foreign men dressed in full suits and fedoras stand with hands in pockets at the part of the dock closest to the approaching ship, one of them leaning rakishly on a bamboo cane. Behind them, a group of working-class Chinese men converse, seemingly uninterested in the spectacle. Other Chinese individuals with clothing ranging from Western suits to traditional *changshan* stand about at various distances on the dock, all watching the arrival. The camera also froze a dockworker in motion, waving a striped signal flag to guide the ship's pilot to shore; the bright sun enabled the Henkes to select a sufficient high shutter speed to freeze the flag in mid-sweep.

Of course, whereas the photograph embodies the presence of individuals gazing back at the camera, the Henkes' perception extended only as far as the new scenes immediately before them. They had yet to learn how to see and navigate this foreign world. As Jessie Mae later noted, while she and Harold gathered their belongings prior to disembarkation, they came face to face with the unfamiliar environment that they were now entering. She was "terrified at the yelling that was going on, on shore," and peered out of the porthole to "see half a dozen Chinese men with a rope they seemed to be wrapping around one of them."[59] Unable to understand their language or the context for the actions, she believed she was witnessing "a hanging."[60] More than simply figures seen from a distance, the previously photographed Chinese laborers were suddenly very much a part of the Henkes' physical space and perception. Yet, even though the photograph does not fully capture the feelings and observations articulated in the text (as much as the text, unlike the photograph, does not show the viewer what the laborers looked like and how they appeared in the environment), the image speaks with other forms of perception. This image was made from a distance, representing a physical as well as a cultural disconnection from the Chinese landscape that the Henkes first encountered. But others, produced during the Henkes' language-school period, indicated that photography was among the driving forces behind the couple's growing associations with space, place, and people. As they gradually familiarized themselves with what they later called "the land of our adoption," the use of the camera allowed them to develop fresh ways of seeing.

Such new visions were buttressed by experiences of acclimation. To prepare themselves for long-term medical missionary activity, the couple

spent late 1927 to early 1929 studying Mandarin Chinese in Beijing.[61] The North China Union Language School (later renamed the College of Chinese Studies, accredited by the University of California), as Harold Henke noted, "was a fin[e] place to start life in China." Jessie Mae later recalled that the school campus consisted of "dormitories, [a] dining room, classrooms, [an] auditorium, tennis and paddle tennis courts. Married couples were assigned two rooms, with common bathrooms and showers."[62] This was a space of familiar people and culture, with the Henkes studying alongside nine other Americans. All of their instructors were Chinese, and visiting academics and diplomats gave guest lectures to supplement the routine lessons.[63] The familiar, however, could also be isolating. The October 23, 1927, letter bears out the school's separation from the outside world, with Harold Henke stating, "Inside the wall, we can hardly realize that this is China, and were it not for the occasional sounds, music of a weird variety, from a passing funeral or wedding outside, or from the flocks of doves that soar around every morning, we would almost think that we were . . . at home."[64] But this space with the trappings of a displaced American home was meant to be a portal, not a shelter. The school was a starting point for the Henkes' life in China, facilitated by experiential, linguistic, and visual immersion.

Students at the language school spent each day in intensive study of "Chinese language, geography, history, and culture" from morning to late afternoon, with Chinese instructors not permitted to speak or use English in any way (so as to encourage their foreign charges not to, either). The Henkes' letters contain multiple references to "learning our Chinese vocabulary and characters." They prided themselves on learning "300 words" by the end of November and a body of 1,000 more, written and spoken, by the end of the academic year.[65] It is possible that the environment of the school's small foreign community, combined with daily exposure to the Chinese language, influenced the Henkes' decision to produce photographs in their spare time. In a literal sense, they developed a collection of sights outside the school as they progressed in language study and understanding of the country. The extant photographs from this year and a half in Beijing focus on images of Chinese architecture and daily life, with a strong emphasis on street scenes and depictions of individuals at work.[66] Yet, as much as these images depicted ways of life very different from the couple's US experiences, they also represented growing relationships between visual practices and the environment. Photography not only enabled visual representations of spaces and places but also guided—or even demanded—greater proximity to people, things, and cultures.

After describing the relatively cloistered campus life, Harold Henke expressed relief at experiencing the outside, pointing out, "Peking is always interesting when we see it from the street." He then listed a number of sights that he witnessed "this morning as [he] went to the American School [a boarding school for foreign children] where [he] . . . took a class of high school seniors in the Sunday school," recounting in particular "a camel caravan which had just arrived . . . vehicles of many shapes . . . [and] several carpenter shops where men were sawing great logs into planks by the system of one man above and one man beneath pulling a saw back and forth by hand."[67] Although Harold did not explicitly mention having a camera with him as he witnessed these sights, several images closely mirror these descriptions. The main difference between the observations recorded in text and the photographs was that the text required the Henkes' audience in the United States to visualize the written contents. By contrast, the photographs allowed others to see elements of what the couple saw and to participate vicariously in their visual experiences. It is easy to imagine Harold and Jessie Mae carrying their camera when out on walks, unfolding it and snapping photographs of things that caught their eyes as passing observers; the camel trains, the carts, and the sawmill all appear in their photographs. The Henkes' street images exhibit a snapshot quality, sometimes evidenced by a tilted horizon, indicating that they were looking down into the small reflex viewfinder and focusing on rapidly tripping the shutter rather than carefully leveling the camera.

Such views soon included symbols of Chinese history and culture, likely created out of a desire to see physical representations of lessons they absorbed in the language-school classroom. Along with street scenes, the Henkes photographed the Forbidden City, the Temple of Heaven complex, and the former imperial gardens at Beihai. Although the resulting images resemble tourist photographs, recording the missionaries' visits at these monuments to former dynasties, their captions note what photography could *not* do in mediating perceptions. On the back of one black-and-white photograph of the Temple of Heaven, Jessie Mae noted that "the roof [and] decorations" were "a vivid blue."[68] Similarly, Harold Henke's caption for a photograph of Beihai's popular and much-visited Nine-Dragon Screen describes the massive Qing Dynasty decorative wall as "[made] of porcelain" with the dragons "in brilliant blue, brown, green, and red."[69] These two prints indicate that the Henkes were well aware that their photographic technology, rendering images in black-and-white rather than color, was incapable of reproducing scenes as seen in person by the naked eye. By recording these details, they

not only attempted to transmit a fuller visual experience to their audiences but also reinforced (to themselves and others) that the images—much like an uninitiated visitor in a foreign land—could not fully "take in" the complex realities of the views before their eyes. Even the camera, as a modern apparatus, was insufficient for this purpose. This tension would undergird the Henkes' experiences, along with those of many other missionary image-makers.

For the moment, to address color limitations, the Henkes purchased hand-tinted prints at Hartung's Photo Shop, a major business in Beijing's Legation Quarter, and had some of their own images tinted there as well.[70] While engaging in apparently touristic visual practices—photographing well-known historical monuments and purchasing commercial postcards and prints to supplement their own images—the missionaries began to merge their developing awareness of the local environment with visual practices. Their photographic activities in the city, combined with their expanding linguistic skills and knowledge of the landscape they would inhabit for years to come, translated into ways of mapping language, place, and culture onto images.

One photograph made that same year, prominently featuring an ornamental archway (*pailou*) over a busy Beijing street, represents this mapping of spatial imaginations. On the back, Harold Henke wrote, "Taken at the main cross streets 2 ½ blocks from here & called SSu-Pailou (the 4 pailous) 2 of which can be seen—all alike. Our post office is at right. All people are Chinese. 2 policemen in the right center, a soldier on either side, 2 men & a lady in rickshaws. Looking north. Language school is north 2 blocks and east to your right—2 blocks. *Hatamen St.*"[71] Henke emphasized the romanization of the Chinese place name first and then attempted to translate it into English, exhibiting an elementary attempt at translingual practice. Moreover, his caption seems to describe the photograph to an unseen audience that is nonetheless somewhat familiar with the photographer's environment; the scene is described as being taken a known number of blocks "from here," using the language school as a reference point. The caption contains a particularly self-referential tone, as if Henke is giving directions to himself ("Language school is north 2 blocks and east to your right—2 blocks") while also reinforcing his own immersion as a foreigner in the environment ("All people are Chinese.") Given that the Henkes were honing their language skills and local comprehension, the image and its caption emphasize a nascent familiarity with specific urban locations as well as the photographer's ability to identify these places and architectural elements by their Chinese designations.

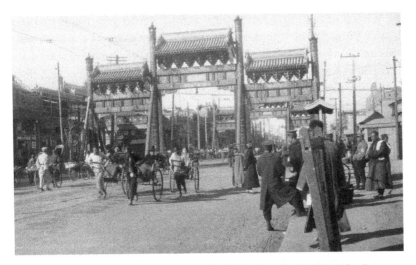

Figure 1.3. "Taken at the main cross streets 2 ½ blocks from here & called SSu-Pailou," photographic print, photograph by Harold Eugene Henke and Jessie Mae Henke, ca. 1927–1928, HFC.

The image also demonstrated the Henkes' ability to differentiate between city policemen and soldiers, who were equipped with similar military-patterned uniforms. This was no idle observation, as the Henkes had arrived in China toward the end of the Northern Expedition, spearheaded by a Nationalist-Communist front under Chiang Kai-shek. The campaign to eradicate warlord powers included anti-imperialist actions by leftist and Communist participants in the expedition, resulting in the looting of churches, the killing of several foreigners in Nanjing, and the large-scale evacuation of thousands of missionaries from inland locations in early 1927.[72] With these events fresh in the historical background, it was not surprising that Harold Henke made sure to identify soldiers (who were widely recognized as having targeted foreigners in Nanjing) and ostensibly more neutral policemen (who might have provided some security). Indeed, the couple observed repercussions of the Northern Expedition's final push in the spring and early summer of 1928. As foreign noncombatants, they occupied a fly-on-the-wall position in relation to the conflict. While on a short trip to Nankou outside Beijing on March 10, 1928, Harold and Jessie Mae met a squad of warlord troops, part of Zhang Zuolin's modernized Fengtian Army, conducting target practice in an open field. The Henkes apparently communicated with them in Mandarin and photographed the drills. In one photograph made from a point near the ground, a prone infantryman glances into the lens a few yards away while in

the process of sighting down his rifle. Harold Henke, who had served as a Marine Corps machine-gunner in the 1919 US occupation of the Rhineland, may have knelt or even lain on the ground next to the Chinese infantryman, his military background informing his apparent comfort with being in close proximity to soldiers firing their weapons.[73] Interestingly, Henke noted in the image caption that the troops were "very courteous."[74] It is unclear if this was meant to reassure viewers that the couple was in no danger while making the image, or if the Henkes found the warlord troops surprisingly different from their reputation (particularly in Western imaginations) as brutal antiforeign forces. Or maybe it was both of these, along with the satisfaction of being able to interact with and photograph an armed group that could easily have posed a threat to the Americans. In any case, the image embodied a literal ground-level meeting between two groups embedded in interwar China, albeit with radically different goals and fates. The soldiers at drill were later thrown into bloody, ultimately futile battles against the approaching Nationalists that resulted in the collapse of Zhang's control over North China by the early summer of 1928.[75]

Jessie Mae Henke noted more indirect encounters with this regime change while she was hospitalized with typhus at the Peking Union Medical College that summer: "A political turn over in Peking took place. One night we were under Chang Tso-lin's [Zhang Zuolin's] rule. The next morning I awoke . . . and looked out the window at a change of flags on the street. I was told that [pro-Nationalist warlords] were now in control and Chang['s] . . . train, retreating to Manchuria, had been dynamited. He was killed."[76] Nationalist forces attacking northward forced Zhang Zuolin's retreat from Beijing, after which his son, Zhang Xueliang, declared allegiance to the Nationalist government under Chiang. This was "the political turn over" that precipitated the "change of flags" that Jessie Mae viewed from her hospital room.[77] Beyond new flags, Beijing would soon be officially renamed Beiping by the Nationalist government to retain the city's significance without overshadowing the Republic of China's new capital in Nanjing—a name that would remain in place until 1949.[78] This period, with its bewildering shifts in terms and symbols beyond any individual purview, made a strong impression on the missionaries' collective consciousness. Evangelists at the Henkes' later North China mission carefully included in their visual collection a commercial photograph (a Hartung's product) depicting Zhang Zuolin's destroyed railway car.[79] What the missionaries could not then know or see was that Japanese forces had orchestrated the assassination, a grim foreshadowing of the following decade's global conflicts in which the missionaries themselves would be

caught up.[80] These were not the last times the Henkes would meet military forces known to history for brutal violence but encountered by missionaries in surprising (even momentarily "courteous") ways.

All this took place as the Henkes began their transition from acclimation to long-term work in the rural mission field. In January 1929, the Henkes moved to the city of Baoding and spent approximately a month assisting the Presbyterian hospital there, after which they began their permanent assignment at the Shunde mission.[81] At the hospital and church compound just outside the city's western wall, the Henkes settled in and joined a diverse group of staff: Chinese and American doctors, nurses, teachers, and evangelists, women and men. Their camera, of course, went with them. In this community—the world of their missionary calling—the Henkes' visual practices took on further meanings, tracing their progressive involvement in medical work while producing images that connected their mission to institutions within and beyond China.

Entering the Mission

A 1931 mission report, written in part by the Henkes, states: "Our patients come to us from an area of about 14000 square miles in which it is estimated that there are living three million people . . . the nearest hospital to us is 80 miles away either in a north or south direction or three days by mule cart either to the east or the west."[82] The medical facilities were centered on two primary hospital buildings, the Grace Talcott Memorial Hospital and the Hugh O'Neill Memorial Hospital, named after Presbyterian benefactors.[83] As with many Protestant medical institutions across China, the compound's Chinese name was simply the "Gospel Hospital" (Fuyin yiyuan), a term that the missionaries used interchangeably as well. It was at this "only modern hospital" compound that Harold Henke took up a position as cosuperintendent, working alongside Dr. Chang En Ch'eng, a Chinese doctor trained at the Peking Union Medical College.[84] Jessie Mae Henke began her tenure as an operating-room nurse before becoming the Nurses Training School superintendent, teaching courses in nursing techniques, medical theory, and hygiene in a large brick classroom building.[85] As simple as this transition sounds, however, running a missionary hospital in North China was no easy task.

The Henkes and their Chinese coworkers faced many challenges, some of which they attributed to antiforeign politics and unsanitary conditions. Jessie Mae noted, "Fear of foreigners was rampant due to [the Northern

Expedition's repercussions] of 1926–1927. Those 'foreign devils [*yang guizi*]' 'cut out eyes and hearts of the Chinese and ground them up for medicine!' they said."[86] Even more pressing than simmering xenophobia was the poor state of the mission's neglected medical facilities. As the Henkes were taking over for missionary personnel who had left Shunde during the upheavals of 1926–1927, they arrived to find the compound in a state of disarray: "All wells—8 in the compound—were contaminated with typhoid bacillus." This meant that the water had to be consistently boiled before use ("[often] not hot enough"), and that medical serums "had to be hung in baskets down the wells," possibly the same wells contaminated with typhus, as these were "the only cool place to keep them from spoiling."[87] The only working medical equipment when the couple arrived was "an old pill machine," and the staff was limited to "several male 'nurses,'" a Chinese female nurse, and a single overworked American nurse, Minnie C. Witmer, who had been at Shunde since 1921 and had not evacuated with other missionaries.[88] With these conditions in mind, the Henkes began by requesting support from congregations in the United States, sending reports back to the mission board. Despite the stock-market crash of 1929, some funds began to flow back to Shunde; subsequent reports recorded the arrival of a laboratory cystoscope and an incubator, as well as the "installation of the new heating plant," but added that the mission still needed "an X-ray and a larger in-patient building."[89] Given the compound's transitional state, it is not surprising that the only images included in the 1931 report were one of a main hospital building at Shunde and a poorly reproduced group photograph of the medical staff.[90]

The dearth of photographs in the early reports does not mean, however, that no meaningful images were produced during this time. Rather, the 1930s were an eventful decade for the Henkes, in medical as well as visual practices. The photographs produced during this time can be separated into two categories: images made to record improvements in the medical facilities and those documenting diseases and patient healing for medical research. Both categories of visual materials now had specifically institutional roles. Although many images still circulated as personal photographs among the Henkes' families and friends, the mission board reprinted copies in publicity material and shared them with churches that supported the Shunde mission collectively or the Henkes as individual missionaries. Together, this mélange of images traces developments in the medical mission while also containing moments in which the limits of this work—or at least the pressures exerted on the Henkes and their colleagues, ranging from environmental effects to incurable diseases—came into clearer focus.

The first category of images parallels improvements in medical facilities and staff training at Shunde. One of the first tasks the Henkes completed once the hospital complex was prepared for use was to photograph the buildings and mail the prints back to a contact in the United States, who then forwarded them to the Presbyterian Board of Foreign Missions in New York. Each print was given a filing number and an office address neatly written on the back to facilitate more efficient handling once it was received.[91] All three photographs depict the Grace Talcott Memorial Hospital. Two of the photographs show exterior views of the building, and the third is an image of Harold Henke shaking hands with another missionary at the doorway to the hospital. The doctor grins comically at the other (far more stoic) man, perhaps out of jest at the image's clearly posed nature.[92]

Successive photographs made by the Henkes represented solutions to the problems that they noted on their arrival. Two prints from May 1935 show a man-powered drilling rig at work in the compound.[93] The photographs, each of which is taken from a different angle, are captioned "Drilling for water at Shuntehfu, China[,] May 1935" and "The apparatus for drilling the well[,] May 1935." The typhus-contaminated wells that troubled Henke so much when she and her husband first arrived were finally being dealt with. The initial shortage of trained nurses was also alleviated by 1931, a development dramatically reflected in the photographs. When the Henkes arrived in 1929, they met and photographed Chang Jui Lan, the single Chinese female nurse in residence at Shunde at the time; a print from that year shows Chang standing by herself, looking rather forlorn.[94] A slightly blurry photograph later that year shows six Chinese men and three women sitting on the same steps, one of the women in the front row grinning shyly as the shutter snaps while she is adjusting her hair. The caption, written in Harold Henke's hand, simply reads, "The students."[95] By 1931, a large professional photograph heralded the results of continued medical education. The original class of nine was now a serious group of fourteen men and six women, gathered on the lawn near their classroom to face the lens of a Chinese studio photographer.[96] The occasion was the departure of Minnie C. Witmer, the American nurse who preceded the Henkes. After a decade of work, she was stepping down as superintendent, to be officially replaced by Jessie Mae Henke and the now larger cohort of Chinese staff.[97] Nurse Chang, looking much less weary than in her 1929 snapshot, stands to Witmer's left in the group photograph, surrounded by her new colleagues and students. Their formal dress, the high quality of the print, and a neatly scripted Chinese caption indicated a visible pride in Sino-US partnership as well as an emphasis on locally driven

professional development. Not only were Chinese members in the majority but the event the photograph commemorated—a medical missionary's return to the United States—also symbolized a small-scale (albeit incomplete) passing of the torch from foreign oversight to greater indigenous agency.

Building medical facilities and training Chinese staff were not the only goals of medical missionary work at Shunde. The missionaries were there to treat local Chinese patients. As they did, they recorded their medical work in informational reports sent to supporting congregations in the United States. Extant copies show that comprehensive medical reports were produced in 1931 and 1939.[98] These publications, professionally printed and bound with thick, illustrated covers, indicated that the missionaries at Shunde took seriously the responsibility of sharing medical conditions with home congregations and the Board of Foreign Missions. Reflecting the professional nature of the medical work, records of diseases treated, patient statistics, laboratory examinations, and surgical operations were collected for the benefit of other medical missionary personnel in China, with wider distribution facilitated by the mission board. The 1931 report, for example, contained information ranging from the treatment of anthrax cases with newly developed drugs to the following recommendation: "All small hospitals [should] prepare their hypodermic medicines in ampoules . . . all of ours are now so prepared . . . we find the method safe as to dosage, convenient, money saving, and simple in preparation."[99]

Although these reports presented an orderly record of medical missionary activities, they were also by nature impersonal and sanitized; diseases, injuries, and treatments were reduced to numbers on a page. The Henkes turned to photographs to present a more human face to their medical work. Some photographs documented successes in medical treatment and evangelistic outreach for the encouragement of support congregations. In contrast to the sparsely illustrated 1931 medical report, the 1939 report features a section entitled "The Fruits of Labour," containing short narratives of successes in connected evangelistic and medical work as well as photographs depicting recovered patients. One such report reads:

Imagine the joy of being able to eat solid food after nine years being on a diet of liquids which could pass between the teeth! Such was the experience of a lad of fifteen who came to us for healing. As a small child, he had had an ulcer which [had] formed in his cheek, destroying much of the jaw . . . in the healing processes of nature, scar tissues and muscle contractions had resulted, so that he was not able to open his mouth. An operation was

performed which relieved this condition and he was indeed happy to be able to talk and eat like other boys.[100]

The effectiveness of this report, however, did not only lie in urging readers to "imagine" the prior condition and recovery of the boy; they could see for themselves. In the accompanying section with captioned images, a photograph shows the boy and his father outside the hospital, smiling. Harold Henke, dressed in a lab coat to identify himself as a doctor, smiles at the boy instead of the camera, indicating a personal familiarity with his patient. In fact, Henke's smile appears in many of the photographs and, later, films, perhaps as a way of signaling confidence and reassurance for viewers (though the Henkes' children and contemporary writings indicate that this exuberance was simply Harold's abiding personality trait). Whether intentional or natural, Henke's smile boosts perceptions of improvement when looking at the photographs in which it appears, whereas those in which it is conspicuously absent present a serious or even alarming tone—subtle emblems of difficulties beyond the frame.

The largest collection of medical photographs taken by the Henkes was not published in the reports at the time. Almost all of the photographs in the 1939 report depict patients who are either under treatment or in various stages of recovery, with the only sign of clearly unusual disease displayed by the "before" photograph of a man with a large growth on his back.[101] Even this is successfully overcome, as suggested by the cheery "after" image. Whereas the missionaries selected these images to share their successes with supporters, they refrained from showing other, more graphic photographs of untreatable diseases. In addition to needing to present an optimistic view of their medical abilities, it is possible that the Henkes and their colleagues also did not wish to casually present images of Chinese bodies that would reinforce a spectacle-like fascination with the grotesque that would have been familiar to US audiences.[102]

The uncirculated photographs present a graver view of medical problems faced by the staff at Shunde. Unlike the aforementioned personal or published images, many of the medical photographs lack annotations; combined with their more clinical composition, this indicates that they were intended for research purposes. They also play a dualistic role. On the one hand, they were clinical documents of severe medical conditions not found in the United States. Referring to this medical photography, Jessie Mae Henke stated: "[Of certain diseases] not seen in our own country, we took more pictures . . . because we didn't see them; it was rare."[103] On the

other hand, the photographs represented the difficult and often unsuccessful tasks of treating such diseases. Several of the photographs in the "Medical Practice" section show what appear to be advanced carcinomas, graphically depicted in close-ups.[104] The existing notations, where they appear, are often rigidly clinical, as if Harold Henke (in whose handwriting most of the captions appear) was attempting to place some distance between himself and the suffering individuals he photographed. An image of a patient lying in the inpatient ward, his back and neck covered with tumors, reads simply, "Von Recklinghausen's disease. Note . . . ulcerated tumor on back."[105]

Beyond performing straightforward documentation, the photographs also captured failure, particularly in working with diseases that were beyond medical capabilities to address, then and now. Another patient photograph, this time of a young, sleeping child with a large tumor enveloping most of his or her right eye, carries the following note: "Is this a tumor of the retina ? ? Babe died 1½ days after of meningitis."[106] The double question marks and the terse note of the child's death from complications, comments not seen in other captions, capture the deep feelings of helplessness that existed in parallel with medical successes visualized in other photographs. Despite the missionaries' training, equipment, and data rooted in modern Western medicine, some of their patients were tragically beyond saving. Here, the camera and its products preserved what could not be fully seen, known, or treated, with such images providing visual representations of gut-wrenchingly clear limits to medical missionary enterprise.

Joining Communities

Dr. Ralph C. Lewis, his wife, Roberta Taylor Lewis, and their four-year-old son, Harry, arrived in Shunde six years after the Henkes, near the end of September 1935.[107] Hailing from Santa Ana, California, and a graduate of Occidental College and Stanford Medical School, Lewis had applied to be a medical missionary to China at age twenty-four.[108] Lewis brought along a secondhand Rolleiflex Original twin-lens-reflex camera with an advanced 75 mm f/3.8 Carl Zeiss Tessar lens, producing twelve 2.25" x 2.25" photos on medium-format film.[109] It was one of the highest quality miniature cameras available at the time, and its owner proudly recalled in his memoirs, "I had purchased a good camera before going out [to China, and] I wanted to learn as much as I could about photography."[110] Whereas other missionaries, like the Henkes, sent their negatives out for commercial developing at

photographic shops like Hartung's, Lewis insisted on developing and print-
ing his own images, despite having limited time in between language study
and other preparations for the mission responsibilities.[111]

After arriving in China in the fall of 1933, while undergoing language
training at the same College of Chinese Studies as the Henkes had attended,
Ralph Lewis accompanied Sam Dean, a veteran educational missionary, to
a small church in a village beyond the city outskirts at "the foot of the west
hills." This congregation was established by the Chinese Christian students
of an engineering school (Beiping huabei gongcheng xuexiao) that Dean
founded under the auspices of the Presbyterian Board of Foreign Missions,
but the church itself was "entirely self-supporting." This description was not
merely missionary wishful thinking. In addition to their formal training in
engineering and architecture, over a period of three years, the Chinese stu-
dents from Dean's school independently built a primary school and church
building from a set of ruined foundations in the village. They staffing it
"with a Pastor who [was] paid by the congregation. The boys from [the
school in Beijing went] out alternately on Sundays to help in the services and
do some street preaching." The Chinese congregants, in turn, received train-
ing and equipment from the engineering students "to weave good cloth . . .
getting along very well with it and [now had] more orders than they [could]
fill." On this December 17 visit, Lewis took his Rolleiflex camera along as he,
Dean, another American Presbyterian missionary (John Hayes), and several
Chinese students drove an old Dodge truck into the village. After arriving,
the students unloaded and began "singing hymns to Chinese tunes," draw-
ing a sizable crowd to whom they preached and shared personal testimo-
nies. Afterward, Chinese Christian villagers and the students gathered in
the church to sing more hymns (accompanied by an organ purchased by a
church member, "a retired merchant," and played by one of the engineering
students), listen to a sermon, witness the baptism of seven new congregation
members, and partake in a Communion service.[112]

As these events unfolded, Lewis removed his Rolleiflex from its leather
case and made a single photograph. This unposed moment before the lens
emphasizes not the agency of foreign missionaries, but the religious work
and experiences of the Chinese Christians who take center stage. The Chi-
nese pastor presides over the seven new members being received into the
church. Behind the group, handmade posters display phrases written in
the manner of traditional matching couplets: "The Temple of God," "The
Heavens Declare the Glory of the Lord," "Peace on Earth Be to All Men."[113]
The community members in the image have assembled their own style of

collective worship, appropriating translations of biblical Scripture as signposts for their Christian identity (the room is not merely another village building, but "The Temple of God") and they are enacting their belief in the moment and space framed by the photograph. The congregation's bowed heads and the pastor's closed eyes indicate that they are in prayer, communing with God individually and as a group.

The angle from which the image was made indicates that Lewis was sitting at the far end of the church, likely on a bench or stool similar to those visible in the frame. He would have braced his Rolleiflex against his body to hold it steady during the longer exposure in the dim interior light; the sharpness of the image indicates that this was successful. The Rolleiflex's comparatively wide lens aperture for its time (f/3.8) enabled Lewis to make the handheld image without having to resort to an obtrusive tripod. Moreover, the camera's design required that Lewis look down and into a reflex viewfinder to frame, focus, and trip the shutter—almost curling himself into a ball. Lewis's huddled position, his spot at the far end of the church (instead of moving to the front and disrupting the service to make the image), and even the near-silent "snick" of the leaf shutter firing all minimized the photographer's presence in the space, at least at the moment of exposure. The image itself thus represents the service from the individual perspective of a hypothetical congregation member sitting and praying together with other Chinese Christians, and the process of making it characterized the missionary-photographer's presence as an unobtrusive participant rather than an intruder. Photography, in this case, mirrored a modern, relational perspective on Chinese Christianity and missionary in-betweenness more than it reinforced a sense of difference and foreignness.

A photograph that Lewis made shortly after the service shows the new members of the church and the Chinese pastor standing in front of the building, dressed in formal clothing and looking proudly into the lens while holding Bibles, the symbols of their new life as Christians and their individual spiritual identity. Although this image was posed, it nonetheless presents a visual parallel to the church's self-supporting mission. The American missionaries (Dean, Lewis, and Hayes) who accompanied the Chinese congregation that day are wholly absent from the photographs—although they (and in particular Dean, given his close association with the congregation) could easily have elected to be present in the group images. The emphasis is on the agency and demonstrative presence of Chinese Christians as opposed to the American missionaries, rendering the missionaries invisible while foregrounding the local church's religious work and community.

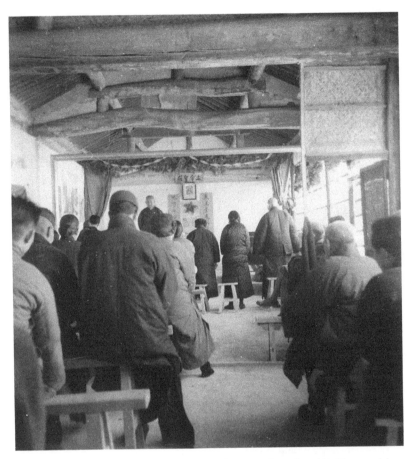

Figure 1.4. Service at a self-supporting church outside Beijing, December 1933. Photograph by Ralph C. Lewis. LFP.

The only indication of foreign presence is the sign behind the group of new converts, which reads "American Christian Presbyterian Church" (Meiguo jidujiao zhanglaohui). Further, the characters for "American" (Meiguo) are scripted much smaller than those for "Christian" (jidujiao) and "Presbyterian" (zhanglaohui), proclaiming the church's Christian and denominational identities over national affiliation. Lewis recognized these characteristics even before he developed his photographs. Over dinner that evening, as Lewis later wrote, "[Dean noted that] this work of his receives no support from home[;] it is entirely Chinese. The [congregants and students] don't feel that they are getting any foreign aid as it is practically all done by them. Sam just goes along occasionally."[114]

The experience and images described above were not a one-directional imposition of foreign missionary ideals onto a Chinese Protestant community. Rather, they represented Chinese Christianity with its own spiritual, cultural, and communal agencies, all of which reshaped Lewis's worldview (especially as a newly arrived missionary) of Christianity in interwar China as a collaborative institution and not solely a foreign project. And even Lewis's photography was not characterized by authoritative seeing as knowing, but by visualizing and participating. Perhaps it even served as a step in the cross-cultural conversion of missionaries to broader perspectives beyond their original American Protestant backgrounds. Writing about his experience in the village church, Lewis noted, "It was a very impressive service even though I could understand very little of the spoken words. [The Christians] were all so devout and sincere." In a later reference to other Chinese Christian worship services in which he and his family participated in North China, Lewis was at first perplexed and alarmed by the congregations' demonstrative worship styles, including public confession and requests for immediate prayer with the pastoral staff, alongside congregational invocations that often culminated in "everyone . . . seemingly shouting to the Lord." But in time, these forms of worship, which initially "[were] something new for [the Lewises] and . . . hard to understand," became a common part of their religious life and perspectives on Chinese Christianity. "We became accustomed to [the style of the services]," Lewis wrote later, "and learned to appreciate it very much."[115] And although he did not know it then, these churches and forms of worship would largely continue to exist even after Lewis, his family, and the camera were no longer present with them in the tumultuous years to come.

In the fall of 1934, almost exactly one year after Lewis arrived in China, he brought his Rolleiflex into the mission church at Hengzhou, his first mission posting after language school. The photograph that he made there demonstrates not only the independent agency that he documented in his earlier experience with the self-supporting church but also Chinese Christian imaginations of a transnational Christian community. At first glance, it seems strange that the image achieves this, as there are no living people present within the frame. Rather, the church altar and three large overhanging wooden panels dominate the scene; painted on them in Chinese is the tripartite proclamation from the First Letter to the Corinthians, featuring the key words "faith" (*xin*), "hope" (*wang*), and "love" (*ai*).[116] Each word is paired with a central Christian article of faith rendered in Chinese. "Hope" is paired with the Lord's Prayer, "faith" heads a transliteration of the Apostles'

Creed, and "love"—"the greatest of these," occupying the largest panel of the three—hangs over a simplified translation of the Ten Commandments.[117] Perhaps to avoid the possibility of what aniconic Protestants might regard as idolatrous veneration of objects, there are no images beyond the scriptural text. Even the cross, the most prominent of traditional Christian symbols, is absent. Yet the articles and architectures of faith are not the photograph's primary focus. That role is occupied by an image within the image. A photographic portrait framed with Chinese inscriptions and draped with white cloth sits atop the altar, surrounded by flowers. Lewis's caption, typed underneath the photograph in a small notebook album he assembled, reads, "The Hengchow Pres. Church after the memorial service for Dr. C.F. Brown who was fatally injured in auto accident September 23, 1934 in Oklahoma."[118]

The memorial's essence is contingent on the presence of a photographic image as a stand-in for the person of Dr. Brown. Brown's photograph, made when he was alive, contrasts with the congregation's knowledge and belief that he is, though physically deceased, already living in a transcendent beyond in the presence of God. The photograph on the altar represents the paradox of Protestant arms-length views on images in worship. On the one hand, the church foregrounds anti-image conceptions and a focus on invisible "faith [as] the assurance of things hoped for, the proving of things not seen."[119] On the other hand, Christian imagination here hinges on the association of Brown's image—an indexical, lifelike photograph—with a sacred environment, connecting the memory of Brown's earthly existence with its continuation in the afterlife. Indeed, it would be difficult not to ponder this otherworldliness, given the photograph's highly visible place of honor in a service filled with prayers, hymns, scriptural readings, and eulogies. Lewis's photograph thus calls viewers to see Brown as a missing and yet visually present individual, with his physical and spiritual existences memorialized in the space of a Chinese Christian church.

Moreover, this particular photograph, though devoid of live people, gestures at transnational imaginations shared by the missionaries and the Chinese Christians who participated in the memorial. Many of these imaginations took place outside of the image frame. Lewis's memoirs reveal how the missionaries received news of the doctor's accident during an administrative meeting, mixing medical details with striking imagery of death that the recipients of the news mentally pictured at the time:

A servant came in with a telegram. Mr. Birkel read it, and then asked that we all be quiet as he read it out loud. It was announcing the death of

Dr. Chauncey Brown. He had been in an auto accident in [Oklahoma]. His wife was thrown from the car into the middle of the highway, causing a fracture of the cervical vertebra with paralysis from the neck down. He had tried to lift her heavy body off the road and developed a severe hernia as a result. Later, following surgery for the hernia, he suddenly died, probably of a pulmonary embolism. (Mrs. Brown lived for several more months before going to join her husband.) This was a shock to all of us.[120]

The shock, perhaps, was not simply that Brown had passed away, but that his unexpected death during a temporary furlough in the United States, while fully intending to return to the mission in China, permanently separated him from the community—at least physically.[121] This dimension is visible in the Chinese congregation's response to Brown's death. Lewis noted, "[Because] Dr. Brown had served at our hospital for many years . . . the local community highly respected him for his services. Several days later the city and the Christians held a big memorial service for him which we all attended. It was a very moving and emotional experience for us . . . as we saw how the local people respected Dr. and Mrs. Brown as Christians and as their physician."[122]

The description of the Chinese congregation by their faith rather than by their race or culture, as "the city and the Christians," represents their religious identities as beyond straightforward secular classification. In one sense, this perception seems to neatly enclose the Chinese within a predetermined Christian cultural construct. But at the same time, it situates independent Chinese Christian agency within a global Protestant community. Transnational imagination is inherent in a commemoration planned by Chinese Christians for a man who died thousands of miles away in Oklahoma, a place that most of the memorial's attendees likely never saw—and that the American missionaries also had to imagine as they sat in the church. Moreover, the memorial was a space of cultural amalgamation, as Lewis's photograph displays. The white cloth surrounding Brown's portrait was a traditional symbol of death used in non-Christian Chinese funeral rites, and there is a lengthy phrase (unfortunately illegible in the print) written in Chinese above the portrait, possibly a farewell message, scriptural passages, or both.[123] These symbols, combined with the total lack of English inscriptions in the image, emphasize the Chinese construction of the memorial. In a sense, Brown was not simply commemorated as a deceased Christian in a larger body of believers, but also made Chinese in collective ritual and imagination.

Coincidentally, the same meeting that was interrupted by news of Brown's death was one in which the missionaries were negotiating issues of doctrinal identification with the American Presbyterian leadership in charge of foreign missions. When the telegram arrived, Lewis and the other missionaries, both evangelists and medical staff, were at dinner with a visiting "well known minister from the eastern part of the U.S.A., a known 'fundamentalist,' who [was] visiting [the] various mission stations to see if [modernist] heresy existed among [the] missionaries. He had been in North China investigating the missionaries there, asking about their beliefs, and embarrassing them a great deal."[124] The guest was Rev. Donald Barnhouse of the conservative Tenth Presbyterian Church in Philadelphia. Barnhouse's visit was occasioned by the doctrinal debates mentioned earlier and was part of an intensive "inspection tour" through "China, Japan, India, and Persia," in which he attempted to "visit all of the Presbyterian Mission stations and meet as many of the missionaries as he [could]." Barnhouse, though "not in favor of [J. Gresham Machen's conservative and later schismatic] Independent Board" was "anxious to find out how the missionaries [stood] in their religious conviction."[125] As Lewis later noted, "Our special guest began asking each missionary very personal questions about his belief and what he had been doing to further the Kingdom of God. It was very hard for us all, as we knew that we were under investigation by one of the important men in our denomination."[126] These tensions quickly rose to the surface, pitting Barnhouse against both missionaries and Chinese Christians:

> [After Barnhouse visited the mission hospital], we had tea for him at which there were about thirty Chinese men and . . . a few women who could speak [E]nglish. He gave a very fine address to them on the subject that to be a Christian one had to be and believe the whole way, that Christianity is not a system of ethics. . . . I hope that the majority could understand him well enough to take it all in. Then in the evening we had a station dinner at Lucinda Gerhardt's house. We had a good chance to get acquainted with him then. Our impressions were that [Barnhouse] is a very conceited man, but a very fine Christian and Bible student. After dinner he began by asking us what we are doing to earn the three thousand dollars that it costs the church at home to support each one of us.[127]

The conflicted relationships between missionaries aligned with the Chinese Christian community in Hengzhou and this intrusive visiting US church leader—who was incongruously concerned about both abstract defenses of

Christian doctrine and the more worldly question of what it cost US congregations to support missions and the Chinese church—could not have been more strongly visible in this moment. It is no wonder that Lewis made sure to mention the mission's collective perception of Barnhouse as "a very conceited man." In any case, the Chinese-organized memorial service for Brown "put an end to [the missionaries] being questioned by [the] VIP guest." Barnhouse quickly left the next morning to continue his journey into southern China, later expressing few qualms when the crewmembers of his riverboat ritually sacrificed a chicken to ensure safe passage through rapids near the Guangdong border.[128] This irony was not lost on the missionaries and Chinese Christians in Hengzhou, who, while grieving Brown's death and reeling from the interrogation, may have received the account with quiet resentment.

It is perhaps unsurprising that Lewis left behind no photographs of Barnhouse's visit to the mission, instead visually documenting the Chinese community's effort to memorialize a missionary as one of their own rather than the "important" Presbyterian who was a "fine Christian and Bible student." Barnhouse and his traveling companions probably made images with their own cameras, but their views were quite literally not shared by the photographic subjects they left behind in Hengzhou, colleagues or converts. Lewis rendering Barnhouse invisible in the photographic record and expressing discomfort with his visit were thus small acts of defiance, an indication of deeper personal alignment with Chinese Christians—and the conversion of missionary perceptions—than met the eye.

Lewis and his colleagues were certainly not alone in representing these multiple shifting frames of reference, with the transformation from uninitiated outsider to critical insider mediated in part by the camera. And such transformative experiences were not restricted to the Protestant missionary enterprise, as we will soon see.

Chapter 2

Converting Visions

Photographic Mediations of Catholic Identity in West Hunan, 1921–1929

On the morning of February 15, 1922, George Tootell, medical director at the American Presbyterian mission station in Changde, Hunan, awoke and prepared for his daily activities.[1] This day, however, proved to be a little different.[2] Instead of his usual rounds at the Kuangteh Hospital, Tootell, accompanied by a nurse, walked down the hill to the Catholic mission that occupied the space directly below and across from his own. There, Tootell was received by two priests, Fr. Raphael Vance, CP, and Fr. Agatho Purtill, CP, members of the Congregation of the Passion of Jesus Christ, otherwise known as the Passionists. Like Tootell, they were Americans, but they had arrived in West Hunan from West Hoboken, New Jersey only eight days before. On this morning, Vance and Purtill—along with three other Passionist priests and one religious brother—awaited directions from Bishop Pellegrino Luigi Mondaini, OFM, the Italian Apostolic Vicar of Changsha, before they could continue to Chenzhou (present-day Yuanling), the group's base area in the interior.[3]

Tootell's appearance was perhaps only a partial surprise to Vance and Purtill, who had over a week to gaze at the Protestant mission above them from the windows of their temporary residence, envying its size and features.[4] Yet, this morning visit was neither official nor ecumenical. Tootell had

come to make photographs. The Catholic mission church's tower afforded a high vantage point and wide view of the area inaccessible from ground level, and the two Protestant visitors wished to climb it to make views of their own mission with their cameras. Father Vance and Father Purtill obligingly "made [themselves] known to them," and Tootell and the nurse told them "all about the election of the new pope" and later sent "over some Hankow papers and also two copies of the Literary Digest. They also invited [the priests] over to see them and have tea."⁵ Two weeks later, on Ash Wednesday, March 1, the two priests took Tootell up on his offer and "visited the American Hospital," noting that it was "quite an up to date place" with "their own electric system . . . and 50 resident patients."⁶

The Passionists may have taken their own cameras with them when they ventured up the hill to the Presbyterian mission. After all, they were also no strangers to photography. A diary entry from the day after the hospital visit records Father Purtill and another priest, Fr. Timothy McDermott, CP, taking photographs of the boat that would "take [the first group of Passionists] to the city of Shenchowfu [Chenzhou]," visually documenting the vessel before it was to effect their imminent departure from the area.⁷ At the end of the week, the Passionist missionaries sailed out of Changde via the Yuan River, leaving behind Tootell and the American Presbyterian mission.⁸

Though this chance meeting may well be a footnote in broader histories of modern China, it is noteworthy in that it was facilitated in part by the act of photography. Although Tootell, the yet unidentified nurse, and the Passionists may well have met under different circumstances, given their residences' physical proximity in Changde, the encounter itself was shaped by visual practices.⁹ Tootell and the nurse needed a vantage point for their cameras and the wide-angle image they desired, and the architecture of the Catholic mission provided just that. Furthermore, the act of obtaining access for this photography opened an avenue for personal contact between American missionaries of different, often contested Christian faiths and cultures, if only for a few brief days. At this time in China, Catholic and Protestant Christian institutions were generally at odds with each other; religious ecumenism, local or global, was sparse.¹⁰ Yet, the presence of the camera and shared American culture, in the case of Tootell and the Passionists, offered a common modern experience that temporarily transcended religious boundaries. Even if Protestant and Catholic ideologies and missionary practices were in conflict, the two groups employed similar or even identical visual technologies to document their experiences in the same time period.

The goal of this chapter, however, is not simply to outline these parallels and differences. Rather, it focuses on photography's role in shaping overlapping conversion experiences and the creation of a Catholic media identity in China, drawing from the visual practices of a single American Catholic order in West Hunan from 1921 to 1929. I interpret the concept of conversion in several registers—not strictly limiting it to the religious sense, and including the makers of the images as well as their subjects and audiences. Although such an approach applies to missionary imaging across modern China, focusing on the Passionists allows for a clearer rendering of these complicated, often historically invisible experiences. I emphasize photographic mediations *as* conversions. In creating a media identity, visual practices converted missionaries from interloping outsiders to embedded image-makers, US Catholics to spiritual partners in the missionary enterprise, and Chinese Catholic communities to globally visible representations. Photography thus mediated Passionist missionary conceptions of self and other (including competing Protestants and indigenous populations) alongside their perceptions of local and global Catholicism, while also shaping visual connections between their geographically isolated missions and the United States. These conversions, of course, had limits. As with the road to religious conversion, Passionist photography was fraught with practical contingencies, the frustrations of ensuring correct visual interpretation (mirroring the eternal difficulty of ensuring right belief in converts), and the impossibility of producing omniscient visual knowledge—especially when unforeseeable death sometimes lay just beyond the frame.

"Go Forth"

Even as the first group of six Passionist missionaries traveled across the United States en route to Hunan in 1921, they were already undergoing a process of conversion in experience and media, though they may not have known it at the time. This process was related to the missionaries' imaginations of media technologies, visual and otherwise, that they could use to record and transmit their future experiences. Although they were competing with the Protestants, it would be several more weeks and thousands of miles before the Passionists came face to face with these groups. But they encountered echoes of Protestant missions in China even before they left the United States—via the radio. During a stopover in Pittsburgh, Pennsylvania,

four days after their celebratory December 11 departure from West Hobo-
ken, "some of the [Passionist] Fathers were allowed to 'listen in' on a con-
cert on the wireless telephone, the concert taking place many miles away."[11]
Recalling the experience in a letter typed aboard the train to Seattle, their
transpacific embarkation point, Father Vance noted that "this invention
ha[d] limitless possibilities" and immediately compared Protestant mission-
ary media with the dearth of equivalent technologies in the Catholic realm:
"On Sunday the sermons in the different Protestant churches are listened to
by thousands through this medium. One good benefactor of the Passionist
Foreign Mission heard the minister on the previous Sunday thanking the
people for their generous contribution to the Chinese Protestant works in
the Far East. [The minister] declared that no time in the history of the Chi-
nese nation was the field more ready for Protestant effort. Would that our
American Catholics could be made to realize this. How much greater would
be their effort to save these children of paganism from the clutches of the
non-catholic missionary[?]"[12]

It is clear from the priests' keen listening in and Vance's imagination of
radio's generative effects on church audiences that the Passionists were think-
ing about media connections between China and the United States at this
early stage in their mission experience, taking cues from technologies em-
ployed by "non-catholic missionar[ies]." Moreover, this interest was couched
in competition along religious lines. By leveraging mass media—which for
the Passionists was then limited to photographic and print forms—Catholic
missionaries could better combat the spread of Protestantism in China. The
struggle for the souls of "these children of paganism" was thus in part a
contest over media advantages.

Fascination with the radio continued on board the SS *Wenatchee*, the Pa-
cific Steamship Company liner carrying the group from Seattle to East Asia.
As the ship made its way across the Pacific, the Passionist missionaries took
turns celebrating daily Mass—with the throbbing of the vessel's machinery
occasionally threatening to distract them from the liturgy—and examined
the onboard radio system on several occasions.[13] Vance and Purtill reported,
"[After] Mass etc. as usual . . . we went to the very top deck and took par-
ticular notice of the arrangement of the wireless."[14] The missionaries also
encountered others on board the ship who were involved with parallel forms
of media in China. Among the handful of fellow passengers specifically
mentioned by name in the Passionists' transpacific account were "Mr. [Loo]
Zeu-lien[,] who [was] interested in movies [and] had in his employ a certain
Mr. Harry Grogin of N.Y.C.[,] an expert photographer. They both were on

their way to China to take movies."[15] Although no further mention is made of this filmmaking duo in the Passionist travel account, the unrecorded conversations that took place between them and the missionaries may well have further galvanized the priests' imaginations about the possibilities of mass media.[16]

Photography, of course, also played a primary role in the transpacific experience. Vance and Purtill, for example, noted that between Mass, games of dominos, and walks around the ship, they "took . . . pictures of one another."[17] The ample free time during the voyage provided an opportunity to not only produce images to send back to family and friends but also to practice photography in an environment and among people comparatively less foreign than those of the country they were to enter. In any case, photography en route was part of the missionaries' experiential initiation into their new life in East Asia, a widely shared unofficial tradition for other camera-equipped missionaries, Catholic and Protestant, as well as for future Passionists.[18] It should be noted that the second group of Passionists, following in 1924, drew the ire of crewmembers on the SS *President Wilson* as a consequence of their visual practices; photographers among them set off the ship's fire alarm when they overheated windowless bathrooms while developing film inside.[19]

Comedic accidents aside, the missionaries' personal visual practices and experiences with radio and film paralleled their imagined connections to the people and places they left behind.[20] They also heightened the sense of cultural encounter and alienation in regard to their growing proximity to China. After one "usual visit to the front of the boat to watch the waves wash the decks" and a trip to the radio room, a few of the Passionists "spied some coffins with chinese [*sic*] inscriptions," leading the diarists to comment, "It is the opinion of the chinese [*sic*] that the spirit of the deceased cannot rest until the body is buried in China." The missionaries likely perceived parallels to their own uprooted nature as Americans abroad and the need for spiritual belonging, even after death. After observing the coffins, as the diary tellingly noted, the priests went back to the "wireless room and made inquiries about [their] position," presumably to compare how far they were from both China and the United States.[21] After taking photographs of each other, a few of the priests visited "the [C]hinese children in the steerage . . . [and] brought them a lot of candy and cake." According to Vance and Purtill, "[The children] flocked around us and seemed so happy to think that we thought of them . . . we were also very happy to see these kiddies enjoying their sweets."[22] Despite their admitted inability to speak or understand

the children's language, the missionaries attempted to make some kind of connection with the Chinese Other, even if only in a culturally limited, paternalistic sense.[23] In this case, the sequence of events—group photography followed by a visit to the Chinese passengers on board—represented the missionaries' sense of their own communal bonds (reinforced by the act of self-imaging) as well as their missionary identity and foreignness in relation to China and its people. Together, routine Catholic liturgy performed in new places (communing with God across space and time), encounters with the coffins and Chinese passengers (cultural-religious Others), and attention to communication technology (links to familiar communities) all shaped the Passionists' perceptions of shifting cultural and geographic distance, as well as the desire to bridge it.

By the time the six missionaries arrived in Shanghai on January 10, 1922, nearly a month to the day after they waved goodbye to their families and supporters in New Jersey, they had undergone shifts in their worldviews and media imaginations.[24] They were also fully aware that they were a minority amid well-established non-American Catholic missionaries in East Asia, a fact that likely strengthened their communal identity as well as the desire to publicize their experiences. During a travel pause in Japan, they were wined and dined by a prominent Catholic benefactor (a "Mr. Susuki [sic]" affiliated with the rapidly growing interwar shipbuilding industry). They were hosted by European Marist and Jesuit clergy in Shanghai; lodged with Irish Columban priests in Hanyang, Hubei; and greeted by Spanish Augustinians when they finally arrived at Changde and Chenzhou for their Hunan mission assignments, singing their postdebarkation *Te Deum* in the church built by Augustinians and Chinese Catholics in 1919 (the same one where George Tootell and the American nurse climbed the tower).[25] They were acutely aware that Chinese locals perceived them almost universally as "European."[26] Fr. Theophane Maguire later noted this existential dislocation in attempting to convince a chatty Shanghai store clerk that he and his compatriots were neither American Protestants nor English-speaking members of the ubiquitous French Catholics, concluding, "It was humiliating to us that the strength of the Church in the United States was so little known."[27] In this light, the first group of Passionists were primarily assistants to the Augustinians, part of the Vatican's response to the Spanish order's "[appeal] to Rome for aid." Though the Americans did not know it at the time, their hosts, "undermanned and with many of their personnel ill," were soon to withdraw from the area, "leaving the newly arrived missionaries with sixteen thousand square miles of Northwestern Hunan."[28]

The six missionaries resorted to small displays of "Americanness" alternating with communal promotion. They affixed a small US flag to the riverboat that carried them to the Hunan interior, for example, and enthusiastically recorded in the travel diary that while in Changde, they had "the FIRST baptism and the first funeral by a passionist [sic] father in China. Father Agatho [Purtill] baptised two little girls that were left at the gate within the first couple of days. The first baby was called Gabriella in honor of Saint Gabriel and the other Justina in honor of Fr. Provincial [Justin Carey, CP]." Paula, another infant christened a few days before by the resident Augustinians (in honor of the Passionists' founder, St. Paul of the Cross), died soon after these two were baptized, fatally weakened by exposure or illness, common following cases of attempted female infanticide. This was "the first funeral" over which the group presided, with Agatho Purtill laying Paula to rest, and the first of many such encounters with abandoned or dying infants, mentioned repeatedly in the Passionists' later writings.[29] Though far from an uncommon incident in the local community—and one to which the Spanish Augustinians were no strangers—it was an apparently momentous occasion for the newly arrived Americans. The Passionists had claimed their first Chinese souls.

Along with their first forays into religious conversion, the priests continued their photography, building up a body of images for sharing with the outside world. Although the first group of Passionists had access to neither radio nor film in China, they and subsequent missionaries from the order did have their own media tools: their still cameras. Many were consumer Kodak rollfilm models that folded flat for easier transport, making them relatively well suited for the missionaries' mobility in rural Hunan. Rollfilm carried from the United States (with later stocks purchased from Chinese suppliers in Hankou), was more rugged compared to the sheet film or glass negatives used by contemporary professional photographers and allowed for ten to twelve exposures each time the camera was loaded.[30] With this equipment, the Passionists set out to document their experiences and surroundings, converting themselves and the people and places they saw into imaged subjects. Fr. Timothy McDermott, CP, a member of the first group, jotted down self-reflective notes about his visual practices alongside his printed images, some of which point to the missionaries' photography as an act of visual conversion.

Among the equipment McDermott brought to China was a clockwork device that tripped the shutter after a delay and allowed him to appear in some of his own photographs. This timer seemed to have worked properly

for the most part, permitting photographs that were otherwise difficult or impossible to make. One such image depicts McDermott, fellow Passionist Fr. Flavian Mullins, and a young Chinese man sitting together in the bow of a small boat headed to Changde, with no one to operate the camera other than the self-timer.[31] Although the priests could well have asked the Chinese man to assist with operating the camera (placing him behind the apparatus and erasing him from the image), his inclusion and the group's relaxed pose signal an attempt to bond with a Chinese Catholic individual, albeit one framed in terms of his position in a missionary hierarchy (the caption describes him as "Padre Gregor's boy") and whose name was unrecorded because of linguistic or cultural barriers. "This is the front of our boat," wrote McDermott, who continued with some pride in describing the technological assistance: "I took this picture by means of my automatic self-timer."[32]

At other times, the timer ran inconsistently or too quickly, leading to unexpected results. One such malfunction (or misjudgment on McDermott's part) led him to write the following caption on the back of one of the first photographs he made in China: "Changteh. Feb 7, 1922. This is almost one picture that I almost got in. Third from the left you can see my ghost. I was using an automatic timer but did not give it enough time. I just got there & was turning around as the camera snapped. Owing to the fact that I am supposed to be the photographer I do not get on many pictures."[33] In the photograph, McDermott's "ghost" is visible as a blurred head and black biretta behind a group of Passionist and Augustinian missionaries; the priest was running to his anticipated position when the shutter tripped. Although this image may be looked at as a simple technical accident, it is also an unanticipated transformation of the imaged subject because of photographic contingencies. The flawed visual product (perhaps more so than more technically normal images) draws attention to the camera as a mediating device, converting everything in front of the lens into imaged subjects via the photographic process. McDermott certainly recognized this fact; his pointing out the error in the final image allows viewers to imagine the act of making the photograph as well as the problem he encountered in doing so. It is not difficult to envision McDermott setting up his camera on a tripod in the courtyard of the Changde mission, positioning the group and the imaging apparatus such that all the priests would be well lit and in the frame, and then running from the tripod to the group as the self-timer counted down—too soon for him to arrive at his spot.[34] It comes as no surprise that a second photograph, taken of the same group from a lower

angle (consistent with a photographer in a kneeling position), appears on the next page of scrapbook, except this time without McDermott in the frame. In an attempt to prevent the same mistake from happening again and wasting another frame of precious film, McDermott sacrificed his own visibility in the image to ensure that he produced an acceptable image of his compatriots.[35]

Such mechanical contingencies were not the only experiential ruptures in the photographic conversion process. There were many other limiting factors, negotiations with visual practices, and environmental factors required to successfully convert subjects to images. The environment shaped the missionaries' photography by imposing technical contingencies. Film, photographic paper, and developing chemicals, all sensitive to temperature and humidity, spoiled quickly in the humid Hunanese climate. Any deterioration was often not detected until the negatives or prints were developed, sometimes well after the opportunity to retake the original images passed.[36] A photograph of "the class [of Chinese converts] baptized on Feast of [the] Holy Founder [St. Paul of the Cross]," produced by McDermott in the summer of 1925, carried a handwritten annotation: "Picture not very clear as my paper and chemicals are both several years old."[37] Although the priest was, impressively, still able to produce visible images with the long-expired developing material, the results were poor. McDermott added at the end of the annotation, "To C.P. [Passionist editor], retouch spots." Two photographs taken by Raphael Vance, depicting the interior of the Baojing mission

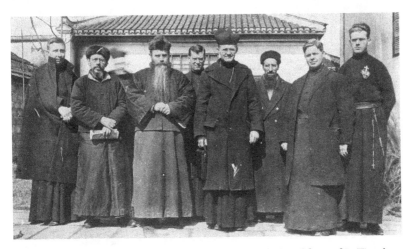

Figure 2.1. "Changteh. Feb 7, 1922." Self-timer photograph with blurred figure of Fr. Timothy McDermott, CP, and Passionist missionary group. File 800.08_004.004, PCC.

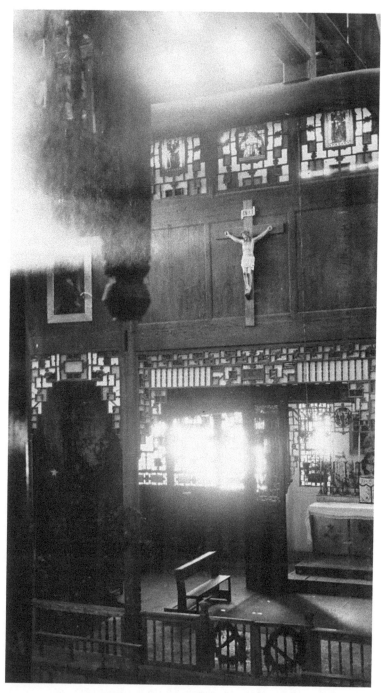

Figure 2.2. "Paotsing Church upper front. Note the windows." Photograph of church interior by Fr. Raphael Vance, CP, exhibiting flare and light leaks. File 800.02_018.015, PCC.

chapel that he administered, exhibit extreme lens flare from the building windows, the main sources of light for the dim interior.[38] Beyond the usual effects produced by an unclean and uncoated lens, these were signs that the constant high humidity in West Hunan—which also caused mold to sprout all over the Passionists' "books and leather goods"—was etching itself onto their photographic equipment and film.[39]

When possible, Passionists in the interior sent undeveloped film to Hankou, where administrators at the order's procuration developed the rolls themselves or handed them over to commercial processors. But even this carried risks. The process typically took over a month and shipments were often lost or delayed in the 340 miles that separated Hankou from West Hunan.[40] Fr. (later Bishop) Cuthbert O'Gara, CP, for example, noted, "[While] I have been able to get some fairly good pictures . . . at present I am out of paper; some was on its way from Han[k]ow [*sic*], but is held up like all other packages and supplies."[41] Other unexpected problems included bandits' theft of Fr. Clement Seybold's camera equipment (neither the last nor most prosaic time the priest would encounter bandits) as well as a traveling photographer who defrauded other Passionist missionaries in Chenxi, producing photographic prints that faded to invisibility after he took payment and vanished.[42] It is thus highly likely that the missionaries were constantly aware of their photography's contingency-laden character. They could not predict if a photograph (perhaps of scenes or people who could not be rephotographed) would appear acceptable after development with spoiled chemicals, if films sent for processing would arrive in Hankou or return successfully to Hunan, or if prints and negatives mailed to the Passionist office in New Jersey or relatives would be lost in the Chinese or transpacific postal services. All of these experiences caused much anxiety about visual practices while adding further importance to the images that did make it.

A photograph taken some time after each of the six missionaries reached their postings across West Hunan brings together these connections and isolations. Produced by Raphael Vance after he settled at his mission in Baojing, the photograph displays the Passionist compound—a single building identifiable by a white cross crudely painted on its roof—nestled in a lush valley surrounded by steeply mountainous terrain. Vance likely climbed up one of these slopes, perhaps doing so on a sunny day to ensure sufficiently bright light for the exposure, in order to fit the mission and some of its surroundings into his folding camera's viewfinder. As he walked, Vance attempted not only to keep the mission compound in clear view but also to situate it within the local landscape, as a visitor departing or coming over the neighboring

hills would have seen it. Later, on the back of the printed photograph, Vance wrote, "The Paotsing mission—white cross on roof—How do you like the mountains? Telegraph connections have been completed between Paotsing and Shenchow. The poles can be seen on the lower row of hills, just outside the city walls." Vance leads the viewer of his photograph to imagine the various connections between the mission and the outside world: a compression of distances in the mission compound's visible presence in the landscape, as well as the emphasis on telegraphic links between the city and the broader region. As with the combined fascination with the wireless and with liturgical familiarities that came to the fore during the Passionists' journey to China, Vance's identification of communications links with the outpost points to the missionaries imagining Catholic mission spaces beyond the edges of the photographic frame.[43]

At the same time, multiple frames in Vance's image emphasize the mission's isolation. The houses in the village physically fence in the mission building, its identity as an outpost defined as much by its close proximity to the other structures as by the visible foreignness of its religious symbol. The mission may be at the center of the photographic frame, but whether or not its influence extended beyond the small number of Chinese Catholic adherents in Baojing is certainly ambiguous. The white cross appears so small in the photograph that Vance must point it out to reinforce its significance for the viewer. His "How do you like the mountains?" comment gestures at the looming slopes that visibly threaten to swallow up the mission and its foreign inhabitants, already dwarfing the lone building near the center of the image. In this place, even the telegraph, the poles of which appear as shrunken thread-like vertical marks in the printed photograph (and which, like the tiny white cross, must be textually identified for clarity), seems like a fragile link that could be all too easily severed. Later Passionist arrivals to the area referred to such tenuous communication, compounded by the geographic remoteness, severe weather, and local language difficulties, as psychologically crippling.[44] Yet, these physical and mental perspectives were already shifting for Vance, Maguire, and the other Passionists in Hunan, with visual and religious practices mediating the changes.

Religious Conversion and Photography

As the Passionist missionaries familiarized themselves with the local environment and worked on their language skills, photography offered unique

opportunities to interact with the people and places around them—closing the distance between image-makers and subjects.[45] When possible, the missionaries walked the streets of the towns in which they resided, carrying their cameras and making photographs along the way.[46] This inevitably required the missionaries to be visually and spatially aware of their movements and of the location of mission buildings and other known landmarks, and also to practice their Chinese speaking and reading knowledge while navigating the local community. Images from such walks display out-of-focus areas, as well as accidental lens obstructions identifiable as errant fingers and clothing sleeves. These indicate efforts at candid photography, which required rapid judgment of camera settings and environmental awareness (a challenge even for experienced photographers with more advanced equipment). Although this street photography was intended as a leisure activity, it did not neatly constitute the *flâneur*-like "armed version of the solitary walker reconnoitering, stalking, cruising the urban inferno . . . adept of the joys of watching."[47] Rather, photography often complicated cross-cultural encounters, bringing the Passionists face-to-face with the Chinese people. The act of using the camera further highlighted the missionaries' foreignness as a source of public fascination. Father O'Gara, writing from Chenzhou in 1925, expressed his frustration with a distinct lack of the "joys of watching":

> I shall see what I can do about pictures in spite of very real difficulties. To get the types which you want will not be easy. The interesting case does not always come at the opportune moment, nor is it easy to take pictures of Chinese. [Their] colosal [*sic*] curiosity . . . is never more patent than when a camera comes in sight. It is next to impossible to get the really characteristic scenes and poses. Always someone crowds the scene if he does not actually peek into the lens. Stop a moment to adjust a camera and before it can be snapped a crowd has gathered.[48]

These "difficulties" revolved around contingencies in space, time, and framing; moreover, missing "interesting case[s]" and "really characteristic scenes and poses," as well as undue attention from people who "crowd[ed] the scene," were all elements beyond the control of the missionary. O'Gara's account, however, points to more than irritation over encroachment on the missionary-photographer's personal space. Despite their attempts at control, the missionaries quickly learned that photography was not a sterile, distanced practice. The camera was not an impermeable barrier between

the imager and the imaged, but a device that, by virtue of its technical re-quirements, left the user open to scrutiny and vulnerability. Visual practices necessitated messy contacts with local subjects in front of the lens, as well as a forced humbling—a constant awareness that the missionaries' life and photography in Hunan were defined neither by predetermined "character-istic scenes and poses" nor by full control over visual or cultural encounters. Rather than distanced observers "find[ing] the world 'picturesque'" in their photography, the Passionists' experiences were inextricably bound up with the people and places they imaged in their mission work.[49]

Despite these contingencies and cultural barriers, the Passionists visu-alized particular perceptions of Chinese Catholic communities in which the missionaries were embedded. Here, visual conversions in photography crossed directly with religious ones. In multiple ways, Passionist imaging and images reflected embodied Catholic identities in spiritual as well as cul-tural senses. Just as Chinese Catholics processed through the Passionists' Hunan churches, knelt and crossed themselves, and engaged in physical-spiritual connection with the Eucharist, their presence in photographs reflected their conversions as religious and visual subjects. Photographic in-dexicality played a role in the merging of spiritual (invisible) and the physi-cal (visible) existences, mirroring key theological perceptions in the religious imaginations of the missionary-photographers, Chinese Catholics, and US re-cipients of the images. As the priests and indigenous catechists explained the mysteries of Christ's real presence in the Eucharistic elements to inquirers, Passionist photographs displayed Catholic conversion as another kind of real presence. As bread and wine were transformed into the spiritual body and blood of Christ, so too were Chinese converts transformed in photographic images into visible members of the global Catholic Church.[50]

Some images define the signs of participation in Catholic community against the less visible possibilities of individual and collective religious growth. In group photographs, for example, the frame encapsulates the peo-ple within it, giving a sense of the Chinese Catholic community's together-ness, while also referencing other local populations, Catholic and non-Catholic (with the potential for conversion), beyond the frame. One such image, de-picting three Passionist priests sitting among a large group of Chinese Catho-lics in front of the Baojing mission church, utilizes the frame's limitations to indicate other, unseen community members. On the back of the print, the photographer, Father Vance noted that the image depicted "not all the Xtians [Christians], just the inmates of the Mission." Another photograph he made in September 1923 is similarly captioned: "With some of the Xtians at

Paotsing."[51] The emphasis is not necessarily on specific numbers of people included or excluded, but rather on imaged community as a portion of the greater whole. The photographic frame is a permeable boundary, pointing to religious conversions among the Chinese population that have taken place (or are taking or will take place) beyond it while also visually unifying the individuals within. When the image was later published, a Passionist editor drew lines in pencil on the original print to further reduce empty space around the figures, heightening the framing effect and underscoring the community.[52]

Other outward signs of conversion, mediated by the camera, included photographs of Chinese orphans who had been taken in by the Passionist missions, wearing liturgical dress and present in sacred spaces. Sometime around Christmas 1924, Father Vance asked five of the altar servers who assisted with Mass at the Baojing mission to stand in front of the altar rail and hold still for his camera.[53] The relatively long exposure necessitated by the dim natural light in the church and the insensitive film emulsion (perhaps further desensitized by environmental damage) caused the boys' bodies to be blurred slightly in the final image, even as they attempted not to move. Vance, guessing the distance between him and the boys, also misfocused the lens slightly, causing further image deterioration.[54] Despite the blurriness, the boys are recognizable as altar servers by their black cassocks, white surplices and, for three of the five, small crucifixes worn on chains around their necks. Along with their dress, the boys' position in front of the altar

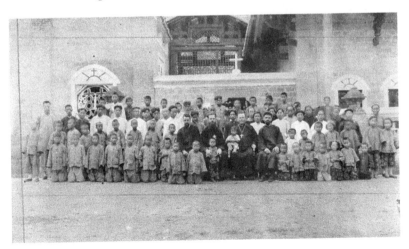

Figure 2.3. "With some of the Xtians at Paotsing. Sept, 1923." Photograph by Raphael Vance. File 800.02_016.009, PCC.

rail, a space that they occupied and traversed during Mass, indicates their conversion from "mere" orphans to key participants in the Catholic liturgy. These visual signs—and even the boys' slight movements inadvertently captured by the long exposure—heighten the fact that they were living, moving members of the religious community. Catholicism had radically changed their environment and their bodily presentation. Their reshaped identity is further strengthened by the photograph's handwritten caption, which notes, "My Altar Boys . . . left to right, 'Tsang John' 'Ho Joseph' 'Fu Paul' 'Lu Gabriel' & 'Su Patrick.'"[55] In listing each boy by his Christian name, Vance indicated that all of them were members of the Catholic Church by baptism. Moreover, the choice to include family names in addition to baptismal names indicated to viewers that each boy represented a broader Chinese family (Tsang, Ho, Fu, Lu, and Su) connected to the Catholic community by relational ties. It is also worth noting that Vance, now two years into his missionary activities in China, was attempting to demonstrate familiarity with linguistic custom in formatting the names in this way and then making a note to viewers of the image: "The Chinese always put family name first." Although it is not clear if this comment was intended to emphasize the otherness of Chinese naming traditions, the complete caption leads viewers to imagine the photographed altar boys as simultaneously Chinese and Catholic. They are paternalistically connected to Vance ("My Altar Boys") in the liturgical hierarchy; to the Catholic Church in their baptismal names and dress presentation; and to local Chinese families by virtue of their recorded surnames.[56]

Beyond such visualizations of Catholic community, Passionist missionaries also included the act of photography in key liturgical or demonstrative moments in religious conversion. One instance is recorded in a June 4, 1922, letter that Father McDermott wrote from Yuanzhou to his father and sisters in the United States. This was one of many letters detailing his cross-cultural experiences in Hunan alongside attempts at keeping up with photography. "I can say the Ave Maria in Chinese now," he wrote in an earlier message. "I shall send you a copy of it sometime, so you can hear what it sounds like to pray in Chinese . . . I have been fairly busy of late, developing and printing pictures . . . I know you shall be disappointed of not getting more of myself. But I shall try to do better later—when my beard gets more prominent??"[57] The June 4 letter, however, was a little different. Instead of mentioning his religious activities, cross-acculturation, and photography in separate categories, McDermott reported photography occurring in the literal service of religious conversion. As he noted, "Yesterday

morning I said Mass shortly after five. Then the Ceremonies began when Padre H. [Hipolito Martinez, OSA] baptized 18 new Christians of whom I enclose a picture. Immediately after the Baptism we had Mass at which they all received. Later after they made their Thanksgiving I took their pictures. It was a lot of work."[58] The final phrase was likely not an overstatement. In addition to rising early to say Mass and perhaps assisting directly in the baptism of the "18 new Christians" and the subsequent Mass, McDermott had to prepare his camera and film to make photographs of the new members of the Church. With eighteen individuals, this would have involved using up two rolls of film (either in one camera, reloaded after all ten or twelve exposures on the first roll were used up, or in two separate cameras). In doing all of this, McDermott would have had to recall not only the liturgical practices and words essential to his pastoral duties as a missionary priest but also the necessary technical processes as the event photographer. Taking the "work" comment further, it is not difficult to imagine the mental gymnastics needed to move from prayers, chants, and scriptural readings to calculating exposure, focusing distance, and composition while making sure to avoid errors like his earlier self-timer accident. McDermott likely also used some of his rudimentary spoken Chinese, perhaps with the help of a catechist, to communicate with the people he photographed. Switching linguistic gears between Latin, English, and Chinese, "in thought, word, and deed," to borrow a liturgical phrase, would not have been easy, especially as McDermott had then been in Hunan less than four months.[59]

Yet, despite these challenges, McDermott recognized that photography was more than simply a way to document the Passionists' evangelistic work for family and institutional viewers; it was also a way to provide the converts a visual and material symbol of their new identity as Catholics. He continued: "I thought it would not be too much to develop & print [the images] immediately. I gave them each a copy. Undoubtedly it is the biggest day in their lives. So I set to work & developed the pictures immediately, hurrying them as much as I could. & by 1:00 P.M. they were ready to be printed. I worked until about five P.M. printing & washing them & gave them each one this morning."[60] Although the reactions of the newly baptized Chinese Catholics to their photographic portraits is not recorded, this is among the few documented instances of missionaries, Catholic or Protestant, producing photographs in close conjunction with religious conversion. Although missionaries in China may have done so on an individual basis, highly dependent on personal choice and the availability of photographic materials

to produce multiple images, this was not a common practice. McDermott's decision, however, points to the importance he placed on photography as a reproducible visual medium that (in this case) connected the image-maker and the subjects, particularly on what the missionary interpreted as "the biggest day in their lives." This sense of importance is clear in the urgent need to produce prints for the baptized Catholics (presumably before some or all of them departed the Yuanzhou mission compound for their own residences in surrounding villages), which required "hurrying" the negatives' chemical development and the four hours spent "printing & washing" before the sun went down and prevented further work.[61] The final photographs thus represented a material tie to the Church, along the lines of a baptismal certificate, while also representing the missionary-photographer's participation in the baptism and serving as a visually lifelike reminder of the religious ceremony to each of the recipients. Although it is not known what happened to the photographs after the converts took them home, or if any of these specific prints still survive in their descendants' possession, it is not difficult to imagine the images kept as iconographic representations of the converts' Catholic faith or at the very least displayed as curiosities.

In any case, McDermott's baptism photography represents both these local connections and the global afterlives of images directly bound up with conversion. On the same day that the group baptism of eighteen Catholics took place, McDermott "also Baptized [his] first Baby." He directly addressed to his sister, Julia McDermott, the part of the letter describing this event:

> It was one we received at the Mission the day before. It is a rather cute youngster. As per agreement I called it Julia and took its picture. The picture was pretty good, but somehow or other I sliced off the top of their heads. The woman holding the Baby is its God-Mother—her name is Marie & the others a party to her mother—Salome—The Daughter & wife respectively of the Catechist here. I enclose the picture so you can see what your namesake looks like Jule. I took another picture today, but have not yet developed it, if it is great I'll send you one.[62]

McDermott did not explicitly state that he gave a photograph of the child to the family supporters of her baptism (though, in context with the group baptisms, he may well have done so). Nevertheless, this incident references the global networks through which these images of conversion traveled. In addition to documenting visual-religious conversions "on the ground"

(McDermott closely related christening the baby and taking her photograph in the same sentence; he also pointed out a framing error with the view-finder that caused him to "[slice] off the top of" the subjects' "heads"), images sent by the Passionists and other missionaries connected supporters abroad to works in China by sight and by imagination. The photograph here worked as a visual bridge, connecting Julia McDermott to the Chinese baby bearing her Christian name. The image allowed McDermott's family to see across time and space in a visually mediated way and imaginatively encounter a child and family whom they were supporting spiritually and perhaps also financially. Although such a connection was one of many made privately, McDermott was far from alone among Passionists in using photography to transmit images of conversion to US communities and publics supporting their religious activities.

"Visible and Invisible"

The Passionists' primary outlet for their images and writings from China was the *Sign*, a magazine published at their mission headquarters in New Jersey. Shortly after the first group of Passionists departed for Hunan, the publication began featuring a section in each monthly issue entitled "With the Passionists in China." It described the missionaries' activities for readers in the United States, with the goal of soliciting both funds and spiritual support.[63] Appeals for these forms of support were often closely linked; pragmatism and prayer were both required as the missionaries considered the Protestant competition. As McDermott wrote in a private letter that mixed distaste with a somewhat inflated view of the Passionists' spiritual adversaries:

> The Protestants surely have been way ahead of us here in Shenchow. They have money galore and that is everything with them. They have schools, colleges, hospitals, play grounds, tennis courts, etc. etc. We shall have to go some to catch up to them. But with it all they have only a few hangers on . . . who are procuring an education from them. Singularly enough the Chinese have little or no respect for them (they are called "Fu In Tang") . . . the Chinese have the greatest respect for the T'ien Shu Tang or Catholic Church. Just wait till we get our Orphanage running and our Dispensary. Then we shall set ourselves to start our School for Boys—then girls—and if possible a hospital later. It is a big work we have ahead of us. All uphill, but please God we shall go ahead with it and quickly.[64]

The "little or no respect" for the Protestants described here (McDermott was presumably taking this opinion from Chinese Catholics) stemmed in part from wishful thinking by the Catholic missionaries and in part from local communal identity opposing encroachment by this other form of Christianity. Another Passionist in Chenzhou later reported that local Catholics ("our Christians") who visited the Protestant hospital for treatment frequently "complain[ed] that they are annoyed while there by proselytizers."[65] Of course, these Chinese Catholics needed to visit the Protestant hospital in the first place because the Passionists lacked a medical facility of their own, though discussions were underway to open one in 1925. These plans reportedly disturbed the Protestant hospital administrators, who were "very much concerned about" the Passionists "opening a second hospital . . . [and] even made the proposition" that the Catholic order "not open a hospital at all but for efficiency's sake unite forces with them."[66] With ecumenical partnership out of the question, the Passionists were strongly concerned about funding for their mission work, not unlike the Protestants at the receiving end of their criticisms. Even in more rural parts of West Hunan, where there were no established Protestant institutions to directly contend with, resident missionary priests and Chinese catechists (with their vitally important linguistic fluency and liaison abilities) required funds and supplies from US Catholic communities. Without funds, Passionist missions could not move forward, and without missionary involvement, Protestants would continue to expand their own religious and humanitarian presence in the region. Here, the *Sign* and its connections between China and the United States came into play, with the Passionists' photographs (published and unpublished) representing transnational struggles over the control of visual meanings in missionary media.

Images collected by the magazine's editor, Fr. Silvan Latour, CP, were reproduced alongside anecdotes or reports written by missionaries in China or their supporters in the United States, and then circulated among subscribers.[67] In the months and years after the Passionists began their work in West Hunan, letters passing between their mission sites and New Jersey negotiated not only the ways in which local reports were used in the official publication but also the interpretation of images. One such letter, written in the fall of 1924 by Fr. Theophane Maguire to Latour "[by] the light of an old time lamp and from a typewriter that [was] stiff with the chills," preserves such an exchange. In addition to reporting that the missionaries had been solicited for "an article" to assist Msgr. William David O'Brien in Chicago to "make an appeal [in the Catholic Church Extension

Society] for thirteen Mass kits," Maguire shared that he was enclosing additional photographs that had been "incidentally delayed" because of work on the article, and hoped that "the [first set of photographs he] sent from Hankow [had] reached" Latour. He went on to state, "On the back of each [print] I have written a few lines. If you want any clue to placing them in the trip you may find it in the accounts the others have sent, or in the lines from my 'Changteh to Shenchow' dairy [sic], part of which Anthony has in the long story he is sending to the provincial."[68] This focus on the text indicated Maguire's desire for Latour to interpret the images (and to convey this interpretation to the *Sign*'s readers) in a way that closely paralleled the missionaries' local experiences. This included statements that more forcefully drove home thoughts behind the images. Maguire instructed Latour, "There is one picture I want you to look at twice: the wreck [of a boat] on the Yuan [River]."[69]

This photograph of the foundering vessel, made by Maguire or another Passionist photographer during a passage to the interior, represented the hazards of the missionaries' journey inland, spiritually mitigated by "the myriad prayers that were offered for [their] safety in almost every part of the homeland, [after which] God's response was graciously and generously given." At the same time, it also pragmatically cautioned against an idealized image of missions. The photograph provided visual support for the assertion that transportation accidents destroyed supplies that US supporters of Passionist foreign missions had funded: "The picture and its story will bring home . . . why for every dollar sent to the missions a result cannot be set up in readable balance against it . . . [and also] prompt some to give more generously of those 'stringless' gifts, less advertised before men, but very vital to the mission's success."[70] For unknown reasons, the letter containing Maguire's commentary on the photographs was itself lost in the Passionists' New Jersey offices, separated from the images that it attempted to narrate. Someone (perhaps an editor or Maguire himself, later on) wrote forcefully in pencil across the letterhead: "Never used." The *Sign*'s misinterpretation—or incorrect conversion—of images to messages was not lost on the missionaries in Hunan, who typically received copies of the magazine in China one or two months after they were printed in the United States.

The repercussions of such errors were still felt more than a half year after the January 1925 issue in which Maguire's photographs appeared. Fr. Cuthbert O'Gara, who had been a staff member at the *Sign* before joining the Hunan missionaries, and who was on board the passing boat when the original photograph was made, wrote angrily in June, "There is much dissatisfaction

on this side. The best pictures are not published. . . . Every time the *Sign* ar-
rives . . . there is a meeting of mild indignation. Why some of the pictures
have been printed is beyond me when so many better ones have been submit-
ted. Then some of the most significant ones have been emasculated in the
magazine. Whoever writes the captions! A description of the scene is always
carefully written out *by the sender.*"[71] In voicing his frustrations about
image-text disjunctures (which he was uniquely equipped to do, as a formerly
US-based editorial recipient and now an image producer in China), O'Gara
highlighted not only the contingencies of photographic circulation but also
the loss of control over images' interpretation when they reached the *Sign*
and its publics. Not only were "the best pictures . . . not published" but the
texts used to frame printed images also "emasculated" them, isolating them
from significances that the missionary-photographers wished to empha-
size. O'Gara thus uncovered the malleability of visual meaning; images
may be converted or reinterpreted in ways not originally intended by their
makers. To drive home this point, O'Gara referred to the photograph of the
wrecked boat, now circulated back to the Passionist missionaries in Hunan
in the *Sign*'s printed version. Evidently, Maguire's instructions for Latour
and the editorial staff to "look at [the photograph] twice" did not have their
intended effect:

> [The] January [issue of the *Sign*] was more flagrant [than earlier omissions
> of detail]. "Sanpan [*sic*] on the Yuan River[,]," nothing more. Now this was
> one of the very best pictures taken during the entire trip. It was snapped
> as we passed by. It shows a large sampan wrecked on the rocks, the rapids
> swirling around. It is sunk to the gunwale. Part of the cargo of oil has been
> salvaged and can be seen on the beach. The woman is obviously the cap-
> tain's wife. The coolies are tugging the next boat in line. This was one of the
> many we passed and graphically showed the perils of travel on the river as
> at any time a similar fate might have befallen either of our two boats. This
> picture helps to indicate in a convincing manner why it takes so long for
> goods to reach us and how it comes about that having got so far[,] every-
> thing is lost in a few moments. Yet not a word about the wreck or what the
> picture signified.[72]

The problem was not merely that the banal caption did not match the image
content, but that the meanings the Passionist missionaries hoped to convey
to their supporters with the photograph—in particular the risk of losing
much-needed, US-funded supplies during hazardous river transport—were

lost. In fact, this was a double loss, of the boat's cargo in the Yuan River as well as of the image's illustrative particularities as both visual documentary and warning sign.

O'Gara continued by addressing other potential issues with image reproduction in the *Sign*, this time focusing not on context but on quality, which O'Gara compared with prints that another American Catholic missionary group produced:

> Better pictures have been sent to the States. Again the prints are very poor. The screen being used is so coarse that the best proofs would be ruined. Some pictures, those among the best, in which there is much detail, we have not forwarded because it would be useless. The fine points are lost in the printing. Please don't think I am holding a grudge in against anybody, but you mentioned pictures and I want you to know just how we stand. I believe it would pay to improve the screen. Maryknoll pictures are always clear and distinct. Perhaps you will be able to drop a hint in the right quarter.[73]

The brief reference to "Maryknoll pictures" indicates that O'Gara and the Passionists were keenly aware that their media identity was defined in comparison with Protestants as well as with the only other American Catholic mission organization in China. The Maryknoll Fathers and Brothers had started work in Yeungkong in Guangdong Province a mere three years ahead of the Passionists in Hunan.[74] The Maryknollers, as they were known, were supported by the newly inaugurated Catholic Foreign Missions Society of America and the *Field Afar*, the first mission magazine by an individual American Catholic order to be widely circulated after the First World War.[75] The umbrella Society for the Propagation of the Faith (Propagandum Fidei), overseeing multiple global Catholic mission enterprises, also published its own English-language magazine, *Catholic Missions* (an offshoot of the French-founded *Les Missions Catholiques*), itself a glossy volume richly illustrated with full-page paintings and enlarged photographs.[76] The Passionists were playing catch-up in their own media production.

O'Gara, who was perhaps taking lessons from secular print media as well as from that of religious competitors, recognized the connections between "clear and distinct" photographic reproductions and the mass interests of US Catholic readership.[77] The priest served as an unofficial field editor for the Passionists, organizing local photography through the 1920s for contribution to the magazine's image repository. His statement, noted previously—"to get the types [of photographs] which you want will not be

easy"—was made in response to a member of the *Sign's* editorial staff in New Jersey.[78] O'Gara's efforts likely drew the attention of Passionist superiors to his abilities as a missionary administrator, resulting in his promotion to apostolic prefect of Chenzhou in the spring of 1930 and later consecration as bishop of Yuanling on October 28, 1934. The latter event, accompanied by parades and a liturgical procession in Hankou, was recorded in a short 16 mm movie, possibly at the media-savvy O'Gara's request.[79] In any case, the dissatisfaction that O'Gara expressed with the magazine's misuse of images—which his fellow priests clearly shared—was strong enough that it dampened the group's interest in photography for documentary purposes. O'Gara concluded his criticisms by noting sarcastically, "I confess to having experienced a distinct cooling of enthusiasm in the matter of *Sign* photography after this."[80]

The case of the wreck photograph was not isolated, and it was not the least problematic of the *Sign's* editorial decisions from the missionaries' point of view. Less than a year later, a sharper epistolary exchange took place over an article in the *Sign.* In this case, the Passionist missionaries' lack of control over visual reproduction and interpretation sparked more intense responses than a mere "cooling of enthusiasm." The last page of the publication's January 1926 issue featured a vertically framed photograph (made by Maguire) of Raphael Vance standing next to a Chinese man and his son, their threadbare clothing uncovered to expose emaciated ribcages below sunken, staring faces. The boy, seated on a table to raise him to the adults' waist-level, holds out a bowl at an angle to the camera. It is white, a stark contrast against the figures' skin-and-bones bodies and Vance's black robes, both darkened further by the halftone reproduction. More importantly, the bowl is empty. Famine, a result of recurring droughts and floods, compounded by regional poverty and lack of compensatory infrastructure, had struck West Hunan yet again.[81] The article's title, hovering over their heads, shouts "YIAO FAN. A Cry of Distress."[82]

One of the first lines of the article declaims: "Look at the picture! A mere child reduced to a living skeleton; a poor man rapidly wasting away and so poverty-stricken that he has scarcely rags enough to cover his nakedness; a Passionist Missionary, once young and vigorous, now grown old, careworn and famished midst the ravages of absolute want, starvation and wretchedness." The text continues, "[While] tens of thousands [of Hunanese] are dying along the roadsides," [Vance himself], "who appears in the picture, has lived for days at a time without food. He has lived for weeks at a time on a daily ration of oats. How can a man who for sheer love of Christ and

his fellow man has sacrificed his whole life—how can such a man eat when others are dying of starvation at his very doors!" Whether that statement was meant as praise or a thinly veiled indictment of the missionaries' advantageous position was not as problematic as the *Sign*'s creative license with the image and text. The article claims that Vance annotated the photograph with "a message which we pass on to the reader: 'Here is an instance of what famine means to us in China. Here are pictured a father and son, both victims of the famine. Little Ambrose died two days after this picture was taken. This is just a sample of the sad sights and heart-rending scenes confronting us over here. I cannot describe the misery around me. No camera could possibly picture it.'"[83]

Vance's handwritten caption on the original print, however, only reads: "Father & son. Victims of famine. Baptized the boy Ambrose who died two days later. August 30, 1925."[84] By poetically padding the description and referring to indescribable, unphotographable situations that presumably

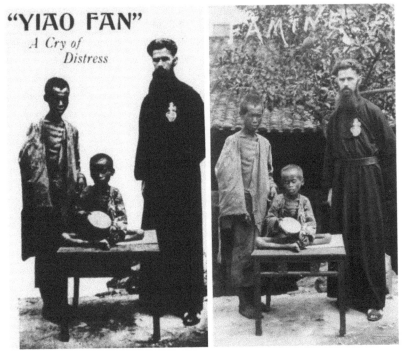

Figure 2.4. "Yiao Fan," photograph reproduced in the *Sign*, January 1926 (*left*). Original photograph by Theophane Maguire, annotated by Raphael Vance, ca. 1925 (*right*). File 800.02_016.021, PCC.

confronted the Passionists, the article fabricated a reality out of proportion to that on the ground, compounded by the photograph's indexicality and viewers' imaginations of unseen "heart-rending scenes." This fabrication extended to the reproduced image as well. The original photographic print that Vance sent to the magazine also included parts of the mission compound in the background. The retouching oils not only covered up distracting buildings to create free space for the dramatic headline but also removed a tree with a plump, persimmon-like fruit dangling incongruously above the subjects' heads—a plainly visible food source that would have destroyed the impact of the empty bowl and emaciated figures. While eliminating these visual elements, the editor also shaved off the right hem of Vance's robe and sharpened the Chinese man's cheeks, making their bodies appear slimmer (and more starved) than they were in the original image.

The *Sign's* textual and visual manipulations did not go unnoticed. Almost as soon as copies bearing the "Yiao Fan" article arrived in China, Passionists there began sending irate messages to the editorial office and apologetic notes to their religious superiors. Fr. Theophane Maguire, who produced the photograph, composed a long letter to the Passionist Provincial, Fr. Stanislaus Grennan, likely hammering away at the same typewriter used earlier to narrate the wreck photograph:

> First let me say that I was deeply grieved at the publication and preaching of so much propaganda about Father Raphael [Vance] going for days without food and living on oats. . . . This is all ABSOLUTELY FALSE. I have been in this territory, of which Raphael has charge, for nigh to a year and he or I or Anthony [Maloney, CP] have never been in this dire want. . . . God has been very good in taking care of us. . . . So when the *Sign* came out with the picture of the star[v]ing boy (that is true for I brought him in to the Paotsing mission and took the picture) and said that Raphael was in want; and when I heard that your Paternity was preaching this same matter (as at St. John's in Brooklyn), I was simply dumbfounded![85]

Maguire confirmed the famine's severity—he noted, "Daily I have been giving rice to about a *thousand* at [Baojing] . . . those [US supporters] would be happy for their sacrifices could they see this crowd of blind, lame, crippled, the aged, children, mothers and their babes really hungry." But he was clearly disturbed that the *Sign* was exaggerating images and information from China while reassuring perplexed supporters (in this case, "Father Raphael's people") that "this was needed for propaganda." Writing that "much

of the description of the famine ha[d] been taken from that of several years ago" and that it was "not true . . that 'tens of thousands [were] dying along the roadsides,'" the priest reminded the provincial that Passionist supporters regularly received letters from the missionaries alongside copies of the *Sign*. Stark discrepancies between the magazine and private accounts, Maguire felt, would lead to confusion ("Will they believe our letters of assurance when our official publication perseveres in printing these comments?"), unnecessary anxiety ("Truly if God sends us sickness or suffering or death our dear ones must bear it . . . [b]ut there is no need, is there, to torture them without reason?"), and destructive misgivings among supporters. Although claiming "a little experience . . . in begging," Maguire concluded that the magazine's actions bordered on sinful deceit. "The general opinion," he wrote, "is that in great measure our support is from those none too well off in this world's goods. And when I think of the value Our Divine Lord set on the widow's mite, I cannot but feel FEAR lest we be guilty in His sight for receiving it under a false plea."[86]

Other Passionists were concerned not only with spiritual repercussions and problematic reception by US supporters but also with the risk that the magazine would damage their public image in the eyes of other Catholic missionaries in China, who were also in a position to accurately judge facts against fabrication. Fr. Basil Bauer, CP, writing separately to Grennan from Yongshun, pointed out, "Not one of us have [sic] written the terrible things the *Sign* is printing about the famine." He warned:

> The *Sign* is read by the other missioners in China and they must think we are gone crazy at what they read. They know conditions and we have to make light of the *Sign* when our men have to speak about it. I don't think there is any place in China that is as bad off as the *Sign* pictures. The reason why many of the men are unwilling to write to the *Sign* is because they disfigure and stick in things that the missioners are unwilling to put their names to. A little touching up in the English no one condemns, but the adding of new paragraphs and leaving out important things, that is what sours the missioner in his writing.[87]

Although Bauer did not specify what he meant by stating that no "place in China" was "as bad off as the *Sign* picture[d]," his reference to "disfigure[ing] and stick[ing] in things" and "the adding of new paragraphs and leaving out important things" pointed to the missionaries' lack of full influence over the publication process and also the inherent slipperiness of

photographic meaning.[88] The Passionist editors had the power to reinterpret and reshape visual material sent from China, for better or for worse, in ways that the missionaries could not. Even when acting in what they perceived to be the missionaries' best interests (e.g., soliciting funds with dramatic but less-than-factual articles), the editorial staff ended up "disfiguring" the missionaries' experiences as related through their visual material. The anger and apprehension with which O'Gara, Maguire, and Bauer responded to these episodes was of course undergirded by the distance and time delay between themselves and the *Sign*'s editorial offices. The magazine reached US audiences long before it did its contributors in China, and the imaginations it aroused, rightly or wrongly, were as impossible for the missionaries to direct as the Hunanese climate and the churning rivers along which their photographic materials passed. These and other similar episodes starkly reminded the missionaries in Hunan that the transnational circulation of photographs did not equate to a self-evident transmission of meanings that the producers attached to the images. Yet, in spite of these struggles over "what the picture[s] signified," not to mention the poor technical quality of visual reproduction, Passionist missionaries continued to produce photographs across the next two decades, many of which were published in the *Sign*. Many more likely did not appear in the final printed product. One wonders how many more original images did not survive the transpacific journey, were wholly misrepresented in the absence of their makers' and subjects' perspectives, or were left on the cutting-room floor in improvised Hunan darkrooms or at the *Sign*'s New Jersey offices. When it came to the *Sign*, the missionaries could not fully control their transnational media identity.

Visual Afterlives, Martyrdom, and the Unknown

The tensions between seeing and knowing and between the imaged and the imagined were constantly present for the Passionist missionaries in Hunan, as they were for the editors and readers of the *Sign*. In some cases the photographic image indicated what the missionaries did not know more than it represented what they did know. The images surrounding the Passionist missionaries' lives and deaths represented forms of angst similar to the "epistemic anxieties" among colonial administrators in the Dutch East Indies that Ann Stoler examines. This angst was mediated by the limits of photographic vision rather than textual documentation.[89] Religious conversion

and continued devotion to the Catholic Church were far more complicated to frame than the baptism of infants and group gatherings. In some ways, proper belief was just as difficult to control as the missionaries' media production and reception. Apart from hands-on attempts to provide religious training for young postulants like Vance's five altar boys, the laity the Passionists ministered to and photographed presumably fell short of desired devotional standards—at least from some missionaries' points of view. One of them, Fr. Arthur Benson, CP, lamented in 1926:

> From what I have seen of the Christians I would prefer our Holy Founders [sic] advice "few but good," but it would take a saint to pick the "few." I have not met one single Chinese Christian whom I would call 100 percent. I have met some very devout ones but they have been either working for the Mission, or profiting from it in some material way. I never saw it fail that if they are discharged, or fail to gain their own personal advantage, they quit coming to the Church, or at least, they remain away, except on . . . big feasts: Easter, The Assumption, and Xmas. The greater the number that enter the Church, the greater the Missionarie's [sic] joy and consolation, but if I could only save one soul that I thought was sincere I would glad[l]y spend my whole life here.[90]

His statement echoed the Passionists' underlying anxieties, and in broader ways, the whole of the missionary enterprise in China. Religious conversions were not easily categorized in terms of clear-cut success or long-term stability. As Benson reported, a "very devout" Catholic could also well be a material profiteer. Not all of the people photographed by the Passionists as having "enter[ed] the Church" could be measured as "100 percent" by virtue of their image. The relationship between visible representations of conversion and true changes in spiritual identity was never as clear as the missionaries wanted it to be. Photographs, in this light, were permanent representations of momentary perceptions of religious conversion; whether or not these conversions were "sincere" or brought lasting "joy and consolation" was beyond the indexicality of the visible image. On the one hand, images could represent success in religious conversion, but on the other, they could just as well embody the missionaries' uncertainty and anxiety. Though the Passionist missionaries possessed the technical ability to produce photographs and exercised some control over visual presentation of Chinese Catholicism, the converts themselves were the final arbiters of their own religious identity. The *Sign*'s embellishment of Vance's photographic

caption more aptly describes the limits in visualizing conversion; when it came to providing visible proof of spiritual identities below the surface, "no camera could possibly picture" them.[91]

In other cases, photographs represented external threats to the Passionist missions and Chinese Catholic communities. Bandits and warlord forces—sometimes one and the same—routinely crossed paths with the Passionists, and their violence, real or perceived, was often referenced in the *Sign* as well as in the missionaries' personal accounts.[92] Although they could not always clearly articulate specific reasons behind criminal activity, its effects appeared in the missionaries' images. On one occasion, a group of bandits who visited the Passionist mission in Luxi "insisted that [the resident missionary] take their photograph." The group lined up in a sunny courtyard and the missionary made the photograph from an oblique angle, perhaps unwilling to stand directly in front of the men, two of whom were brandishing unholstered automatic pistols. Multiple prints of the image were made, with at least copy marked with a black "X" in ink hovering over the head of one man "recently executed shortly afterwards."[93]

In other cases, image captions clearly referred to violence, as with a group photograph of orphan boys, all wearing Western boy scout–style uniforms, holding bugles and flanked by US and Chinese national flags. The verso was inscribed, "The boy at R[aphael Vance]'s side (holding the flag) is Fu Paulo—one of the postulants. His Father was recently murdered by bandits. A few days' [sic] later one of our boys from Se-wan-chu was cut to pieces by bandits. Can you find Pat and John and Joseph—the other postulants—in the picture?"[94] The "known" imaged group, which included the five altar boys previously photographed by Vance in the mission chapel, takes on another dimension in relation to the regional violence mentioned in the caption. The national flags, the presence of the US priests, and the boys' clothing represent symbolic, albeit tenuous, forms of protection. The specific reference to "Fu Paulo," orphaned as a result of bandit activities, suggests that the Passionists perceived a need to offer this communal protection in their mission work—and not merely as a short-term project or in this case, as a recreational activity.[95] But this visible display of the boys' connection to the Chinese Catholic community (and by extension, foreign and global Catholicism) is shadowed by the invisible violence that was present in their lives and in the collective consciousness of the Passionist priests who reported it. The unknown and unseen was more threatening than what photographs could display alone.

The missionaries' own encounters with death are visualized in another photographic scrapbook, assembled sometime after 1929. Composed of

photographs made by various Passionists, including all of the individuals mentioned thus far, the scrapbook opens with a seemingly idyllic cross-section of the missionaries' visualized life in Hunan: pages of local landscapes and buildings, group gatherings, Chinese adults and children, "Wangtsun, China. The Feast of the Assumption," "lovely Wuki on a Sunday morning," and so on.[96] Then, on a page near the middle of the scrapbook, a different photograph appears. Five Chinese soldiers stand together in a slightly slouching line. All have military caps, slacks, and puttees; three have Sam Browne belts; one is armed with an ammunition belt and holstered pistol. The soldiers stare stoically at the camera and its Passionist photographer. The caption on the front of the image, penned in blue ink along the print's lower white border, reads "HUNAN SOLDIERS 1929." Turning over the photograph reveals a different annotation: "Some of our boy friends. The soldiers of China. They may be bandits next time you see them."[97] Soldiers' political allegiances often shifted, a fact that the missionaries were certainly aware of. Nevertheless, the difficulty of visually identifying one's ally ("our boy friends . . . the soldiers of China") or enemy ("bandits next") was strongly salient for the photographs' annotator and viewers, for specific reasons seared in their minds as they looked at the images.

Immediately following this scrapbook page, the visual narration turns darker. The next image, a photograph taken from across a rice paddy framing village buildings in the background, reads on the verso: "Where the murdered Fathers took their last dinner 'on earth' near Hwa Chiao, Hunan, April 23, 1929."[98] This is followed by a group image of seventeen Passionist missionaries sitting together and squinting into the bright sun behind the camera, a moment of rest at a religious retreat in Chenzhou a week before that date; above three of the men's heads, black marks in ink indicate their fate. They did not live to see the photograph printed. The next image displays four newly completed coffins, their black lacquer finish shining in the window light, lying together in front of the Gothic high altar in the same church where the missionaries had recently undertaken their retreat.[99] One held the remains of Fr. Constantine Leech, CP, who had died of typhoid fever and overwork, while the other three belonged to the men marked in the retreat photograph. They were Frs. Walter Coveyou, Godfrey Holbein, and Clement Seybold, CP, who, while returning to their individual missions after the gathering, spent the night of April 23 in the village of Huaqiao.[100] En route the next day, they were ambushed by bandits, stripped, and shot to death—their bodies thrown into a mine pit and discovered thirty-six hours later by a company of Chinese troops and Passionist personnel alerted by

servants who had escaped the killings.[101] Seybold, whose battered body now lay decaying in a Chinese coffin photographed by his living colleagues, was also the same missionary who reported his "best camera" stolen by other Hunanese bandits the year before.[102]

The three missionaries' murders brought to a head the tensions between the real and the imagined, the known and unknown for the Passionists, the Chinese Catholic community in West Hunan, and their US supporters. Photographs surrounding the event contrasted life and death, the imaged and the invisible. Embedded in Christian approaches to religious community and martyrdom, they symbolized multiple temporalities, distances, and belongings. For the Passionists (and other Catholic and Protestant missionaries in China) photography not only documented visible reality but also referred to alternative, invisible realities. The village of Huaqiao, consisting of a few buildings and a rice paddy framed in the scrapbook photograph, was transformed by indexical image and text into a spiritual space in which the deceased Passionists "took their last dinner 'on earth.'"[103] Although the men did not die in the village and their bodies and murder location were not photographed (as far as the archival record shows), the image is colored by the imaginations of the violence that followed. The missionaries' one-time existence in that visualized space renders them similar to Roland Barthes's photographic subject, "here and yet immediately separated . . . irrefutably present, and yet already deferred."[104] The photograph and caption conflated the missionaries' temporal and physical existence with their unforeseen deaths and spiritual afterlives, as well as linking their experience to the Last Supper—itself a pivotal (and famously visualized) event preceding Christ's own death that was imbued with religious meanings not confined to time or space.[105] Similarly, the photograph of the coffins lying in state before the Chenzhou high altar would have been received by Catholic viewers as the four Passionists coming together in death with Christ's presence in the "sacrifice of the Mass," reinforced by the sacred space in which their bodies and the eucharistic elements were displayed.[106] Although the image is grounded in a specific time and space, it also references a collective, invisible, nontemporal spiritual experience—which presumably included the Passionist photographers and viewers as well as the Chinese Catholic community in which the photograph was made. Finally, the subsequent scrapbook images (several taken in rapid sequence with rollfilm or a sheet-film pack, almost mirroring still frames from a movie) of the funeral procession visually link the Passionists—living and dead—to the Hunanese people.[107] In these photographs, the coffins are carried in veiled catafalques

resembling those traditionally used for funeral rites of the elite, led by men exploding strings of firecrackers and accompanied by massed groups of Chinese Catholics and foreign missionaries wearing white mourning robes. This signals the transformation of the murdered priests from Americans and Catholics in life to imagined members of the Chinese people and landscape in death.

Across the Pacific, eulogies published in the *Sign* underscored this cultural-spiritual convergence. Two months after the three priests were killed, the magazine released an issue largely dedicated to their martyrdom. In an article by Silvan Latour entitled "At the Rainbow's End," Coveyou, Holbein, and Seybold's portrait photographs—taken in a commercial studio before their departure to China and showing them wearing their simple Passionist vestments—are enlarged to such an extent that they take up nearly half of the printed page. The typed text reporting their life and death and extolling their sacrifices as martyrs wraps around each image, leading the readers to repeatedly scan across the portraits as they read each page from top to bottom. Phrases emphasize the priests' purported good spirits immediately prior to the event ("[They] were happy, almost gay . . . not a care filled their hearts"), the violence of their deaths ("The priests were shamelessly stripped and one by one shot down in cold blood"), and their spiritual transformation from missionaries to martyrs. One statement, quoted from Fr. James A. Walsh of the Maryknollers—the Passionists' competitors and colleagues—proclaims, "Today we witness the blood of Americans flowing into the soil of China, and, recalling that 'the blood of martyrs is the seed of Christians,' we cannot help feeling that the mission effort of American Catholics will be greatly benefitted by this libation."[108] Of course, none of the US readers were (or could have been) physically present at the funeral rites in West Hunan, but their imaginations and religious beliefs, reinforced by photographs, made them witnesses by proxy. These photographs of deceased Passionists confronted readers of the *Sign* as images of persons who, viewed through the lens of Catholic martyrdom, were at once living and dead.

This presentation emphasized the images as visceral photographic encounters with loss and longing—what Barthes calls "that-has-been."[109] The three priests looked out of the page at readers who not only knew that they were physically deceased but also believed that they had died for the Passionist missionary enterprise and were spiritually alive as martyrs (and, in a uniquely Catholic sense, as potential spiritual intercessors for the living) in heaven.[110] It was presumably these same photographic portraits or enlarged copies that were displayed in the Passionist seminary in Chicago for years

after Coveyou, Holbein, and Seybold died, reminding viewers of their martyrdom and even disturbing a few with their photographic lifelikeness and embodiment of death. At least one viewer would meet a fate similar to that of Coveyou, Holbein, and Seybold. Fr. Carl Schmitz, CP, "the first American Catholic priest to die a violent death in the Philippines . . . interviewed for the Passionist seminary [at age fourteen] in 1931 in the Chicago seminary where the picture of the three priests in China hung on the wall." The future missionary was noticeably "impressed but frightened by these three black-clothed men wearing the Passionist heart."[111] Perhaps this fearful awe at encountering the photograph played a role in Schmitz's motivation to pursue his own spiritual vocation. The connections, if any, between the image and the young seminarian's perceptions of martyrdom will likely remain unknown, but it appears that the image effected a Barthesian *punctum* for Schmitz and his Passionist biographers.[112]

The Passionists in West Hunan lived in and imaged a world of their own. Their visual, cultural, and spiritual conversions (among themselves as well as the Chinese people) were shaped by two distinct registers. The first was the local—the development of Catholic community in West Hunan. The second was the transpacific or global—the construction of their media identity through image and text. While contending with bandit and warlord activity, famine, disease, and complicated relationships with Chinese Catholics, their experiences and visual practices were not (and perhaps, taking into account hindsight and the limits of individual perspective, could not be) focused on the larger historical changes taking place elsewhere in the province. That is not to say that the group was blind to the repercussions of regional conflicts and political shifts. As warlord and bandit activity gave way to the Chinese Civil War from 1927 onward, the Passionists made careful note of growing antiforeign and anti-Christian sentiments among the communities in which they were embedded, changes that they and their US colleagues routinely ascribed to the lurking presence of "Bolshevism."[113] More astute members of the order, including Timothy McDermott, sympathized with local iterations of Chinese national identity and attempted to distance themselves from a staunchly American identity. While decrying the presence of "Bolshevist Propaganda rampant among the Student Class in the coastal cities," McDermott insisted during local antiforeign demonstrations:

> The foreigner is not wanted in China—much less so today than he was three years ago—and you can't blame the Chinese . . . there is no doubt about it—this Big Brother Talk of the [Western] Powers is not to help China but to

further their own commercial interests. The Foreigner is making his future at the expense of the Chinese and doing much by his materialistic [and] even pagan morals to discountenance all foreigners. Thus untold harm is done to the spread of Religion. Some of our own men are quite proud of their nationality—it is America this, America that, we do this in America, we do that in America—and they make sure that "Mei Kwo" [America] is printed on their name cards as tho[ugh] that were something infinitely better than "Tien Chu T'ang S[h]en Fu"—"Priest of the Catholic Church." For my part, I banish the words America and American from my vocabulary. I want to be known only as a Priest of Holy Mother Church. My citizenship is no advantage.[114]

On the one hand, this is another example of the conversion of missionaries, an alignment with Chinese nationalism (also evidenced by linguistic attachment) and liberal ideologies that were not part of McDermott's worldview when he first arrived in China. On the other hand, his sympathy toward antiforeign grievances and claimed alienation from US nationality was ultimately entrenched, for better or for worse, in his identity as a missionary priest. As representatives of "Holy Mother Church," McDermott and his fellow Passionists were embedded in the local environment but simultaneously connected to a religious institution that extended far beyond China, the United States, and even the world as a whole. Their vocational attentions, cultural worldviews, and visual practices were defined by what they saw immediately around them, while their religious imaginations and approaches to conversion were shaped by their Catholic belonging. They were representatives of Catholicism in a Chinese context and visualized both mission and conversion for US audiences. But they were not representatives of China. Others, located not far from the Passionists, were taking on that role. Unbeknownst to the priests, shortly before the first six missionaries arrived in West Hunan and as subsequent others settled, proselytized, and died in the area, another group of individuals in the same province were thinking about their own communal and national identities along somewhat similar, albeit secular lines.

As Father Vance and Father Purtill opened the door of the mission to allow George Tootell to climb the church steeple and photograph the American Presbyterian mission, as McDermott fiddled with his temperamental self-timer, and as Maguire mailed his print of the "wreck on the Yuan" to Passionist editorial staff in New Jersey, a group of men in the city of Changsha, a mere ninety-three miles southeast of the Passionists' mission area,

were moving ahead with their own conceptions of communal transformation. They were Hunanese political activists, inheritors of a long tradition of grassroots reform movements in a province that China's imperial and Republican governments regarded as a backwater. They were also the proponents of an identity that was linked, like those of the Passionists and the Chinese Catholics in Hunan, to foreign ideologies. The group was defined not by Catholic Christian but by an unlikely convergence of liberal American thought and Russian Marxism, the progenitors of the "Bolshevism" that the Passionists reported. In the early 1920s, after extended clashes with Tan Yankai, Hunan's presiding governor, the activists publicly announced their plans for the province to take on a self-governing identity as the constitutional Republic of Hunan.[115]

One of the individuals organizing the reformers was in the process of forging a historical legacy that would overshadow that of the Passionists in China. Also engaged in media dissemination, the principal (and former student) at the elite First Normal School published a 1920 essay proclaiming the "Republic of Hunan" in the Changsha newspaper, *Da Gong Bao*. He worked hard to promote nascent Chinese communist principles among Hunanese laborers and peasants while Passionist missionaries baptized infants, celebrated Mass, and produced photographs at their mission outposts.[116] None of them (or even the man himself) could foresee that over two tumultuous decades later, he would proclaim the establishment of a different republic. This one would extend beyond the rugged Hunan landscape and ultimately sound the death knell for the foreign missionary enterprise in China.[117] The man's name was Mao Zedong.[118]

Chapter 3

The Movie Camera and the Mission

Vernacular Filmmaking as China-US Bridge, 1931–1936

One week before Christmas in 1930, a group of eight church elders met in the well-appointed chapel of the Presbyterian Church in Rye, New York.[1] The mid-evening meeting was brief, with only two major points of discussion. Before resolving that no prayer meeting would be held on New Year's Day (perhaps to some private relief), the session voted that the church's Christmas Day collection would be used for a special gift to "their missionary," Dr. Harold Henke in North China.[2] After the adjourning prayers were said and the clerk's notebook snapped shut, the men returned home to sitting rooms with newspapers and books, among them the ubiquitous yellow covers of *National Geographic* magazine. China and the special gift for which they had voted were not so far from their minds. The commercial sections of that year's magazine featured advertisements for a Cine-Kodak Model B movie camera, Kodak's contribution to the nascent world of amateur filmmaking. Touted as "camera[s] that understand amateurs" the Cine-Kodaks were aimed at well-heeled travelers and their armchair compatriots, urging them to consider "bringing back" films of "Rome[,] Timbuctoo[, and] Main Street . . . as easily as snapshots."[3] Yet, none of these three locations appeared in the ad's illustrations. One depicted a stylish woman holding a Cine-Kodak with its lens pointed at the other image, a camel train traversing a dusty road

in front of Beijing's city walls, a place presumably as exotic (to most Westerners) as Timbuctoo but still as traveler-accessible as Rome.

As the advertisement circulated around the world, Jessie Mae Henke, now nearly four years into her tenure in China, mailed a letter to friends in Los Angeles from a post office mere blocks away from the ancient walls featured in *National Geographic*.[4] In it, she acknowledged the receipt of supporting funds while discussing her and her husband's participation in refresher courses at the Peking Union Medical College.[5] Near the end, Jessie Mae broached some exciting news, scribbling it into the middle of the penultimate paragraph. "We . . . are getting a movie camera this summer, a gift from the church at Rye, New York," she wrote, "of course we can hardly wait, both to take pictures and to get them sent home to let our folks know and see what this place we are living in is like."[6] The Christmas Day collection had made its mark. The special gift was none other than the Cine-Kodak Model B, yet another form of support provided by the Rye Presbyterian Church, which since 1928 had funded the Shunde hospital's equipment and operations, medical education for Chinese personnel, and the Henkes' $1,575 annual salary.[7]

Although the Henkes were not the wealthy tourists for whom the Kodak advertisement was intended, their supporters in Rye may well have been among the readers who encountered the ad and considered purchasing the camera for a religious and humanitarian cause. Even before receiving the Cine-Kodak, Jessie Mae was already thinking along the lines of the advertisement's opening statement: "How wonderful it is—that you can bring home your trip . . . a day-by-day record of all that you see. Think of having a travel diary made up of living pages to look back on at will!"[8] Just as the movie camera was to be shipped westward across the Pacific, Jessie Mae envisioned the international circulation of finished film through familial and institutional networks, its products sent eastward to audiences in the United States. "Our folks" included not only the friends to whom the letter was addressed, but also a larger religious family—the Presbyterian and Congregationalist congregations in the Midwest and on the East Coast that supported the Henkes' work in China through financial contributions, material gifts, and prayer.[9]

The Henkes' films feature a mix of private and public content, produced in multiple places for local and transnational audiences. Moreover, the films were moving images not only within the literal film frame but also in their circulation and interpretation. As visual artifacts, the Henke films were products and representations of what film historian Patricia Zimmermann

calls "family life, minoritized cultural practices, fantasies, [and] the quotidian" elements that made up the microhistorical experiences of American Protestant missionaries in the interwar period.[10] Although the films contain multiple meanings and visual practices, they are isolated from the broader extant body of missionary filmmaking. At face value, they are the products of a single Protestant missionary family fortunate enough to receive a movie camera from well-funded supporters at a time when consumer filmmaking was still in its infancy.

Nonetheless, a deeper look at the films' content and known circulation indicates that they were intended as visual bridges. Produced in local Chinese and US spaces for audiences located in both countries, they connected groups of viewers through their visual format and mobility. The Henkes carried the films back and forth between the world of the mission and the world that sent them to the mission. The films encompassed cross-cultural contact, friendly gestures, and fellowship. The last point was perhaps the most particular to film, as screenings brought together and animated large audiences in ways that still photographs could not (at least not in their printed, non-projected form). Thus, not only did the films' content portray fellowship but their visual displays also created it. In showing films, the Henkes and other missionaries elicited a range of responses, framed by outreach to both US and Chinese viewers, wonder making (which included instances of confusion and disturbance), entertainment, and spiritual and cultural enlightenment. Furthermore, in their vernacular narration of community, these films touched on the broader milieu of 1930s documentary expression, while largely occupying a liminal space at a distance from contemporary politically charged images.[11] Although it is impossible to fully recover the films' specific modes of production and reception, the remaining fragments illuminate bridge-making characteristics, connecting times, spaces, and people in the missionary enterprise.

The World of Missionary Film

American Protestant churches of the 1930s were no strangers to film or to its use alongside similar visual materials in missionary presentations. The relationship between secular commercial cinema and US Christian culture was marked by long-term struggles over content and control. But film's narrative format, its inherent ability to be viewed by a mass audience, and its visual spectacle all lent itself well to church use and congregational consumption.[12]

Early links between missions and film were rooted in a longer global lineage of lantern slides with similar presentation modes, deployed in China from the nineteenth century onward. In the 1880s, for example, the famed British Baptist missionary Timothy Richard deployed a gas-powered lantern slide projector in a highly successful series of scientific lectures "in a Christian spirit" for Qing officials and local elites in Shanxi and Shandong.[13] In the following decades, the YMCA, educational and medical missionaries, and the Shanghai-based Commercial Press all engaged in the production, presentation, and marketing of lantern slides across China.[14] Although movies were a new arrival in comparison to this longstanding visual medium, as early as 1909, films were employed alongside lantern slides in Protestant mission conferences. An article entitled "Missionaries and Moving Pictures," published in the first issue of the film trade magazine, the *Nickelodeon*, reported, "[Though] a considerable portion of the opposition to moving picture theaters has come from clergymen and other church people . . . these same people hold nothing against the moving picture itself, however, and . . . they fully appreciate its scope and value in all kinds of work[,] shown by the increased use of films for depicting biblical scenes, missionary work, etc."[15] Giving an example of films presented to support missionary work, the writer noted:

> Aided by more than 150 stereopticon slides and half a dozen moving picture films projected on a screen by a large double lantern . . . President [Archibald] McLean, head of the Foreign Christian Missions Society, closed the annual foreign missionary rally of the Christian [Disciples of Christ] churches of Indianapolis, Indiana, in the Central Christian Church. The audience which [sic] listened to the talk was the largest which has ever attended a missions meeting in the church . . . Pictures of the missions [sic] hospitals [in China] were thrown upon the screens. In [McLean's] discussion of these hospitals . . . the audience was shown some of the maimed patients treated and cured by the missions [sic] physicians. A moving picture film gave the details of an operation which restored the sight for a little blind child.

This presentation displayed an impressive array of imaging apparatuses while also representing modern medical and visual methods in the service of missions. The audience watching the film of the "operation which restored the sight for a little blind child" could have easily conflated technological advances (in both the visual medium and medical content) with religious traditions. Here, in awe-inspiring moving images on a large screen, was their

church carrying out modern-day forms of Christ's healing of the blind and sick.[16] Harold and Jessie Mae Henke, who were young children in Indiana and Illinois at this time, may have witnessed such slides and films; other American missionaries to China were certainly influenced by such presentations.[17] Although the *Nickelodeon* did not report the sources of the films and lantern slides at the Disciples of Christ conference, the denomination's missionaries abroad likely contributed still photographs to the lantern slide presentation. Members of the audience may well have identified particular missionaries whom they knew personally or supported as part of an affiliated congregation. For those not already in contact with missionary subjects, such presentations were intended to arouse the interest of conference attendees through visual spectacle, leveraging film (or film-like visuality) to highlight domestic support for foreign missions, as well as to invite them to consider the possibility of becoming missionaries.

Protestants, of course, were not alone in this, and the visual conversion experience was not limited to Americans considering missionary careers. Chinese revolutionary writer Lu Xun's own "Damascene moment" resembled the soul-shaking experience of witnessing these dramatic visual presentations in an audience charged with emotional fervor.[18] Lu gave up a potential medical career after witnessing a graphic anti-Chinese lantern slide presentation while a student in Japan during the Russo-Japanese War.[19] In Catholic circles, Fr. Joseph Henkels, a priest with the Society of the Divine Word (SVD), wrote that a "slide lecture" given by a missionary visiting from Shandong Province when he was in the fifth or sixth grade "made a deep impression on" him and other children present.[20] The presentation included vivid hand-tinted images of blood-stained clothes worn by two priests "martyred" by Chinese attackers in the 1897 Juye Incident, a precursor to the Boxer Uprising.[21] Within a year of seeing the "holes in the garments . . . made by the spears" (recalling similar imagery linked to the crucified Christ), Henkels "realized that [he] had a vocation to the priesthood."[22] He went on to be a long-term missionary in Henan and had multiple brushes with violence during the Second Sino-Japanese War—experiences that will be discussed in the following chapter. Although such conversion experiences were motivated by more factors than the visual encounter alone, connections between mass visual presentations, spectacle, and recruitment for missions clearly led a wide range of individuals to consider the call.

Missionaries also carried films abroad. A little over a decade after the 1909 missionary rally in Indianapolis, the *New York Times* noted that eighty-six American Methodist missionaries departed for "posts in Africa, China, India,

and Malaysia . . . equipped with moving-picture films [and had] been specially trained for their work."[23] The title of the article, "Taking Films to Heathens," reflected secular beliefs and stereotypes that missionaries and their films were spearheading moral uplift among "primitive" native groups. These popular US perspectives lagged behind realities in China, as contemporary religious viewpoints and missionary identities were already in radical flux. The *New York Times* article and others by film-trade writers emphasized the perceived evangelistic power of film in missionary enterprises, at least in a cultural sense. One author claimed in *Motion Picture Education*, "[In] the Philippines . . . the motion picture has succeeded in preaching, among other important things, the gospel of sanitation, [and] . . . when 'Quo Vadis?' was shown in Japan under the auspices of the Protestant Episcopal Board of Missions, it was seen by many distinguished folks, including members of noble families, rich merchants and people of the court who cannot be persuaded to attend church."[24] Although the novelty of film presentation undoubtedly attracted local audiences for whom missionaries screened their motion pictures, it is unclear whether the films described in the reports actually convinced "distinguished folks"—or people of any kind—"to attend church." Rather, the cause and effect in such cases may have been overstated by trade writers conflating presentation efforts with religious results (which were also one-dimensionally conflated with cultural uplift) in their efforts to close the gap between the developing US film industry and Christian institutions, then actively engaged in condemning commercial films on charges of moral corruption.[25] Even the article's author concluded that the Japanese response to such missionary film presentation was a feeling of "indirect influence" and sarcastically suggested that missionaries refrain from screening commercial films to indigenous viewers, lest secular genres like slapstick comedies cause the target audiences to "[become] so unruly that the missionary [would have] great difficulty in continuing the performance."[26]

Moreover, the eighty-six film-equipped Methodist missionaries seem to have been the only concerted effort by a US mission organization to systematically use film as an evangelistic tool overseas in this period. Most missionaries from the 1920s through the 1940s practiced film presentation on an individual basis. These activities were heavily dependent on supplementary funding to purchase films and screening equipment in addition to prioritized goods like medical supplies and educational materials. Further, rural areas often lacked electricity to run projectors (ironically, these were the same places where "heathens" were located, according to film trade publications), and pressing mission responsibilities often took priority over public

film screening.[27] Given these circumstances, isolated Protestant missionaries screening films in China did so for the crowd-drawing liveliness (*renao*), which then provided ready opportunities for American and Chinese evangelists to interact with the gathered audience using sermons, lessons, and religious print media (e.g., posters and tracts) in a more conventional manner.[28]

Almost exactly twenty years after the *New York Times* article, another report detailed on-the-ground use of film for Christian community building. This account (which has its own idealistic veneer), written in 1940 by American missionaries in an unnamed Chinese city under Japanese military control, is worth quoting almost in full:

> One of the [educational] missionaries has a movie camera. She took pictures of the women and their children. They had never seen a picture nor a camera[,] so they had no idea when their pictures were being taken. Thus, the pictures were most natural. One afternoon they were told to come early. After the baths, they were brought into a room and shown the movie of their children and themselves. They screamed with delight. Then they were given tea and cakes, they played a few games and went home.
>
> The women and children were now our friends. But every woman has a husband, and what about the men? These ricksha pullers, load bearers and carriers work from dawn till dark seven days a week. How can we give them the Gospel message? These missionaries are high-school teachers. Said they, "We stumble along feeling our way. . . . No, God is leading us, all the way. We felt to do something for the men, beginning small, with not too many people."
>
> So they said, "Let's show these pictures to the men folk—the men who are too tired for anything except gambling, and too tired for that." One day they gave tickets to the women who came to give their husbands. The men came—My! How they came! Three times the pictures were shown to three crowds. There was the Monday crowd, the Wednesday crowd and the Friday crowd. The only trouble was that some men sneaked in three times.
>
> And out of that grew the men's club. We did not know how to handle men, but it was laid on our hearts. We broached the matter to the Chinese Christians and two men came to help us. We had our school buildings and our gym. So we went to one of our seven valley villages. "Here we called from house to house," said the missionary. "We told the men. Tonight when the bell rings, *you* are invited to come to the school . . ."
>
> Forty men came. There were 20 minutes of singing; 20 minutes of games; three deep, musical chairs, passing the basketball, running. Then followed 20

minutes of elementary geography and hygiene: "The world we live in." "The people of the world we live in," "Our bodies." . . . A talk was made explaining why the missionaries are here.[29]

In this case, the "most natural" candid filmmaking and screening (the latter drawing from commercial practices, complete with tickets and controlled screening times) served as an entertaining spectacle that formed the starting point for networked community building. Evangelism was facilitated first by the cooperation of local women who established tentative relationships with the missionaries ("they were told to come early"), followed by their own outreach to male members in their families who then attended the film screenings, along with the partnership between missionaries and Chinese Christians to provide a fellowship for local men mobilized by the women. The film itself, with its apparent vernacular content, did not necessarily drive spiritual conversation. Similarly, the screening's successes at gathering local men, women, and children did not miraculously transform them into an audience receptive to the Christian message. It is no accident that the missionaries and Chinese Christians decided to conclude the men's event with "the story of the Good Samaritan . . . [and] a talk explaining why the missionaries" were there. But film presentation, a field counterpart to the aforementioned uses at religious conferences and in congregational settings across the Pacific, provided a catalytic experience that could be employed for other kinds of mission activity.

The 1940 account also provides tantalizing glimpses into the intertwined technical and social processes of missionary filmmaking in China. First, the presence of the portable movie camera, along with the apparent ability to process the film quickly enough to screen for a local audience in conversation with the missionaries, indicate that vernacular filmmaking technologies, practices, and commercial networks were well established by the time the educational missionary made her film. This was certainly not the case even for the Methodist evangelists traveling to Asia with their projectors and ready-made film reels in 1920.[30] More remarkable is the fact that the entire process took place under wartime conditions in a "[Japanese] occupied city," signaling some continuation of normalcy (or perhaps a desire for it) even as unspoken specters of military brutality and local collaboration—discussed at greater length in the following chapter—loomed large outside the frame.

Moreover, this was a specifically gendered production. The missionary behind the camera was an American woman, and the first audiences of the film were Chinese women and children. Here, vernacular filmmaking

merged with modern twists on the gospel of gentility in the missionary enterprise. The screening took place in a domestic space that included not only the film but also demonstration baths (a common public health initiative aimed at mothers), games, and tea and cakes. Mapped onto a long tradition of female missionaries and Bible women paving the way to family and male conversion, the camera and film in this case literally set in motion gendered community building. Women gave screening tickets to their husbands; perhaps prefiguring future hand-offs of religious texts and Bibles. According to the missionary's interpretation, the film provided a wholesome—and eye-catchingly unusual—distraction from gambling and other male-dominated vices. The female fellowship ("the women and children were now our friends") that began with visual encounters gave way to "do[ing] something for the men," and from there, a shift to the "men's club" with its masculine activities of basketball and foot races. The entire experience inverted patriarchal tendencies (with female initiatives leading the way) while working through family structures to answer the question "what about the men?" Although this community building fits well into histories of female evangelism, this particular occurrence is noteworthy in that it began with a movie camera.

The Henkes' experience in the summer of 1931 was an early documented instance of a US church supplying its missionaries to China with the equipment and materials necessary to produce film on their own. In many ways, the Henkes' eclectic filmmaking is well characterized by the later missionaries' comment on their own work: "We stumble along, feeling our way . . . No, God is leading us, all the way."[31] Harold and Jessie Mae Henke were at the forefront of this vernacular filmmaking, though they may not have realized it. At almost exactly the same time the couple began producing films in Shunde, the International Institute of Educational Cinematography in Rome published an article on potential missionary contributions to documentary and educational films. Entitled "Missionaries and the Cinema," the July 1932 article stated with an air of triumphalism, "The cinema has not entirely taken the place of the photographic camera as a means of visual documentation for missionaries any more than it has for other people, but . . . the missionaries have given us numerous films, which are all the more interesting inasmuch as the missionary cinematographist does not go to more or less unexplored countries merely to make films according to his taste and judgment, but as a result of long residence in one country has the time to observe and choose those objects and events which are worthiest of being registered."[32]

Most notably, the article emphasized missionaries' proximity to their living environments and local subjects as the primary advantage for producing more realistic documentaries. This intimacy excluded most professional filmmakers and commercial travelers with movie cameras, who might go abroad to produce films for a limited amount of time while lacking any prior relationships to the cultures and peoples in front of their lenses. Providing examples of Catholic missionary filmmakers in North Africa and Alaska who were producing ethnographic and scientific documentaries in places not ordinarily looked at by "other [secular] operators," the article concluded, "The documentary cinema is already in debt of the missionaries for some notable pictures." Granted, the missionaries the article referred to were certainly more adventurous than most. The article noted that an American Jesuit priest to Alaska, Fr. Bernard R. Hubbard, covered "over 4000 miles by airplane and over 1500 on sleighs, the greater part of the time alone, in order to visit the Jesuit missions on the banks of the Yukon . . . also cover[ing] some 300 miles on foot, carrying over 100 pounds of baggage on his back."[33] These dramatic ventures in documentary filmmaking secured Father Hubbard's place as an ethnographic filmmaker bridging secular and religious institutions in the film industry.[34] Clearly, not all American missionaries engaged in such physically demanding filmmaking practices, and most did not possess the professional equipment and industry contacts leveraged by Hubbard and other individuals. However, alluding to broader possibilities in missionary filmmaking driven by developments in consumer film, the article noted, "More may be expected of [other missionaries] . . . improvements in cinema technique have placed at their disposal a magnificent instrument, which in some countries can only be used by persons acting under the impulse of a powerful ideal, faith or science or maybe both."[35]

Documentary Imaginations

The "magnificent instrument" that the Henkes received in 1931—the Cine-Kodak Model B movie camera—was both a product of cutting-edge consumer technology and a luxury commodity by early 1930s US standards. The church's gift was certainly not inexpensive for photographic equipment purchased at the height of the Great Depression. A 1927 Kodak magazine advertisement lists the camera's precrash US price as a hefty $150, lowered only slightly to $140 in the *National Geographic* ad three or four years later.[36] The Henkes certainly could not have afforded the camera on their own.[37]

Despite the heavy financial outlay, the members of the Rye church, located in a wealthy New York suburb, made a prudent choice in selecting this model to send to China. The first complete amateur movie camera system marketed by Eastman Kodak, the Cine-Kodak was first introduced in 1923 as a solely hand-cranked model paired with an electrically driven Kodascope projector. Both used the new 16 mm film format, which was physically smaller and more economical than the 35 mm stock then in widespread use by professional cinematographers.[38]

By the time the Henkes received their Model B in 1931, the basic camera had been upgraded to feature an internal spring-driven motor. The user only needed to wind a small crank—which folded neatly back into the camera body after winding—to tension the spring sufficiently to expose fifteen to twenty feet of film before rewinding.[39] Other elements of the Cine-Kodak were also tailored for nonprofessional consumers like the Henkes, who were more familiar with the operations of contemporary still cameras. A *Scientific American* review of the Cine-Kodak system described it as "as simple in operation as the usual Kodak," and the Cine-Kodak's supplementary manual claimed that users would "find [it] an indispensable traveling companion to supplement their Kodak still pictures."[40] In addition to a direct viewfinder that could be folded away when not in use, the Cine-Kodak featured a

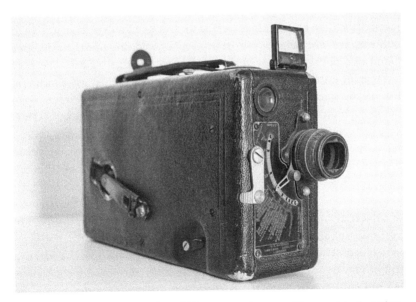

Figure 3.1 The Henkes' Cine-Kodak Model B 16 mm movie camera. Photograph by the author.

second, waist-level "Reflecting Finder" permanently built into the camera body, identical in design to the simple reflex viewfinders of box and folding still cameras. This second finder allowed the user of the Cine-Kodak to hold the camera at waist level while filming, as he or she would a similarly configured still folding camera.[41]

These continuities between Kodak products extended beyond similarities in camera use. In order to maintain consumer-corporation continuity, which was key to Kodak's global presence, the company opened finishing stations across the United States and in major cities around the world to process consumer movie film. Cine-Kodak users in China were encouraged to send their film to the Kiangse Road office in Shanghai, which opened in 1927 and remained the country's sole processing point for amateur films for years to come.[42] Given that Japan was a prime transit location for transpacific travel, another Kodak branch was located in Osaka's commercial district.[43]

Even so, vernacular filmmaking was radically different than still photography. Instead of slices of time frozen in single frames, the Henkes—like all filmmakers, past and present—now had to contend with extended segments of it. In addition, they faced the inherent challenges of framing motion (that of the subject as well as of the maker and medium), editing and constructing a filmic narrative, and numerous other production and presentation characteristics. Although the Henkes had been consumers of US cinema prior to coming to China, they had no experience in producing films before they received the Cine-Kodak. After opening the black-and-red packaging box and removing the new camera from its protective cardboard inserts, the Henkes found two pocket-sized manuals supplied by Eastman Kodak—the only filmmaking instruction available to them.[44] The first booklet was a technical manual on operating the camera (e.g., loading and unloading film, charging the spring motor, focusing, and setting correct exposure) and the second was a supplementary guide entitled *Making the Most of Your Cine-Kodak Model B f/1.9*. The latter concluded: "You are undoubtedly beginning to appreciate that amateur cinematography is an almost unexplored field—opportunities await you everywhere and the fascination of the hobby becomes more gripping every day."[45] At the most fundamental level, the Henkes had to be aware of subject motion and the movement of the camera as well as moving images spanning an extended amount of time. To this end, the instruction manual advised: "Experience has shown that usually twelve seconds or about five feet of film are sufficient for most scenes in which the action is continuous but not changing in character: For example, a waterfall; a street with the

usual traffic; close-ups of people who are not acting, etc. Some beginners make the mistake of using too much film in taking one scene with the result that . . . the picture becomes tiresome before the scene changes."[46] The first page of the supplementary guide included the warning, "A fundamental principle of all cinematography is camera *steadiness*. We cannot too often repeat or too firmly emphasize the importance of *holding the Cine-Kodak steady*."[47] And in case the point was lost on the user, the word "steady" appeared no fewer than ten times throughout the slim thirty-six-page instruction manual. Even when moving the camera to track a subject, users were admonished, if they "deliberately sw[u]ng the camera more or less violently from side to side, spraying it about like a garden hose" their pictures would "be absolute failures."[48]

Although the Henkes had basic instructions for camera operation, filmmaking was another story. Visualizing time, motion, and narratives on film meant that the Henkes had to think in radically new, experimental ways. Although a few pages in *Making the Most of Your Cine-Kodak Model B f/1.9* covered "Planning Your Motion Pictures," including "scenarios for children" and basic directions for acting, the guide gave no explicit advice on documentary or street filmmaking.[49] In fact, reading the it in the Shunde mission compound was likely a jarring experience. The guide suggested film subjects with wealthy domestic consumers (and traditional gender divisions) in mind, mentioning elaborate costume dramas, games of golf, "men . . . engaged in a keen business argument . . . ladies . . . examining a rose bush or pansy bed," and "the new coupe to display." These examples pointed to a class and culture far removed from the missionaries in North China.[50]

Kodak's suggestions for visual subjects were couched in a particular domestic subjectivity, an approach that was to define amateur filmmaking through the postwar years. Patricia Zimmermann, writing about the evolution of consumer filmmaking, defines this subjectivity in terms of an "[emphasis on] the beauty and harmony of Hollywood-style pictorial composition as well as control over narrative continuity" in the 1930s that evolved into an "isolation [of amateur film] within the bourgeois nuclear family" in the 1950s, in which "filmmaking became the visual equivalent of gardening: an activity in the family home rather than on the streets."[51] But the ways in which Kodak's suggestions entered reality were far from static. When producing films in the United States for consumption in China, for example, the Henkes focused on views of rural life that touched on, but were separate from, those advanced by contemporary documentary photographers

to mobilize public opinion.[52] Although the Henkes' films contain some of these documentary themes, their filmmaking cannot be described as wholly reflecting either "Hollywood-style" narrative control, insulated US domesticity, or activist visions in a secular sense. Instead, the Henkes' filmmaking practices were eclectic, shaped by the couple's desire to record life at the mission, by missionary embeddedness in local and global communities, and informed by their previous still photography in China.

Inspiration for the Henkes' filmmaking also came from an unexpected source. Jessie Mae and Harold visited a movie theater in Beijing at least once during their six-week residence in 1931. The theater was one of over twenty owned by Luo Mingyou, an entrepreneur who had founded the North China Film Company (Huabei dianying gongsi) in 1927, the same year the Henkes arrived in the country.[53] There, the couple watched their "first 'talkie,' [With] *Byrd at the South Pole* and thought it very nice." They "had seen the pictures in the [National] Geographic but of course, real moving ones were much more thrilling."[54] This event was mentioned in the same letter that included the news of the movie camera, and it is possible that the Henkes revisited their experience in the theater as they contemplated their own filmmaking. Composed of footage shot during Richard Byrd's 1928–1930 Antarctic expedition, *With Byrd at the South Pole* was a Paramount Pictures documentary released in the summer of 1930, winning Best Cinematography at the Third Academy Awards that November.[55] Almost one month before the award ceremony in Los Angeles, the film's Chinese premiere took place at Paramount's luxurious Capitol Theatre (Guanglu daxiyuan) in Shanghai.[56] On this occasion, the *China Press* praised the film's dramatic qualities while promoting the "realism" of the production: "Never before has such a colorful pictorial record been spread on the screen. More than 30 miles of film were required to perfect it . . . 'With Byrd at the South Pole' . . . is not fiction. It wasn't made in any studio. There are no actors in it. It is the true, blood-and-bone romance of . . . high adventure, actually lived by the men you see on the screen."[57]

By the time the Henkes viewed it in Beijing, *With Byrd at the South Pole* had been in circulation in Chinese theaters for nearly half a year.[58] Although Jessie Mae described the film as a "talkie," it was only partially so, having no true diegetic sound. Instead, prerecorded music, sound effects, and narration were played in synchronization rather than performed live with the screening, as was typical for silent films of the period. Incidentally, the *China Press* reviewer explained away this fact by gushing about the film's lack of "live" sound that heightened its visual drama, telling of "sublime and awful . . . scenes that subconsciously . . . support[ed] the

dramatic action with a silence in the darkened auditorium that [became] almost tangible."[59] Although the Henkes' activities in Hebei were often far from the Paramount film's "high adventure," their encounter with the documentary's reflection of experiences "actually lived by the men you see on the screen" may have influenced their filmic narratives. After all, they and their colleagues would be the actors, producers, camera operators, and editors of their own movies.

Moreover, as Jessie Mae mentioned that having "seen the [still Antarctic] pictures in the [National] Geographic" prior to *With Byrd at the South Pole*, she and Harold were considering relationships between still and moving images, using these comparisons to evaluate how they might translate their experiences with still photography into the new film medium. Because the Henkes lacked the technology to record any sound along with their films, they intended their finished film products to be accompanied by their live narration, a setup that was validated by the semi-silent nature of the Paramount documentary. Thus, the Henkes' 16 mm films mirrored documentary tropes encountered in the Beijing theater and prior viewing experiences in US cinemas. Their close-ups, multiple camera angles, inclusion of commercially produced intertitles, and deployment of local individuals as documentary guides are evidence of this appropriation. All of this reflected the Henkes' awareness of film as a visual medium for mass reception, in which screening was intended for both public and private groups.

Although the Cine-Kodak's journey to China began with a group of men in a church hall, Jessie Mae Henke gave the camera and its films a voice. Harold Henke occasionally mentioned filmmaking in writing, but nearly all the quotes on these pages (and in letters from that time) are Jessie Mae's. Her detailed observations and near complete absence in most of the films suggest that her filmmaking agency, and likely her presence behind the camera, extended beyond the gendered practices suggested by contemporary visual culture (men as photographers, women as subjects) and longstanding social norms in the missionary enterprise. Even decades later, the ways in which she presented the films in audio recordings—with the descriptive skill and cadence of a seasoned narrator—indicated that she was closely involved in this production from the start. This places Jessie Mae in close conversation with the unnamed missionary camerawoman in the "occupied city" of 1940. Even across time and widely disparate places, these women served as interlocutors and image-makers in ways that challenged the maleness of filmmaking culture. Although the Henkes as a couple are responsible for the films, a closer look reveals that Jessie Mae's participation enabled the Cine-Kodak

to document not only the missionary enterprise as men wished to see it but also the roles of American and Chinese women in the communities framed by its lens.

The 16 mm Bridge

In testing the Cine-Kodak and producing their first films, the Henkes began with family subjects, shot primarily within the mission compound at Shunde. This was the kind of domestic filmmaking espoused by the Kodak instruction manuals. It was relatively convenient to produce, given the controlled spaces and people with whom the Henkes were most familiar. They limited their early experimentation to comfortable, known places and people. The first reel of film that passed through the Cine-Kodak was used primarily to image Harold and Jessie Mae's first son, Robert, who was born in September 1931, very shortly after the camera arrived.[60] Harold, writing to his father-in-law and brother Sam that December, noted, "I showed [an audience of Presbyterian missionaries] all the movies we have from here and they especially enjoyed Bobby and his life. We should get this roll of film off to you sometime this week and hope it gives you some idea of our life that you haven't had before and that you can see something of us until we are there ourselves."[61] The short film depicting "Bobby and his life," was 100 feet long, exactly the capacity of a single film load in the Cine-Kodak, and spooled neatly onto a metal projection reel about 3.5 inches in diameter. The reel's compact size and light weight made it convenient for mailing to the United States and circulating among family members there. This particular film, which was later spliced into a longer 400-foot reel depicting Robert as an older infant and family activities during the Henkes' 1932 furlough in the United States, opens with a handmade typed subtitle: "A 'China Doll' goes into action at three weeks of age." Jessie Mae, sitting in a chair on the Henkes' mission house porch, smiles as a uniformed Chinese nurse hands Robert to her. Immediately thereafter, Harold leaves the camera running on the tripod to jump into the background for a few seconds before rushing back behind the camera (jarring it in the process), causing both Jessie Mae and the nurse to break into laughter. The same nurse appears several more times in the succeeding scenes, giving an unclothed Robert sunbaths for vitamin D exposure, helping hold him while Jessie Mae runs the camera to include Harold, and playing with the family's pet dogs.

All of the scenes take place in the vicinity of the mission residence, with the principal actors being the Henkes, the Chinese nurse, and a group of servants with their children. At one point, one of the female evangelists at Shunde, Marjorie Judson, appears and speaks to one of the toddlers (the cook's son) in Chinese, shaking his hand. In the shot made immediately after, the boy sits on the front steps of the house while Harold entertains him by having the dogs perform tricks. Up to this point, it appears that the Henkes' early filmmaking was limited to scenes little different from those

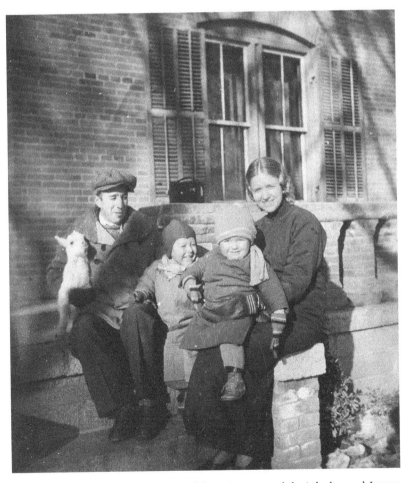

Figure 3.2 Henke family in Shunde, Cine-Kodak movie camera on ledge in background, January 1936. Photograph by Ralph C. Lewis. LFP.

produced by US hobbyists.[62] However, as Jessie Mae continued in a separate letter to her family, comfortable domestic tropes were not the whole picture. After all, the Rye church had not gifted the Cine-Kodak to the Henkes for family filmmaking alone.

After mentioning the short reel of domestic life, Jessie Mae wrote, "We now have about 1300 feet of film of Chinese arts and crafts as well as of our work[,] and we are anticipating showing them to you while we are home. We have had rather good success for amateurs[,] we think[,] and our results are improving as we have more experience and see where our mistakes are."[63] It was now almost exactly one year to the date since she had penned the first letter mentioning the Cine-Kodak. It is clear from Jessie Mae's description that during this time, the Henkes had sufficient film to load the Cine-Kodak at least thirteen times (a hundred feet of film per reel) and had sent out the negatives for commercial processing at Kodak's Shanghai branch. After receiving the developed footage, the Henkes viewed the short reels when there was enough free time, indoor darkness, and electricity in the mission compound to power the Kodascope projector. Taking stock of "improving results" and "mistakes" (which included setting the lens to the wrong distance, resulting in out-of-focus shots), Jessie Mae and Harold decided what footage to keep and cut as they sat in front of the screen in their living room.

The Henkes also presented the films to other members of the local missionary community for information and entertainment. In fact, one of the first nonfamily audiences was a regional meeting of Presbyterian missionaries at the city of Baoding, about 135 miles north of Shunde. The Sunday before writing his December 1931 letter to family, Harold Henke traveled with the Rev. John Bickford, one of the American evangelists at Shunde, by rail to Baoding. After numerous mission committee meetings, Henke "showed [the gathered attendees] all the movies we [had] from here and they especially enjoyed Bobby and his life."[64] Given that the Kodascope projector's storage box doubled as a transport case, it is not difficult to imagine it accompanying Harold on his trip. He may also have borrowed a projector belonging to another missionary at that city.[65] At these and other mission meetings in North China, Harold and Jessie Mae also employed the Cine-Kodak to transform other missionaries and Chinese Christians who viewed the films into filmic subjects themselves.

This filmmaking took on a particular format, repeated on multiple occasions and visible in later films. The missionaries and Chinese Christian leaders present at the meetings were asked to file out of a building as Harold or Jessie Mae ran the Cine-Kodak, held stationary by hand or fixed on

a tripod. This setup, which involved minimal camerawork beyond framing the general view and running the Cine-Kodak continuously, mimicked early "actuality" films by the French brothers Auguste and Louis Lumière.[66] In these cases, mass subjects' movement into the view of an immobile camera displayed both their numbers and their membership in a community (or an industry) beyond the frame. Unlike the subjects of the Lumière films, however, the groups who passed in front of the Cine-Kodak were fully aware that they were to be viewed by audiences elsewhere. One by one, the people present—some smiling at the camera and waving, others chatting with each other or strolling alone—appear at the doorway and walk out into an open space, often brightly lit by midday sunlight for easier film exposure and sufficient depth of focus. In a few cases, camera-shy individuals attempt to hide in the entrance but are eventually coaxed out by people behind them, visibly amused. Other setups that did not involve the subjects moving took the form of gathering people (as if to take a still photograph), and then panning the Cine-Kodak horizontally across the group to film each person individually. This effectively created a group panorama, emphasizing individual expressions as well as collectivity.

Eventually, the Henkes spliced together just over 427 feet of film from the first attempts as a single reel running nearly twelve minutes, which the couple entitled the "Occupational" film. The absence of commercially printed subtitles (which appear in later films) and the somewhat crude splicing indicate that the film was assembled by Harold or Jessie Mae before the couple left China for their first furlough in the late summer of 1932.[67] At least one duplicate reel was made for circulation among family members and supporting congregations, which doubtless included the Rye church. The duplicate's image quality was somewhat lower than that of the original, with dust, heavy scratches, and mottling from liquid damage indicating that it passed through many projectors multiple times.[68] The audiences who watched the "Occupational" reel in 1932 encountered an eclectic mix of local people and scenes, imaged by the Henkes in and around Shunde. The film's flâneur-like quality is evident in the scene selection, echoing the Henkes' earlier attempts at producing still photographs while walking the streets of Beijing.

The film begins abruptly with a bright sunlit shot of laborers attempting to get heavily laden wheelbarrows going along a sunken road just outside the compound, assisted by donkeys hitched to long ropes and overseen by a Chinese man dressed in Western-style rolled-up slacks, shirt, and cap. A few street vendors immediately behind the wheelbarrows stare curiously at the

scene, while a soldier wearing an officer's cap (a member of a regional military force) walks casually down the road in the background. As the soldier slows his gait to look at the filmmaker, the camera awkwardly shifts to the right on the horizontal axis, as if the cameraperson were adjusting his or her grip on the body before stopping the motor. The subsequent scenes cover local businesses—street vendors engaging in shoe repair, tailoring, noodle making, and crafting papier-mâché grave goods (*zhizha*), as well as women producing thread with hand-cranked spindles—and are followed by a one-man acrobatic performance with musical accompaniment, laborers winching water up from a well, students in Western dress threshing wheat at an agricultural school (possibly established by Y. C. James Yen's rural reconstruction movement in Hebei), and blacksmiths shoeing a water buffalo.[69] These scenes culminate in the film's visual centerpiece, a packed market day next to the mission featuring hundreds of people buying and selling local goods while partaking in games and street food.

The film transitions from solely medium angle shots to wide panoramas of the massive crowd as well as close-up shots of individual groups engaging in various market activities. The scenes exhibit various camera movements; the Henkes practiced filming with the handheld Cine-Kodak on the street. Some of the shots feature a jerky back-and-forth movement, as various elements in the changing scene catch the cameraperson's eye (this movement mirrors Harold or Jessie Mae's first-person gaze), whereas in others, the camera is held relatively still or panned smoothly. The Henkes were clearly trying to follow the manual's guidelines to "hold the camera steady," but tracking action in quickly changing environments and being confronted by passersby inevitably led to some "spraying [the camera] about like a garden hose" that the instruction manual guide derided.[70] At the same time, the shakiness lends an unintentional human presence to the film, reminding audiences of Jessie Mae or Harold holding the Cine-Kodak and highlighting the difference between still and motion pictures.

The handheld camera movements and proximity to the filmed subjects also indicate that the Henkes were physically moving through the mission environment and engaging with the local population in their filmmaking. When either Jessie Mae or Harold was engrossed in filming a scene, the other stood off to one side, speaking with subjects in the frame and attempting to use his or her nonnative Mandarin to communicate with the local speakers of Hebei dialect. In a few scenes, a Chinese staff member from the Presbyterian mission appears in the frame, sometimes standing among the groups being filmed and at other times talking casually with individuals,

assisting the Henkes with the regional dialect or engaging in his own discussions. In this way, the Henkes' filmmaking practices were a source of casual entertainment for local people, and in some cases an avenue for the couple and Chinese Christians at the Shunde mission to make connections (if only tentative) with the filmed subjects for building relationships and the possibility of evangelistic opportunities.

The Henkes' presence registers in the various reactions of people who appear in the "Occupational" film. Some of the men and women smile and laugh at the camera while talking among themselves. One man, standing in the extreme foreground of a wide shot on the market day, cheerily pantomimes the posture of aiming the Cine-Kodak at eye level, a gesture possibly unnoticed by the Henkes until the film was processed. Vendors go about displaying their wares as they would have to the general public. The noodle-maker in the first minute of the film, for example, gazes proudly into the lens as he swings and twirls a thick strand of dough—part of his performance to attract customers.[71] In other cases, the spectacle associated with the street filmmaking was a source of momentary social disruption. One woman bargaining furiously with a seller of cookware is visibly irritated by a large crowd of children drawn to the camera, and in a subsequent shot, she stands up angrily to wave the group away. The camera quickly pans to the vendor whose sale was disrupted, who rises to his feet with a resigned look before the motor is abruptly shut off, an indication that the Henkes were aware of their intrusion.

For the most part, however, the people in the film take ambivalent notice of the Cine-Kodak and the Henkes, regarding them as part of the mélange of figures, Chinese and non-Chinese, that passed through the environment. A large group of bystanders in the market-day background laugh and stare, while a mass of people in the foreground, climbing up a set of steps toward the camera, jostle and shove one another. The frame is particularly shaky, and it is easy to imagine the bodies of people brushing against those of Harold or Jessie Mae as they pass around the running camera, bumping it in the process. The scene cuts and the camera shifts to a more stable location on the opposite side of the street, still in view of the crowds. Then the first vantage point is revealed. The crowd moving around and in front of the Cine-Kodak was in fact composed of church attendees entering the gate leading into the mission compound. The market day is also a Sunday morning, and the service is soon to start.

In the letter describing the first "1300 feet of film," Jessie Mae reminded readers at home that the family planned to return to the United States in

the late summer of 1932.[72] At the same time, the couple held some uncertainties about the opening portion of the trip. As Jessie Mae penned the letter in mid-March, Chinese and Japanese troops in Shanghai were still firing at each other in a bloody three-month-long conflict later termed the "Shanghai Incident" or the "January 28 Incident" in Chinese sources, while the League of Nations and the Nationalist government scrambled to negotiate a ceasefire.[73] Because of this instability, the Henkes ultimately decided to leave China through Tianjin instead of Shanghai. They took an indirect route through Kobe, Japan, on board the Nippon Yusen Kaisha (NYK) liner *Yokohama Maru*, and transferred to the Dollar Lines' SS *President Coolidge* for the remaining voyage to San Francisco.[74] The Cine-Kodak accompanied the Henkes on board the *Yokohama Maru* in Tianjin, but was not used until the ship was underway down the Grand Canal toward the open sea, accompanied by a pilot boat flying the Republic of China civil ensign.[75] After passing a number of river flatboats and fishing junks, one ferrying partially uniformed, possibly demobilized Chinese soldiers, the *Yokohama Maru* set a northeasterly course across the sea "smooth as glass" that the Henkes had first photographed on their way to China five years earlier. This time they recorded it in movie film.[76]

While filming scenes typical of tourist movies—ship passengers disembarking and embarking, Kobe's local attractions, and candid encounters between Robert and Japanese children—the Henkes honed their filmmaking techniques shot by shot. People waiting for the arrival of the *President Coolidge* became foreground silhouettes framing the ship docking in the harbor, gangways transformed into compositional leading lines, and passing watercraft and cranes loading cargo provided Harold and Jessie Mae further practice in following moving objects. Steadier close-ups, juxtaposition (a long shot of a Japanese sailing vessel passing behind the *President Coolidge*, visually contrasting old and new transportation forms as well as emblems of East and West), and a linear narrative all entered the reel shot during the eastward voyage. By the time the Henkes arrived in San Francisco—an event heralded by a US flag fluttering in the sea breeze while a ferry passes in the background—they had developed practices that would characterize all their future filmmaking activities in China. At this time the Henkes also began to think not only about what it meant to carry film from China to US audiences but also about the possibilities of doing the reverse for their Chinese community.

After their arrival in the United States, the Henkes produced films as a two-way visual bridge between missionaries and their supporters. Traveling

first from San Francisco to Los Angeles, the family reunited with the Palmers, the senders of the funds and family photographs that Jessie Mae described in her first letter on the movie camera. In the same way that they filmed members of mission meetings who watched the results of their early filmmaking attempts in North China, the Henkes filmed the families and friends in the United States who had supported them in China, and for whom they screened their eclectic "Occupational" film. Even before leaving China, the Henkes envisioned that their furlough plans in the United States would include screening and making films. A letter written in February includes a note: "We plan now to spend up to a week [in Los Angeles]. There are many relatives and friends and all the people here have families or friends there who wish to see the movies."[77] The visual setup that characterized groups in China was repeated in Los Angeles, with Ethel Palmer and other friends or family exiting the home of a Dr. Starr into a jarringly bright Southern California afternoon. They were undoubtedly filmed so that the Henkes could screen their images after returning to China postfurlough. Similarly, when the couple returned to the Midwest, they recorded extended-family members chatting and gesturing while getting into position for still photographs. Although much of the couple's midwestern filmmaking was devoted to leisure activities around Baraboo, Wisconsin, a single reel produced sometime in 1932 features a strange set of subjects with an unlikely connection to China.

This eight-minute-long film opens with a shot of two workmen driving a combine, followed by wide views of a massive power shovel digging a mine trench. The meaning of these scenes would have been a mystery had Jessie Mae and her son Robert not sat down in front of a tape recorder sixty years later.[78] As the projector rattled and the audiotape rolled, Jessie Mae spoke:

> Now, these pictures were back in Illinois. They are some pictures we took to take back to China[,] to show them some of the huge machinery that was used in our farming here in the States. They were absolutely amazed; they couldn't believe that such equipment was necessary[,] because their farms averaged about five acres apiece and ours of course averaged about a hundred-and-sixty acres. . . . And this is a strip mining operation in Southern Illinois, we also wanted them to see this huge crane that pulled up the dirt and stripped the whole top off of the . . . field so it got down to the coal there. It was such a big operation we wanted the Chinese to see it too. . . . [The] Chinese looked on these films with absolute amazement. . . . Nor had they ever seen four horses pulling a plow—that was an amazement to

them too—they did it, all of their farming, by hand, sometimes an animal helped them pull . . . but never any horses like this. It would be a little donkey or a cow.

It is apparent that the Henkes produced this film with an eye to present scenes that emphasized the differences between the United States and China, visible in the emblems of modernity: mechanized farming techniques and large-scale mining machinery that had been literally reshaping the US Midwest for nearly a hundred years—encompassing the lifetimes of both Harold and Jessie Mae.[79] This technological embeddedness in the landscape would have been generally unfamiliar to rural Chinese audiences, who would have primarily encountered mechanization in the form of the railway running through Shunde.[80] At the same time, the film attempts to draw parallels between the North China landscape and recognizable visual analogues in the United States. The Henkes avoided including urban landscapes in the furlough film, although they had plenty of opportunities to do so during their travel back to the Midwest via San Francisco and Los Angeles. The footage of the combine and four-horse plow echo views of the Shunde countryside, with farmers pumping water and threshing grain aided by horse-drawn machines. The parallels between the two rural backdrops provided an immediate visual touchstone for Chinese viewers.

Chinese melodramatic films of the time represented the countryside as "the essence of China . . . [with] life in the unspoiled rural area [as] simple and pure." One popular contemporary film, *Taohua qixue ji* (*Peach Blossom Weeps Tears of Blood*), produced by the Lianhua Film Company in 1931, explicitly pits rural purity against the spiritual pollution of the urban areas, which one historian defines as "corrupt, evil, and un-Chinese . . . the symbol[s] of an aggressive Western presence in China[;] the village embodies the sacred past, [but] the city exemplifies an uncertain and immoral present." At the same time, *Taohua qixue ji* and other films that followed it "badly distorts the nature of China's encounter with the West and misrepresents the condition of China's rural sector in the early Republican period[;] director Bu Wancang offers no fresh vision of the future. Instead [the film] makes a superficial and sentimental appeal for the restoration of a vaguely defined traditional morality."[81] Although the Henke film lacks the cinematic genre, production scale, and wide viewership of Chinese commercial films, it provides some of this "fresh vision for the future" in the shots of the modern US countryside. In this landscape, modern machinery and rural labor exist simultaneously, but without the explicit urban influences that may have put off local Chinese

audiences (at least in regard to issues of Western "spiritual pollution").[82] But the Henkes' film provides no sense of rural poverty. Here the Henkes' visions diverged sharply from those of contemporary professional documentarians like Dorothea Lange, Walker Evans, and others who photographed destitute farming communities with gritty intimacy. These photographers' images gave "firsthand witness to a social condition" and "human misery" across the Midwest and South.[83] They were a world away from those of a mechanized agricultural heartland produced by the Henkes, with their middle-class sensibilities. The US government's documentary project was not the same as the Henkes' mission, and the opposite was true as well.

In spite of these invisibilities (and perhaps because of them), these views may have appealed to some of the audience members who watched the furlough film at Shunde. They included medical staff and Christian leaders whose cosmopolitan contacts and educational backgrounds linked them to urban centers where commercial melodramas were screened, and who were more familiar with the popular culture tropes found in such films. Moreover, as individuals moving between urban and rural communities and merging Chinese and Western modernities, these viewers may well have recognized the possibilities (as well as disruptions of traditional order) represented by the furlough film. One such person was the young nurse Liu Ju, who remembered the experience of watching these films as "eye-opening."[84] Her contemporaries were also aware of rural reconstruction projects headed by Y. C. James Yen in Hebei Province's Ding County. Yen advocated for "practical training for farmers in scientific agriculture and in rural economics" alongside an comprehensive social-welfare program, modeled on Western institutions, that included experimental public health and medical divisions.[85] On a national scale, while the Henkes were on their furlough, Soong Mei-ling was organizing efforts between the Nationalist government and Methodist and Episcopal missionaries for Christian rural reconstruction in Jiangxi and Fujian Provinces. The efforts targeted areas recaptured from Communist forces, using Yen's North China work as a model.[86] Thus, the furlough film represents a hybrid vision that may have resonated with Chinese Protestant reform sentiments, with the US countryside presented as a successful marriage of tradition and modernity.

Although the furlough film skirts the cultural complexities of urban space, it prominently features national symbols. These appear in almost exactly four and a half minutes of film, included immediately after the rural scenes, that the Henkes produced in the early spring of 1933 while visiting Jessie Mae's sister (Lois) and brother-in-law in the Washington, D.C.,

area. This East Coast trip that included screenings of the "Occupational" film for the Rye church and other supporting congregations.[87] It is clear that the Henkes wanted to give a sense of US culture in terms of both scale and spectacle, drawing from visual tropes that they felt would best represent Americanness but that were also within the limits of the couple's filmmaking capabilities and travel. These include a brief wide shot of the Washington Monument, followed by the pillars of the Lincoln Memorial (with Jessie Mae in the foreground), a panning shot of Mt. Vernon and the Potomac River on a sunny day, and views of Niagara Falls. The film concludes with an extended sequence of a Ringling Brothers and Barnum & Bailey circus in Baraboo, Wisconsin. Despite the intended Chinese audience, these scenes resemble countless other US vacation movies, and may well have served as such in later family contexts. But in these scenes as with the opening farming sequence, the Henkes took into account visual tropes that linked Chinese and US national imaginations. Perhaps influenced by their earlier photography of monuments in Beijing that represented China's cultural essence, the Henkes sought out the closest available US equivalents: the Washington Monument and Mt. Vernon. Chinese viewers mindful of contemporary national identity making may have drawn parallels between these monuments to George Washington and the Sun Yat-sen Mausoleum near the then capital, Nanjing, completed merely four years before as a grand memorial to China's "father of the nation" (*guofu*).[88] After all, Sun, a devout Protestant, was strongly involved with missionary networks during his formative years and claimed political inspiration from Abraham Lincoln for key parts of his nationalist ideologies.[89]

Moreover, the inclusion of Niagara Falls and the circus provided Chinese audiences with a visual taste of US natural and cultural scenes that the Henkes considered representative, and with which they were most familiar with from their youth.[90] The circus footage mirrors that of the Shunde market day, both representing local iterations of mass culture. The Baraboo sequence comprises close shots of animals and large groups of circusgoers, images that match those of the Chinese crowds that passed in front of the Cine-Kodak outside the mission compound only a year or so before. At one point, the camera suddenly focuses on Jessie Mae holding Robert in her arms, providing two faces recognizable to the Shunde audience while also placing the family within the gathering of circus spectators, as participants in a US parallel to Chinese festivals. But such familiarity is undercut by foreignness, some of it oddly circular. Ironically, as the Henkes film inside the big top, for a fleeting six seconds, a procession

of clowns with exaggerated queues and an oversized ricksha march across the underexposed foreground, performing orientalist stereotypes. One wonders what the Chinese audience thought of this, if they caught it at all in the longer sequence.[91]

Spectacular settings aside, the US circus and the North China market sequences share similar responses to the filmmaker. Each show of guarded gazes, bemused reactions, and jocular responses—all produced with the same camera in communal settings. The furlough film thus served as a visual bridge for Chinese viewers to look into US culture, comparing and contrasting their communities and the Western Others who looked back at them. Perhaps the "absolute amazement" and "eye-opening" feelings described by Jessie Mae Henke and Liu Ju included not only the imaging apparatus and its mechanized subjects in the United States but also the parallel ways in which US communities appeared on screen, in their gazes, actions, and engagement with the camera. "Amazement" and "eye-opening" are of course ambiguous terms. It is impossible to know if Chinese viewers encountered the film with feelings of surprise, awe, or distaste—or perhaps all of these. Though the firsthand responses to the furlough film are no longer recoverable, it reveals cross-cultural perceptions behind missionary filmmaking and Chinese viewership, with its windows onto US life, its intended audiences in China, and transnational contexts of production and reception.

Body and Soul in Three Reels

After their yearlong furlough, the Henkes returned to medical work at Shunde with a renewed vigor and plenty of need for it. "Dr. Henke is hard at work trying to pick up the loose ends in the hospital," Jessie Mae wrote one month after returning to Hebei. "We found our staff seriously crippled with the necessary dismissal of our best Chinese doctor a few months ago . . . the hospital is well filled for this time of year with young and old, rich and poor. A glance through the wards at the young chap with the huge sarcoma of the leg; at the man next to him with an ugly tumor of the lower jaw . . . at poor Mrs. Li, who for almost a year now has been in bed here with tuberculosis of the back, and who in spite of it all, is a living witness to the other patients of His Sustaining Grace . . . at the eye cases, gunshot wounds, and other perhaps less interesting diseases, makes us glad and grateful that God has opened the way for us to go on with our service for Him in China."[92]

The medical responsibilities and large numbers of patients also proved to be ready subjects for the Henkes' return to filmmaking in China. As they screened the reels of home life in Illinois and other US scenes for Chinese audiences at Shunde, the Henkes began to consider producing more advanced visual narratives: filmic tours of religious and medical work at the mission. Perhaps taking cues from Chinese audiences encountering landscapes and communities in the United States through their films, the Henkes decided to use the Cine-Kodak to stand in for US audiences' eyes and bodies. Moving beyond the eclectically spliced-together mélange of local scenes produced in the mission environment, the films now visually narrated spaces and places in which Chinese Christians—"living witness[es]" like Mrs. Li—acted as guides.

From the winter of 1933 to the fall of 1935, the Henkes shot several hundred more feet of 16 mm film in the mission compound, traveling clinics, and rural fellowships organized by Chinese church elders.[93] The new footage was spliced together with portions of the first 1,300 feet of film made in 1931–1932 and spooled onto three 400-foot reels running exactly 1,020 feet. When projected back to back, this film ran twenty-eight minutes and twenty seconds. Two of these reels were marked as "Hospital" or "Hospital Comp[ound]," and the third as "Church" or "Church Tour." With a pause to change reels and respool the projector, the complete viewing time easily fit an hour-long presentation.[94] The Henkes opted to include professional intertitles as part of the hospital film, unlike in their first films in China and those produced during their US furlough. This involved composing a list of titles and mailing a copy to the nearest Kodak facility, after which "[technicians would] make [the intertitles] and send . . . the proper amount of film with the title printed on it, which [the filmmaker could] then splice into [the] film in the proper place."[95] The Henkes did just that. Printed in white letters and framed in stylized flower-print borders, the film's opening title—the first of eighteen spliced into the two "Hospital" reels—proclaims, "A CONDUCTED TOUR THRU THE HOSPITAL COMPOUND AT SHUNTEHFU, HOPEI, CHINA." The tour's guided nature is highlighted by the title following this one: "MEET THE CONDUCTOR—DR. EN CHENG CHANG."

After this introduction, Dr. Chang, dressed in a *changshan* and wearing a fedora, emerges from the mission hospital gate and into the afternoon sunlight, kicking up a puff of the pervasive North China dust from the ground. Doffing his hat to the invisible audience, Chang turns around with an outstretched hand, a sweeping motion that runs into the next intertitle: "FU YIN

YI YUAN—THE GOSPEL HOSPITAL." To emphasize the point in action, Chang points to the hospital's title characters (Fuyin yiyuan) above the gate and then to a wooden placard hung to the right of the door. The camera pans up and to the side both times, mimicking the gaze of a visitor following the doctor's gesture. With another sweeping motion and without looking back at the camera, Chang then turns and walks back through the gate. In the final moments before the Cine-Kodak is shut off, a woman abruptly appears at the frame's far right side as an unexpected participant in the film (perhaps not visible to the Henkes in the viewfinder), grinning at the disappearing doctor and then at the camera.

Several forms of translation take place in the film's first twenty seconds, setting the tenor of the tour as a whole. The opening features Dr. Chang as the primary tour guide or "conductor," reflecting a conscious decision to emphasize the local Chinese-led nature of the mission hospital. By selecting a Chinese leader rather than a foreign one (when the Henkes or other US colleagues could easily have stood in), the film implicitly responds to critiques of foreign dominance, answering contemporary calls for a missionary "to be willing to *serve under* the nationals to whom he goes."[96] Even the choice to phoneticize the Chinese name of the hospital first, when a simple "Gospel Hospital" notation would be sufficient for Chinese-illiterate US audiences, represents an effort to visually indigenize the missionary project. After all, as Chang points out by gesturing at the "Fuyin yiyuan" title, the English name for the mission hospital would not have mattered to most patients the facility received. But the Chinese version, emphasized on screen, certainly did. In this way, the film subtly bridges the modernist-fundamentalist divide, reiterating to US audiences the mission hospital's combined goals as a Christian institution dedicated to both spiritual and physical salvation. Jessie Mae Henke, writing in a 1934 illustrated report (*A Pen Picture of Shuntehfu Station, Presbyterian Mission, North China*), described the hospital's ideology in this way: "In every contact which the patient may have with our institution, whether it be with the doctors, nurses, pharmacist, business manager, or servants, we know that our Gospel is being weighed, and how we long not to be found wanting!"[97] Patients entering the gate, as the film audience is about to do, were reminded that the hospital existed because of (or in some abstract connection with) Protestant Christianity.

Furthermore, the film visually translates the mission compound's spaces, with the audience following the patients' footsteps. With each new scene, the camera and Chang move deeper into the hospital complex, the doctor's walking figure leading the eye further into the frame. This matches

Jessie Mae's description of the patient care process as one of movement through a transformative space:

> Day by day the clinic presents a busy scene as patients are first gathered in to the waiting room where the evangelist, in song and story, tells them of the Great Physician. They are then ushered by the nurses through what to them must be a maze of bewildering performances. The doctor first sees and talks with them, often taking minutes of patient questioning to elicit perhaps the simple fact that they have had a pain in their foot . . . [that] has now become a first class infection. A subsequent dressing is applied in the dressing room, and then a visit is made to the pharmacy for some pills to allay the accompanying pain, and finally they are led to the door with a last smile and admonition not to disturb the bandages and to return on the following day.[98]

The Cine-Kodak was handheld for the majority of these scenes, sacrificing steadiness for ease of movement between scenes, but also standing in for the eyes and body of a hospital visitor. The shot immediately following the introduction shows Chang walking past the reception booth with the Hugh O'Neill hospital building visible in the far background. An intertitle captures (and translates) the receptionist's voice stating that visiting patients must pay "1/2 CENT FOR A TICKET, PLEASE!!"—a nominal fee for medical treatment subsidized in part by US congregations.[99] The receptionist himself, prepared for his brief role, peeks out of the booth's window and hands Chang a ticket, which the doctor displays to the camera before walking farther into the hospital yard. Aside from a few bystanders, the rest of the walking tour shows a deserted compound, with no one present except for the doctor. It is likely that the couple decided to shoot these parts of the film during uneventful days with sufficiently good weather, with the free time allowing them and Chang to work together on these shots. Chang continues past the hospital (a spliced-in shot panning up to the O'Neill Memorial sign allows the building to serve as its own intertitle), his family residence, a classroom building for nurses, the Grace Talcott Hospital housing "fourth-class wards" for inpatients ("COST 2 ½ CENTS PER ROOM"). He points at the hospital's heating plant before the camera cuts.[100] Between scenes, Chang's outfit changes inexplicably from the fedora and *changshan* to a thicker fur cap and padded robes to ward off the cold, while the foliage on the compound's trees suddenly vanishes. The accidental jump cut indicates that the Henkes shot the walking footage over several weeks or even months in the fall or early winter before splicing the film together.

The dearth of human figures in the film's first three minutes is suddenly broken by an intertitle proclaiming "DR. CHANG'S FAMILY." The camera cuts to Chang's family members—his wife, teenage daughter, two younger sons, and one bespectacled young-adult son wearing a bow tie and overcoat standing in a row on their home porch. Chang then proceeds to go down the line, pointing at each person. The family laughs at the absurdity of the action before an intertitle appears: "'OH—ONE MISSING.'" When the action continues, the doctor rushes into the house to lead out another son, a toddler who stumbles toward the camera. Holding his hand, his father pushes gently on his back to prompt him to bow toward the lens. The Cine-Kodak stops and starts again in time for a grinning Chang to appear carrying the youngest member of his family in his arms, a little girl bundled in a miniature fur shawl and an oversized beret. The incorrect intertitle—the daughter not counted, as there are two additional children rather than one—serves as a subtle nod to patriarchal preference for male children (*zhongnan qingnü*).[101] Yet, Chang's visible pride at carrying his younger daughter, the prominent place of his wife in the group's center, and his teenage daughter's Western-style outfit all reference a modern, progressive sensibility. In this way, the film makes Chang's family culturally recognizable to US audiences while emphasizing participation in cosmopolitan Chinese nation making.

In a similar way, the scenes immediately following Chang's family foregrounded the staff's modern lifestyle and leisure activities. With an intertitle proclaiming "ALL WORK AND NO PLAY MAKES JACK_____" leaving the audience to fill in the adage, the film cuts to an afternoon volleyball game in progress, played by young Chinese male nurses wearing dress shirts, slacks, and sweaters, and a double tennis match with four Chinese men.[102] Most remarkably, one of the tennis players moving quickly toward the net is an amputee with a wooden prosthetic limb and crutches. This is Tu Ch'ung Chen, the hospital's lab technician. He was an important staff member and the Henkes' close friend, and the couple likely pointed him out by name while screening the films.[103] Tu was also known by his Christian name, Stephen, and his responsibilities involved running microbiological tests on patient samples, amassing data subsequently included in US reports and medical databases at Peking Union Medical College.[104] Robert and Richard Henke, who knew Tu personally while they were young children at the mission, later admiringly recalled his tennis skills, as did Ralph Lewis in his memoirs.[105] As Lewis reported, the sports matches—along with the free time to film them—were a part of the mission routine, while also being at the mercy of infrastructure limitations. After all, the hospital's electrically

powered equipment could not be used until Shunde's municipal power plant came online in the late afternoon, whereupon the staff dropped their tennis rackets and volleyballs, "rush[ing] back . . . to the X-ray room to take pictures or take the patient under fluoroscopy . . . hurry[ing] before people in the city would turn on their lights[,] making the current too low for taking pictures."[106]

Up until this point in the film, all of the people visible are Chinese, with foreign affiliations limited solely to Western dress and the benefactors' names emblazoned on the hospital buildings. Apart from the Henkes behind the camera, the emphasis is on the indigenous medical staff as the prime occupiers of the mission hospital space. The subject matter is rather benign—beside the hospital buildings, there is little to indicate the medical mission's specific works, and the domestic scenes of Chang's family and the athletic nursing students seem only to be idyllic slices of modern life in the hinterland.

Almost as if anticipating this, the film's narrative suddenly shifts to show patients coming to the hospital from surrounding areas on sedan chairs, wheelbarrows, and litters, often accompanied by family or members of their village communities. One intertitle describes these modes of transportation as "Chinese ambulances." The audience has been brought into the compound and is ready to see the work in which the Henkes and Chinese staff engage. From this point on, the film resembles a documentary on medical practices rather than an introduction to the hospital's spaces and staff. In the shots that follow, made over a period of several months (with more changing foliage), various patients enter the hospital compound. Reemphasizing Sino-US collaborations, Chang appears in all of these scenes, accompanying patients from the front gate into the courtyard, sometimes wearing a white surgical cap and gown and speaking with concerned family members. The film gives the impression that although the foreign medical staff is operating invisibly in the background—both behind the camera and on patients within the buildings—modern medical care is primarily given for Chinese, by Chinese.

The camera moves closer until the audience is brought face to face with the patients and their treatment. Much like the Henkes' still medical photographs, these parts of the film document medical successes and challenges, visualizing disease and healing. But the film's inherent action highlights engagements between medical staff and patients. In a segment preceded by the intertitle "A GROUP OF KALA AZAR PATIENTS," Harold Henke moves down a line of young boys, prompting each one to stand up and

expose distended midsections, the result of a swollen liver and spleen because of parasitic infections transmitted by sandfly bites.[107] Henke's expression alternates between cheerily reassuring the boys and a concerned look he gives Jessie Mae (behind the Cine-Kodak) as the lens tracks with him across the group. Following one in-camera cut, Henke says something to one of the boys he has examined, who smiles in response. These actions parallel a following scene in which a Chinese female doctor, Lucy Kao, surrounded by Chinese nurses, examines squirming toddlers while they sit on a hospital porch ledge.[108] An American female medical missionary is briefly visible watching the scene nearby, but the primary focus is on the Chinese staff and the children's expressions. The visual parallel was probably intentional—patient-doctor interactions and treatment cut across racial, gender, and cultural lines, with US and Chinese women and men equally invested in the medical project.

After presenting an encouraging, intimate perspective on Sino-US medical cooperation and successful patient results in these scenes, the film moves on to darker issues. Here, the film presents both the limitations of medical treatment and violence beyond the mission that rendered itself visible on the bodies of Chinese patients. An intertitle, "AN INNOCENT VICTIM OF WAR. HE FOUND A BOMB," suddenly cuts off the images of the smiling nurses and fidgeting toddlers. A young boy standing in front of the hospital's door with an older man and woman, presumably his relatives, stares blankly at the camera as the man slowly removes two cloth bags to reveal the boy's bandaged hands. The thumb, index, and middle fingers—or what may remain of them—are wrapped up completely. He was not the only one to be treated for such wounds while the Henkes were in Shunde. In July 1931, the city came under "the direct line of fire in the war between the troops of Shih Yu San and Nanking," a regional conflict between the North China warlord Shi Yousan and Nationalist forces from the south (Nanjing) commanded by Chiang Kai-shek and supported by Zhang Xueliang's allied troops.[109] "For ten days," the mission report read, "we lived in the midst of a Hell made by undisciplined soldiery and constant shell and rifle fire . . . the almost daily bombing of the city and railway . . . filled us all with terror and fear, tho[ugh] . . . [t]hru the grace of God and His care of us not a single refugee, patient, or worker among us was injured."[110]

Others outside the compound's safety were not so fortunate. The hospital record for that year designated a separate category for "wounds—gun shot and bomb," and received 161 inpatients and 301 outpatients from such injuries alone.[111] Although no single author is designated for these parts of

the mission report, Harold Henke, who oversaw the hospital's data collection and was perhaps recalling his military background, likely prompted the wording of the report and the wounded boy's inclusion in the film.[112] Although it is unclear if the explosives that maimed the boy originated in this particular conflict, or if they were related to later clashes perpetrated by "bandits" (*tufei*) universally referenced by Chinese and missionaries alike, his appearance provided a harrowing physical representation of regional violence.[113] Even as the Henkes wrote about their postfurlough work in 1933, they referred to gunshot wounds as "less interesting diseases"—not out of indifference, but rather because they were all too frequent.

Further patient images fell under the next and final medical category to appear on screen: "HOPELESS CASES." These were primarily close-ups of large tumors or skin growths that presumably could not be treated with conventional surgical methods. As with the couple's medical still photographs, the film staging for these shots assumed a more clinical mode. Extreme close-ups and a white cloth or sunlit hospital wall backdrop emphasized the shape and severity of the growths. This style of filmmaking was a clear extension of the Henkes' medical photographs and situated in longer traditions of Chinese-Western medical imaging.[114] The key difference between still images and the moving ones was the latter's ability to capture multiple angles of the subject in one take, showing not an isolated body in a still frame, but a living person reacting to the environment and medical staff. In one sequence, Chang and a surgical assistant gingerly flex the arm of a boy with a webbed skin growth, and in another, a young Austrian Jewish medical assistant, Richard Frey (known to the Henkes as Richard Stein—an alias—Frey later joined Communist guerillas as a military doctor), guides a patient with a large abdominal growth.[115] Frey himself holds a camera as he steadies the patient with his other hand, and he probably made his own photographs around the same time. Running an agonizing forty-five seconds, these sequences skirt the line between clinical documentation and medical voyeurism. The expressions on the patients and medical staff are visibly pained, and it is conceivable that the viewing audience was similarly unsettled. This discomfort drew attention to physical suffering and the hospital's limits in addressing such ailments—galvanizing sympathy as well as material support. At the same time, the clinical documentation was considered important enough that the Henkes screened this film for Chinese doctors with whom they worked over a decade later, when they and their children were living in postwar Beijing.[116]

Some hope for these "hopeless cases" is found in two places, which take up most of the remaining film. These—a new hospital wing and rural clinics—expand the possibilities of medical treatment within and beyond the walls of the mission. No intertitle introduces the new hospital wing, but the shift from ailing individuals to a young Chinese man, dressed in Western clothes, walking across a yard filled with raw building materials signals a transition from hopeless patients to new potential. As the Henkes wrote in a 1934 bulletin,

> Since July we have each day been watching the growth of the addition to our in-patient building, Grace Talcott Hospital. . . . All of it has been done using the very least amount of machinery, a very expensive item out here, and using instead . . . man power. All excavating was done by hand. Dirt was carried away by long strings of men, each two with a pole on their shoulders carrying a basket slung on a pole. . . . One group of men did nothing but mix (all by hand) the concrete which was prepared for them by other groups, one did nothing but carry the bags of cement, another brought and dumped water, another sand. About sixty men were used just in carrying the concrete . . . to the third floor.[117]

In a series of shots closely paralleling this report, almost as if the Henkes were writing down their thoughts on the scenes they filmed (or filming while thinking of ways to textually describe the scenes), the Cine-Kodak pans across Chinese laborers sawing wood, chiseling stone, and hauling bricks and mortar up a winding scaffold to complete the new three-story building. The construction activities are filmed from both the ground level and the third story, emphasizing the height of the structure as well as the physical labor needed to create it.

The film narrative quickly unites labor and community participation. With the construction completed, the camera cuts to a panning shot of large group of medical staff and mission personnel, women and men, standing together with community leaders, local gentry, and a row of military officers and policemen as they pose for a still photographer just out of the movie camera's view. The group's large size, stretching nearly from one end of the building to the other, as well as the presence of a professional photographer, reinforces the weight of the occasion—the multiple imaging apparatuses signifying that this is a moment to be memorialized. Moreover, the many community subgroups (doctors, nurses, medical staff, gentry, laborers, soldiers, men, women, and children) and leaders seated

in the front row all highlight the locally oriented nature of the institution. The Henkes (in this case, Harold, with Jessie Mae behind the Cine-Kodak) and the other missionaries literally take second-row seats. The written report on the hospital construction ends with a line echoing the film: "Patients were moved in several weeks ago and *everyone unites* in admiring the large airy wards and the conveniences of the utility rooms." To further highlight the mission's community presence, the reel concludes with large crowds inspecting the new hospital and attending a health exhibition (*weisheng zhanlan hui*) organized by the medical staff. This exhibition was intended as both an open-house tour and an opportunity for public evangelization. The Henkes filmed a Chinese doctor gesturing animatedly at a wall of x-ray photographs and posters displayed inside a tent, in front of a large group of onlookers.[118]

"Church Tour," the 16-minute reel of film that was screened before or after the two-reel "Hospital Tour," provided a visual and religious parallel to the medical missionary work. This film focuses explicitly on the Christian community in and around Shunde, displaying the outward signs of collective spiritual growth among Chinese Protestants affiliated with the Presbyterian mission. Unlike the hospital film, which focuses on clinical studies of small groups or individuals, "Church Tour" places significant emphasis on mass activity and the visualization of community. Moreover, the film may have been intended as a middle-of-the-road rebuttal to conservative arguments that missions abroad placed undue emphasis on physical healing or humanitarian activities rather than spiritual conversion, as well as the opposing liberal criticisms of missionary heavy-handedness in micromanaging or delaying the organization of the indigenous church. Instead, it provided US audiences with a more balanced, intimate glimpse into the Chinese Christian community as a growing, self-sufficient body of local people. This film covers some of the same spaces within the mission compound as the hospital film, but highlights their use for religious rather than medical activities. The audience, having viewed all three reels, would have recognized some of these parallel spaces.

Even before they turned on the Cine-Kodak, the Henkes clearly envisioned their footage of the hospital and church as companion films, shot and screened in sequence. Like the hospital film, "Church Tour" begins with Dr. Chang gesturing for the invisible audience to accompany him into the church gate, directly adjacent to the larger one he passed through for the previous film (the Gospel Hospital sign is partially visible at the side of the frame). This time, the doctor guides the audience's gaze past the hospital and down

an alleyway to the church and missionary residences. This sequence was shot on November 28, 1934, according to the moveable calendar on the church gate, and was likely produced on the same day as that of Chang entering and walking through the hospital compound to introduce the hospital film. Chang's clothing is identical in the two sequences, and the close similarities in direction and qualities of the afternoon light suggest that both sequences took place within the same hour—perhaps within minutes of each other.

Moreover, the film reflects the close proximity of the medical and religious roles of the mission in physical space and in meaning. Chang, a medical doctor, also serves as a representative of the Chinese Christians who worship in and extend the spiritual community beyond the walls of the mission. And unlike the polarized conservative and modernist views expressed by US Protestant leaders, the two films together indicate that there is little separation between the church and the hospital in daily activities. Many of the hospital staff were closely involved in church programs, just as members of the church came to the hospital for treatment and were involved in evangelism to non-Christian patients.[119] Jessie Mae noted this dual relationship in her 1934 *Pen Picture* commentary: "To see, through one's efforts, pain leave a face, and peace and rest replace it, is indeed a wonderful experience. But oh! The added and unspeakable joy that comes with seeing pain leave a warped soul, being replaced by the peace and rest of a reborn soul in Christ. Pray with us that our hospital may be a Temple of Healing, in its deepest, fullest sense."[120] And as the films' audiences may have noted, the "Temple of Healing" was only a stone's throw away from its spiritual counterpart, the church that stood directly across the courtyard from the hospital, separated only by a low, ivy-covered wall and clearly visible from the windows of the inpatient wards.

Most of the scenes in the church film are characterized by a focus on communal aspects of Christian life in Shunde, emphasizing the number of Christians as well as the diversity of religious and educational activities in which they were engaged. Following the opening shots of Dr. Chang walking through the church gate, there is a sequence of congregants exiting the church on a Sunday morning in which the camera operator moves progressively closer to the church building and the people between shots. The number of people streaming down the steps out of the sanctuary is emphasized by the long duration of the sequence, as one person after another exits and passes in front of the camera, some pausing to drop their offerings into tithe-collection boxes overseen by two church elders. This sequence, mirroring the shots of missionaries and family members exiting buildings, allows the

audience to witness the Chinese Christian community in a visual cross-section; women, men, children, elderly and young people, well-dressed gentry and poorer congregants in simple clothing, and a man with a bandaged foot on crutches representing hospital patients attending the church service. Although the Henkes presumably could easily have opted to film the service in progress, which would also have displayed this collective attendance, they decided to document the congregation in this way so as to emphasize each individual congregant as well as their collective numbers. Moreover, the extended inclusion of the postservice financial offerings by each member represents the Protestant community in Shunde as indigenously supported and on the road to full self-sufficiency, at least in terms of the church institution. This visual setup served as a reminder to Depression-era US audiences that despite substantial hardship, Chinese Christians continued supporting the local church, and that perhaps US viewers should likewise persist in spite of their own economic pressures.

As with the other film's movement from within the hospital to rural clinics, the church film takes the audience from the mission church to rural fellowships led by Chinese evangelists. The sequence after that of the congregation exiting the church and mission gate shows a sizable group of rural Christians—now segregated along gender lines—participating in a hymn singing led by an evangelist. Instead of a formal, neatly constructed church sanctuary, the setting is a courtyard surrounded by a crude mud-brick wall. As the camera pans over the group, it is clear that this is somewhere outside the city, perhaps an affiliated fellowship that drew from the Shunde church for its pastoral staff but was composed of members who could not attend services in the mission proper. From the disproportionate number of hymnbooks used by the men as opposed to the women, it is evident that many of the women are illiterate or semiliterate, and many of them— lacking hymnbooks and unable to participate in singing words they did not know well—stare at the camera operator instead (possibly Harold Henke, given the camera position on the men's side).

Despite the gender divides in this scene, the film rapidly moves on to provide multiple views of women's roles in the Christian community. These scenes were likely produced by Jessie Mae Henke, reinforcing the centrality of female participation in the church's mission. Several scenes show middle-aged Chinese women traveling in a group on a horse-drawn cart to surrounding areas. As they step off the cart, nearly all of them are carrying Bibles and other texts, indicating their literacy as well as their status as evangelists. Lillian K. Jenness was the principal of the Truth Bible Institute for Women and

Girls affiliated with the Shunde mission, which enrolled fifty-eight women at the time the film was made. Jenness reported:

> The curriculum all contains possible [forms] of Bible study and simple forms of home economics . . . [but] by no means is [the students'] education confirmed to books. Being 'witnesses' is one essential form of preparation. Four little Sunday Schools are carried on by students and teacher, and our preaching bands go everywhere into the city and adjoining villages. We even go farther afield. Five or six times a year, I take bands to villages where we spend six or seven days of intensive work, preaching and teaching. During the past ten months, our bands alone have had the joy of seeing 130 souls won for the Lord.[121]

This mobility in "preaching and teaching" that is visible in the film is not only physical but also social and cultural, with women portrayed as students and teachers. With Jessie Mae behind the camera and accompanying the "preaching bands," the Cine-Kodak records women attending an outdoor Bible study led by evangelist Marjorie Judson, as well as Bible-carrying Chinese women (different from the group mentioned previously) greeting each other as they enter a home to teach. In another sequence, shot inside a courtyard, three women prepare a meal of boiled dumplings (*jiaozi*) before sitting down with a larger group of women (one of them the Henkes' colleague, nurse Chang Jui Lan) and small children; a woman sitting at the head of the closest table mouths a blessing before all partake. The Cine-Kodak shuts off momentarily during the saying of the grace, as Jessie Mae joins in prayer with the group, before starting again for the eating. The only two men in the scene appear briefly to serve food to the seated women in an inversion of gender roles. Although teaching domestic skills and the role of women in "establish[ing] Christian homes" was part of the Truth Bible Institute's stated goal (paralleling longstanding goals in women's missions), the visibility of Chinese Christian women as educated, physically mobile witnesses indicated that their role in local community building extended well beyond the domestic sphere.[122] Moreover, their presence in the film provides a counterpart to male participation in church activities, driving home the point that the church and medical community was working across gender lines.

With the exception of two isolated close-up shots (one featuring a Chinese man singing or reciting a prayer, and the other a woman with two young boys gesturing at the camera), all of these scenes in the church film convey a sense of community action. Among the scenes are those featuring children

playing and listening to outdoor lessons in the Shunde mission school, a Christian wedding procession, a large group of missionaries exiting a building after a mission meeting, and teams of young Chinese evangelists preparing materials and bicycles to set off on preaching trips into neighboring villages. The film, with its recording of church members moving through space and interacting with each other, lends itself well to the visualization of this kind of cultural and spiritual communal vibrancy. Even with groups of people standing still, as in a few shots of Chinese pastors, church elders, and other men gathered outside the church on a sunny day, the panning motion of the camera simultaneously emphasizes each individual and the group. Individual details—a young man strolling quickly into the frame to join the larger body of people, an elderly deacon holding a Bible to his chest, evangelist John Bickford mouthing some words as the Cine-Kodak scans across his position behind a group of Chinese church leaders—all blend into a communal visual fabric.

Nowhere is the sense of community more evident than the centerpiece of the film, shot on Christmas Day 1934. On that day, the Chinese Christian community and members of the Shunde mission staged a parade that began in the mission compound and wound through the city streets. Led by Chinese men carrying large Republic of China flags and vertical banners reading "Church of Christ in China" (Zhonghua Jidu jiaohui), a large group of Chinese Christians files out of the hospital gate, passing underneath the Gospel Hospital sign, into a crowd of onlookers. As the procession turns sharply left down the street, it moves past the running Cine-Kodak. The bodies of individuals passing closer to the lens are in shadow, providing a sense of depth that frames the more brightly lit part of the procession still exiting the compound. As the camera rolls, more and more people—men, women, and children, many bearing smaller banners and flags—emerge from the gate, some talking with each other or laughing, and others singing. The occasion was important enough to not only to be filmed but also recorded in text and still image in the *Pen Picture* by a missionary observing from the same locations as the Cine-Kodak:

It is a bright clear Sunday afternoon. . . . We are standing outside the big gate of the Mission Compound and, with a little group of shop keepers and ricksha pullers, we watch the open gate. Presently the singing of a hymn is heard and out through the gate there streams a procession.

First come two men bearing large flags, the national flags of China. They are followed by a line of Bible School girls and women. Behind them are the

students and teachers of the Men's Bible School; then the doctors, nurses, and orderlies in the hospital. And then follows a large group of city and country Christians. Finally bringing up the rear, are Pastor David Sung, the elders and deacons of the church, and the men missionaries.

The procession is fully two blocks long and the many banners and streamers, carried by the marchers, make it an impressive sight. Through the main streets of the city they march, singing as they go, and the side paths and shop fronts are crowded with people, eager to see this unusual sight, a big Christian parade on Christmas Sunday![123]

These are individuals from various classes, genders, and mission activities acting collectively to expand the Protestant mission beyond its walls—literally pouring out into the physical environment in a public demonstration of their faith, a performative spectacle for the inhabitants of the city as well as the unseen audience of viewers in the United States. The missionaries disappear into the crowd and behind the camera. This invisibility foregrounds the Chinese Christians' visual importance and their collective identity as members of the Church of Christ in China. The visual connection between the beginning of the film and its midway climax is clear. Dr. Chang enters the hospital and church gates as a single Chinese Christian, but many others emerge, representing the religious-medical enterprise of which he, the film's subjects, the filmmakers, and the multiple audiences were a part. Moreover, the flags underscore the participation of Chinese Christians in national life—as well as the potential for indigenous Protestantism in future communities beyond Shunde, Hebei, and North China.

Despite this seemingly triumphal, quasi-nationalist midpoint, the denouement of "Church Tour" brings the visual narrative back to a more locally oriented perspective. The film shots immediately after the parade exiting the city gate show the parade's aftermath, with the marchers gathered back in the mission compound for a festive congregational meal—an anticlimactic scene that nonetheless brings attention back to the close-knit Christian community while referencing non-Christian surroundings that lie beyond the courtyard. Although the ideal future for China from the missionaries' and congregation's points of view might be the kind of Christian nationalism performed in the Christmas Day parade, the reality was of course quite different.

In a similar way, the last sequence on the reel leaves the audience with a sense that more religious community building remains to be done. In the final minutes of "Church Tour," the Henkes film the Rev. Richard Jenness (Lillian Jenness's husband and one of the most active evangelists affiliated with

The Christmas Parade

Figure 3.3. Screenshot from "Church Tour" film (*above*); "The Christmas Parade," still photograph from *A Pen Picture of Shuntehfu Station, Presbyterian Mission, North China* (n.p., December 1934), HFC (*below*).

the mission) and a Chinese evangelist preaching to a group of mostly male onlookers on a city street. Changing positions several times, the Cine-Kodak records the gathering crowd. The roadside food vendors, craftsmen, and shopkeepers haphazardly filmed in the "Occupational" film are now drawn

together not by the spectacle of the camera or a market day, but by two evangelists—one representing the American mission, and the other the Chinese Christian pastoral staff—speaking to them. A uniformed soldier strolls casually by, and in the next shot, he too is listening to the Chinese evangelist, while smoking a cigarette. Jenness shifts from a primary to a supporting role, holding a religious poster while the evangelist speaks and gestures. For the film's final shot, the Cine-Kodak looks down from the second story of a building (perhaps an inn or a large store) to obtain a wide view of the entire group, now grown to include several dozen people. A woman with a sleeping child listens while leaning against a wall, a man with a bandaged head stands at the rear, and still others mill around. The Chinese evangelist has removed his hat and now stands on a box to see over the crowd, still speaking emphatically. Jenness himself is gone, and perhaps was standing behind the camera as it rolled. The scene suddenly cuts to black; the Cine-Kodak's 100-foot reel has reached its tail end, cutting off the shot and abruptly concluding the church film.

Cutting and Fading

As with Chinese audiences, it is impossible to know exactly what US audiences thought and felt at the end of the film, staring at the empty screen while either Harold or Jessie Mae shut off the Kodascope. Whether intentionally or not, the last scenes of the "Church" and "Hospital" reels represent ambiguous hopes. Here are medical and evangelistic missionaries working alongside Chinese Christians in close partnership, the results of which are visible as bodies undergoing treatment and the number of church attendees taking part in day-to-day religious work. But the limitations of the partnership are also visible. The "hopeless cases" represent many other, unseen individuals for whom healing is not possible, and the Shunde church's congregants are still an "unusual sight" to the non-Christian populace in the provincial city—one among many in China. And despite the films' visual storytelling linking space, place, and people thousands of miles apart (and as of this book's writing, almost ninety years distant), many questions about them remain. As the Henkes intended to narrate the films in person, few traces of film description remain in their existing correspondence; even the recorded narrations made by Jessie Mae decades later are limited to portions of a couple films.

Despite the great unknowns, these vernacular films provide a window onto the complexities and possibilities of interwar missionary activities.

They connect the United States and China in filmic presentation, pro-
duced by and for people who were involved in the transnational Christian
experience. For brief minutes, viewers see "through a glass, darkly" com-
munities and places that were important to the Henkes, their colleagues,
and the subjects of their films.[124] This importance is partially recoverable,
though it may lie in small, highly localized visualizations of Protestant mis-
sionary perceptions, and there were likely other contemporary meanings
and interpretations of these films that are now lost to time. For the Henkes,
these films memorialized experiences in the closest possible visual analog to
bringing faraway contacts to the mission and the people affiliated with it, for
reasons of education, fundraising, or the pleasure of seeing visual images
that were previously still or entirely unseen. Certainly, the films—along with
the still images, texts, and personal experiences that existed in parallel with
them—presented Protestant missionary identities in China as not belonging
to either the modernist or fundamentalist pole. The films' contents subtly
bridge the gap between Christian humanitarianism and Christian salvation
that the modernists and fundamentalists threatened to divide. The Henkes
as both missionaries and medical personnel, were not unaware of this as they
made and presented the films. For the Chinese Christian viewers, the films
were an opportunity to glimpse fragments of US life and landscapes, as well
as to present themselves for an audience whom they could not see but were
somehow connected to—through the apparatus of the Cine-Kodak and the
ties of religious faith and shared culture.

For multiple audiences with changing imaginations over time, these
films—and the knowledge that they were not only grounded in a particular
environment but also physically moved across time and space—offered the
experience of visually encountering Barthes's *"being-there* of the thing."[125]
The bodies and camera frame moving on screen, the movement of the 16
mm film drowned out by the clattering projector, and the thoughts and emo-
tions that flashed through their minds connected the viewers to the visual
remains of a past reality. These encounters engender the desire to see more,
for the films to give a more comprehensive view or a more complete story,
speaking to the kinds of cinematic voyeurism from which few audiences
are immune. But in their fragmentary nature, the films preserve the visual
traces of localized activities and imaginations, simultaneously embedded in
and detached from the broader interwar experiences of American mission-
aries and Chinese Christians.

Although the films discussed in this chapter were not the only ones that
the Henkes made during the 1930s, and certainly not the only ones they

created in China during their missionary tenure, they were the last complete reels of the interwar mission at Shunde. Apart from them, the Henkes made no other attempts from 1935 to 1946 to produce films that contained the kinds of narrative structure found in their pre-1935 films. Although the Cine-Kodak continued to be used for family filmmaking, recording the growth of the Henkes' children and their colleagues' families (including Ralph and Roberta Lewis's when they arrived in Hebei the fall of 1935), the Shunde mission and its people did not appear again in visual motion. In fact, the Cine-Kodak was with Jessie Mae, Robert, Richard, and baby Lois Henke at the Beidaihe summer resort when the Marco Polo Bridge Incident took place on July 7, 1937, igniting the full-scale Japanese military invasion of China.[126] Vacation images gave way to a complete absence of filmmaking as the Henkes were caught up in the war.[127] Though the Kodascope projector was used in the mission under Japanese occupation, during which Liu Ju encountered the Henkes and their films, light in China would not pass through the Cine-Kodak until after the Pacific War. At that time, the Cine-Kodak would be back in Beijing, where Jessie Mae Henke had written about the movie camera's arrival sixteen years before. The 16 mm film passing through the camera would include full-color Kodachrome; the subjects and settings urban rather than rural. And the Shunde hospital and church would no longer exist as it appeared in 1931–1934. In the interim, the compound was first occupied by the Japanese military and then looted by Nationalist and Communist armies for medical equipment as war-torn Hebei changed hands.[128] The Church of Christ in China, the Protestant missionary enterprise, and the Republic of China itself ceased to be the same institutions whose banners preceded the singing crowd passing in front of the Cine-Kodak on Christmas Day 1934.

As for the films, they are stored today in two hefty metal storage cases in Robert Henke's home in Whittier, California. When the cases are opened, the sour-sweet odor of vinegar wafts from the inside, a sign that the films are decaying. Parts of the footage already appear out of focus when viewed, as the acetate emulsion base warps and shrinks with environmental changes.[129] Whereas their still photographic counterparts age relatively slowly, with every passing day the Henke films come one chemical step closer to being permanently unviewable. As the footage has been digitized, it is highly unlikely that the films will ever again be screened with the Kodascope projector, as originally intended. The films' inherent silence (with the original narrators no longer living and their surviving children advanced in age) as well as the material's cloistered immobility, divorced from original viewing

technologies, may mean that the visual perspectives contained in them will not last much longer. Time flowed around the films' makers, subjects, and viewers, and continues to etch itself onto the films themselves. But still they wait for future audiences, echoing Harold Henke's anticipatory words to another group of intended viewers in 1931: "We hope [the film] gives you some idea of our life that you haven't had before and that you can see something of us until we are there ourselves."[130]

Chapter 4

Chaos in Three Frames

Fragmented Imaging and the Second Sino-Japanese War, 1937–1945

On May 15, 1938, *Life* magazine featured a frame-filling cover photograph of a lone Chinese Nationalist soldier, wearing a German-style helmet (*stahlhelm*) and staring into the distance against a cloudless blue sky, toned a dark gray in the black-and-white print.[1] Entitled "A Defender of China," the image was made by Robert Capa, better known for his iconic Spanish Civil War photographs and mobile, documentary imaging characterized by heavy use of 35 mm rangefinder cameras.[2] Earlier that spring, Capa had been based in Hankou and chafing against what he perceived to be heavy-handed Nationalist control over his photographic activities. These limitations on his mobility and the inability to document wished-for battle scenes were compounded on the US side by Henry R. Luce, *Life*'s chief editor and ardent supporter of Nationalist China's wartime cause. Capa's images, at least those printed in the May issue, focused largely on large-scale rallies organized by the Nationalist government in Hankou to promote mass mobilization and national defense. They featured flags and marching bands, Chinese Boy Scouts listening to speeches, and the young soldier with his firm gaze, described as "15 years old . . . now standing at attention while schoolchildren, only a few years younger, are giving his company a farewell before they leave for the front."[3] The article in which the image appeared

was optimistically titled "China Puts Japanese Army on the Run: A Unified Nation Reverses Its War Fortunes."[4] But the propagandistic, almost festive images and claims of national solidarity belied a far more complex moment. China in 1937–1938 was beset by widespread political uncertainty and chaotic violence across the country's central and eastern areas as Japanese invasion forces advanced inland.[5] Capa's photographs, despite their maker's professional credentials and aspirations, showed none of these things. Yet, images of the starker reality were still present in this issue of *Life*—but produced by a different person.

Immediately following the photographs of cheering crowds and parades in Hankou, a page entitled "These Atrocities Explain Jap Defeat" featured ten grainy black-and-white images, printed in small format—almost requiring the reader to stare closely at the page to make out the details. Several close-ups of burned, stabbed, and mutilated bodies, mostly produced in hospital settings and showing graphic wounds, appeared next to images of decaying corpses spread across a city street and floating in canals. These were the civilian victims of Japanese military brutality in Nanjing, a city occupied by the Imperial Japanese Army (IJA) on December 13, 1937 after a protracted battle with ill-equipped and demoralized Nationalist defenders.[6] Captions beginning with the bolded words, "Horrible death," "Decapitation," "For resisting assault," and "Struck by an axe" accompanied the images, underscoring the visual shock. Although the Japanese were far from defeated, as the article claimed, these were the first images of the "rape of Nanking" (a phrase used twice in the article itself) to reach both US and global readers of *Life*. These graphic visuals were not produced by a photojournalist or newsreel cameraperson. Rather, they were still frames reproduced from 16 mm film footage shot by an American Episcopal missionary living in Nanjing, the Rev. John Magee.[7] The article noted, "These ten pictures . . . were taken after the Japanese occupation of Nanking, Dec. 13. The photographer was an American missionary whose name must be concealed. He used a 16-mm. amateur movie camera carefully hidden from Japanese eyes. The most dreadful pictures of the rape of Nanking this amateur photographer could not take. He knew that if he filmed civilians being shot down or houses looted and burned, he would be arrested and his camera smashed."[8]

The statement that the missionary's identity and camera had to "be concealed" for safety reasons, along with the implication of other unvisualized scenes of military brutality ("the most dreadful pictures of the rape of Nanking this amateur photographer could not take"), not only defined the

images as on-the-ground visual evidence but also identified Magee's embeddedness as a missionary in China—now a war zone. By virtue of his close proximity to the local population as well as his preexisting ability to produce and circulate vernacular images, Magee as an amateur image-maker was able to do what Capa and other outside professionals could not: visually document the war and its effects on Chinese civilians from an insider perspective. Moreover, Magee's more neutral political identity (though this was subject to contention, as discussed below) and his ability to move within local conflict zones with better linguistic and cultural fluency than most foreign journalists provided an additional layer of access that was denied to others. It did not hurt that Henry Luce, the editor who assembled these images and texts, was himself a child of American Presbyterian missionaries in China.[9] Luce spent his first fifteen years in Shandong Province and his personal connections to both the missionary enterprise and Nationalist political circles undoubtedly helped secure publication of Magee's film stills in *Life*.

It is necessary here to step back and discuss the historical trajectories in which American missionaries found themselves, not only in the opening year of the Second Sino-Japanese War 1937–1938 but also in the wider conflict that would soon evolve into the Pacific War. With the massive Japanese ground invasion of North China sparked by the Marco Polo Bridge Incident on the night of July 7, 1937, and subsequent attacks on Shanghai by IJA and Imperial Japanese Navy forces in August, missionaries' roles as visual producers were radically transformed.[10] They were no longer merely individuals whose images embodied particular religious and cultural experiences in China. And their images' reception was no longer limited to church audiences and Christian communities in East Asia and the United States. As witnesses to war, some missionaries became documentarians in the eyes of an international mass public, catapulted to circuits of global visual transmission not envisioned before the conflict. In many ways, it was an opportune time for missionary visual practices to reach such audiences. The worldwide public that looked at Magee's *Life* stills in the spring of 1938 had already been exposed to other searing visuals from the war's first year. As the public demand for images of the Sino-Japanese conflict grew, lines between vernacular and documentary imaging by missionaries for international audiences (mission-related and not) became increasingly blurred. At the same time, while certain kinds of missionary visual production took on photojournalistic qualities and a sense of being a personal eyewitness to catastrophic wartime events, the war splintered missionary imaging and experience.

In some instances, missionary photography and filmmaking in wartime China simply ceased. Missionaries, American and European, were often preoccupied with matters greater than their usual visual practices. As the *Life* article noted, they were often "too busy, like other foreign missionaries and doctors, saving what civilians [they] could."[11] In this environment, gingerly navigating fraught relationships among occupiers, occupied, and neutral noncombatants, many erred on the side of caution. The ability to make photographs and films of sensitive subjects had to be carefully weighed against the threat of Japanese discovery and significant risks for missionaries themselves, Chinese associates, and civilians under their care. It was thus easier to fall back on a strained ambivalence about image-making.

Moreover, as the war disrupted the flow of photographic supplies (which was particularly taxing for missionaries in rural areas, where such supplies were already difficult to obtain) and military censorship restricted postal communications within and beyond China, many missionaries simply could not use their cameras, even if they wished to do so.[12] Most fell back on or increased their writing, a communication and documentary format they could more readily practice, without the technical complexities, material requirements, and personal risks inherent to photography and filmmaking.[13] Writing about military atrocities in private letters, for example, was far easier than photographing violent acts (or the equally horrific aftermath) with the perpetrators nearby. The contingencies that had previously underlain missionary imaging were exponentially magnified by the war's tensions and chaotic circumstances. In this light, American missionary visual practices in wartime China must be examined as fragmentary, locally specific experiences rather than broadly shared ones.

Wartime restrictions on imaging, however, did not mean that visual practices disappeared completely. Rather, depending on individual position and local conditions, missionaries who were able to gain access to supplies or maintained usable amounts of imaging material continued their photography and filmmaking under limited circumstances.[14] Not all of the resulting images or the circumstances under which they were made were as graphically sensational or widely visible to international publics as those of John Magee in Nanjing. But even vernacular images in this period reflect (or by their absence, imply) experiences that were indicative of the political realignments in a nation torn by violent conflict, as well as multiple forms of wartime trauma sustained by both the missionaries and the Chinese people. The limitations described above heightened the shift from visual meanings specific to the missionary enterprise to broadly documentary visions. The

risks of image-making and image-sharing meant that what photographs and films were made (and made it out, so to speak) were elevated to eyewitness status. Their vernacular qualities, personal confrontations with war, and circulation in spite of extensive limitations on production and reception thus placed them in closer alliance—to a certain extent—with the visual power of photojournalism.

Finally, the broader modern missionary experience in China offered unique perspectives for missionaries' wartime imaging, with their identities and locally embedded presence reshaped in partisan ways. Regional and global conflict sharpened missionaries' existential in-betweenness—even after the United States became involved in the Pacific War in 1941. This shift sometimes aligned missionaries' visual practices with broader senses of Christian internationalism.[15] One young member of the wartime generation of missionaries to China (who was also an accomplished photographer) described himself in terms that represented this worldview: "An idealist interested in social justice, a Christian pacifist with a strong commitment to the study of international relations . . . an individual with a Congregationalist's conscience about the importance of work, and a paralytic inability to spend money joyfully."[16] These general characteristics, interwoven with differences in personal convictions and regional specificities, suited many other missionaries, both those who arrived in China with such perceptions already set and those whose ways of thinking were shaped by the war. With these transformations in mind, this chapter is divided into three frames. The first two focus on American missionary imaging of specific wartime events in the public realm. The third looks at private missionary imaging *in* occupied China. The first two involve visual practices hidden in plain sight behind well-known histories of wartime China; the latter, a patchwork history of invisibilities, silences, and orphaned materials.

Negotiating Vision, Visualizing Violence—Nanjing

Almost exactly two weeks before *Life* printed Capa's and Magee's images, a pair of American missionaries, Miner Searle Bates and Lewis Smythe, went out for a Sunday afternoon walk through Nanjing's southern section.[17] Both of them were members of the United Christian Missionary Society and professors at the University of Nanking. Bates—named university vice president that January to strengthen foreign protection for the institution—taught history, and Smythe, sociology.[18] They were also on the International

Committee for the Nanking Safety Zone, a group formed by foreign residents in Nanjing in the wake of the Japanese occupation to provide humanitarian care and some protection for civilian refugees. The two had witnessed atrocities that Japanese troops led by General Iwane Matsui committed against the Chinese civilian population after they occupied the city on December 13, 1937.[19] Bates's and Smythe's writings to family and colleagues in the United States were filled with horrified (and at times, seemingly numbed) reports of violent sexual assaults on women, mass murders and torture, and other brutalities at times taking place before their eyes on the grounds of the university campus and near mission residences.[20] Although neither Bates nor Smythe reported the Sunday walk as anything other than an innocuous stroll, the Japanese occupation forces did not see it that way. Their activities that afternoon exposed the risks associated with wartime missionary visual practices and Japanese perception of those practices as a threat to Japan's control over documentation in occupied China. As the two missionaries quickly discovered, the battle for China was also a battle for control over visual production.

That day, Bates carried with him a compact 35 mm camera, perhaps a Leica or Contax rangefinder. As he and Smythe walked along, he "took some pictures of street scenes and canals. . . . At about 4:15 [p.m.]," the pair "turned into Chung Hwa Lu and walked northward." As Bates reported later, "[There] I took a picture across the street, and remained carrying my small camera in my hand. There were no soldiers in sight, and neither then or at any other time did I take a picture of anything military." Shortly after this, "several trucks with [Japanese] soldiers, drawing good-sized guns on mounts behind them" overtook the duo, passing them from behind and heading north. Bates noted, "I did not wish to have any difficulties, and slipped my camera into my pocket." With the trucks having moved on, Bates resumed photographing, believing that there was little risk of interference. Minutes later, however, "a group of soldiers came running southward and blocked [Bates and Smythe's] way. They were followed by an officer in a car."[21] The troops accompanying the trucks and artillery had evidently spotted Bates and his camera, even as he tried to conceal it, and had come to investigate. The confrontation that followed sparked a series of pointed negotiations between the American missionaries and the Japanese authorities, all concerning photography as a form of surveillance. Bates continued:

> The officer asked me in English if I took pictures, and I said that I did, pulling out my camera to show to him, while stating that I had snapped

buildings and scenes. The officer said, apparently following the statement of the soldier who pointed to me while speaking in Japanese, that I had photographed the Japanese army. I replied that I had not done so at all. The officer . . . seemed puzzled to know what to do next. I offered to give him my film so that they could see I had taken nothing military. He encouraged the idea, and I took out the film with some difficulty and loss, since the roll of 36 exposures had been only partly used and I was not accustomed to the process of removing a film before complete exposure (my camera requires complete use of the roll, then reverse winding for removal). The officer asked me for my name and address . . . [and] said that the pictures would be returned in about three days.[22]

Bates's surrender of his film, couched in terms that indicated his photographic knowledge and his "miniature" camera's high image capacity, was accompanied by debates over what was considered acceptable to photograph ("buildings and scenes") and what was not ("the Japanese army"). Handing over the film represented a transfer of power from the photographer to the (presumably) photographed; after all, the extracted film needed to be developed and examined to confirm Bates's story about nonmilitary visual subjects. At the same time, there was ambiguity about what exactly to do with the photographer and his companion. They were in a public space, even if it was officially under military control in occupied Nanjing. The "courteous" officer and the more suspicious infantrymen apparently had some sense that unauthorized photography was a potential security risk, but as Bates noted, were "puzzled to know what to do next."[23]

The argument picked up again four days later, when Bates was called to the Japanese embassy in Nanjing at the request of a "Mr. Takatama" of the Consular Police (an individual whom Bates had reported a few months earlier as forcibly procuring Chinese women for sexual services).[24] Behind closed doors, embassy officials carried on an extended conversation with Bates about what they ominously termed "the incident of May 1st," with Consul-General Yoshiyuki Hanawa noting that his contacts in the IJA were "very indignant at" Bates "taking picture[s]" and had reported that he was "stopped by soldiers while taking military pictures."[25] Bates and Hanawa engaged in rapid-fire verbal sparring, with the consul-general suggesting that even if the missionary had not made any military photographs prior to being stopped, he was "about to take a picture," concluding that Bates "ought not to take pictures under present conditions." (He also conceded, however, that the military letter reporting on Bates's activities "was not very specific

in its suggestion that [he] was stopped in the process of photographing.") In return, Bates drew a crude diagram on paper to indicate his position in the street, "emphasizing that this was all apart from the actual taking of a picture."[26] In defending his and other foreigners' ability to continue their photography, Bates pointed out in frustration what he considered a basic right to produce images in a public space, as well as the unequal lack of restrictions afforded to Japanese photographers in the occupied city: "I said that if it was considered an offence to photograph a scene on a main street, when nothing military was involved, it would be better to give notice in advance. Certainly no foreigners realized that such was an offence, since several Japanese shops sell photographic equipment, and since Japanese are freely taking pictures everywhere."[27] Hanawa finally relented and mentioned the elephant in the room. "The military," he admitted, "consider that foreigners in Nanking are really supporting the [Chinese Nationalist] Hankow Government"—a statement that he himself did not seem to take seriously, glancing at the other consular official in the room, Yasui Kasuya, and "laugh[ing] heartily."[28] The missionary did not see the humor in the situation, and replied with apparent seriousness that "American residents, whom [he] knew well, were not engaged in any sort of political and military activity, and were attending to their proper business. Such an attitude as that of the military was unfounded and irrelevant."[29]

The military's approach to foreign photographers in Nanjing was perhaps not as "unfounded and irrelevant" as Bates claimed. After all, unfavorable images of the Japanese invasion had reached (and clearly outraged) mass audiences worldwide in the months leading up to this small-scale incident involving the missionaries and the military. One was an iconic photograph made on August 14, 1937, by *Shanghai News* (*Shen Bao*) and *Hearst Metrotone News* cameraman H. S. Wong—also using a Leica 35 mm rangefinder camera—of a gravely wounded Chinese baby screaming in the ruins of Shanghai's South Station after a Japanese air raid. *Life* printed the image in its October 4, 1937, issue and estimated its public reception at over 136 million people.[30] Many of the same readers, while settling into their seats at movie theaters in the United States and other countries, were treated to dramatic newsreel footage of the sinking of the US Navy gunboat *Panay* by Japanese aircraft on December 12, 1937. Norman Alley, who produced the footage, was a Universal camera operator on board the vessel and filmed the attack almost in its entirety.[31] Although Hanawa could not fully predict the upcoming *Life* article featuring Magee's film stills (Bates, with his close association with Magee and the International Committee, may have

been quietly anticipating it), US public opinion had by then turned strongly against the Japanese, reinforced by the wide circulation of images in international media (though most individuals, as a 1938 study showed, were still undecided about direct intervention in the war).[32] These sentiments were not lost on the Japanese military officials in Nanjing. In any case, the conversation ended without a clear conclusion: "Mr. Hanawa thanked me for my report, and said he would talk again with the military. . . . I gathered the impression that the military letter was a vague explosion, and that the Consul-General was really trying to ease things if my account gave him a basis for doing so." Nonetheless, after leaving the Japanese embassy, Bates penned a letter of complaint to John M. Allison, the US consul in the city, which concluded: "I resent any implication of guilt [in making the photographs], and believe the Japanese authorities should clear it entirely with the military, for the sake of the organizations and interests with which I am connected."[33]

These negotiations, though outwardly civil and characterized by appeals to US neutrality and the legality of public photography of a "non-military nature," demonstrated the broader lack of control by the Japanese military over missionary (and other foreign) imaging in occupied China. Moreover, it displayed the missionaries' ability to use their multiple identities—here, Bates's open-ended appeal to the US consul—to protect personal mobility and visual practices in wartime. Incidents of this kind demonstrated that missionaries who owned cameras were capable of continuing their imaging if they wanted to. And even as American missionaries in Nanjing submitted detailed losses compensation claims to the US secretary of state, testifying to the theft or destruction of their possessions by Japanese troops, photographic equipment was conspicuously absent from lists that included items as specific as "3 Dozen Mason Jars filled with canned fruit, pickles and jelly glasses."[34] Missionaries who owned cameras (like Bates and Magee) undoubtedly kept such valued equipment close at hand and potentially ready to use.

Moreover, Consul-General Hanawa's comment about threats to military control was likely an expression of Japanese authorities' persistent fears that the on-the-ground images and reports sent out of Nanjing by missionaries and the International Committee's other members were strongly at odds with their official visualizations of occupation. Whereas Japanese photographers were seemingly free make images in and of the city, missionaries and other foreign observers unanimously perceived these visual practices as incongruously one-dimensional, particularly against the

backdrop of widespread, highly visible violence against civilians. Smythe, for example, wrote in a letter to US supporters loudly marked "DO NOT PUBLISH!" (ostensibly for safety reasons): "We also better understand Japanese propaganda! In the midst of such great suffering in January [the month in which he and his colleagues reported a horrifically high number of mass rapes and executions], Japanese news squads went around staging pictures of Japanese soldiers giving candy to a child or an Army doctor examining 20 children. But these acts were not repeated when no camera was around!"[35]

Another missionary on the International Committee, George A. Fitch, formally affiliated with the Nanjing YMCA, also noted plans for "moving pictures [to] be taken [by the occupation forces] of happy people waving flags, and welcoming the new regime [during a January 1 celebration of the Japanese occupation at the Nanjing Drum Tower] . . . [while] the burning of the city continues [and] cases of girls of twelve and thirteen years of age being raped or abducted are reported."[36] Numerous Japanese propaganda posters plastered on walls and buildings across the city "[said] that they [were] now looking after the welfare of the people"—visual displays of benevolence that were utterly at odds with the massive bloodshed taking place in the same spaces. "One poster," Fitch noted, "showed a smiling Chinese woman and child kneeling before a [Japanese] soldier who was giving them a loaf of bread . . . [while another] picture [was captioned] 'Soldiers and Chinese children happy together, playing joyfully in the parks. Nanking is now the best place for all countries to watch, for here one breathes the atmosphere of peaceful residence and happy work.'" Perhaps this stark contrast between military propaganda and the brutal reality, along with the public boast—ironically cutting both ways—that "Nanking is now the best place for all countries to watch" helped galvanize Fitch's subsequent actions. Not long after encountering the propaganda posters, and having already witnessed widespread atrocities, Fitch obtained a military exit permit to travel through the lines to occupied Shanghai. On January 19, 1938, he boarded a crowded Japanese military train departing the embattled city. Fitch noted later that he was "a bit nervous," and not only because he was in a railway car packed with a large and "unsavory crowd of soldiers," in his words. Rather, "sewed into the lining of my camel's-hair great-coat," he recorded, "were eight reels of 16mm. negative movie film of atrocity cases, most of which were taken in the University [of Nanking] Hospital." This was John Magee's unprocessed film footage, now on its way to an international public.[37]

Fitch arrived in Shanghai, having avoided detection of the films during Japanese security checks. He wrote, "As soon as I could . . . I took them to the Kodak office for processing[;] they were so terrible that they had to be seen to be believed . . . the Kodak representative rushed through four sets for me and of course I was asked to show the film at the American Community Church and one or two other places."[38] It is not surprising that the Community Church on Avenue Pétain in Shanghai's French Concession, attended by a thriving American expatriate community, was the first place Fitch publicly screened the films.[39] Mirroring peacetime missionary practices, churches—with their preexisting projection equipment and capacity to host congregations-turned-movie-audiences—became the prime location for this visual dissemination. Magee's film production in Nanjing and Fitch's smuggling of the raw footage for processing in Shanghai were only the beginning of the movies' mission-driven circulation. Protestant missionary networks carried the films out of China to an unlikely place: Japan. The audience stunned by the first screenings included individuals thinking critically about utilizing transnational Christian connections to bring the films into broader public view. One of them was Muriel Lester, a pacifist activist with the British Fellowship of Reconciliation. As Fitch noted, after the Shanghai screening she "expressed the thought that if some of the Christian and political leaders in Japan could see the film they would work for an immediate cessation of hostilities." Sadly, the results she and her colleagues anticipated did not come to pass: "Some weeks later she reported that she had shown [a copy of the film] before a small group of leading Christians in Tokyo, but that they felt only harm could come from an effort to show it further[,] so she finally abandoned her plan."[40]

It is not surprising that Japanese Christian leaders felt it too much of a political and institutional risk to continue publicizing the films, as the footage was extremely graphic and Magee's descriptions harrowing. Yet, Magee's written introduction expressed hope that the film might somehow make it to Japan and expose audiences there to the brutalities in occupied China, along with drawing a clear differentiation between the uninformed Japanese civilian population and the military behind the atrocities. Channeling Christian internationalist ideologies paired with the idea that his films might act as a visual missionary agent, Magee noted: "These pictures have been taken with no thought of stirring up a spirit of revenge against the Japanese, but with a desire to make all people, Japanese included, realize how horrible this war has been and to determine that every legitimate means should be used to stop this conflict manufactured by the Japanese military." Appending

a personal note to this plea, he continued, "The photographer has often been to Japan and knows how beautiful that country is, and that many noble people are to be found there. If the people of Japan could really know how the war was made, and how it has been conducted, a vast number of them would be horrified."[41]

The footage that the eight reels contained (later re-edited into twelve individual films altogether) is indeed horrifying. Magee's descriptions narrate the atrocities in extreme detail. To give an idea of the enormity of the events partially visualized in his footage, the missionary began by stating, "The pictures shown herewith give but a fragmentary glimpse of the unspeakable things that happened following the Japanese occupation of Nanking on December 13, 1937. If the photographer had more film and more time, he could have taken a great many more scenes." Then he noted (in a statement quoted in part by *Life*), "Great care had to be exercised not to be seen so as not to have his camera smashed or confiscated . . . he [therefore] could not take pictures of people being killed or of the vast numbers of dead lying about in many parts of the city."[42] The first footage that does not show aerial bombings (which were filmed from a distance as aircraft targeted multiple areas in the city before occupation) was shot three days after the Japanese army entered the city. It consists of "Chinese women on Shanghai Road, Nanking, kneeling and begging Japanese soldiers for the lives of their sons and husbands who had been collected at random on the suspicion of being ex-soldiers. Thousands of civilians were taken in this way, bound with ropes, carried to the river bank in Hsiakwan, to the edges of ponds, and to vacant spaces where they were done to death by machine guns, bayonets, rifles, and even hand grenades."[43] These scenes were filmed at a distance, through a damaged window of a vacant house, using a telephoto lens attached to Magee's Bell & Howell Filmo 70D 16 mm movie camera. As the women kneel and gesture frantically, the camera turns on and off several times. Magee was likely attempting to avoid being spotted by the Japanese infantrymen, who were armed with bayonetted rifles and guarding a group of Chinese men, some wearing white armbands, before marching them out of sight (and presumably to their deaths). The image's shakiness, magnified by the telephoto lens and combined with the long-distance shot, indicates Magee's need to film surreptitiously and reminds viewers of the person whose hands held the running camera.[44] The lens, rotated out of the way when not in use, appears as a rounded silhouette at the top right in wide-angle shots, a subtle if unintentional reference to the camera and its user's presence in the environment.[45]

Figure 4.1. Screenshot from John G. Magee Nanjing film, reel 9, ca. 1938, John G. Magee Family Papers, Special Collections, Yale Divinity School Library, New Haven, Connecticut.

Despite these visual cues indicating Magee's filmmaking presence on the ground, much of the violence in the film is visualized after the fact, in shots of unburied corpses, camps packed with throngs of refugees, and wounded and dying individuals undergoing emergency treatment in the University of Nanking hospital. The latter scenes, both in visual framing and textual description, mirror the medical imaging produced by missionaries before the war. Magee filmed nurses and doctors examining horribly injured patients at close distance, focusing on their wounds. The textual descriptions accompanying these scenes routinely drift into clinical language, perhaps as a result of collecting information directly from the medical staff.[46] For example, Magee noted that a man filmed in the hospital had "six bayonet wounds, one of which penetrated his pleura giving rise to a general sub-cutaneous Emphysema. He [would] recover."[47] These images, however, do not simply rehash preexisting narratives about medical missions and humanitarian care. Rather, they recontextualize them, with broken bodies and images of treatment pointing to the military brutalities that caused the grotesque wounds and deaths.

Magee thus used the images as a focal point for numbingly detailed textual descriptions of violence against civilians. The films' indexicality serves to heighten horrors not seen on screen. One particularly disturbing example appears in shots of an elderly woman followed by "the picture show[ing] the bodies of . . . 16 and 14 year old girls, each lying in a group of people slain at the same time." Although the images are visually jarring in their own right, the events that lay behind them were even more so. The woman was in fact the survivor of a terrifying attack—an entire family shot and stabbed to death, the girls gang-raped, mutilated, and then brutally killed by Japanese troops—on which Magee reported at such breathless length that the full accompanying text could not possibly be read or even accurately paraphrased while watching the film in real-time. Enacting vernacular investigative filmmaking, Magee not only filmed the survivors and victims of the killings but also interacted directly with the subjects of his film to collect as many eyewitness details and additional footage as possible. The missionary, using linguistic skills developed in peacetime mission work, assembled his descriptions by interviewing the survivors of the killings, not least an eight-year-old girl who hid in another room of the house ("where lay the [bayonetted] body of her mother"). She and an uninjured four-year-old sister had subsisted for two weeks "on puffed rice and rice crusts that form in the pan when the rice is cooked [guo ba]," surrounded by their murdered family members. "It was from the older of these children," Magee wrote, "that the photographer was able to get part of the story, and verify and correct certain details told him by a neighbor and a relative . . . after 14 days the old woman shown in the picture returned to the neighborhood and found the two children. It was she who led the photographer to an open space where the bodies had been taken afterwards. Through questioning her and Mrs. Hsia's brother and the little girl, a clear knowledge of the terrible tragedy was gained."[48]

On a separate occasion, guided by the children and their uncle ("Mrs. Hsia's brother"), Magee visited the house with his camera and filmed the survivors standing in various spaces related to their testimonies, visualizing specific parts of the house related to the killings: "a little courtyard off the room where their two older sisters . . . were raped and killed . . . a table upon which one of these tragedies occurred [with] blood . . . on the table and on the floor . . . the room where their mother was raped and killed," and even the "spot in the courtyard where the Mohammedan Ha was killed, the blood still showing on the stone." The camera transformed the courtyard, room, and ruined furniture into visual markers

of violence. Through Magee's mind's eye, audiences would have merged the descriptions and stark, flickering images of the murder scene (remnants of off-screen brutalities) with their imaginations of the killings that took place there. To further underscore the near-absurd incongruity between the atrocities and Japanese propaganda—and echoing George Fitch's (and other missionaries') reports on such discrepancies—Magee made sure to film "a Japanese poster on the wall of the very next house to that in which these tragedies occurred. A Japanese soldier is shown carrying a small child and giving a bucket of rice its mother and sugar and other edibles to its father. The writing on the upper right hand corner says: 'Return to your homes! We will give you rice to eat! Believe in the Japanese army! You will be saved and helped.'"[49]

In producing and circulating the film, Magee hoped that he might lead international audiences to "believe *not* in the Japanese army," but rather in the power of filmic realism and missionary embeddedness, contrary to propaganda on the ground. As with his hope that the work might serve as an exposé in Japanese civilian circles, Magee perceived that the raw footage was going on to larger audiences beyond his knowledge or direct control. In preparation for this, he included notes in his description for later editors, for example: "The scene shown here should be joined to Film 4, Case [scene] 9—the story of a household of eleven persons who were killed as it is the same case."[50] The carefully categorized, visible physical results of atrocities, viewed alongside Magee's textual reports detailing unvisualized events, constituted a highly damning record of the Japanese army's atrocities in Nanjing. But this format, along with several other key contextual factors, contributed to the film's undoing. As mentioned previously, the extensive descriptions of violence often outpaced the onscreen images, making it extremely difficult to match vision with text, particularly when the films were screened and narrated for a mass audience. (Intertitles, when introduced later, were gross simplifications of Magee's reports.) This disjuncture meant that few audiences could take in Magee's documentary material as produced. Even in the later historical record, studies of the Nanjing Massacre focus strongly on Magee's written film descriptions, largely disconnecting the text from the visual materials they were originally meant to accompany.

Moreover, because these films were shot by a missionary and circulated through missionary networks, they were generally divorced from popular mass media like the news organizations that stunned a much larger international population with the *Panay* footage and H. S. Wong's photograph

of the wounded Chinese baby. Although Magee's stills and fragmentary descriptions reached *Life* readers with Henry Luce's intervention, his films and larger reports remained largely in the circulatory networks of missionary organizations. The format of missionary film screening (scheduling a special screening date in a church or auditorium, narrating the silent film as it was projected, and responding to audience dialogue afterward) further limited the films' distribution, requiring significant labor on the part of its lone narrator (George Fitch) before and during screening. Fitch attempted to show the films in various churches and Christian organizations in the United States, but grew tired of the process and the lack of greater response; by 1939, he had ceased public presentations.[51] Even when confronted with such graphic footage, US audiences were still grappling with the question of whether the United States should continue its nonintervention and isolationism. Further, the invasion of China progressed so rapidly that Nanjing was soon, in the eyes of many observers, only one of several major cities to fall to the Japanese.

Finally, Magee's role, as seen from an outside perspective, was as a missionary, not a filmmaker or newsreel cameraman. As *Life* put it, "The most dreadful pictures of the rape of Nanking *this amateur photographer* [author's emphasis] could not take." Despite his extensive footage and background reporting, Magee was clearly labeled an "amateur," a term that carried even less cachet and greater stigma of unprofessionalism in the 1930s than in later periods. Vernacular filmmaking, even with such content as war atrocities and mass murder, simply operated on a different scale compared to the filmic format, mass distribution, and audience accessibility of professional newsreels or Hollywood-produced films. Although *Life* attempted to parlay Magee's amateur status into a portrayal of dramatic on-the-spot filmmaking by a neutral individual confronted by violence, it was also a double-edged sword. The statements "the most dreadful pictures . . . [he] could not take" and "besides, he was too busy, like other foreign missionaries . . . saving what civilians he could," without the context of Magee's larger body of films and texts, likely led skeptical readers to imagine that the few poorly reproduced film stills were all that the missionary could manage. To them, his real work was in a church, school, or hospital, not behind a movie camera. Furthermore, world audiences did not yet have the visual literacy to take such films seriously. The chasm between amateur and professional modes of filmmaking meant that Magee's images were never seen as widely as he had hoped. But Magee's shaky handheld camera and embeddedness in the war zone prefigured later trends, as wartime military filmmaking, Hollywood's adoption

of gritty handheld cinematography, and on-site news films and television reportage conditioned mass audiences to appreciate (and look for) such forms of visual realism.[52] And his films and descriptions form a focal point for responses by historians to present-day Japanese ultranationalist denials of the Nanjing Massacre, as well for as major studies by Chinese and global scholars investigating the violence that appeared in the images alongside atrocities beyond the camera's point of view.[53]

Interestingly, twenty-first-century dramatizations of the Nanjing Massacre reframe Magee's and his missionary colleagues' experiences in Nanjing by portraying him, Miner Searle Bates, George Fitch, and Lewis Smythe as filmic characters.[54] Whereas the other missionaries' photographic roles are entirely absent from these films, Magee and his camera stand in as a reference to contemporary visual documentation of the atrocities, signaling to audiences that yes, there was a filmmaker on the scene (though, ironically, these contemporary visual representations take place in professional productions and wide networks of circulation denied to Magee's films in their original contexts). The framing and reframing of Magee's Nanjing images—then in *Life*'s article, now in commercial dramas and docudramas—reflect the power of vernacular imaging by a missionary eyewitness in wartime China, as well as the slipperiness of such images, which simultaneously shock and defy clear-cut definitions across time.

National Identity and Mass Imaging—West China

As millions of refugees and core elements of Chiang Kai-shek's Nationalist government retreated to Southwest China ahead of the invasion, American missionaries who found themselves in the path of the national exodus followed suit. Chongqing, Chengdu, Kunming, and Guilin—formerly peripheral cities in comparison to Shanghai, Beijing, and Nanjing in the east—were reshaped as wartime metropoles, centers for industrial production, higher education, and Nationalist military resistance.[55] American Presbyterian educator Gerald F. Winfield was among the missionaries who elected to leave their prewar locations, moving to Chongqing in Free China (a wartime term coined by the Nationalist government, denoting areas unoccupied by the Japanese) 776 miles southwest of his former post in Shandong, where he had been parasitology instructor and public health specialist in Cheeloo University's medical college.[56] The university, along with forty-seven other religious, private, and national universities, evacuated from North China to

West China, with many faculty and students joining the West China Union University in Chengdu as one of several emergency institutional mergers.[57] While in Sichuan Province, Winfield continued his biomedical studies, attempting to combat infectious disease in areas of West China lacking sanitation infrastructure. Some of this work became the raw material for a postwar book entitled *China: The Land and the People*, an eclectic scientific, historical, and cultural analysis peppered with snippets of autobiography.[58] While the grander schemes of Nationalist military operations, political alliances with Western powers, and Japanese aerial bombing of interior cities swirled around him, Winfield wrote and photographed as an uprooted American missionary whose responsibilities and regional base were reconfigured by the war.[59] And in his role as a Cheeloo University faculty member, Winfield documented the institution-in-exile's medical and scientific education efforts under wartime constraints. Thus, his photographs—mostly made with a 35 mm Leica and occasionally with a Rolleiflex or a borrowed 4″ x 5″ press camera—represent an embedded perspective on wartime communities in the western interior. The images frame Chinese resistance as a mass phenomenon, visualized in terms of collective action in labor, education, and political participation.

The majority of Winfield's extant photographs are a cross section of wartime modernity, juxtaposed against the stark environmental, geographical, and military challenges that West China faced from 1939 to 1945. In some cases, the mobilization of mass labor overcame these obstacles. Winfield made numerous photographs of transportation methods employed in the interior, including images of riverboats dragged over rapids by teams of trackers as well as man-powered wheelbarrows laden with cargo. But though such views of rural transport were already common in prewar missionary imaging, Winfield's images reframed them in light of the incredible collective physical exertion that moved entire industries, communities, and resources to wartime Sichuan. In this time of national emergency, China was literally saved by the blood and sweat of its population.[60] Winfield's photographs of men straining at tow cables, hauling boats up the Yangtze River, and of overloaded carts towed along dirt roads by fatigued, muscular laborers emphasized the communal efforts that enabled the successful 1938–1939 retreat—contributions that continued even as the Japanese attempted to invade the southwestern provinces, culminating in the extensive aerial bombing of Chongqing and Chengdu.[61]

In vision and meaning, Winfield's images closely aligned with themes in Chinese nationalist cinema that glorified collective labor as a method to

resist Japanese aggression before and during the war years. *The Big Road (Da lu)*, a popular leftist film produced by the Lianhua Film Company in 1934, three years before the Second Sino-Japanese War, prophetically concluded with a group of laborers building a modern highway (the eponymous "big road") to carry military supplies, only to be strafed and killed on the job by a harassing Japanese warplane. Visually resurrected by double-exposure cinematography, the workers' spirits dramatically arose from their corpses to continue building the road on screen, accompanied by the martial strains of patriotic music. Coincidentally, Winfield was acquainted with exiled Chinese filmmakers during his time in the interior, and in his postwar study made specific mention of Shen Xiling, a prominent playwright and director employed by both Lianhua and the Nationalist Central Film Studio (Zhongyang dianying gongsi).[62] Though Shen died shortly before Winfield's arrival, it is highly likely that Winfield worked alongside other individuals affiliated with these studios, given his later visual projects.

Collective education and political participation were also Winfield's primary subjects. Along with candid portraits of prominent scholars who had joined the ranks of educators in wartime exile—among them John Lossing Buck (an American Presbyterian agricultural economist and Pearl Buck's ex-husband) and Marion Yang (former director of the First National Midwifery School)—Winfield turned his lens to student groups affiliated with Cheeloo and West China Union University.[63] The students were photographed in their cramped living spaces. One typed caption states, "Fourteen girls lived in this one small room in the dormitory of Cheeloo University while it was refugeeing in West China. The room was so crowded that all of its occupants could not sit down to study at the same time."[64] Similar tight framing shows students of both sexes crowding around an instructor to observe a laboratory demonstration, as well as smartly attired male students sitting and listening to a standing female professor in an open-air seminar session—an inversion of gendered hierarchies and divisions in higher education. Whether restricted by lack of space or because of deliberate visual choices, the crowdedness of these images underscores the collective nature of wartime education, with students and faculty continuing their studies despite being far from their hometowns and prewar institutions, thrown together in the rural interior but able to function as a cohesive learning community.[65]

When Winfield attended university athletic events held in Chongqing and Chengdu, his camera pulled back to encompass public events intended to strengthen allegiance to the Nationalist cause. In the images, student

athletes from various institutions participated in large rallies led by military officers, cheering in front of large portraits of Chiang Kai-shek and Sun Yat-sen. Wartime education in West China was exemplified by a sense of progressive modernity that crossed gender lines (e.g., coed classrooms and graduation ceremonies, senior female professors teaching young men), institutional efficacy under difficult circumstances (students studying and living in crude environments and participating in medical relief work), and participation in mass demonstrations. These experiences were bound up with collective expressions of Nationalist identity. Winfield's photographic styles and subjects mirrored those made by photographers embedded with Communist forces in northwestern China, who also employed tight framing, mobile photography, and group imagery to reinforce their visualizations of wartime community.[66] Although it is not possible to determine a direct correlation between these imaging styles, Winfield collected a number of images of Chinese students in Communist guerilla units, possibly made by a journalist or fellow missionary who traveled to Yan'an on a fact-finding trip (at least one of which took place in 1944), and he may well have compared these photographs from the other side with his own.[67]

Winfield's visual practices, however, were not limited to personal images of collective resistance and community building in West China; they soon extended to the visual dissemination of such ideas for a mass audience. After the United States entered the war in 1941 and initiated extensive military support for the Nationalists, Winfield was recruited by the US Office of War Information (OWI), with headquarters in Chongqing and Chengdu.[68] His new responsibility was to organize an official filmstrip production program, drawing explicitly on his prior missionary expertise in education, photography, and visual presentations. This was the United Nations Filmstrip Propagation Department (Lianheguo yingwen xuanchuan chu) or United Nations Filmstrip Library in Chongqing, jointly supported by the OWI, the Chinese Ministry of Education, and the British Ministry of Information.[69] Writing to his younger sister as the initiative was getting underway in the late summer of 1942, Winfield described the work in detailed terms:

> We put together from 60 to 80 pictures that tell a story and photograph them with Chinese captions onto a strip of film about five to six feet long. These pictures are then projected by means of small projectors which throw them up to almost a full commercial movie house screen size. As they are being shown a commentary which we write out and m[i]meograph is read

by one of the local folk so that the dialect problem is solved. We now have on order 500 of these small projectors which will be located all over the country and will be showing pictures to thousands of people night after night . . . in addition to filmstrips . . . this child of mine is named the United Nations Filmstrip Library [and it] produces photograph exhibits and a little pictorial magazine. [T]he work is mostly done by a staff of Chinese workers . . . [and] as time goes along what I do myself will decrease in in quantity and variety as different ones get able to do their share of what they are being trained to do.[70]

Although Winfield's expertise lay in the field of public health and medicine, the process he devised was defined by missionary approaches to information dissemination. The visual material intended to reach a mass audience by virtue of its technologies, and the ways in which it would do this echoed methods of evangelistic outreach. The production of a centralized script for local individuals to present (solving the "dialect problem") resembled the communal work of Chinese evangelists equipped with religious tracts, posters, hymnals, and Bibles. So too did the creation of a library of material from which images and texts could be assembled for distribution. Finally, the idea that Western experts in partnership with the Nationalist government would train up a base of Chinese associates to ultimately take over the work matched the modern mission enterprise's evolution from foreign to indigenous control. Winfield noted, "We are trying to tell the story of how this war is being fought." But the initiative was undergirded by a larger education project: "I am really more interested myself in teaching other things to the Chinese popula[ce] . . . I am getting strips on public health, agriculture, and many other subjects worked into our program even now." In this light, the filmstrip program was more than a propaganda tool to serve the Nationalists' political cause or an evangelistic agenda. Anticipating a greater mission for the portable projectors, filmstrips, and their operators, Winfield wrote, "When the war is over, we shall have ready at hand an educational instrument for use in the reconstruction of China."[71]

This new beginning, however, was still several fraught years away. In the moment, Winfield's project was born out of close interactions between international actors in this part of wartime West China. Winfield lived in a house shared by a branch of British Ministry of Information as well as individuals responsible for the filmstrip project. It was representative of Chongqing's mixed sociopolitical landscape, with refugees, the Nationalist

government in exile, and Western military and civilian allies in shoulder-to-shoulder proximity. In reporting to his family, Winfield shared that this "interesting and mixed household" contained

> one New Zealander, two Australians, one Chinese born in Canada, one man from Ceylon, and two Anglo-Indians . . . [as well as another] Chinese, a lady with two sons. She was born and grew up in Australia, and recently escaped from Hongkong. All of these folk with the exception of the Chinese lady are new to China. . . . The two Australians are picture men who have had lots of experience in movies. In fact they have just about run Fox Movietone News in Australia for the past several years. Now they are working with me on the filmstrip business. . . . Mr. Edwards is a splendid camera man and laboratory man who is helping us get our technical problems worked out. We have now completed the editing work on 17 filmstrips and are getting them photographed as fast as we can.[72]

With this communal environment facilitating cooperation across national lines and backed by a pooled $100,000 start-up fund from the British, US, and Chinese governments, it is not surprising that Winfield selected "United Nations" as the moniker for this project. The filmstrips themselves, containing photographic reproductions or hand-drawn Disneyesque cartoons with paired narration, were produced by Chinese technicians, who made use of commercial film studio facilities in the new metropole as well as others specifically constructed for the program.[73]

Transnational cooperation made possible the filmstrip program's local success. As Winfield later testified before the postwar Committee on Foreign Affairs of the US House of Representatives, the program resulted in "a projection network in free China of 450 projectors and produced 200 different films to tell the Chinese people about the war effort."[74] In addition to promoting the war effort, the program's goal "[was] one of popular education, using audio-visual materials to teach the Chinese people how to . . . care for their health, improve methods of plant and animal breeding, the cultivation of crops, and so on. We use . . . media posters, graphic portfolios, booklets, and film strips, in coordination to achieve the saturation of the whole community with the information to be taught."[75] OWI instructors trained groups of field projectionists in operating filmstrip equipment, ranging from lantern slide machines refashioned from Coleman lamps to electrically powered Society for Visual Education (SVE) projectors with portable generators and loudspeakers. The projectionists

were then assigned to certain rural districts, either working individually with the oil-fired projector (the projectionist could "take about 5 gallons of gasoline or kerosene and stay out in the country and show all of this material" before exhausting the fuel supply) or in four-person teams with generator-powered equipment.[76]

On at least one occasion, Winfield photographed the projectionists' training process with a borrowed press camera and flashbulbs. In his images, Chinese instructors lecture on projection techniques and technologies before giving an example screening. During one of these shows, a still image of Chiang Kai-shek standing before a microphone in mid-speech (perhaps paired with a recording of the Generalissimo himself or a transcript presented by a narrator) was cast on the screen, a sample of the Nationalist propaganda intended for rural audiences who did not have wide exposure to other media forms (e.g., movies and radio) typically employed by the government. Afterward, groups of students worked with SVE projectors, five to seven people per machine, practicing loading and projecting film strips. Their training *en masse* mirrored the scale of the audiences for which the students' work was intended. One photograph in the series shows young men with military-style khakis and identification badges crowded into a single room, making test projections onto sheets of paper propped up against the projectors' carrying cases. An instructor at the far end of the room, speaking into a microphone (perhaps using the same public-address system his students would later use in the field), reads instructions aloud from a manual; behind him, a cutaway diagram of a filmstrip projector hangs dog-eared from a blackboard alongside a partially erased word: "Ko[dak]."[77] And on the wall, a Chinese slogan painted in bold black letters encourages the tinkering students to think about the broader implications of their work, strengthening the idea that the wartime filmstrips were much more than a novelty: "An excellent projection team is an excellent school of film education" (*youliang de fangyingdui shi dianying jiaoyu de youliang xuexiao*).[78]

These mobile "school[s]" of film education" were intended for large groups of illiterate people in the Chinese interior. Winfield estimated, "By the use of loudspeaker equipment it is possible to set up and show film strips to 3,000 to 5,000 people, and that is the kind of crowd you are going to have . . . in the villages when you go in to put on one of these shows, because the people come from miles around to see them. They will stand there for 2 or 3 hours in the evening in order to see a film strip show of this kind." Whether or not the filmstrips' official medical and political messages were effectively carried across was a different issue entirely. As seen in the previous

Figure 4.2. Trainees examining filmstrips and equipment, West China, ca. 1942–1943. Photograph by Gerald F. Winfield. WSFC.

chapter on interwar missionary filmmaking, missionaries knew (or suspected) that visual presentations were often more a form of entertainment than of education. Winfield, aware of this unintended effect, designed the presentations such that "as part of the total show, film strips [were] included telling about America and other parts of China, and even cartoon strips that [were] just fun and entertainment . . . then in the middle of the show, much like a 'commercial' on the radio, [was] the education material . . . to saturate the community with."[79] In July 1944, one filmstrip "telling about America and other parts of China" (intended more as political commentary than as mere "fun and entertainment") made it from West China to a global audience via *Life* magazine, which reproduced the individual frames storyboard-style under the heading "Speaking of Pictures . . . Fable of Birds Tells War History to Chinese."[80] Framing anti-Japanese resistance in a cartoon entitled *Story in the Woods*, with anthropomorphic birds representing Japan (blackbirds), Nationalist China (sparrows), and the United States (eagles), the filmstrip was intended to give a broad view of the US alliance with China—including a not-so-subtle critique of the Americans' late arrival in the war from the Chinese perspective.[81]

Winfield was credited as the project's "instigator" (and described as a "36-year-old Johns Hopkins graduate who taught public health in China for 11 years with pictures like these"). The article claimed that the filmstrips had "already been seen by over 2,000,000 people" and had "gone as far into the Asian wilderness as Lhasa, Tibet."[82] Perhaps because of the publicity garnered by *Life*'s publication of the film stills and the project's close proximity to other, larger American and Chinese collaborative reconstruction ventures in West China, Winfield's work on mass visual education would continue to have great effects (visible on both national and international scales) even after the war ended. The United Nations Filmstrip Propagation Department would eventually find a postwar afterlife in the Sino-American Joint Commission on Rural Reconstruction (led by Y. C. James Yen).[83] Incidentally, rural propaganda teams in the early People's Republic of China would use almost exactly the same methods of production and dissemination as the department, with the core patterns set by Winfield's program expanded to include Chinese Communist Party–produced political films and postscreening discussions.[84] Although it is nearly impossible to track the exact geographical reach of Winfield's filmstrips or their specific effects on the audiences that viewed them, this was undoubtedly one of the first cases of mass imaging technologies and wartime politics reaching a mass audience in Nationalist West China—with one American missionary's visual practices at the nucleus.

Fragments and Invisibilities—North China

In North China, missionaries continued their visual practices on a more limited scale, though their images lacked the visible results of violence, governmental engagement, and international viewership that characterized John Magee and Gerald Winfield's respective imaging in Nanjing and Chongqing. Missionaries in North China did not explicitly visualize acts of war. Rather, the conflict informed their experiences and registered indirectly on what they did (and did not) photograph. This, however, did not mean that the war was invisible to missionaries or absent from the images they produced. In North China, missionary activities and life were dramatically disrupted by the Japanese invasion in July 1937. Many Protestant missionary families were already separated during that time. Men who were doctors or evangelists stayed behind to staff mission stations while their spouses and children went to Beidaihe, an oceanside resort in Hebei Province, to escape the summer heat. The

missionaries, attempting to continue their prewar patterns of summer work and travel, were caught up in the invasion, witnessing the repercussions in individual, fragmentary ways as they moved through China.

Harold Henke had begun the summer of 1937 with a brief respite with Jessie Mae and their children at the retreat, but returned to Shunde to relieve Ralph Lewis, who was recovering from scarlet fever and planned to rejoin Roberta and his family vacationing at Beidaihe.[85] Lewis, carrying his Rolleiflex camera but declining to use it along the way, perhaps because of his weakened health and rough travel conditions, arrived at the coast after a chaotic mid-July trip by rail and bus through Baoding and Tianjin. At times, he was the "only Caucasian" and surrounded by anxious Chinese civilians who "all wanted to talk, telling [him] about the battle going on near Beijing, but as far as they knew . . . not in Tianjin."[86] Less than a month after Lewis's departure, Henke and his evangelist colleague, the Rev. John Bickford, also left Shunde to reunite with their families in Beidaihe, having grown uneasy about the war situation.[87] To skirt military engagements in Shanghai and the northern provinces, they traveled south by train to Hong Kong (narrowly missing floods and landslides) and from there back north to Qinhuangdao (a major port near Beidaihe) on a British coal ship.[88] On the way, Bickford wearily noted that they were covering 2,700 circuitous miles to reach a destination only a few hundred miles northeast of their mission.[89] This frenetic movement in the shadow of the growing conflict, with missionaries traveling alongside or against the exodus of Chinese refugees (whose experiences included families separated for survival, not leisure) meant that visual practices were far from a priority.[90]

Although Lewis's photographs from that summer in Beidaihe appeared to be ordinary peacetime vacation scenes, with pictures of his children playing together with those of other missionaries and gatherings of families and friends, the war was already close at hand. In the early hours of the morning after Lewis arrived in Beidaihe, as his Rolleiflex sat unused in its case, he and the other missionaries were awakened in their seaside cottages by the roar of "many Japanese military planes, heavily loaded, flying south over [their] heads. About an hour later, several groups of planes, this time lightly loaded [were seen] flying back toward Mukden . . . Later in the day [the missionaries] heard that their objective was to completely destroy the Tianjin R.R. Station. Just the day before [Lewis] had been in that station waiting for a train to Peitaiho [Beidaihe] and now it was in ruins."[91] The warplanes Lewis observed were in the process of bombing Tianjin in preparation for the July 29 IJA ground attack on that city, which fell after a fierce daylong

battle.[92] And as if foreshadowing the global conflicts to come, from the same vantage points at the resort, "in the evenings [the missionaries] could hear from [their] porch the U.S. Marine Corps holding their target practice south of [the resort], just this side of the port of Qinhuangdao. Sometimes [the missionaries] could see the tracer-bullets flying off above the ocean at night."[93] At one point, Lewis, Roberta, their eldest son, and the Henkes' two sons, Robert and Richard, took a small boat out from Beidaihe to visit a US Navy warship anchored off the Shandong coast, likely as a security measure to protect foreign interests in the area while the Japanese invasion swept through North China.[94] In a strange dual encounter with both hard US military presence in China and soft popular visual culture, the group was escorted onto the vessel to find that the off-duty sailors were enjoying "a movie going on the after-deck[;] . . . it was a talkie and Shirley Temple was playing."[95] This was not the last time that Beidaihe, American missionary images, and the US Navy were indirectly involved with each other. After the United States entered the Pacific War, Federal Bureau of Investigation personnel visited American missionary families (including that of Gerald Winfield) to collect pre-1941 vacation photographs taken at the resort, to be used as reference materials for a proposed amphibious landing to recapture the area.[96]

In many cases, as battle lines moved on and parts of the country settled into an uneasy but relatively quiet occupation under the Japanese, missionaries continued their prewar projects in an environment that differed only somewhat from their previous experiences. The Japanese military authorities generally treated American and other foreign missionaries as noncombatant neutral parties. So long as their activities were not openly anti-Japanese and took place in relatively stable and well-controlled areas (unlike Nanjing in the first few months of occupation), they were not seen as much of a threat. Indeed, for the missionaries to continue their work in North China, cooperation with the occupation forces was necessary, especially given that many of the Chinese staff members—doctors, nurses, pastors, and Chinese Christians—had either fled to other provinces ahead of the invasion or were otherwise incapacitated. The Americans staffing missions in occupied areas thus found themselves in a politically ambiguous position. Strong personal alignment with the Chinese wartime cause gradually shifted into a strange friendship with the Japanese, partially driven by the need to mediate between the military authorities and the local Chinese population. These day-to-day interactions were characterized less by constant antagonism than by a form of normalcy, even if begrudgingly accepted.[97]

Harold Henke, for example, after moving back and forth between Shunde and Beijing in the fall and early winter of 1937, determined that he ought to continue his medical mission work regardless of the war situation. He returned to Shunde, temporarily leaving behind Jessie Mae, their two sons, and infant daughter in Japanese-occupied Beijing for safety. Anticipating the need to work with the occupying forces, Henke emphasized that it was "an answer to prayer" when John Bickford brought with him from Beijing "Dr. An . . . a native of [the] province who . . . had two and one half years postgraduate medical work in Tokyo. He [spoke] Japanese easily. . . . He . . . agreed to work [at the mission hospital] for at most six months. He [would] spend two thirds of his time in medical work, the balance in teaching Japanese and in aiding as interpreter." This collaboration was crucial, as the local leadership and Chinese Christian communities with whom the missionaries were previously familiar were largely in disarray, replaced by Japanese military authorities on whom the Americans needed to rely. Moreover, Henke's emphasis on An "teaching Japanese" to the mission staff meant that he believed that the occupation would not be a temporary situation. In any case, there were greater needs at hand. With a cobbled-together staff of a few student nurses led by the resilient Chang Jui-lan (who had worked alongside the Henkes since 1929), Stephen Tu (the laboratory technician with one leg who appeared in the prewar photographs and hospital film), and scattered, untrained helpers, Henke now faced "increasing numbers . . . of in-patients [with] gunshot and bomb wounds . . . some of these [were] the worst [he had] ever had to care for and many [had] been neglected before coming to the missionaries." These conditions were further complicated by "more than 500 refugees living in [the] schools and in the basements of the church and O.P.D. [outpatient department] and also dormitory for [the] student nurses."[98] Among them was the twenty-year-old Liu Ju.[99] In the face of the invasion, her Protestant family had evacuated from their home city of Shijiazhuang, sixty-eight miles due north of Shunde, but only made it as far as the latter city before taking shelter at the Presbyterian mission there. With her father's encouragement and given the pressing staff shortage, Liu volunteered as a nurse trainee. It was at this time that she began a half-century-long friendship with the Henkes and with Jessie Mae in particular, given their shared faith and interest in nursing. Within two years Liu appeared with other student nurses in a photograph by Ralph Lewis—the image that ultimately found its way into the Henkes' scrapbook.

The war produced a large spectrum of incidental, sometimes transformative contacts between Chinese civilians and missionaries of other

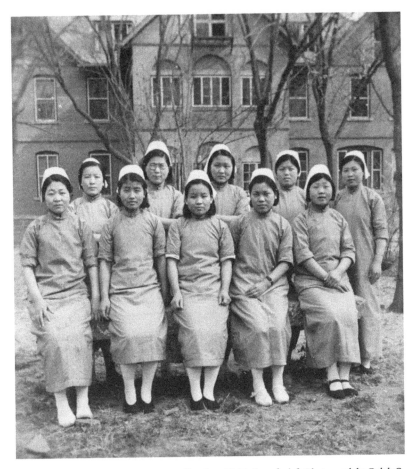

Figure 4.3. "Student Nurses" in wartime Shunde, with Liu Ju at far left. Photograph by Ralph C. Lewis in Henke scrapbook album, HFC.

denominations, whose missions were also affected by the massive influx of refugees. In Henan Province, directly south of the Henkes' location, refugees flooding into the city of Xinxiang ahead of the Japanese included a young mother, her daughter, and an elder son about nine years old. Taken in with over a thousand other displaced civilians by Catholic Society of the Divine Word (SVD) priests after the nearby Anglican mission evacuated its clergy, the small family remained in the SVD compound, the boy remembering the time as rather idyllic. It was also there that two American Catholic priests from Illinois, Fr. Joseph Henkels (the priest who realized his vocation after viewing lantern slides from China as a child, described in the previous

chapter) and Fr. Thomas Meagan, SVD, played an influential role in shaping the boy's religious and cultural convictions.[100] The boy, who also showed significant interest in foreign languages, was baptized, given the Christian name Joseph, and supported by the SVD for his seminary education. Little did he know that almost a decade and a half later, he would be standing steps away from Pope Pius XII in Rome. It was in this way that the future archbishop of Taipei, the Most Rev. Joseph Ti-Kang, was received into the Catholic Church.[101] The future archbishop's family also converted to Catholicism at this time, though his maternal grandfather converted not so much in a religious manner as in a general acceptance of missionary involvement in China. A local elder in charge of keeping the peace during the invasion (and who had also encouraged his family to seek protection at the Catholic mission), he had formerly felt all foreign missionaries to be "pioneers of imperialism"—a view he formed after gaining a general knowledge of Anglican missionaries, for whom church and state (particularly in colonial contexts in China) were often linked. But the war and the American missionaries' more independent roles in protecting Chinese civilians in opposition to another imperialist power changed his perspective completely. As the immediate military dangers passed and the Japanese occupation became entrenched in North China, he was among those who found a more moderate position in relation to the foreigners with whom he was formerly at odds.[102] Similarly, his grandson's American mentor, Father Henkels, soon experienced two contrasting encounters with the Japanese occupiers. On one occasion Henkels was violently beaten by a checkpoint sentry attempting to confiscate his bicycle; on another, he lent his technical skills to repairing a blown RCA radio receiver for a neighboring Japanese garrison—whose troops applauded heartily when the device roared back to life, blasting a shortwave broadcast from Berlin.[103]

From the missionaries' perspective, there were some visible lulls in the upheavals brought by the invasion and occupation. By the spring of 1938, Harold Henke was able to return to Beijing. He reported with some relief, "Shuntehfu has been quite peaceful and there are many signs of [a] return to normalcy. Many stores are open and every public service, except the postal office[,] is open again. The railroad station has been rebuilt."[104] This stability under Japanese occupation meant that Henke and other missionary staff were able to travel more freely in Hebei Province, allowing for the Presbyterian hospital staff in Shunde to "increase . . . to over 50 again," as Henke noted, and for itinerant medical personnel to fill temporary positions while they were away from their home institutions.[105] Harold

and Jessie Mae obtained special Japanese military identification documents, enabling them to get through checkpoints within and beyond Beijing. On several occasions, they used these passes to visit commercial districts where they watched at least three "very good movies."[106] In a case of life imitating art, one of these films was MGM's 1937 production of Pearl Buck's *The Good Earth*, which was partially shot on location in China prior to the war's outbreak and in which the leading roles were played by Caucasian actors in yellowface.[107]

However, despite the outward "return to normalcy," Harold Henke revealed that some "200 to 700 refugees" still lived within the relative safety of the Presbyterian mission at Shunde, while the hospital treated rounds of "40 to 60 patients, about nine tenths of these [having] gun, bomb, or knife wounds, for banditry is rife in all our country districts."[108] In regard to "banditry," Ralph Lewis, who returned with his family to Shunde after a 1938 furlough in California, explained:

> There was a great deal of terrorist activity in North China at that time with marauding bands of the old [warlord] troops that were neither loyal to the [Nationalist] Central Government nor to the Japanese or Communist troops. They were trying to make their own living by preying on the local population, making night raids on small villages near us [in Shunde] to get grain, livestock, and capturing young men, forcing them to join their forces. We often heard the wailing of women not far from us as their men were being dragged from their homes . . . During those raids we would occasionally hear bullets ricocheting through the trees.[109]

Under these chaotic circumstances, interactions between the American missionaries and the Japanese authorities became more frequent. The occupation forces, ironically, were the closest providers of regional military stability, as well as the primary arbiters of missionaries' access to supplies, transportation, and communications networks (though access to all three was often hindered by military operations or Chinese Communist guerilla warfare in the northwest).[110] As the occupation of North China moved into its second (1939) and then third (1940) years with no major changes in sight, partnerships between the missionaries and the Japanese became commonplace. Although the missionaries were in enemy-held territory and aligned with a (now more nebulous) conception of Chinese national identity, their relationships with the Japanese grew still more ambiguous, while their medical work and evangelism increasingly resembled prewar

activities.[111] Lewis expressed sympathy toward the Japanese who were now the primary local security force, writing, "We often saw Japanese troops leaving the city, marching out west to the mountains where the Communists were entrenched, trying to flush them out. Often these soldiers were crying as they marched by our [mission], leaving the fortified city, knowing that many of them would never return."[112] Henke, on one of his trips returning to Shunde from Beijing, traveled with a Japanese Protestant minister ("a returned student from Columbia University") and a Japanese soldier. According to Henke, "[The soldier] was our escort over the last 80 miles. He was most thoughtful . . . and we enjoyed several afternoons together studying English and Japanese before he went to Taiyuan."[113] Taiyuan was located in one of the rugged northwestern provinces where Communist forces were most active; it is possible that the "thoughtful and courteous" soldier later joined the IJA troops whom Lewis witnessed marching off in tears to attack Chinese Communist strongholds.[114]

Yet the missionaries also witnessed retaliation against Chinese individuals suspected of aiding anti-Japanese guerillas in the region. Communist troops (purportedly attached to the locally supported Eighth Route Army) carried out an unsuccessful raid on the Shunde railway station after crossing the border from nearby Shanxi Province. Following the raid, Ralph Lewis wrote, "the Japanese Army came to the [mission] hospital and told me that we had spies in our staff . . . they took three or four men away, one being our business manager, the chief accountant, and one or two laborers."[115] When visiting the men in prison, Lewis found the mission accountant "being held in a wooden cage, like an animal . . . covered with body lice [and] . . . very concerned about his wife and children," and he overheard terrible screaming from another part of the facility. "Several days later[,] the person who had been screaming . . . was brought to our hospital by his family. He had been falsely accused and the Japanese had beat him to get a confession . . . [using] a bamboo pole that had been sliced down to fine, tiny slivers . . . [which] caused the skin to be cut [into] just raw flesh with no skin left." Though he was able to save the man with extensive surgery and skin grafting, the incident disturbed Lewis greatly, not least in a spiritual dimension. "I will never forget . . . that terrible beating," he wrote in his memoirs, "and when at our Communion Service, I think of Jesus suffering for me when He was beaten by Pilate's soldiers." Lewis later learned that the mission's business manager "had made contact with the Communist Army and had given them signals from [the] hospital" the night before the attack on the railway station. When this man did not return from prison (he was likely executed

by the Japanese), Lewis concluded that he "was a loyal Chinese citizen doing what he thought best for his country."[116]

In a less overtly violent case, one of the evangelists at Shunde, the Rev. Richard Jenness, witnessed troubling machinations "behind closed doors" when attending a regional meeting of religious leaders organized by Japanese military authorities in late June 1938. This assembly included representatives from local Confucian, Buddhist, Daoist, Catholic, Protestant, and Muslim groups. Noting that the atmosphere was one of "no freedom, only a strained look of anxious expectancy," Jenness reported that the purpose of the meeting, as announced by a coalition of Chinese elites and Japanese "handlers" ("the district magistrate of the local puppet government," "a young Chinese gentleman, head of the local bureau of education," and "a young Japanese army officer, the advisor to the magistrate . . . and other military men"), was to encourage the religious communities "to join together in helping forward the plans for a 'New China.'" It was clear to the American evangelist that the religious leaders "were there to be formed into a tool for organized Japanese propaganda," and he refused to bow to the Japanese flag when the group was requested to do so at the opening ceremonies. His act of defiance was shared only by a Polish Catholic missionary and a Chinese Catholic schoolteacher (perhaps because these individuals, unlike most others present, had direct contacts with Western religious institutions). By refusing to express support for the Japanese occupiers, the Catholic missionary and the schoolteacher earned the Presbyterian Jenness's undisguised respect.[117]

The North China missionaries continued their photography when possible, with fragments of complicated interactions appearing in their images. For example, the Henkes' scrapbook album, assembled in the postwar era, contains two pages of photographs (taken by the Henkes and the Lewises in 1938–1939) directly facing each other. One of the pages, which follows a series of medical photographs, is covered with photographs of people engaged in what appear to be routine Protestant community building. These include groups of smiling Chinese evangelists, elders, and pastors; doctors and two classes of nursing staff (one of which included nurse trainee Liu Ju); and Christmas celebrations for the church congregation (including several successive images highlighting the Henkes' and Lewises' less-pictured musical talents—Harold playing the violin; Ralph, the trombone; Roberta, the cello; and Jessie Mae, the harmonium while singing). Were it not for the "Christmas 1939" annotation and the following images, it would be difficult to determine whether these innocuous photographs were made in peacetime or wartime.

On the facing page, however, further images from the Christmas service indicate that the mission is packed with a large group of refugees. A photograph taken from the top of the outer compound wall includes throngs of people (far more than a prewar service) packed into the courtyard, listening to a sermon given on the same platform where the missionaries performed their Christmas music. This and other images from the service reveal signs of the war's effects on the civilian population. Below them a number of other prints are pasted in, including a small print of Japanese army officers standing together with greatcoats and sheathed swords, photographed when they visited the mission compound. The occupiers, the occupied, and the missionaries are all visualized in the same space. At the bottom of the page, two enlarged prints feature Harold Henke and Ralph Lewis flanking a Japanese officer on the steps of the hospital; Henke's now two-and-a-half-year-old daughter, Lois, may have insisted on standing with her father for the photograph. These images were clearly made in quick succession, with two different officers between the Americans. Harold and Ralph's gazes and facial expressions (bearing ambiguous smiles) shift slightly between exposures, but their postures remain roughly the same while the officers join the group. These were among the few enlarged photographs from this time, a rarity compared to the much smaller contact prints typically produced by the missionaries. This may indicate that they were made by a photographer accompanying the officers or by Ralph Lewis, the only individual in the compound with a photographic enlarger (a homemade device that he built before the war). Perhaps Lewis produced enlargements as gifts to the visitors, keeping lesser-quality reprints for himself and Henke.[118] Next to these prints, a group photograph shows two Japanese officers (one of whom also appears in the previous images with Harold and Ralph) surrounded by individuals Jessie Mae captioned as "Catholic friends": a foreign nun in her hooded habit and two dark-robed missionary priests (likely Polish Catholics), along with a Chinese medical staff person. This was one of the few images depicting Catholic missionaries in Shunde that the Henkes kept, indicating that the war, and perhaps facilitation by the Japanese, forged greater ecumenism between Christian missions normally separated in peacetime by denomination and nationality, even within the same mid-sized Chinese city.

Finally, the bottom right corner of the page contains a portrait of a young, clean-shaven Japanese enlisted man. This image was not made by

the Henkes or the Lewises, but was instead a commercial photograph made in Japan prior to the infantryman's arrival in China, with a studio's stamp: "TSUDANUMA."[119] More likely than not, the pictured soldier gave this photograph to the Henkes, indicating that some kind of relationship existed—or at least a brief but friendly exchange occurred—between him and the missionaries during occupation. Jessie Mae Henke and her sons recalled off-duty Japanese cavalrymen stopping their mounts at the Presbyterian mission to play an informal game of baseball with the boys (who were equipped with baseball uniforms and equipment gifted by supporters in the United States).[120] On several occasions, Japanese Christian officers and enlisted men attended the Christmas and Easter services at the mission, sitting next to perturbed Chinese congregants who were typically on the receiving end of their military presence outside the church walls.[121] Perhaps one of these soldiers presented his portrait to the Henkes on such a visit, and the Henkes duly kept it in their postwar scrapbook as a keepsake of a lost friendship, even after the later events of the Pacific War formally categorized the Japanese as the Americans' national enemy.

Moreover, the war and occupation shaped missionary imaging in a material way. Still photography, which could be done with less specialized

Figure 4.4. Page from Henke scrapbook album with group photographs of Harold Henke, Lois Henke, Ralph C. Lewis, and Japanese officers (*bottom left*), and Japanese infantryman's commercial portrait (*bottom right*), 1939, HFC.

film stock and easily processed in a residential darkroom (as opposed to a commercial facility elsewhere) was preferred given wartime shortages and the difficulties of regional shipping. The Henkes practically stopped their filmmaking with the Cine-Kodak, save for brief snippets of footage shot in 1939 and depicting only medical cases.[122] Military censorship was also an ever-present challenge not always visible to intended audiences, especially as missionaries in occupied North China attempted not to draw unwanted attention to themselves or their Chinese colleagues (lest either group be accused of anti-Japanese activities, with potentially tragic consequences). Unlike John Magee and Gerald Winfield, who benefited from a significant community of foreign supporters as well as relatively fluid access to church networks and like-minded governmental parties, missionaries remaining in smaller towns or rural regions under "deeper" occupation were at the mercy of Japanese censors' strong control over mail traffic.[123]

As a result, self-censorship was quite common. The Shunde hospital report for 1939, for example, made no direct mention of the war, stating only, "The 'incident' in the fall of 1937 . . . and the press of medical work and the shortage of staff have prevented the completion of the work [of preparing a report] until now."[124] The only reference to war events—beyond the absurdly understated reference to the Japanese invasion as a mere "incident"—was a patient testimony accompanied by a photographic portrait by Ralph Lewis, describing a local mayor and new Christian convert who was brutalized by Chinese troops when they recaptured his village from the Japanese "for a short time only."[125] It is unclear how much of a hand the occupation authorities had in such textual choices (or the extent to which such documentation captured the slipperiness of occupation experiences), but to sharp-eyed readers elsewhere, these phrases likely sounded incongruous, though they may not have known why. Recipients of photographic prints, however, would have seen the censor's imprint, as in the case of prints made and sent from Jining, Shandong by Dr. Frederick G. Scovel and Myra Scovel (the Presbyterian medical missionaries who also enjoyed popular dance records). At some point between Shandong and the United States, the envelopes bearing their photographs were opened and the images—even mundane ones depicting the family on vacation at Mount Tai or standing in front of their mission residence in Jining—stamped with the symbol of a Japanese military censor, approving them for release.[126]

The Scovels, like the Henkes and Lewises, had continued their medical mission work under the Japanese occupation. Unlike the other two

missionary families, however, they were direct victims of violence. No more than a year before the censor approved the photographs above, Frederick Scovel was shot by an intoxicated Japanese infantryman in the courtyard of the Bachman Hunter Hospital compound in Jining.[127] The soldier had entered the compound in search of women to rape, and resisted attempts by members of the Chinese nursing staff to block him. As Scovel stepped in front of the soldier, he shot the doctor in the lower back, fired again as he fell (missing the second time), and would have killed him had the gun not jammed on the third attempt.[128] Scovel's life was saved not only because of a malfunctioning firearm but also because of close contacts between the Presbyterians and the local German Catholic mission. A family friend, a Catholic lay brother surnamed Linoldhus (with whom the Scovels conversed exclusively in Mandarin, their only shared language), raced through Japanese lines on his bicycle before the authorities shut down the roads, carrying a message to the US consul in Qingdao requesting medical assistance.[129] Although the attempted murder was serious enough to be reported, if only briefly, in the *North China Herald*, and the Scovels produced a deposition for use by the US consulate, tight Japanese control over the Shandong area and Scovel's rapid recovery meant that the news was not picked up by broader media channels. Instead, high-ranking Japanese military officers and medical personnel visited the Presbyterian compound to make amends and the soldier was quietly executed afterward, against Scovel's explicit wishes.[130]

Frederick Scovel owned an early-model Leica rangefinder, purchased for its excellent portability and medical microphotography capabilities (its screw-mount for interchangeable lenses and small size made it well suited for attachment to a hospital microscope already on hand). Myra Scovel used a folding Kodak camera for her snapshots.[131] Although no existing visual materials directly depict events associated with the shooting or Scovel's prewar and wartime microphotography, this likely indicates that vernacular photography served as a form of pleasure—carried over, of course, from the prewar period—and that Scovel chose to photograph people and things that were not direct parts of the war violence and daily stresses. It is unclear whether or not the 1938 shooting played a role in this, but it is likely that the trauma was not far from the family's minds in the years afterward.[132] Their photographs from the period depict domestic scenes divorced from the war. At some point, Scovel obtained at least one roll of Kodachrome color positive film, a cutting-edge medium made commercially available only in 1935 and

not yet widely used in most parts of the world (let alone war-torn China). With it he produced 35 mm color slides in Jining and during a family trip to Qingdao in the summer of 1940.[133] Given the need for very precise exposure measurement, along with the color film's slow speed (insensitivity to light), high cost, and limited supply, the number of images was small, and therefore precious. Even in this limited set of color images, however, it is possible to see what Scovel felt was most important to visualize in his private wartime experience: immediate family members and Chinese medical colleagues— all people who stood by him when he was shot.[134]

With the formal outbreak of war between the United States and Japan, missionary imaging in North China underwent a precipitous decline. Ralph Lewis and the Scovel family were asleep in their mission houses when the bombs fell on Pearl Harbor several time zones away on December 7, 1941. Despite being in different parts of North China, their experiences rapidly began to converge. On the morning of December 8, they were promptly placed under military house arrest as civilian noncombatants. Making his usual morning rounds in the hospital, Lewis was alerted by a Korean interpreter working with the IJA that troops were waiting outside the clinic. He walked out to see "a group of Japanese soldiers standing there in formation, with their arms and two heavy machine guns . . . [a] tall, good-looking Japanese officer shouted something" at Lewis and the interpreter told him "that war had broken out between the United States and Japan" and that he "would be held as a civilian prisoner until such a time when they could send [him] back home."[135] The Scovels, preparing for breakfast, were abruptly greeted by a somewhat more sympathetic Japanese officer, whose troops were now guarding the mission gate. Mixing official regimen with a personal touch, he offered to hold and comfort the Scovels' crying ten-week-old daughter, Judy, while he read the arrest document aloud to the stunned family.[136] The mission churches and hospitals (now considered enemy property) were to be confiscated by the occupation authorities and turned over to a "newly formed Church of Christ in China" under Japanese supervision.[137] Shortly thereafter, with guards posted inside and around their residences, the missionaries settled into a tense waiting period. With their movements limited to the houses in which they were confined, what visual practices they could engage in reflected a forced domesticity.[138] Using up the last of the Kodachrome on the roll in his Leica, Frederick Scovel made a few images that reflected the experience of being shut in. Those that still exist are rather mundane, showing a corner of the courtyard next to the mission residence and a distant view of a factory smokestack visible from

just over the wall.[139] These limited views reflect the isolation felt by the people behind the lens; after all, they were the only images Scovel could make in his family's strained confinement in Jining. Lewis, however, stopped making photographs completely. It would be over a year before the missionaries left their stations, but even then, the war had small but lasting effects on their images' existences.

When the time came in late 1942 and early 1943 for missionaries across eastern China to be moved into Japanese-organized internment camps to await repatriation to Europe or the United States (though the specific circumstances of this internment were not yet clear to them at the time), visual materials were among the first personal items that they thought of. As they prepared to leave their mission stations for a nebulous fate, the materiality of their photographs and film—and these materials' underlying connections to missionaries' private lives—became a central part of the transition experience. Lewis, on being informed "on a sunny day in late November [1942]" by Japanese officers that the missionaries "could each take two suitcases of [their] best belongings which [they] cherished very much," immediately "planned to take [his] two photo albums and other photographs" alongside "two of [his] best Bibles that [he] had been using in studying with John Bickford." Lewis described the day he had to leave Shunde:

> Our things had to undergo inspection. We were told to bring out our suitcases, opening them for examination so they could see what things we were taking. They started with the other two [missionaries, John Bickford and Lillian Jenness] first . . . going through everything very thoroughly. I do not recall anything being taken from the others, but when they came to my belongings and found my photo albums[,] they had a great time. They went through them page by page, stripping out pictures of my family and making remarks . . . about them all and tearing them into bits before my eyes, laughing loudly. There was nothing I could say, as they were in charge of our well-being. So I was left with NO pictures . . . I tried to show no anger and prayed that the Lord would give me grace under this situation. . . . Now, knowing more about the true war situation, I believe [the Japanese officers] were showing their anger because of recent reverses the Japanese army and navy were experiencing.[140]

In Lewis's eyes, the destruction of his photographs by the Japanese officers was an invasive attack on his family and private life. In this moment, not

only did photographs represent their missionary makers' experience but their materiality also carried emotional ties to the image contents as well as Lewis's imaging labor—both of which were intruded on (and destroyed) by the authorities.

Perhaps to prevent a similar fate from befalling their personal belongings and visual materials, when the Scovels were notified in spring 1943 of their imminent transfer to an internment camp, they became "squirrels" and "hid things." As Myra recounted,

> We took all of Beloved Grandmother's [Louise Kiehle Scovel] old family mahogany and stowed it behind a chimney in the attic. Then we built a false wall across the room and plastered it over to look as if there were nothing behind it. We took our precious music records and slid them down on ropes between two walls. We scrambled up to hidden recesses under the eaves and concealed our best-loved pictures. Fred filled an old camphor box with our wedding silver . . . and buried it in a deep hole under the porch, along with his stamp collection, Father [Carl W.] Scovel's pulpit Bible, and the children's baby books.[141]

Myra continued, "A Japanese officer and five soldiers arrived to search the house . . . the officer was either extremely stupid or extremely kind; I incline toward the latter view, for he found nothing." After the war was over and the Scovels returned to Jining in 1947, they knocked down the false wall, pulled up the ropes, and retrieved most of their belongings.[142] Not everything was recovered immediately, however. Their 16 mm home movies (concealed with the phonograph records between the walls), most of which were shot before they arrived in China in 1930, were gone, but not lost.[143] The ropes holding the family films snapped sometime between their concealment in 1943 and the Scovels' postwar return, and the reels fell into an inaccessible space between the walls of the house. There they sat in darkness, protected from the elements by their airtight metal canisters. In the early 2000s, workers demolishing the house broke through the walls and found the reels; the director of the Jining City Museum was called and discovered that the films were miraculously still intact. The footage was subsequently digitized and screened in a surprise presentation for the two eldest Scovel sons, Carl and Jim, when they revisited their childhood home in late April 2016.[144] As far as the Scovels knew in 1947, however, the fate of their films had been sealed.

Lewis and the Scovels were destined to meet again at the Weihsien Civilian Assembly Center in Shandong, a prison camp for foreign noncombatants that was, ironically, housed in the former American Presbyterian mission compound where *Life*'s Henry Luce had spent his childhood.[145] There, Ralph Lewis and Frederick Scovel lent their skills to the community medical service, became acquainted with the eclectic group of foreigners with whom they were interned (Lewis crossing paths with a certain young Scottish missionary and former Olympian, Eric Liddell), and settling into a harsh but strangely colorful confinement.[146] Myra Scovel, who documented the internment in her own words some two decades later, shared the same experiences with a greater challenge. She was several months pregnant when she and her family were interned, and formed a community with other expectant and nursing mothers. They met daily to drink crushed eggshells dissolved in thin bone broth, attempting to provide sufficient nutrients for their unborn children.[147] But even as the missionaries began their largely unphotographed internment without access to cameras or film, a visual remnant of their prior experience was already traversing the wartime world.

Sometime between their house arrest in December 1941 and Weihsien internment in spring 1943, Frederick and Myra Scovel made a brief 8 mm Kodachrome color movie in their mission residence. Like the Kodachrome slides and the couple's writings on their confinement, the four-minute, fifteen-second footage, shot almost entirely in the courtyard and interior of their house, reinforces the sense of isolation. Though the background scenery changed little, the Scovels tried to fit as many of their family, friends, and missionary colleagues into the film as they could before the reel ran out, passing the camera from one person to another as needed. Brother Linoldhus, the man who saved Frederick Scovel's life, makes a brief appearance, as do Chinese associates, caretakers, and their own families. As the Scovel family walks back into the mission house together, the film fogs and cuts abruptly, an appropriate visual metaphor for the end of their time in Jining.

The undeveloped footage then made a remarkable journey across China, the details of which must be guessed at. The only location in the world at the time that could develop Kodachrome color film was the Eastman Kodak company plant in Rochester, New York, and so the film needed to be sent there.[148] With the war preventing the film's direct shipment eastward across the Pacific, it was likely mailed into the interior, passing through Japanese-occupied territory via the wartime Chinese postal service and heading south

past Shunde, where Ralph Lewis was also under house arrest. After its arrival in Free China, where Gerald Winfield was based, the film was loaded with other mail into air transports flying over the Himalayas to India, making its way from there by sea to the United States. Having circumnavigated the war-torn world, the film somehow arrived safely at Rochester and was duly processed, going through "twenty-eight stages [lasting] three and a half hours, and . . . three separate processing machines."[149] And there it sat for lack of a return address.

In late December 1943, Frederick Scovel, released from Weihsien with Myra and their children, also arrived at Eastman Kodak in Rochester, taking up a position as the company physician. In their repatriation journey, the family had followed a path around the world similar to that of the film.[150] Not long afterward, in early 1944, a Kodak employee made the connection between the doctor and the orphaned film. "Are you Scovel?" one son later recalled the employee saying, "we've got a package here with your name on it." The footage shot in China was reunited with its makers.[151] In another apt parallel, Myra Scovel noted that en route back to the United States via Portuguese India, "in the first batch of mail to reach [the Scovels] in Goa, a friend had sent a [biblical] verse that had become a prayer: 'Behold I send an angel before thee to keep thee in the way, and to bring thee to the place which I have prepared.'"[152] Of course, she was thinking of her family's wartime experiences, but the verse could have applied equally well to the film. The passage was from the Book of Exodus.

Missionary Imaging beyond the War

In navigating the chaos of the Second Sino-Japanese War, American missionary experience and visual practices were profoundly shaped by new identities and encounters. Although violence, political realignments, and wartime contingencies disrupted missionary activities on national and global scales, the abilities, interests, and technical capabilities of missionaries to visualize China and their experiences continued on a microlevel. For some, this meant taking advantage of their photographic and filmic abilities for wartime humanitarian or political aims. For others, this meant withdrawing from or limiting visual practices as the pressures of the war grew too great. These shifts in individual experience also paralleled broader changes in the way that world audiences perceived (and literally pictured) wartime China and

US involvement there. Even as missionary visual practices were curtailed, American perceptions of China and public sentiments were broadened and reshaped by the war; the audiences, therefore, were no longer the same as those before the conflict began. As images of wartime China moved through US mass media channels imbued with new ideas about Sino-US national alliances and cultural encounters, the meanings of missionary images and missionaries as Americans in China were colored by these interconnections. No longer were American missionaries primarily defined by their religious institutions and modern Christian activities abroad as they had been before the war. Nor were they considered insular emblems of extraterritoriality, aligned with Western imperial intervention in a backward China, as missionaries had been during the Boxer Uprising nearly half a century before. More strongly than ever, the US public saw missionaries as modern mediating figures, defined by dual identities as both citizens of the United States and "friends of [a modern] China" in wartime.[153] Moreover, their presence in China was more strongly colored by Chinese nationalist ideologies in the wake of the 1937 Japanese invasion and, after December 1941, their collective experience as the largest body of American noncombatants on the receiving end of Japanese military aggression in East Asia. Their images, therefore, reflected both documentary and mediational impulses, creating bridges not only between missions and US religious bodies but also, more broadly, between wartime China and the United States.

Missionaries' identities would continue to play a crucial role in the postwar era, as the American missionary return to China reestablished institutional and communal ties broken during the war. At the same time, the missionary experience and imaging during the Second Sino-Japanese War prefigured greater historical changes to come—changes with even more drastic effects on missionary activities in China and Chinese Christianity as a whole. The wide attention paid to China as a modern nation confronted by Japanese imperialism and the country's complicated roles in global conflict would carry over into the postwar world order. As the guns fell silent across the Pacific, missionary cameras, photographs, and films would continue to play roles in shaping and documenting experience, framing communities, and tracing transnational networks. The belligerents, alliances, and meanings of modern mission in China, however, would change dramatically. The postwar world would focus on a nation confronted by crippling internal strife and the resurgence of Chinese Communism, now well within the shadow of the global Cold War. Within four years after the 1945 conclusion

of the Pacific War, American missionaries would experience a striking sense of déjà vu, with their lives shaped again by violence, national chaos, and individual and institutional contingencies. This time civil conflict resulted in the ultimate expulsion of all foreign missionaries from China. Then and afterward, missionary visual practices would be characterized by nostalgic longings reinforced by images of an unrecoverable past, a present that was fading away, and a future that could not be. These visions would outlast the missionary enterprise itself.

Chapter 5

Memento Mori

Loss, Nostalgia, and the Future in Postwar Missionary Visuality

On December 22, 1949, Fr. William Klement, SJ, a Catholic priest affiliated with the California Jesuit Province, composed a letter mid-Pacific aboard a ship steaming eastward to Asia.[1] The letter was intended for his colleague, Fr. Bernard Hubbard, SJ, a Santa Clara University lecturer nicknamed the "Glacier Priest" for his numerous Alaskan expeditions in the 1930s.[2] Klement began his letter with disappointment, noting, "It's the darnest thing the way I had to miss you all around."[3] Hubbard had returned to California after a lecture series on the East Coast and in the Midwest in November 1949, arriving around the same time Klement boarded the vessel for the trip across the Pacific. Klement, however, was not merely thinking of a missed meeting. There were other, greater losses at play. As he sat at the typewriter, he was at the end of over a decade of life in China, half of which had been spent as a rural mission pastor (*vicar forane*) in Yangzhou, Jiangsu Province. But this time, his ship was headed not to China but to the Philippines, where Klement was to join the administration of Maison Chabanel, a major Jesuit language school that had just relocated to Manila from its original location in Beijing.[4] It was a chaotic conclusion to the foreign missionary enterprise in which Klement—and many other American missionaries like him—were now caught up.

Three months before, on October 1, 1949, Mao Zedong stood before a battery of microphones in front of a jostling crowd in Tiananmen Square. Speaking in his distinctive Hunanese dialect, he stridently proclaimed the official founding of the People's Republic of China (PRC).[5] While politicians and pundits in Washington, D.C., continued pointing fingers over the loss of China and Shanghai's citizens crowded into city streets to watch the new Public Security Bureau conduct executions of "counterrevolutionaries," foreign missionaries and Chinese Christians were caught between nations, conflicts, and their multiple identities.[6] Many, both Protestant and Catholic, had perceived the writing on the wall and permanently left the mainland during the previous year. Others remained by choice or by necessity, unsure of the immediate future, but holding out hope that their activities in China could continue under the new regime.[7] Klement was among the American Catholic missionaries who left ahead of the PRC's founding, departing Shanghai on December 1, 1948—nearly a month to the day after the California Jesuits' Father Superior, Paul O'Brien, notified the provincial headquarters in Los Gatos that "the Nationalist Government [was] about to fall."[8] These recent events were undoubtedly on Klement's mind as he wrote to Hubbard in late 1949.

But the immediate subject at hand was something else entirely; the priests were in fact corresponding about filmmaking. Attached to Klement's letter was a lengthy twenty-one-page screenplay containing commentary to accompany several thousand feet of 16 mm color film footage that Klement and Hubbard had shot together in China before 1948. At the same time, there was something different about this discussion of visual practices. Times had changed, along with the people and visions in them.[9]

Klement and Hubbard's films were among the final kinds of visual material produced by American missionaries before the PRC's establishment in 1949. Many of these images were shaped in production and reception by degrees of collective hope, loss, and nostalgia. In some senses, the images recapitulated missionary experiences during the Second Sino-Japanese War, political and personal. The missionaries who had lived through the wartime period had developed stronger ties with an embattled China and Chinese nationalism, as well as parallel nationalistic connections to the United States as it was involved in the Pacific War after Pearl Harbor. In the postwar era—as the Chinese Civil War reignited and the global Cold War loomed large—these political imaginations were more strongly colored by US domestic fears of Chinese Communist expansion, with its escalating

antagonism toward foreign religious institutions and their perceived links to American "imperialists" meddling in Chinese affairs.[10] At the same time, the meanings behind postwar missionary images cannot be reduced to one-dimensional products of political or national ideologies. On personal levels, the war had profoundly changed the ways that missionaries viewed their identities and presence in China. Many had experienced losses of their own, measured in both human and material terms, and also witnessed among their own communities and colleagues the wartime destruction and loss of life that devastated the Chinese population. The end of the war in 1945 thus brought relief and renewed opportunities, but not without underlying uncertainties and anxieties. The experiential and spiritual in-betweenness of missionaries and Chinese Christians framed these postwar images just as much as it had their complicated prewar identities. Yet the historical changes experienced by missionaries in postwar China were in many ways more collectively traumatic than those previous years, not least because of the rapid shifts in national identity and threats to foreign missionary activity that took place from 1945 to 1949. The optimism and possibilities of renewed missions in the immediate postwar moment were replaced in less than four years by feelings of impending loss, as the Chinese Civil War reshaped the national landscape in ways that stymied further missionary activity.[11] These feelings were especially salient as the massive regime changes of the late 1940s, with the relatively pro-Christian Nationalist government (embodied most prominently in US public consciousness by Methodists Soong Mei-ling and Chiang Kai-shek) retreated to the island of Taiwan in the face of accelerating Communist military victories on the mainland.[12] As long-term mission enterprises collapsed in 1949–1951 and broader Cold War developments in East Asia—particularly the Korean War—expedited the final expulsion of all missionaries still residing in the PRC, the future of Christianity in China and foreign missionary involvement looked progressively bleaker.[13]

Under these circumstances, as mission institutions and personnel were gradually cut off from the Chinese communities and environments with which they were once associated, photographic images of Christian activity and missionary life in the pre-PRC era provided visions of a more stable past as well as indexical icons of hope and religious futurity. The missionaries' mixed feelings, centered on vision, were well represented in 1951 by a Presbyterian educator at Hangchow Christian College in Zhejiang Province, who wrote of straining "to get a last look at [the college campus]" as the

train carrying him and his American colleagues steamed out of Hangzhou "and the College became lost to view."[14] Physical sight was replaced by nostalgia, framed in spiritual terms, as the missionary continued:

> And now we were leaving, not through any wish of our own but in order that our continued presence might not become a source of embarrassment or even danger to our Chinese colleagues. We were leaving with no sense of utter frustration, as though all we had been helping to build would come crashing in ruins to the ground, but with a deep, ineradicable belief that what was permanent in our building was of God and would remain. It was something spiritual and what is spiritual is indescribable, is inheritable, because it is of the essence of eternity. As the Scripture says: "Be ye steadfast, unmovable, always abounding in the work of the Lord, forasmuch as ye know that your labor is not in vain in the Lord."[15]

Visual materials strongly represented and reinforced the desire to grasp remnants of an idealized Christian past in the crumbling present and to hope for an alternative future "of the essence of eternity." As initial hopes turned to angst-laden uncertainties and institutional losses led to nostalgic longing, photographic images became symbolic windows—"*memento mori,*" in Susan Sontag's words—through which missionaries and Chinese Christians looked back at experiences and communities that no longer existed (and forward to an uncertain future).[16] Sontag's elaboration of the term, composed less than two decades later, fits well with this moment in missionary visual practices: "It is a nostalgic time right now, and photographs actively promote nostalgia. Photography is an elegiac art, a twilight art . . . a beautiful subject can be the object of rueful feelings, because it has aged or decayed or no longer exists. All photographs are *memento mori*. To take a photograph is to participate in another person's (or thing's) mortality, vulnerability, mutability. Precisely by slicing out this moment and freezing it, all photographs testify to time's relentless melt."[17] In a similar way, Roland Barthes described images' relationships to change: "The photograph possesses an evidential force, and . . . its testimony bears not on the object but on time."[18] Though referring explicitly to photographs, this perspective may be also applied to vernacular filmmaking. Missionaries and Chinese Christians, confronted with historical collapses taking place around them (often before their eyes and sometimes their cameras) witnessed "time's relentless melt."

Time, vision, and imagination—among the many elements that had undergirded missionary experiences and visual practices for decades before the

end of the mission enterprise—now coalesced in the images that remained once their makers were no longer in China or able to return to it (prefiguring Barthes's lament that "what I see has been there . . . and yet immediately separated.")[19] With these intersecting contexts in mind, this chapter traces the final forms of missionary visual practices in late Republican China and the tumultuous early years of the PRC. These practices produced images that were deeply shaped by hope, loss, and nostalgia. To understand the full trajectory of the missionary enterprise's decline in China, however, we must start by looking at the beginning of the end.

Revisualizing Post-1945 Republican China

Almost as soon as the Second Sino-Japanese War ended, American missionaries flooded back to China to resume their activities across the country. Those who had relocated to the wartime interior now migrated again, following paths of beleaguered refugees and Nationalist government elements returning to areas formerly occupied by the Japanese military. Some of these places were still occupied by demobilized IJA personnel awaiting repatriation, a fact that inflamed contemporary criticisms of Nationalist mismanagement (or perceived leniency) in regard to China's recent enemies.[20] In the United States, missionaries who had been repatriated from internment camps across East Asia during the Pacific War or who were fortunate enough to have left China before December 1941 now booked passage on contracted US Navy transports plying peacetime waters. In many cases, men and single women affiliated with Protestant missions went ahead of time to secure mission properties and reestablish contact with Chinese colleagues, with married individuals sending afterward for spouses and families.

The missionary reoccupation proceeded quietly at first, but quickly grew into a larger, more publicly visible diasporic return. In the fall and winter of 1946, for example, over 1,300 Protestant missionaries departed San Francisco on two separate voyages aboard the SS *Marine Lynx*, a chartered cargo ship that had that summer returned Jewish refugees to Europe from Shanghai (to which many had escaped from Nazi-occupied territories). The *Marine Lynx* would later ferry United Nations troops during the Korean War.[21] The September 29, 1946, departure of four hundred missionaries on the *Marine Lynx* was preceded by a standing-room-only celebration at the San Francisco Opera House, attended by family members and friends, more than three thousand representatives of 123 Protestant churches, and public figures

including none other than Henry Luce (who, in the spirit of his mission-ary upbringing, gave a lay sermon titled "Faith, Hope, and Love, but the greatest of these is Love.")[22] Luce was followed on the stage by Chinese historian and sinologist William Hung, secretary of the Harvard-Yenching Institute and a prime mover in Yenching University's prewar development. Speaking before the assembled audience, Hung, himself a wartime refugee and a celebrated orator, framed China's postwar future in both politically dark and liberal Christian terms: "When I say welcome I mean not only these [missionaries] who are here but to the thousands to augment the few who are already there [in China]. China has great need of these men and women. A civil war is raging and as bad as that may be, it may develop into another world war. Suspicion has already arisen. But I am one of those who still believe in the possibility of the elimination of civil and world wars by reconciliation, faith, and love of God."[23] It was with such hopeful sentiments that the returning missionaries, along with numbers of their Chinese and US supporters, perceived the immediate postwar moment. Among the groups of veteran returnees were also younger missionaries who had never been to China and had committed to vocations during the war. They were buoyed by even more spirited approaches to rebuilding missions and postwar Sino-US contacts, echoing the optimism once expressed by their interwar predeces-sors.[24] Although diplomats, military commanders, and scholars (like William Hung) perceived that China was entering a precarious period of national instability, missionary connections to the United States as an ally in aid and reconstruction were still regarded, at least by the US public, in optimistic and sometimes triumphalist terms.

The renewed US-China exchange extended to visual materials. Chih Tsang, a businessman turned economist at the New York–based Institute of Pacific Relations, calculated just before the war's end that "photographic goods [would be among] the most important imports from the United States" to China after the conflict.[25] Tsang estimated that the nation would see an annual import of $2,340,000 worth of such products, but also implied that such projections were dependent on the maintenance of political and economic stability:

> The limited purchasing power of the Chinese people postwar will not be conducive to large-scale imports of photographic supplies and motion pic-tures. The probable influx of tourists after the war, the growing popularity of American motion pictures in China and the increasing use of films as a means of propaganda and education will certainly create a greater demand

for such goods than existed during the war years. But until general living conditions improve, photography and motion pictures will remain a privilege for a limited few. Imports will at most, therefore, approximate the prewar level but, with the temporary elimination of Germany and Japan as important suppliers, United States manufacturers should certainly take a much larger share of this trade.[26]

Although Tsang was primarily thinking of secular travelers in the "influx of tourists" that might reactivate the Chinese photographic market (and did not foresee the postwar resurgence of major German and Japanese camera industries), missionaries certainly played a role in doing so.

Among the first small groups of American missionaries to return to China in late 1945, just over three-and-a-half months after the Japanese surrender ceremony in Tokyo Bay, was Harold Henke. Sailing on a Liberty ship built too late to take part in the war ("new and clean as a whistle"), he temporarily left behind Jessie Mae, their two now teenaged sons and young daughter, and a medical practice in Lockport, Illinois, that he had taken up during their time in the United States.[27] Traveling with him was the church-gifted Cine-Kodak movie camera, now on its fifth journey across the Pacific. Frederick Scovel and Ralph Lewis returned by a similar route, each carrying their own still cameras. Shortly after arriving in Shanghai, and with photographic supplies not yet fulfilling demand, Frederick wrote back to Myra Scovel in Rochester, New York, requesting that she bring rolls of black-and-white Kodak Plus-X film to resupply his Leica when she and their five children returned.[28] Supplementing his nearly two-decades-old Rolleiflex with newly-available photographic technology, Lewis purchased a rather ungainly Kodak 35 rangefinder when it became available in early 1946, experimenting with Kodachrome color film before leaving his family's wartime home in San Anselmo, California.[29] Unfortunately, unfamiliarity with the new camera's focusing system and the inability to see results until Kodak processed the slides (as opposed to faster development of black-and-white negatives at home or at a local photographic business) resulted in most of Lewis's early color slides, taken first in Southern California and then across Hebei, being significantly out of focus.[30] Jessie Mae Henke and Myra Scovel and their respective children followed Harold and Frederick in separate *Marine Lynx* voyages of late 1946, nearly a year to the date after their husbands left the United States. Roberta Lewis and her children sailed in August 1947.[31] Also on board the *Marine Lynx* with the Henkes and Scovels on its September 29 voyage were a large number of American Jesuit missionaries, including California

Province personnel destined for the Catholic mission in Yangzhou, the later site of Klement and Hubbard's filmmaking. One of them, a twenty-eight-year-old Chinese scholastic named George Bernard Wong—born in Macau and educated in Shanghai, California, and Washington state—headed to Maison Chabanel (the same language school Klement would administer after its exit from China) for advanced training before going to Yangzhou.[32] Wong would himself cross paths with the filmmakers not long afterward. In any case, the Catholic missionaries who boarded the *Marine Lynx*, traveling in close quarters with greater numbers of Protestants, imagined their sailing date a little differently than the latter. September 29 was also the Feast of St. Michael the Archangel, the leader of heavenly armies destined to vanquish the forces of hell in the Last Judgment.[33]

But 1947 was not 1927. Lewis's defocused slides were a good metaphor for the views that greeted the missionaries on their return. The Chinese landscape that they encountered was generally familiar, but also profoundly reshaped by the war and undergoing rapid change. As with the chartered US Navy transports that took the missionaries to China, US military presence was now highly visible in major cities like Shanghai and Beijing (then still officially named Beiping), where the US wartime alliance with the Nationalist government, along with postwar occupation forces, resulted in a large number of military personnel on the ground.[34] With the railways between Shanghai and North China cut and an air ticket insufficient to cover the two hundred pounds of luggage that he carried, Henke hitched a ride to Qinhuangdao on Navy LST (Landing Ship, Tank) 557, one of multiple US vessels ferrying Nationalist soldiers from the south to northern mobilization points in preparation for renewed anti-Communist campaigns. Along the way, he assisted the ship's overworked doctor in treating seasick Chinese infantrymen and at one point took part in detonating a floating mine with a borrowed rifle (his shots missed, but Henke nonetheless described the experience as a "thrill").[35] After arriving in Beijing via Qinhuangdao and Tianjin, Henke wrote from the large Presbyterian mission compound at No.14 Erh Tiao Hutung, "Everywhere here . . . one sees the evidence of 8 long years of war[;] autos, buses, streetcars, carts, houses, people, all show the effects of overwork, lack of replacement, lack of repair, strain. Windows unbroken still have strips of papers pasted there in all kinds of designs to absorb the force of explosions."[36]

Conditions in rural Hebei, to which Henke and Lewis intended to return, were far worse. Four Chinese staff members who traveled from Shunde to Beijing to greet Henke on his return. Henke summarized their report:

"[Though] the churches have held together finely[,] the hospitals have all been run to the ground . . . nothing has been replaced during these war years. All 3 [of] them [likely including the Grace Talcott and Hugh O'Neill Hospitals in Shunde] have lost varying amounts of equipment. Shunteh has lost the most, things having been taken in successive lots, the last one taking the sterilizers, beds and even the windows. It is now the center of one of the areas so much under discussion, the railroad has been destroyed north and south for a distance of 80 miles."[37] Hebei as an epicenter for renewed fighting clearly prefigured the greater damage of the developing Chinese Civil War. Although Henke did not mention (or perhaps know) the identity of the group that carted off the hospital equipment from his former mission, the countryside was indeed ravaged by guerilla warfare and scorched-earth practices in the final war years, followed by the destructive movements of Nationalist and Communist forces jockeying for position in areas left vacant by the retreating Japanese.[38] By early October 1946, Harold Henke reported, "There is a [Nationalist military campaign] on to drive the Communists into the mountains [in Hebei]." He lamented that most of the family belongings left behind in Shunde would "probably be lost now."[39] Nonetheless, Presbyterian evangelist Lillian Jenness (whose husband Richard had appeared near the end of the Henkes' prewar film "Church Tour" and had died from exhaustion in 1941) staunchly elected to stay in Shunde in spite of the developing conflict.[40] By mid-December 1946, she was under house arrest by the Communists who had taken control of the city, though she fared better than the Catholic mission in the city, where priests and nuns were quickly arrested and imprisoned in the aftermath.[41] In the end, the Henkes, Lewises, and Scovels were unable to resume work in their prewar locations. Less than two years after their return, Shunde and Jining were already caught in the civil war crossfire.[42]

Nonetheless, the missionaries and the Chinese individuals who survived the war took up collective attempts to rebuild their institutions and restart life, albeit in a far more complicated postwar world and for some, in radically different places. Liu Ju, the nurse who underwent training at Shunde from 1937 to 1941, took up a position at the Tianjin Central Hospital. By 1947, she had met her future husband, Li Qinghai, who was then working on surveying projects in North China.[43] The two of them were married and photographed in the Presbyterian compound in Beijing in 1948, with the Henkes hosting the wedding reception. Fr. Joseph Henkels, the SVD missionary who baptized the future archbishop Joseph Ti-Kang, now moved between Shanghai and Henan, coordinating medical-supply shipments distributed by

the United Nations Relief and Rehabilitation Administration (UNRRA) and the Chinese National Relief and Rehabilitation Administration (CNRRA).[44] He and his camera became minor actors in a political drama beyond China when, in early 1947, he was privately asked by a US Graves Registration Service officer to photograph a certain burial site, which Henkels described as belonging to "a Protestant minister from Georgia, who was with the 14th Air Force as a consultant and interpreter." In Henkels's words,

> [The minister] had been killed after the war was over when the group he was with was ambushed by the Reds near Hsu-chow. [The survivors] bought a Chinese coffin and got permission from the local authorities to bury him among the graves of the deceased monks in the temple grounds on a knoll outside the city. At the head of the grave they erected a stone monument with his name engraved on it. The colonel [David Barrett] told me that his parents had requested him to send them a snapshot of John's grave. . . . [H]e told me that his Graves Registration Unit had received orders from Washington forbidding them to take or send photos of graves to any relatives requesting them. He asked me to take a picture . . . and send it to John's parents since I . . . could ignore the order.[45]

During a railway layover in Xuzhou, Henkels climbed the hill to the temple and photographed the grave with his "[35 mm] mini camera." After returning to his Catholic mission base in Xinxiang, Henan, he "developed the film, made several prints, and sent the negatives and prints to the address of John's parents," which Barrett had given to him and which Henkels noted in his *agenda missionarii*.[46] The priest could not have known at the time, and was apparently unaware when writing his memoirs decades afterward, of the role he played in supplying images later used to bolster the anticommunist mythos of John Birch.[47]

Other American missionaries' postwar activities, though dramatic in their own ways, had less long-term political import. Frederick Scovel, unable to continue working in Jining because of the approaching Communist-Nationalist fighting, relocated alone to Huaiyuan in Anhui Province. There, he and the war-ravaged Hope Hospital were confronted in rapid succession by a drought, two major floods, a cholera epidemic, and a locust plague of biblical proportions that wiped out much of the area's food supply.[48] Contending with these issues, Scovel produced practically no photographs with his Leica after returning to Huaiyuan, perhaps because of a lack of film, personal fatigue, or both. His diary entries reported suffering from

unrelenting fever in Anhui's heat and humidity as well as deep feelings of isolation. After sending off his sixtieth letter to Myra in late September 1946, he scribbled at the top of one page: "295th day of separation."[49] Personal photography, as during the Second Sino-Japanese War, was the last thing on his mind.

In North China, Harold Henke fared somewhat better while restarting his work in urban Beijing, writing optimistically to US supporters, "[This return] has given me a chance to renew old friendships and make new contacts with the doctors and nurses in Peking. It has been most encouraging to find the Chinese doctors now in charge of the National Health Administration here, in charge of CNRRA, the Chinese counterpart of UNRRA, and in the hospitals to have the very same spirit of service and sacrifice that is the aim of Christian missions . . . the Chinese doctors and nurses that I have talked with this week have a splendid program ahead and already have some fine projects underway."[50] Religious activities at Henke's new position in Douw Hospital, affiliated with the American Presbyterian mission directly across the street from the hospital complex, resumed with similar kinds of optimism. In another postwar letter, Harold and Jessie Mae reported "a series of evangelistic services . . . held for [the] hospital staff and workers and a large number either gave their hearts to the Lord for the first time or rededicated them to His Service."[51] For patients at the hospital, the Henkes employed a new follow-up method that had been developed, but not fully implemented, by prewar collaborative work between evangelists like John Bickford and the Presbyterian medical staff at Shunde. This evangelistic strategy combined sociological and statistical tools (with strong echoes of medical surveys) in the epitome of a modern missionary approach to Protestant conversion. As the Henkes described, "[The hospital provides] each patient [with] . . . an evangelistic record sheet along with his clinical record, which gives data as to his attitude towards the Gospel, progress, et cetera. Upon discharge, the lower half of the sheet is filled out and mailed to the resident [Chinese] evangelist nearest his home in the hope that in this way many doors that are opened through our medical work may continue to stay open."[52]

The Chinese hospital staff, many of whom had attended religious meetings and were also responsible for implementing the new evangelistic methods alongside their medical duties, also formed entirely new audiences for the Henkes' film screenings. During at least one social gathering, the prewar films that the family shot from 1931 to 1935 in Shunde were projected for some of the Douw staff. "The movies we showed the doctors," Henke wrote,

"were of our medical work in Shuntehfu, which now seems so far removed from the relatively well hospitalized and staffed city of Peking." The films, originally produced for US church audiences, now served as a reminder of a prewar life "so far removed" in time and space from the Henkes' postwar activities. The Henkes also screened the 1934 furlough movies they "had taken of Ringling Bros. circus, the zoo, farming pictures, etc." But instead of informing prewar rural mission attendees about US life and leisure, these films were now simply a form of entertainment for their postwar urban audience. After all, when the projector was shut off that evening in Beijing in 1947, the Henkes treated the Chinese doctors not to an informative lecture about life in the United States, but instead to "guessing games, repeating a short poem when the trick [was] to first clear your throat, etc . . . [and] Chinese checkers."[53] Amusement aside, the film's visual-temporal transport may well have reminded Harold and Jessie Mae (and their children) of the distance between their prewar mission and the postwar environment in which they now found themselves. Immediately after mentioning the game night, Harold reported, "The new language administration here is changing the whole system of Chinese romanization from the one we have used all these years and which all dictionaries are based upon. How these new students are going to get along is questionable for they will have to learn TWO romanizations or else not use dictionaries." "These new students" likely included himself, Jessie Mae, and other returning missionaries.

The Henkes also encountered rapidly growing signs of anti-US sentiment around the same time they viewed their old films in early to mid-1947. Beijing had been rocked by heated protests after two US Marines raped a Chinese female student at Peking University on Christmas Eve, 1946.[54] Although not discussed in detail by the Henkes and their immediate colleagues, the crime galvanized anti-American demonstrations across China (furthering tensions between Nationalist and Communist groups) and drove a noticeable wedge between American missionaries and military personnel. A Marine chaplain reported, "Missionaries here in China tell us that the American Marine has unknowingly done irreparable harm to the mission work of the church."[55] In the midst of these unsettling experiences, the prewar films heightened the sense of dramatic change across time, mediating past visions and present viewing experiences and enabling the missionaries to situate memories in the new environment.

Reforging ties with the postwar Chinese professional and missionary community paralleled broader, private reconnections to space, place, and peoples. As Jessie Mae wrote six months after returning to China with

Robert (aged sixteen), Richard (twelve), and Lois (seven), "The children had some drastic adjustments to make just at first as we knew they would have after six years of life in the States [1940–1946]. Starting late in school, being unable to speak Chinese, being the only missionary children in the school, beside the fact that they were the only Americans there whose father was not at least a Colonel had its drawbacks."[56] The Henkes' three children were far from alone in this regard. As Protestant missionary families flooded back, they brought with them children whose experiences were deeply influenced by profound cultural shifts between life in prewar China, life in the wartime United States, and relocation to postwar China. These experiences, which they often found difficult to articulate to others not in their situation, were described by sociologists less than two decades later as those of "third culture kids."[57] Missionary children, like their parents, sought ways to visualize China and their own experience, particularly if their mothers and fathers were also engaged in visual practices. Some of them purchased or received cameras from relatives. While living at residential schools like the Peking American School (PAS, for families based in North China) and Shanghai American School (SAS, for those from Central and South China), they also developed connections with other children who were interested in photography.[58] The SAS, for example, boasted a photography club and well-equipped darkroom managed by Val Sundt, a Protestant minister and English instructor who owned a German folding camera. The club had twenty to thirty student members, many of whom were missionary children.[59]

Ralph and Roberta Lewis's oldest son, Harry, who attended both the PAS and the SAS because of his family's movements between both North and Central China, assembled a scrapbook containing photographs made with his own medium format-camera as well as the Kodak 35 and Rolleiflex occasionally borrowed from his parents.[60] Carl Scovel, Frederick and Myra's second son, befriended SAS classmate Theodor "Teddy" Heinrichsohn, whose background as the son of an aristocratic Manchurian-Chinese mother and German ex-missionary-turned-businessman father enabled him to develop early interests in photography, first using his father's Leica II and then an US-made Univex Mercury 35 mm camera after the war.[61] The two of them were active in the SAS photography club, and sometime after 1948, Scovel obtained a Mamiyaflex Junior (one of the first postwar cameras to be exported from Japan) to make his own photographs in Shanghai and his family's postwar mission postings in Huaiyuan and Guangzhou (Canton).[62] Other missionary children took the opportunity while living in urban centers (sometimes far

from the rural environments where their parents were based), to gain access to commercial developing. David Angus, whose father was an evangelist in Fujian with the Reformed Church in America, sent his negatives to a studio down the street from the SAS, where the rolls (made with a Kodak Box

Figure 5.1. Negative sleeve with inflated price for developing two rolls of medium format film in Shanghai, ca. 1948. Angus Family Collection, Lansing, Michigan.

Brownie) were processed at a cost of 68,000 yuan in the spring of 1949—an indicator of the nationwide inflation preceding the Nationalist government's collapse.[63]

For the most part, the children's vernacular photography followed in the footsteps of their parents' in general style and content. Their visual practices, however, continued beyond their immediate life in postwar China. Photographic skills picked up or honed at the SAS and the PAS developed into longer-term interests in visual practices. Harry Lewis continued taking photography courses during his undergraduate studies at Whitworth College in Spokane, Washington, after 1949, and Theodor Heinrichsohn collected high-end photographic equipment as a pastime, supported by his later position as the president of Bayer Japan.[64] A number of others took up missionary callings as adults (including three of the Lewises' four children and one of the Scovels', variously based in Indonesia, Pakistan, and Thailand in the decades to come), combining photography with their vocations in strong echoes of their parents' imaging in China.[65]

Jessie Mae concluded a 1947 letter with an observation of the overlapping contradictions—familiarities and uncertainties, hopes and anxieties—that characterized the postwar moment:

> Peking outwardly is much as we remember it in 1940. The colorful wedding and funeral processions, the noisy New Year celebrations, even the pigeons with whistles tied to their backs flying in musical circles. The enticing shops are still enchanting. The terrific inflation and corresponding sky rocketing prices are at once ridiculous and tragic if any semblance of economic stability is to be realized. Foodstuffs are plentiful, coal is scarce, both are too expensive to be purchased except as absolute necessity demands. There is a new spirit in the air, perhaps a healthy sign of growing pains, perhaps evidence of disease that sooner or later must be eradicated. It is a great time to be living here and to have even a small part in moulding [*sic*] the thought and direction of this young democracy.[66]

These experiences translated into the Henkes' postwar visual practices. Harold and Jessie Mae, after all, had returned full circle to the city where they had first undertaken their formal language training in 1927–1929, where they had made their first still photographs in China, and where they had traveled before and during the war. It is not surprising, then, that their visualizations of the city were shaped by their past experience and their new encounters with an environment that had undergone two decades of change. Perhaps in

an attempt to access familiar sights, the Henkes went around the city imaging sights as they remembered them.

One of the great differences now, however, was that color-based visual technologies (namely the wide availability of Kodachrome) had finally caught up with the Henkes' desire to visualize "the colorful wedding and funeral processions" and other details that the couple had tried to record alongside their black-and-white photography twenty years earlier. One of the Henkes' films, likely made in 1947 with the Cine-Kodak, displays a mélange of color. The film is filled with other shots of brilliant paper lanterns shaped as fish and other animals, a bright red catafalque and white mourning outfits at a lavish funeral (that of a person known to the Henkes, whose family permitted them to film the proceedings), the khaki uniforms worn by a US infantryman on leave, and children wearing cold-weather army caps with Nationalist insignia, gaping at three picnicking American visitors. The Henkes' imaging now blended more strongly with genres of postwar touristic and home movies. With no clear imperative to produce films for US congregations or Chinese audiences, the Henkes filmed Beijing's general outward appearances (e.g., parks and markets, the Forbidden City, and Coal Hill) and US-style leisure activities at the Presbyterian mission (including holiday parties with conga lines). The Henkes' choice of subjects stemmed from their new environment and their desire to produce scenes for personal viewing enjoyment.

Examining the images against the backdrop of the Henkes' history in China and Jessie Mae's words, however, indicates that the films and the Henkes' postwar production represented a search for meaning—as well as a grappling with the knowable present and an unknown future. In a sense, "old China" (at least the place that the Henkes first encountered as young, newly married missionaries in 1927) still existed in visual forms: the traditional handicrafts, open-air markets, public rituals, and thronging crowds that appear in the colorful 1947 film. But the Henkes had aged, moved in and out of the country in war and peace, and were now encountering changes in "new China" that were beyond their full comprehension—though they, in their twentieth year as missionaries, were no strangers to conflict and political change. As the days passed, the Henkes and other American missionaries in urban positions like theirs became more and more aware of the intense pressures that the local population was undergoing, recognizing that a massive change was coming. During the Lunar New Year of 1947 firecrackers exploded across Beijing and weary families gathered for communal meals ("these people," the Henkes observed, "generally have so little enjoyment in

life that this period means a great deal to them"). But Harold Henke, hands bloodied, kept working at Douw Hospital, operating on several individuals who had attempted suicide by slashing their own throats. "One of the customs of the day," he noted, "is that all bills must be paid before the last day of the old year. With depression so extensive, prices so high and business generally so poor, I suppose that that explains why we have had three attempted suicide cases. . . . Two nights I have been up this week with men who tried to end their worries this way[;] both of them are still alive but one has a hug[e] defect in his windpipe and the other has a very deep and long neck wound. . . . The first was a woman[,] and she died the second night after the injury."[67]

By mid-1947, around the time the Henkes made their family films in and around Beijing, the US-led Marshall and Wedemeyer Missions' negotiations between Nationalist and Communist representatives had largely broken down.[68] In the wake of these failures and rising public sentiment against their presence, US military forces began a swift withdrawal from the city, a change in atmosphere that the Henkes noted.[69] Perhaps because of the growing lack of American influence over the Chinese political situation in the summer of 1947, the latter mission's commanding officer, Gen. Albert Wedemeyer, had sufficient free time to attend a Sunday evening reception at the Presbyterian mission, during which he demonstrated his little-known talent of riding backward on a bicycle (to the delight of the Henkes' children) and was filmed by Harold Henke and the Cine-Kodak while doing so.[70]

At the same time, fighting between the Nationalist and Communist armies in Northeast and Central China was bloodily shifting the tide of the civil war in favor of the Communists. Missionaries received this news in bits and pieces, even if they were grounded in the Nationalist-controlled areas where they worked.[71] There still was no clear indication from the ground-level point of view that monumental changes were about to take place. The Henkes, describing radio broadcasts reporting that Nationalist and Communist troops were now "fighting both north and south of the [b]each" at their former vacation spot in Beidaihe, remarked, "[This] will put a crimp in our summer vacation plans"—"a shame[,] since we had hoped to get started on some needed repairing on the house [at Beidaihe] as well as have a good vacation[,] but there is no other way out."[72]

Perhaps because of these uncertainties as well as hopes for national stability, Jessie Mae focused her letter on "[the] new spirit in the air, perhaps a healthy sign of growing pains, perhaps evidence of disease that sooner or later must be eradicated." Did "disease that . . . must be eradicated" refer to the resurgent presence of Chinese Communism? Chiang Kai-shek had

famously employed the metaphor during the earlier iterations of the Chinese Civil War. Or did the phrase refer to Nationalist corruption and nationwide disillusionment with the reigning government?[73] Were the growing pains the sacrifices endured by Chinese church members and missionary hospital patients in the hopes of physical and spiritual salvation? In some ways, these questions were unanswerable. In particular, they could not be answered by what was immediately visible to the postwar missionaries. The definitive end of missionary activities in China had not yet arrived. Perhaps the Henkes believed that if they helped shape "the thought and direction of this young democracy," the end might not come at all.[74]

These feelings are captured, perhaps inadvertently, by a segment of the Henkes' Beijing color film shot from a mountain summit on the western outskirts of the city. The Cine-Kodak pans across a muddy brown landscape gridded by rice paddies and moves upward to frame Longevity Hill and Kunming Lake, which form the Summer Palace complex visible in the distance. But before doing so, it focuses shakily for a few seconds on a line of antlike figures marching in formation along a major road in the immediate but still distant foreground, with a tiny box of a lone supply truck taking up the rear. The line—which stretches along the snaking, sunlit road and disappears into the horizon near the Summer Palace—is likely a company of Nationalist troops advancing out of the city, conceivably armed with US-made weapons and materiel.[75] It is unknown what these troops were doing, including whether they were on routine movements or reinforcing an outlying Nationalist garrison in preparation to meet encroaching forces of the People's Liberation Army (PLA). What the Henkes perhaps did not fully understand was that their lives as American missionaries in China were already intertwined with these faceless, nameless soldiers (from the camera's point of view) representing a government that was soon to fall. The camera had brought them together in a distant way, against the backdrop of an "old China" and a new era, as both groups headed toward an uncertain, ultimately life-changing fate.

Loss and Longing

The day before Jessie Mae Henke typed her 1947 letter, a khaki-clad US officer walked the streets of Beijing, carrying a professional Bolex 16 mm movie camera and several fresh reels of Anscochrome color film for reloading.[76] Accompanied by two other men with still cameras, the officer visited typical

historic sites, strolling through the Forbidden City and climbing to the top of the Ming-Qing era astronomical observatory, where he prefocused the movie camera and handed it to a companion to film himself sighting through the aged theodolite. The feat required the officer to pull hard on the weather-worn apparatus to get it pointing heavenward, but he did not seem to mind manhandling the centuries-old equipment. Sometime afterward, the officer changed out of his military uniform, laying aside the pressed khaki fatigues with a small silver lapel cross, and putting on a black cassock identical to those worn by his traveling companions. In this outfit and with his Bolex camera running in the hands of another person in a courtyard near Beijing's North Church, Fr. Bernard Hubbard, SJ, approached, genuflected, and kissed the right hand of Cardinal Thomas Tien Ken-sin, SVD, the archbishop of Peking and China's first "Prince of the Church."[77] Behind him, scholastic George Bernard Wong stood by as a translator, having accompanied Hubbard—a stranger to the Catholic mission in China—during his brief three-day visit to Beijing.[78] Within a few days, Hubbard was reattired in his chaplain's uni-form and on board a transport aircraft flying southward to Nanjing and then Shanghai, where he continued his fast-paced filmmaking before leaving the country entirely.[79] Some weeks later, with the unprocessed 16 mm footage packed securely for transport back to his home base at Santa Clara University in California, the Navy chaplain made a similar trip through Japan, where he was photographed, again in his uniform, by a US Army Signal Corps photographer—this time demonstrating the Bolex for a young kimono-clad Japanese girl at the Sacred Heart Academy in Tokyo. This was the first and only time that Hubbard was in East Asia, with the priest regarding his 1947 trips through the two countries as another set of fortuitous experiences to add to an international (and domestically marketable) filmmaking portfo-lio.[80] His greater fame had already been made elsewhere.

Hubbard's long-term mission base, unlike those of other missionaries previously discussed, was in Alaska and California rather than East Asia, and his career as a semi-professional filmmaker differed quite radically from that of a typical Catholic mission priest. He was an unabashedly self-promoting character, having built his reputation on ethnographic films shot on well-publicized scientific expeditions to Alaska in the early 1930s. These films translated into lucrative lecture tours, which further expanded his public image.[81] As with the transitions between his chaplain's uniform and cleri-cal garb, Hubbard moved fluidly between multiple commercial, military, and religious spheres. Unlike most missionaries in China, who kept fund-raising logistics well within the purview of overseas mission organizations,

Figure 5.2. Fr. Bernard Hubbard in US military uniform, displaying 16 mm Bolex camera to Japanese girl in Tokyo, June 1947. Author's personal collection.

Hubbard saw no problem in directly leveraging his personal and commercial contacts to finance his filmmaking and vice versa, displaying the products of his travels for public consumption. The Anscochrome color film stock that Hubbard used in China was donated by the Ansco company, based in Binghamton, New York, probably on the condition that he publicize its use in his filmmaking.[82] He certainly did publicize it, orchestrating a not-so-subtle

product-placement shot of himself handing a gift of an Ansco film pack to a clearly perplexed Chinese child in Yangzhou.[83] And almost exactly a year to the date after Hubbard left China, the American Bolex Company, the producers of the 16 mm camera he extensively used, released a full-page advertisement in *Popular Photography* hailing the priest (prominently displaying his clerical collar while cradling the Bolex) as a "famous explorer, scientist, and educator," framed by still images from various countries that Hubbard had filmed during his 1946–1947 world tour of Jesuit missions. The advertisement also reproduced a testimonial by Hubbard touting the camera as rugged enough to withstand "the dust and heat of Egypt, Palestine, Lebanon, and Iraq . . . the humid[ity] . . . of India, Ceylon, and the Philippines," and of course, "the dust of North China."[84]

China, however, was not at first a planned stop on Hubbard's tour. After landing in Manila from Ceylon in the spring of 1947, Hubbard received a cable from Fr. Paul O'Brien, SJ, the mission administrator of the California Jesuit Province, requesting him to come to China and produce films there.[85] Hubbard's reputation and filmmaking expertise, O'Brien hoped, would help to publicize (and secure further support for) the Jesuit mission institutions in the country, even as the political situation deteriorated. Though O'Brien's 1947 thoughts on the filmmaking impetus were not clearly articulated from Hubbard's point of view (beyond a desire to support existing fundraising efforts), it is highly likely that the O'Brien perceived that foreign missions were slowly being squeezed out of existence in China, and desired a filmic record of the Jesuits' missionary work before further instability prevented such visual practices. As a result, Hubbard, the interloper, became a filmic collaborator with Catholic missionaries already in China, especially William Klement at the California Jesuits' community in Yangzhou. Their collaborative films were also framed by competing visions of old and new China and Chinese Christianity as the mission enterprise faded from view. They represented ideas about missionary loss and nostalgia from two different registers: the Chinese interior and the American exterior. The shifts between the films were partially a result of their makers re-editing and reframing as historical changes took place around them.

Less than two years after his Beijing sojourn, Hubbard was back in his dedicated editing laboratory at Santa Clara University, surrounded by reels of film that he had shot around the world. Sitting on his editing table, next to a well-used 16 mm splicer and viewer, was the color footage he and other Jesuit missionaries had produced in China, along with William Klement's December 22, 1949, screenplay, recently arrived from the Philippines.[86] Most

of the China footage had already been edited in an earlier form by October 1947, intended as publicity films for then-current Jesuit missions in the country.[87] But with the outcome of Chinese Civil War now clear, Hubbard began to re-edit the collected footage into two new, separate films. The first, *Yangchow 1948*, is composed primarily of mixed silent footage, including film shot from 1946 to 1948 by Klement and other Jesuits formerly based in the eponymous city. The second film, containing more of Hubbard's 1947 material, is titled *Ageless China*. It was printed to include a soundtrack, for which the priest composed a spoken narrative and included generic orchestral background music. The intended audiences for the films are still not entirely clear. Klement described his screenplay as "some ideas which [he] had used in showing the pictures." He asked Hubbard, "[Would you rather] use the explanation of my script here to compose your own commentary bringing the contrast with today's Red China . . . or just send me a list of the titles used and their sequence and I will try to make a running commentary?" But neither filmmaker revealed for whom they hoped to share the products of their extensive labor.[88] Given Klement's route from California to the Philippines and Hubbard's lecture circuits across the United States, however, it is highly possible that the films were intended for missionaries and Catholic laypeople who had previously worked in Yangzhou, now relocated to institutions in Southeast Asia or elsewhere, or for US congregations that had contributed funds to Jesuit missions in pre-1949 China. In both cases, the goal would no longer have been to drum up support or to inform others about current missionary efforts, but rather to present a visualized, idealized past in a way that would elicit (and also, to certain extent, satisfy) feelings of loss and nostalgia.

Yangchow 1948, the film that was edited along the lines of William Klement's letter-screenplay, reflected a communal nostalgia that could only be felt by viewers and producers who had been in Yangzhou before 1949—communities that included both women and men. Although most of the Anscochrome footage was produced by Hubbard and Klement, female missionaries affiliated with the Jesuits contributed to the films as supporters, subjects, and missionary colleagues. Among these were the Society of the Helpers of the Holy Souls, a group of nuns and Chinese Catholic laywomen that Klement specifically named as "a really poor outfit [that has] done so much for us in China that we owe them a great debt." Advancing the idea that *Yangchow 1948* would serve as a visual commemoration of the Helpers' efforts, Klement highly recommended that segments of the film (covering work with female orphans, deaf children, and Chinese girl scouts) should be donated to the representatives of the Society after Hubbard completed

his editing.[89] Although the film's visual tropes straddle the line between expanding gender categories (with the girl scouts' military and athletic exercises) and reinforcing gender divisions and stereotypical maternal views of women, its production and reception included communal gender-crossing efforts in Catholic contexts from the outset.

The film also represents the collective view of American Catholic former missionaries looking back at visual remnants of a mission project and Chinese Catholic community that by 1949–1950 was already in disarray.[90] This view was shaped by temporal and physical distance juxtaposed against a strongly localized interiority. The film opens abruptly with a shot of the gleaming white Gothic church in Yangzhou, the building's spires filmed from a long distance with a telephoto lens. Klement's narration, as he framed it in the letter, began: "Approaching the town from the East the first thing to catch the eye . . . are the towers of the Catholic church peering over the walls of the city."[91] This focus on the church's architectural prominence is not only intended to serve a typical missionary ideal (emphasizing the prominence of the building as an important site for local Catholic worship) but also heightens the imagined distance and the sense of loss. The missionaries who made and watched the film could not inhabit the same space as the faraway church and its communities, as they were now separated from Yangzhou and the Chinese Catholics there by new Cold War divisions. The distance was as emotional and spiritual as it was visual. Klement referenced this in a striking mix of defiant and wishful terms, noting, "The present church was erected just after the Boxer Rebellion. . . . Persecution has hit the Church more than once before. But always in the History of the Church back she comes stronger than ever. Christ and His Church will stand in China long after Stalin and his red hordes are but pages of old histories lying on dusty library shelves."[92] By positing a parallel between the Boxer Uprising and the nascent PRC (and, interestingly, ascribing Communism's success to Soviet rather than Chinese origins) Klement simultaneously drew viewers' imaginations to the implied long-term permanence of the Yangzhou church and to the spiritual triumph of "Christ and His Church" across time. Surely, if the church—building and people—withstood the chaos of the Boxer Uprising, it could just as well weather contemporary "red hordes," who in time would pass into historical irrelevance (from Klement's point of view), as did the Boxers. By conflating the visible with the invisible and anticipating eternal Christianity ultimately defeating earthly Communism, Klement's narration reshaped the view of the church building and the unseen Catholic community around it in a spiritual dimension.

Shifting from the distant view to the ground level, the camera immediately cuts to street scenes in Yangzhou (e.g., merchant vendors, food preparation, and local residents and passersby) that were already common in prior missionary imaging. This environment was, of course, highly familiar to Klement, the veteran missionary and local guide, but not at all to newcomer Hubbard (who may have insisted on filming these scenes with the curiosity of a visitor). The street scenes intersect with the highly visible presence of uniformed Nationalist soldiers boarding a ferry, walking through alleyways, and at some points staring with a mix of interest and disdain at the cameraperson. One scene filmed across the Grand Canal features passengers disembarking from a riverboat in front of a Nationalist propaganda slogan emblazoned on a wall: "Good men never desert the army" (*hao nan'er jue bu taobi bing*). The warning is darkly ironic, given the widespread desertions, defections, and popular disenchantment the Nationalist government was then suffering, as well as the Communists' clear victory in the civil war by the time the film was complete.[93]

Many of these scenes, as well as the long-distance view that precedes them, would have been recognizable to the missionaries who once walked through the streets, purchased foods and goods from the vendors, and interacted with the local people—military and civilian—on a regular basis. But in the post-1949 moment, Klement's narrative mixed feelings of hope and loss, particularly as the film focuses on elements of Catholic mission activities and communal development that were cut short by national change. Following several shots of khaki-uniformed Chinese boy scouts marching past the camera at drill—images of quasi-nationalistic cohesion distantly framed by the then-salient Republic of China rather than the People's Republic—the camera moves on to the same boys in a "Close Up of Hearing Mass." "All these boys attentively hearing Mass," Klement wrote. "Nine out of ten are still pagans or at least not yet baptized [*sic*], though all study the catechism, fervently say their prayers and attend Mass."[94] As close-ups of the scouts (all gazing intently at a brilliantly adorned field altar) flashed across the screen and their scoutmaster, local missionary priest Fr. Louis J. Dowd, SJ, celebrated the Mass and preached a sermon against the backdrop of Yangzhou's Slender West Lake, the film's intended narrative script asked the unseen audience for their support.[95] But rather than asking for financial or physical contributions, Klement requested only religious intervention: "This young pagan still not baptised [*sic*] desires only to be a priest. Yours [*sic*] prayers especially during these times in China will help him realize his dream." With long-term mission aspirations (embodied by a Chinese boy who reportedly

"desire[d] only to be a priest") crippled by overwhelming contingencies, only prayers were of continued efficacy in linking American Catholics to Chinese converts—or potential converts.

At the same time, these sequences convey a defeat-tinged pathos, even as they present the potential Catholic futures of the boys on screen. On their way to the campsite where the Mass is celebrated and the group performs a martial arts drill and a short skit for the camera, the boy scouts pass through Yangzhou, likely a creative choice by Klement or Hubbard to highlight their local environment as a backdrop. In the process, heightened by edited sequences depicting the group taking various routes and a riverboat as they travel to the camp, the boys march by crowds of curious onlookers (likely drawn by the spectacle and the foreign priest behind the camera) that include stony-faced Nationalist officers and infantrymen. The strong contrast between the boys seemingly playing at soldiers and the adult Nationalist troops—largely co-opted or defeated by the PLA by the time the film was edited and screened—only serves to strengthen viewers' recognition that the boy scouts' personal lives and the world of the Catholic mission behind their organization had been dramatically altered, and would soon be even more so.

A shot following the boy scout sequence, depicting "Fr. Fahy and Sister Catechizing Group," is framed in Klement's screenplay with the same mixed language of hope and defeat: "Though 90% of [these] kids are pagan still they take all catechism and learn the doctrines of our Faith, the prayers, etc. It can be hoped that when they grow up, they will become Christians, or at least have no objection to their children becoming so. Of course with the closing of Christian schools even this remote hope vanished."[96] These references to forced separation and dashed hopes extend not only to living communities but to those of the dead. A black cross (visible in the background of one shot, behind a catechist and a young boy engaged in a lesson) marked a then temporary grave for a Jesuit missionary who died shortly before the film was made, is described: "[While] it is not permitted to bury inside the city at present . . . when people have become accustomed to it we will make it a regular cemetery. The first plot has been reserved for Fr. Simons who will be brought here in a more peaceful day."[97]

Mixing already untenable plans for the present with those for the future, this sentiment prefigures later political narratives regarding the desire of Nationalist leaders (including, most prominently, Chiang Kai-shek) to be reinterred in their lost homeland after their deaths in exile, while the visual framing subtly conflates visible Chinese Catholic communities with

American missionary bodies interred in their shared land.[98] At the same time, and somewhat tellingly, references to the disappearance of a "remote hope" are buried in an overarching narrative that attempts to give a more hopeful view of Catholicism in China. The film suggests that even if the indigenous church is cut off from the West and the visible scenes are now mostly memories, the communities and individuals associated with Catholicism in Yangzhou will continue to exist into the foreseeable future under divine protection (rather than the limited reach of earthly institutions).

This conflation of loss and hope colors a mass view of the Yangzhou Catholic community in the film's centerpiece, a four-minute-long sequence that William Klement produced in the Yangzhou mission compound. This sequence covers the preparations for an open-air Mass, beginning with American priests, Chinese nuns and seminarians, and laymen setting up a massive altar in the courtyard. Several smile and banter with each other, and one Chinese priest proudly carries a German-made Exa 35 mm camera around his neck.[99] The red-clothed altar stands in front of a verdant green backdrop and a billowing golden canopy. The camera pans upward to show a row of yellow-and-white flags (colors traditionally associated with the Catholic Church) and the red-blue-white flag of the Republic of China on a tall pole forming an apex above the altar. In a single view, the Chinese Catholic laypeople and religious who face this altar—and the audience of the film—take in the symbols of their faith, institutional allegiance, and pre-1949 national identity in a swath of colors.

The film then visualizes collective identity, comprising both Chinese and Western elements, in the Mass, itself characterized by pageantry and liturgical regimentation. As strings of firecrackers smoke and explode at the far end of the courtyard, a procession led first by a boy scouts' drum corps and then by a line of acolytes (with no fewer than four swinging censers) march toward the altar before the priests ascend it and remove their birettas for the ceremony. Klement filmed all this first from the top of the altar platform and then from the side, enabling to him to pan across the mass of participants while also including the liturgical actions taking place at the front. These privileged positions (close or in front of the altar, outside of rather than within the body of communicants) translate into filmic views that mirror the visual perspectives of a priest celebrating the Mass, gazing out at the community which he is simultaneously a part of and apart from. Klement, in the moment of filming, probably envisioned his filmmaking—especially the wide-angle panning views—as a prosaic way of displaying the size and mass participation of the Catholic

community in his mission. But viewers after 1949 (especially those who were formerly missionary priests in China had celebrated Mass in spaces and before peoples much like these) would more likely have watched these scenes with nostalgic emotions. In looking at the participants looking back at the camera, they may also have sensed the irrevocable spatial and temporal disconnect between themselves and the imaged people—wondering, perhaps, what became of the boy scouts, the acolytes, the nuns, and the staring, kneeling, moving mass of congregants left behind in Yangzhou after their departure.

Perhaps in a nod to the former subjects of the film now viewing it in a different historical context, *Yangchow 1948* ends with three and half minutes of prosaic footage that is entirely separate from the prior filmic narrative. This is the Catholic-mission parallel to Protestant home movies. The film depicts American priests—several of whom have been shown earlier in formal religious or educational activities—in their mission residence, chatting and laughing, shaking hands with each other (while exiting a house, no less—the same trope seen in Protestant films) and speaking casually with Chinese staff and colleagues. The final shot, interestingly, depicts one of the younger, goateed Jesuit priests—now wearing the dirt-covered uniform of a

Figure 5.3. Screenshot from *Yangchow 1948* with open-air Mass procession led by American priests and Chinese boy scouts. JARC.

laborer—working amiably alongside a small team of Chinese workmen to construct a brick structure, perhaps an outbuilding to be used in the mission compound. The film cuts to black with no clear resolution, inviting (perhaps inadvertently) the metaphor of the mission as a work in progress now left incomplete.

Bernard Hubbard's sound film, *Ageless China*, articulates these perceptions of communal separation, loss, and hope on a national scale. This film, however, is more characterized by Hubbard's external identity and less by the nostalgic longing of Klement's visual narrative. Both his and Klement's films play with past-present temporal continuity; both are views of the past shaped by an uncertain present and a hopeful religious futurity. Hubbard, who shot his footage in major cities (Beijing, Nanjing, and Shanghai) under Nationalist control in 1947, now presented them as an idealized perspective of a lost China, an approach that probably influenced his decision to describe the country in the title as "ageless." Hubbard's idea of China's agelessness meant a persistence of the traditional and ancient, even in modern times; shots of Ming- and Qing-era architecture take up most of the film's running time, especially given that Hubbard seemed especially taken with the grandeur of the Forbidden City. These shots give *Ageless China* the flavor of a travelogue or ethnographic film, apparently drawing on Hubbard's prior film experiences.

At the same time, *Ageless China* advances arguments about Catholicism's (and by proxy, Christianity's) long-term resilience in China. The agelessness, therefore, is not merely an orientalist vision of traditional Chinese culture and antimodernity (though Hubbard's commentary plays up that perspective as well), but rather a statement that the regime changes that expelled Nationalists and missionaries alike would ultimately be insignificant bumps in the road from a religious perspective. Some of this took a blatant political turn. Paralleling Klement's sentiments about Chinese Communism's illegitimacy with a visual anachronism, Hubbard decided to retain—and emphasize near the film's beginning—a long shot of the Tiananmen Gate decorated with Chiang Kai-shek's portrait, as opposed to the internationally visible image of Mao Zedong that was already in place by the time the finished film would have been viewed.[100] Interestingly, the shot is accompanied by a lengthy monologue about Beijing's former capital status during the Yuan Dynasty, as part of "Kublai Khan's . . . greatest empire in the history of the world." After this description, Hubbard pauses for effect and adds: "It was far greater in area than the Communist empire of today, inside the Iron Curtain."[101]

As Hubbard also peppers the film's commentary with descriptions of Jesuit (and other Catholic orders') accomplishments in China, it is clear that he intends his filmmaking journey to visualize the long-term historical traces of missionary presence. His casual experimentation with the three-hundred-year-old astronomical instruments is accompanied by a discussion of Fr. Ferdinand Verbiest's role in designing them for the seventeenth-century Qing court. He and other Jesuits appear gazing at the tombs of Verbiest and Matteo Ricci still intact in Beijing. Even his visit to Shanghai ("strange city that is a hodgepodge of European, American, and Chinese influences," Hubbard declaims) primarily features the French Jesuit orphanage, crafts workshops, and educational center at Zikawei rather than any other sights in the city.[102] Visible spaces and places are all framed by Catholic missionaries' past presence. Hubbard describes a long hallway near the Temple of Heaven (shot lengthwise, so as to appear as though stretching into infinity) as a place where "it was interesting to reflect that back in the 17th century, many a Jesuit missionary walked these same corridors, these same paths, looked upon these same architectural wonders." The audience is thus invited to overlay what they are seeing—spaces framed by Hubbard's film and his presence at historic sites with Catholic importance—with imaginations of a past-present missionary legacy. The film suggests that though both viewers and filmmakers are now to be counted among those past missionaries who walked through, looked upon, and lived in China (groups also consigned to "pages of old histories lying on dusty library shelves," the fate the missionaries hoped would befall Communism), it is entirely possible that future generations of missionaries and Chinese Catholics will follow, despite the ravages of time.[103]

The film's overarching theme, therefore, demonstrates the historical lineages of modern Catholic missions in China rather than the missions themselves. And to reassure viewers that indigenous Catholicism is fully capable of continuing without foreign missionary presence, even Hubbard's audience with Cardinal Tien at the North Church—not least the filmmaker's on-camera demonstrations of deference and submission toward the cardinal—conveys the message (couched in highly idealized terms) that the indigenization of the Catholic hierarchy in China is well underway. As Hubbard notes during his narration,

[Tien was] not the first [Chinese] bishop by any means. There was a Chinese bishop in the 17th century, and there have been many since, and there are many today. But Cardinal Tien was the first to become a Prince of the

Church. And here he is [onscreen]. His elevation marks a great step nearer the goal of all missionaries in China. Most of the foreign missionaries belong to various religious orders; almost every order of the Church is represented in China. But all of them have a single goal. They all look for the day when the Church in China will be entirely in the hands of a native episcopacy and clergy . . . The missionary orders are but John the Baptists preparing the way, ready, even anxious to step aside as soon as the secular clergy are ready to take over.[104]

Although the characterization of missionary orders as "John the Baptists . . . ready, even anxious to step aside" is an enthusiastic overstatement, it is undeniable that the Catholic Church in China was at its strongest and most stable period of growth when Hubbard and Klement produced their films in 1947.[105] And certainly by the time the films were screened in their final forms, after 1950, the metaphor of John the Baptist was far more applicable in a tragic rather than an triumphal sense. Like the New Testament herald of Christ who was beheaded on the orders of a tyrannical leader (his head being famously delivered to Herod Antipas on a silver platter), so were missionaries now targeted by government campaigns and forced out of China, victims of political contingencies far beyond their control.[106] Thus, any visual, statistical, and imagined references to the strength of the indigenous church—able to self-govern, evangelize, and maintain its structural integrity in the absence of foreign aid or intervention—provided an element of hope for viewers watching the films.

It is not surprising, therefore, that *Ageless China*'s narrative arc and Klement's typed screenplay both end with images that reinforce the idea of a resilient indigenous Catholic community, strengthened not by association with foreign power but by divine protection that transcends earthly boundaries. This viewpoint is most clearly articulated by an extended sequence showing Chinese Catholic laypeople, foreign missionaries, Chinese clergy, and members of Catholic religious orders strenuously climbing the steep green hills of Sheshan (or Zose, in the more commonly used Shanghainese pronunciation) in mass pilgrimages to the Basilica of Our Lady of Sheshan.[107] Indeed, "in May 1946, Mary was crowned Queen of China at Sheshan" only one year before Hubbard was in Shanghai.[108] Although William Klement, perhaps running out of typing paper or time, neglected to discuss the footage in detail in his December 1949 epistle (though bookmarking it at the end of his screenplay), Hubbard incorporated a large portion of it in the conclusion for *Ageless China*.[109] As the soundtrack features pipe-organ

strains of Schubert's "Ave Maria" and Hubbard's voiceover extolls the devotion of Shanghai's Catholics, long lines of Chinese pilgrims jostling, kneeling at the Stations of the Cross, and climbing to the Sheshan summit fill the screen.

By leveraging film's ability to visualize movement, space, and temporal continuity in parallel with religious imagination—grounding spiritual identities in communal practice and space—the Sheshan sequence provides viewers with conceptions of mass devotion in relation to the Catholic community remaining in China. The hope was that these communities and individuals, expressing their public commitment to Catholicism in the pre-1949 period, would continue to do so even as the mission church passed away and the indigenous church militant succeeded it in the face of domestic political persecution and further institutional isolation in the global Cold War.[110] In the case of the Chinese Catholics in Shanghai, this was not merely wishful thinking by foreign clergy but a matter of communal identity. Though Hubbard and Klement had no way of knowing it at the time their films were shot, even as Hubbard edited the films in Santa Clara, many of the Shanghainese pilgrims, religious, and clergy visualized in the Sheshan sequence were already (or very soon would be) involved in anti-Communist resistance based primarily on their religious convictions and allegiances to the global Catholic Church. Shortly after the PLA takeover of Shanghai on May 24, 1949, a dissenting movement organized by the bishop of Shanghai, Ignatius Kung Pin-Mei, took to both public and underground resistance to Communist power. The new government responded by initiating Public Security Bureau crackdowns on Catholic communities in the city.[111] So resilient was this confrontation with the authorities that it was not until 1955 that Kung and other church leaders in Shanghai and elsewhere were finally arrested in wide-scale purges, with the bishop (later cardinal) subsequently sentenced to life in prison, where he spent the next thirty years.[112] To symbolize Christianity's spiritual saliency under political fire, the final shot in Hubbard's film is of the basilica's spire, filmed from ground level against a brilliantly white cloudy sky. The apex features the Virgin Mary holding the infant Christ, described by Hubbard in his solemn intonation as "the light of the world, arms outstretched over the plains of China, in intercession for this great people of this great and ancient land."[113] These plains, of course, are in the background of the shots that precede this one, with pilgrim bodies forming lines leading up from the green flatlands to the basilica behind the camera. The visual and imaginative focus on prevailing emblems of Catholic belief, the moving participation of Chinese masses, and even the poignant soundtrack all point to hope in a collective

Christian identity that transcends political boundaries as well as the contingencies that separate missionaries and Chinese Christians.

Such parallels in imaging and imagination—representing spiritually salient connections to God while earthly links between peoples and institutions crumbled—were certainly not limited to Catholic missionaries. The Sheshan sequence is strikingly mirrored in a Protestant sense by another film, made by Harold and Jessie Mae Henke in Beijing on Easter Sunday 1948. Foreign and Chinese Protestants associated with the Peking Union Church ascend the Ming-era Circular Mound Altar (instead of a Gothic basilica) for a joint sunrise service conducted by in part by Rev. Wang Mingdao of the city's popular Christian Tabernacle (Jidutu huitang).[114] A small table topped with a plain altar cloth and a white cross serve as a liturgical focal point—albeit characterized by unadorned Protestant simplicity. Wang and a foreign minister (possibly Rev. Wallace C. Merwin of the China Christian Council) preside over the service in black Geneva gowns, ruffled by the morning breeze blowing across the flat-topped ancient altar space.[115]

The Henkes filmed the service on Kodachrome with the well-used Cine-Kodak camera that had accompanied them through North China since 1931.[116] And though the Henkes had no official connections with the Catholic Church or any of the more advanced filmmaking by Fathers Klement and Hubbard, their film contains striking visual parallels. The Circular Mound Altar is filled with Protestant congregants and imaged in several succeeding shots that frame the large architectural scale and group participation. The final part of the sequence, filmed from the top of the altar at the service's end, shows the mixed congregation streaming down the steps into the Temple of Heaven complex. Not only have they participated in a collective celebration of the Protestant Easter liturgy but they are now carrying this personal identification with the Christian faith as they return to their own residences and communities in the city, dispersing yet remaining. With great changes looming on the horizon in the form of the rapidly growing Communist presence in North China, it was fitting that the service took place in an aptly coincidental appropriation of former Chinese imperial space.[117] The Protestant communities in the city, both foreign and Chinese, were commemorating Christ's resurrection and their public faith in a sacred space where Ming and Qing emperors had also prayed and presented sacrifices, beseeching heaven (*tian*) for rain in times of drought.[118] In the fall and early winter of the same year, as PLA units led by Lin Biao and Nie Rongzhen launched devastating attacks on Nationalist forces stationed immediately north of Beijing and Tianjin, civilians poured into the

Temple of Heaven to seek refuge from the fighting.[119] As American sinologist Derk Bodde noted in his diary:

> [While] the outer grounds looked much as we remembered them . . . inside
> [the Temple of Heaven] all the buildings . . . are filled with hundreds of
> young men (also in certain quarters, girls) . . . wartime student refugees
> from Shanxi, some of whom seem hardly older than twelve or thirteen.
> Most of the stone terraces outside, as well as the floors of the temple it-
> self, are covered with their thin sleeping pads and meager possessions. . . .
> The columns of the great temple and adjoining buildings, much faded from
> their former brilliant red, are covered with ugly written notices, and dust
> and debris lie everywhere on the once gleaming marble. As one mounts the
> steps toward places once reserved for the emperor and his followers alone
> at the most solemn of religious ceremonies, one can but turn from this
> scene of human misery and degradation.[120]

Bodde concluded by noting that "even the lower tiers of the Altar of Heaven itself," where the Henkes and their fellow Protestants had sung, prayed, and appeared on film in the Easter sunrise service not long before, were now "littered with . . . half-dried excrement."[121]

Shifting Visions and "New China"

At this time, the Henke and Lewis families were not far from the front lines themselves. They witnessed firsthand the starving refugees (for whom the Presbyterian mission opened a soup kitchen, with unknown success). They heard the ever-approaching explosions and gunfire (as Nationalist armies desperately struggling to escape to Beijing from the north—perhaps including the troops that they had filmed from a distance earlier that year—were surrounded and destroyed by the PLA). They faced the now daily exponential increases in monetary inflation.[122] Ralph Lewis, who had taken over the Presbyterian hospital in Baoding soon after returning to China, found himself cut off from the rest of Hebei by fighting immediately north of the city. On October 4, 1948, Lewis departed for Beijing on one of the final air transports to leave the area ahead of the Communist advance.[123] Harold and Jessie Mae, still in Beijing, decided to evacuate their children. In strong echoes of their colleagues' experience during the last war, the couple packed up whatever belongings that they could ship via prearrangements with the

Presbyterian Board of Foreign Missions in New York, including their "movie projector and extra typewriter." The couple also shot one of the last segments of their remaining Kodachrome film stock, a short and somewhat surreal sequence depicting their children and those of other families—now confined to limited movements around their Beijing mission compounds—displaying homemade Halloween costumes.[124]

Two weeks later, using the typewriter not packed away in Jessie Mae's outbound luggage, the couple composed what they felt might be their final open letter to supporters in the United States, expressing their dashed hopes in uncharacteristically ominous terms:

> With the fall of Manchuria to the Communist armies, North China is being evacuated by all who can leave, both foreign and Chinese. This is being done with great regret. Most of us have had high hopes of reestablishing a work interrupted by the Japanese war. Civil war, however, has raged throughout North China ever since and our mission has worked under difficulties in the two stations [Baoding and Beijing] in areas not under Communist control. We managed to keep a foreign staff [including Ralph Lewis] in our hospital in Paoting until October. Wherever Chinese Communists are in control, mission work sooner or later has had to close. However, up until now they have controlled no large center.[125]

This was undoubtedly written with a sense of personal loss. The day before, US Consulate had notified the Henkes about a transportation opportunity, and on the same day they wrote the letter, the couple had sent their two teenage sons, Robert and Richard, by train to Tianjin and then by an LST to Qingdao, where they boarded the troopship USS *General H. W. Butner* to return to the United States for good.[126] After some indecision as to whether to stay in Beijing or not, Jessie Mae and Lois Henke left for the comparative safety of Shanghai twelve days afterward. They joined the Lewis family, who had also migrated there in November, following Ralph's narrow escape from Baoding in October.[127] Before departing, however, Jessie Mae paused to sit for a professional group photograph with the Chinese nurses she had worked with and trained in Beijing, who would continue working there and in other institutions after she left.[128] She would see few of these colleagues again in her lifetime.

As Douw Hospital was still open and there was some possibility that the mission as a whole could continue operating, Harold decided to stay behind in North China. Unlike the movie projector that was shipped off to

the United States, the Cine-Kodak remained with Harold in Beijing with the last segment of color film still left inside. Visual production was still considered a viable option in the moment, even as visual display (for home entertainment and educational purposes) was no longer needed. In a way, the decision to keep the camera indicated that there was more to be imaged and more work to be done, whereas the sending away of the projector reflected uncertainties about continued domestic instability in China. It was still not clear what would happen to the missionaries as a group, but hopes persisted that their activities could continue under Communist government, even with restrictions and further anticipated anti-American pressure.[129] The Henkes concluded their letter with a statement, predicated on the persistent otherworldliness of Christian faith, that could have well fitted the previous war, or any number of earlier pressures and losses across the longer spectrum of missionary activity in China: "We have our work to do here. There is a great need for us to stay and carry on. We have a great investment here in property and staff. We have God's commission to carry His word. Hence, we feel now that this is the right thing to do. Events as they come, conditions here in Peiping [Beijing], and God's leading will direct our future path. We trust in Him."[130]

On the morning of January 21, 1949, the commander of Beijing's Nationalist defenses, General Fu Zuoyi, formally surrendered his twenty-five thousand troops after intense pressure from PLA representatives and Communist agents in his inner circle (including his own daughter, Fu Dongju).[131] Less than two weeks later, Harold Henke was walking to a Rotary Club meeting at the Hotel des Wagons-Lits, a few blocks east of the US Consulate, when he was sidetracked by a massive parade of PLA troops and vehicles rolling wave on wave through Beijing's main street. "The city," he wrote to his mother hours later, "is very peacefully being taken over by the Communist armies which came in today in force. They look fine[,] well equipped and are the best disciplined Chinese soldiers that I have seen so far. . . . [they] have a great deal of rolling stock, most of what I saw looked to be USA."[132] Henke did not have the Cine-Kodak at hand (he certainly did not report filming or photographing the events) and made no film of the momentous occasion. He also had other concerns on his mind. After observing the parade, Henke continued on his way to the meeting and then hurriedly back to Douw Hospital. He needed to perform an emergency skin graft on a young boy with a hand mauled by a firecracker (possibly celebrating the PLA's arrival), followed by the amputation of a fifty-six-year-old woman's leg. She had chanced on someone in her village playing with

an unexploded grenade that subsequently detonated, echoing the "innocent victim of war" who appeared in the Henkes' prewar film.[133] The doctor also feared that with the PLA finally entering Beijing, it might not be long before other wounded civilians and soldiers from the prior fighting would follow in these patients' wake.

In many ways, the stark incongruities between national change and local life (or, at least from the missionary point of view, attempts at maintaining a typical daily routine) were jarring. What they saw, what they visualized (or could not or did not visualize), and what they imagined about this "new China" often differed widely, especially now that a growing number of them had come face to face with the relatively unthreatening Communist forces, until then only a faceless specter on the horizon. This likely contributed to a sense of further confusion in the moment and deeper nostalgia later on, as it seemed that life for both ordinary Chinese citizens and foreign missionaries really could continue as before. As Ralph Lewis walked through the streets of Shanghai in April 1949, four months after Beijing surrendered to the PLA and a month before the army entered this city as well, daily life for many inhabitants in the metropolis seemed to go on as normal. Using his Kodak 35 (and now familiar with its finicky focusing mechanism), Lewis produced a number of Kodachrome slides of street life in the city on a sunny day. Although food riots had been reported in Shanghai only a few months before and a thriving black market was in full swing, Lewis's candid photographs seem to reflect a more prosaic atmosphere: one of strained but unpanicked day-to-day survival.[134] A young man prepares thick slices of flatbread at a street stand not far from the Bund, shoppers inspect piles of gleaming green cabbage, and an aproned woman and a toddler take an afternoon stroll in the sun. For a few moments, time stands still.

These, along with other color slides made in Hong Kong in the summer of 1949—the Lewis family had moved to the city briefly in early May, ahead of the PLA occupation of Shanghai—were among the last photographs Lewis produced in China that still exist in any form. The family, however, would remain in the country well after the regime change, staying until 1951. It is not known whether the Lewises produced any more photographs during this time. Along with their three younger children (the eldest, Harry, had gone on to college in the United States), Ralph and Roberta returned to Beijing in the early fall of 1949 to take up work at Douw Hospital and relieve Harold Henke, who was leaving China. They arrived on October 1.[135] To avoid drawing attention to themselves as they returned to the now severely undermanned Presbyterian compound, the family—riding in pedicabs from

the railway station outside the city wall and then quietly huddled in Douw Hospital's service jeep—made a winding trip through deserted city streets. Coincidentally, at that moment, most of the city's population was gathered in Tiananmen Square to hear Mao Zedong proclaim the founding of the People's Republic. As the family drove along, they saw brilliant red banners strung up on buildings lining the streets and heard roaring cheers echoing from Tiananmen, later joking among themselves that the celebrations were intended for their return.[136] Although the Lewises continued to work and live in the PRC's new capital until September 1952—with the children, by virtue of their Caucasian features and the Sino-Soviet cooperation then in full force, often mistaken as Russians rather than Americans—they soon experienced the pressures of the new regime and anti-American sentiment that spilled over from the Korean War. The children jumped at executioners' gunshots instead of celebratory cheers and spotted limp bodies being carted through the streets, part of the new government's continued campaign in 1951–1952 against counterrevolutionaries, now far removed from the prying eyes of a larger international public.[137]

Much farther to the south, Frederick and Myra Scovel and their six children (the two eldest sons Jim and Carl then already enrolled at the SAS) encountered further experiential ironies while based at the Presbyterian-founded Hackett Medical Center, affiliated with Lingnan University in Guangzhou. Moving from north to south ahead of the Communist advance, the family departed in August 1948 from their previous posting in Huaiyuan, transported by aircraft from the nearby city of Bengbu.[138] They boarded the *St. Paul*, a C-47 transport operated by the Lutheran Church in China and reportedly kept operational with parts from a nonflying aircraft named the *St. Peter* (thus "robbing Peter to pay Paul"). Climbing to clear mountain ranges between Anhui and Guangdong Provinces, the children and the Scovels' frail grandmother, Louise, nearly passed out from oxygen deprivation in the unpressurized cabin.[139] In Guangzhou, Frederick finally renewed his 35 mm photography along with his medical activities as Hackett's superintendent. He produced Kodachrome slides that highlighted continued (and thoroughly modern) medical missionary activities there. These slides focused on the Chinese staff—including a blind female evangelist who preached using a Braille Bible and played the piano at services—and technologically advanced facilities, including a public address system with headphones by which bedridden patients could listen to sermons and songs broadcast from a central control room.

When the PLA finally entered Guangzhou on October 14, 1949, the Scovels suddenly found themselves having more in common with the Communist

occupiers than with the local population.[140] Having spent their entire prewar and wartime lives in North China, Frederick and Myra spoke Shandong-inflected Mandarin, a linguistic background that strongly separated both them and the PLA troops (many of whom also hailed from Shandong and other northern provinces) from the local Cantonese speakers.[141] The Scovels and the Communist arrivals thus felt a surprising kind of home-place bond when encountering each other on the ground in a part of South China that was comparatively foreign to both of them. Such odd but peaceful commonalities, however, belied more difficult shared fates. By March 1950, after Guangdong Province was largely under PRC control, the Scovels found themselves on the receiving end of Nationalist retaliation attacks launched against the mainland from Taiwan. On March 3, Nationalist bombs fell on Guangzhou. One, probably intended for the city's railway yards, detonated in an alleyway near the mission residence. The concussion knocked the Scovels' youngest son, Thomas, off of his feet (without seriously harming him) as he was running to his mother, who was frantically calling for him to take shelter.[142] Hackett Medical Center filled with bloodied and dying victims (some of whom were students from a bombed-out primary school), and a PLA antiaircraft gun emplaced next to the compound now fired into the sky in a futile attempt to defend both Chinese civilians and American missionaries against their former ally.[143] Frederick Scovel, a universal donor, quietly drew his blood to give to a Chinese woman whose leg had been torn off by an explosion, after which he was named a "hero" by the Communist authorities and gifted with a gold pen.[144]

The heating up of the post-1949 Cold War changed all of this.[145] Half a year later, as the Korean peninsula erupted in chaos, the same authorities organized public struggle sessions and regular interrogations of the Scovels and the other hospital staff, bombarding the mission in the meantime with recorded accusations broadcast from ubiquitous public loudspeakers. Allegations included stories that Frederick had received surreptitious air-dropped Nationalist materiel on the roof of his residence, neglected wounded patients under his care, and was altogether an enemy of the Chinese people and an "American imperialist spy."[146] Other rumors labeled Myra as Frederick's "concubine" and not his real spouse; these, combined with death threats shared with the younger Scovel children by local cadres, targeted the close-knit family.[147] As tensions mounted, Frederick discarded a broken pistol from ten-year-old Thomas's small collection of war detritus, lest it be used as evidence against them. Later, when the Communist police combed the Scovels' home for hidden weapons, Thomas himself playfully took part

in the search, realizing only later the stress his actions likely caused for his embattled parents.[148] Such were the dizzying ironies faced by American missionaries who lived through the early years of the PRC and into their shared countries' Cold War clashes in Korea.

In between these events in 1949–1950, Harold Henke was one of a few foreign witnesses to a vivid foretaste of Chinese Protestant Christianity's immediate future: one without Western missionaries. As Chinese Communist Party (CCP) leaders formulated approaches to urban control and infrastructure, land reform, and the country's political directions in the wake of the Nationalist withdrawal, so too did Chinese Christian leaders debate next steps for the Christian church in "new China"—even months before the PRC formally came to be. Henke, perhaps as the representative of the mission-organized Douw Hospital and a member of the Chinese Medical Association, was invited as one of only four foreign observers at the aptly titled "Peiping Religious Workers' Retreat," held on June 3–4, 1949, at the YWCA meeting hall.[149] Henke missed the morning session of the conference because of yet another emergency surgery at Douw and, when attending the second day, found the "language hard to understand."[150] One of his American Presbyterian colleagues, Robert C. Miller, and a longtime Methodist evangelist, Ellen M. Studley, however, were on hand to take copious notes, translating as furiously as they could from the rapid-fire discussions taking place before them.

The participants gathered there included individuals who would soon lead Chinese Protestant churches into a new, broadly nondenominational, PRC-aligned era. They expressed hopes and possibilities that differed radically from those held by missionaries in the post-1945 period. The attendees numbered well over fifty in all, and included theologian T. C. Chao (Zhao Zichen) of Yenching University, "representatives of the medical and educational institutions," and three "government representatives"—Y. T. Wu (Wu Yaozong), T. L. Shen (Shen Tilan), and H. J. Pu (Pu Huaren). These three were Protestant leaders and CCP supporters who would quickly become key figures in the post-1949 development of the Three-Self Patriotic Movement.[151] As Henke sat quietly (and apparently cameraless), the representatives debated their identities as Christians in relation to the Communist state and their role in forging a new Chinese Protestant organization divorced from the foreign missionary enterprise. The topics ranged from the role of modern theology (Chao's opening presentation was entitled "Faith for a New Day and Its Commission," citing intersections of scientific thought, Marxism, and Christian doctrines), to moderate views ("the [Chinese] Church will always have [a spiritual link] with the West. . . . American

money is from Christian brethren, not capitalists"), to approaches to religious militancy.[152] In regard to the third category, H. J. Pu delivered a closing talk entitled "What the Peoples' [sic] Government Hopes from the Christian Church." He outlined:

> Three possibilities for the Church: 1. To have clear discernment—those who are intelligent and alert, who move ahead with this tide; 2. Those who are standing still—the same as before. Complacent; 3. Those seeking faults or sleeping. The beginning church [*chuqi jiaohui*] was [a] property-less movement [in the first century AD]. Grew to transform the world. Saw many oppressed. [The] Church has changed. . . . The government hopes: 1. The Church leaders will study politics—let there be mutual criticism. Send letters of wrongs to Mao Tse Tung; 2. That the Church will not go back to its old ways, but go forward; 3. That the Church will give benefits to others . . . 4. That it will express its opposition to imperialists and feudalists; 5. That it will . . . excommunicate the Chiangs [e.g., Chiang Kai-shek], Kungs [e.g., H. H. Kung], Soongs [e.g., Soong Mei-ling], etc.; 6. That it will promote peace; 7. That it will oppose interference with China.[153]

Defining the new Chinese church against the old—and especially against its former allies in the Nationalist government and among Western powers—was one of the overriding themes of the conference. The other was expressions of support for (or submission to) the CCP in a broad sense and for a strong movement toward interdenominational unity.[154] Speakers strongly implied that missionaries had little or no part in this future, although none explicitly stated this; some more moderate speakers emphasized foreign missionary sacrifice and contributions to anti-Japanese forces in wartime China. Missionary modernity, already fading from the horizon in institutional form, was giving way to modern Chinese Christianity with its own structure and standing in the soon-to-be People's Republic. In fact, the compiler of the proceedings, Robert Miller, noted in his commentary, "It will interest you to know that this meeting limited the number of foreigners in order that all the Chinese leaders would feel perfectly free to criticize any aspect of the Church or mission program without fear of embarrassment to themselves or foreigners . . . I wish to add the assurance that the criticisms were always in a friendly and constructive vein. [All] . . . were anxious that the Church be enlarged and strengthened, that it be pliable enough to meet the needs and thinking of the new times." Miller's final note to readers was also framed as an inversion of "the loss of China"

narrative in constructive (and Marxist) terms, while subtly criticizing his own mission institution for its oversights:

> There are large numbers of people who think they know China, who keep saying, "We've seen these revolutions, and they are all the same. And this one will be like all the rest." But I do not believe that is true. This new tide of thought sweeping China has its counterpart in most of the countries of the world. Economic and colonial imperialism are about over as far as the East is concerned. Feudalism is rapidly losing out here[.] Racial equality is being insisted upon, and should be a reality. The Church should ever stand in the forefront of any battle that fights for the rights and equalities of the common man. The Church in the West is not outspoken against the various forms of exploitation that mankind is afflicted with.[155]

The church in the East, however, was seemingly a different story—and that story, at least in this moment and the years to follow, was not for foreign missionaries to tell.

This may well have been in Harold Henke's mind when he ventured out to Tiananmen Square on a sunny late spring or early summer day sometime around the Religious Workers' Retreat. While going about his medical and administrative duties, seeing off other Americans leaving China, partaking in religious services with remaining foreign and Chinese Christian colleagues, and enjoying whatever leisure activities he could manage (including watching more films, among them a "color movie—the *Spanish Main*, which [was] not too good" at the Chen Kuang Theater), Henke quietly collected material on "new China," perceiving that his time in the country was limited.[156] This material included a full set of English-language propaganda newspapers published under the *New China Daily* banner; these were the nascent forms of the present-day Xinhua News Agency. And four days before he left China for good, obtaining an official exit visa (*waiqiao chujing zheng*) only a day before his departure, Henke bought up unused sheets of PRC stamps from Beijing's Central Post Office (most simply over-stamped former Nationalist issues, so new was the government) as a present for his fifteen-year-old son, Richard, then awaiting his father's return in the United States.[157]

On the day he visited Tiananmen, however, Henke was repeating something he had done in China scores of times before. He stopped, raised the Cine-Kodak to his eye, and framed the massive red edifice in the folding optical viewfinder—its glass elements shrinking the view to a tiny projected image, as if seen from the far end of a tunnel. Henke pressed the release

lever and the spring motor whirred to life. The last of the Kodachrome film, somewhat damaged by heat and light after sitting in the camera unused for nearly a year, sped through the film gate. The running time was an agonizingly brief twelve seconds, as two horse-drawn carts rolled by, then ten seconds more, after Henke changed positions, approaching the gate and pointing upward at the dual portraits hanging there. This short footage would tell yet another story: the end of an age and the beginning of another one.

The smiling, larger-than-life faces of Mao Zedong and PLA Commander-in-Chief Zhu De, symbolically presiding over a nation moving into a new era of its own, looked out at the American missionary and his camera. Then the film ran out. There was simply no more material left for further imaging. In any case, by September 30 of that year, Henke and the Cine-Kodak were in a different place entirely, sailing east across the Pacific. Man and machine had missed the ceremonial founding of the People's Republic of China by a mere two days. Harold rejoined Jessie Mae and their family in Lockport, Illinois, soon afterward. There, they processed and watched the movie film, perhaps marveling at (and longing for) what and whom they had left behind. The couple also assembled a large number of black-and-white prints, some

Figure 5.4. Screenshot from final segment of 16 mm color film by Harold Henke, showing Tiananmen with portraits of Mao Zedong and Zhu De, 1949. HFC.

dating back to the first moments they had set foot on Chinese soil in 1927. Jessie Mae prepared paste and a pen. Before her and her husband lay an open book with fresh, blank pages: the *Chicago Tribune* scrapbook.

The Henkes' final visual practices aptly reflected the end of American missionary life and visual practices in modern China. After all, films and albums—like human lives, national revolutions, and photographic exposures—have a beginning and an end. Produced as part of historical moments in which uncertainty, hope, and loss defined missionaries' perceptions and imaginations in China, these visual materials were imbued with meanings that passed away as the pre-1949 mission enterprise became a memory. The convergences of Christianity, Chinese community, and American missions gave way to diverging historical trajectories, particularly as Christian institutions in China redefined their identities in the tumultuous decades to follow. The films and photographs, products of experiences from a now ended period, remained as visual-material traces of possibilities and losses just as meaningful for their makers as they were for their subjects. In some senses, not only were the missionaries leaving China but China, with its religious, cultural, and political changes, was leaving them. But these dual departures and the moments that led up to them were tied together not only by nostalgic imagination and memories of shared experiences but also by images. As the many missionaries began new lives elsewhere in the world, and the Chinese individuals with whom they were once linked went on with their own—in a new nation with its own uncertainties and opportunities— the photographs and films that bridged them remained. "All photographs are *memento mori*," but the opposite was true as well.[158] These images were also *memento vivere*: "Remember that you must live." The tensions and transcendences reflected in them may well have fitted the opening hymn of the Religious Workers' Retreat, sung together by the four American missionaries and the assembly of Chinese Christian leaders as their two groups diverged in time, space, and vision.[159]

O God, our help in ages past,	*Shangdi shi ren qiangu baozhang,*
Our hope for years to come,	*Shi ren jianglai xiwang,*
Our shelter from the stormy blast,	*Shi ren jusuo, diyu fengyu*
And our eternal home.	*Shi ren yongjiu jiaxiang.*
A thousand ages in Thy sight	*Zai shen yanzhong, yi qian wan nian,*
Are like an evening gone;	*Huang ruo renjian gesu,*
Short as the watch that ends the night	*Huang ruo chu wen, ziye zhong sheng*
Before the rising sun.	*Zhuanshun dongfang ri chu.*

Time, like an ever-rolling stream, *Shijian zheng shi dajiang liushui,*
Bears all its sons away; *Lang tao wanxiang zhongsheng,*
They fly, forgotten, as a dream *Zhuanshun feishi, huang ruo mengjing,*
Dies at the opening day. *Chao lai bu liu yu hen.*

O God, our help in ages past, *Shangdi shi ren qiangu baozhang,*
Our hope for years to come, *Shi ren jianglai xiwang,*
Our shelter from the stormy blast, *Shi ren jusuo, diyu fengyu,*
And our eternal home. *Shi ren yongjiu jiaxiang.*

Epilogue

Latent Images

The photography and filmmaking of American missionaries in China were products of transnational confluences—between global Christian missions, Chinese Christianity and national histories, US power and cultural influences in East Asia, and modern visual practices. The image-making experiences of the American missionary enterprise occupied strange spaces between visible realities, cultural and political imaginations, and religious faith—just as makers and subjects embodied transnational identities that did not fit a single cultural construct, national history, or political affiliation. And though the images framed time, place, and space, the contextualization and recontextualization of visual materials was hardly fixed. The elements of missionary modernity in China, like the visual practices and materials themselves, were subject to change over time. As moving frames, these identities and images contained tensions between temporally bounded existences and temporally capricious afterlives, mutable imaginations and photographically structured visions.

Missionary modernity and visual practices, as traced through the prewar, wartime, and postwar histories of Republican China, were historically contingent experiences. The religious and humanitarian activities in which American missionaries and Chinese Christians engaged from the 1920s to

the early 1950s were all predicated on interconnected (though not neatly parallel) global, national, and local conditions. The overlapping modernities of Nationalist governance, cross-cultural religious missions, and US diplomatic and commercial presences in East Asia, among others, provided driving engines and opportunities for the transnational lives discussed in this book. These conditions, with their own historical changes and contingencies, directly shaped missionaries' experiences and visual practices over time while also obscuring their visibility. The visual and existential world-making in which missionaries engaged was not merely the production of imperialist utopian visions or impositions of US power, though it included and complicated both. It was the visualization of experiences within a specific world of modern mission and Chinese Christianity—a world that, over time, was subsumed by the same histories of nation and global encounters in which it existed. And missionaries' specific visual practices and ways of seeing, overshadowed by the indexical visibility and malleability of their products, also faded from the broader historical record. Like exposed but yet unprocessed photographic negatives, the histories explored in this book are best analogized as latent images, existing at certain points in time, but now lying beneath larger historical narratives that flatten the granularities of the experiences and visions involved.

The greatest difficulty, therefore, is to determine how to develop these latent images—that is, how to select and draw analytical boundaries around such fluid experiences, meanings, and materials. This book offers new possibilities, attempting to recover a subset of historical experiences by looking at and through the scattered visual traces that remain. This is not the only approach that may be taken, given the capaciousness inherent in any history of images, imagination, and invisibility. In unsatisfactorily acknowledging the challenges of examining categories as multilayered as missionary modernity in China and as specific as missionary visual practices, I would like to end with a few remaining themes and tensions, focusing on the general temporal endpoint of the histories uncovered here and the fragmentary afterlives—of individuals, communities, and images—that extend beyond it.

As American missionaries left China behind in time and space, and as the missionary enterprise to which they formerly belonged faded after the founding of the People's Republic, many who had not reached the age of retirement continued their work in other parts of Asia. With pre-1949 missionary modernity supplanted by the competing Communist state in China, missionaries looked to new opportunities—alternative modernities—in other

parts of the world. Their linguistic, political, and cultural backgrounds, shaped by their previous experiences in China, played a role in this post-1949 reordering of the missionary enterprise, now framed by Cold War geographies.[1] In some cases, American missionaries shared diasporic trajectories with Chinese Christian expatriate communities as they moved away from the mainland and a government that was increasingly hostile to their activities.[2] People like Fr. William Klement, SJ, who had either lived in postwar China or were slated to take part in missions there (but completed their preparations as mainland-based institutions crumbled), now joined Catholic communities elsewhere, first in Hong Kong or the Philippines and then in Taiwan after the retreating Nationalist government secured political and social control over the island.[3] In parallel, the Protestant exodus resulted in the wide dispersal of former China missionaries to other regions. Ralph and Roberta Lewis and Frederick and Myra Scovel were among those who elected to continue their activities outside China. After living in Beijing until they were expelled during the height of the Korean War, the Lewises subsequently joined a Presbyterian medical mission working alongside Chinese communities in Bangkok, Thailand, where they would remain until 1972. After a short residence in New York, the Scovels returned to Asia to continue medical activities at the Ludhiana Christian Medical College in India's Punjab region. John and Margaret Bickford, the evangelists who worked with both the Lewises and the Henkes at Shunde, traveled the furthest geographically. They left Asia entirely to take up a new pastorate in West Africa.[4]

Each of these cases reflected a post-1949 turn to alternative missionary modernities, playing out in places outside mainland China where missionaries (or former missionaries) continued their lives and activities while drawing from prior experiences. Images that the missionaries produced in new locations reflected a profound shift in culture and a worldview that was no longer focused on China. In turn, visual materials produced in pre-1949 China now entered visual narratives that extended beyond their beginnings in a missionary modernity that no longer existed, in locations and among peoples that could no longer been seen (often quite literally) in the same ways they had been before the collapse. The ways in which missionary images were viewed by their creators thus shifted repeatedly during the Cold War, from the early PRC, to the violence of the Korean War and Cultural Revolution, to the reconfigurations of Sino-US relations that followed the 1972 rapprochement. Across this time, missionaries looked at pre-1949 with feelings of institutional failure and nostalgic longing. These feelings were reinforced by the

separation that missionaries felt in relation to former Chinese environments, particularly given the fact that nearly all photographic images of the mainland that circulated internationally were produced by state-sponsored channels.[5] China, however, did not entirely disappear from post-1949 American missionary consciousness. Missionary images' close association with former lived experiences and visions did not allow it. The presence of these visual materials on the walls of residences and churches, in photograph albums, and in slide projector trays and movie canisters all called for continual reimaginings of the past, foregrounding questions of what had been, what was no longer, and—far more tenuously—what might be.

Although further histories of American missionary photography and filmmaking in Asia after 1949 remain to be examined, their immediate afterlives in the 1950s bear mentioning here. Missionaries' visual practices exited the mainland with them, and their later careers redefined the material afterlives of their photographic equipment. Some missionaries continued to employ the same cameras they had used in China, whereas others discarded or retired them when the opportunity arose, especially when relocating to places with thriving photographic supply networks unaffected by Cold War polarization. Fr. Joseph Henkels, SVD, recorded in his missionary ledger that his first purchases after arriving in Hong Kong in September 1949 included large amounts of film, developing chemicals, and two new cameras: a higher-end German-made Leica IIIc rangefinder and an economical Argoflex twin-lens reflex built in Ann Arbor, Michigan.[6] He immediately put these to use, continuing his photography among Catholic groups in the city. Frederick Scovel, on returning to New York after his family's expulsion from Guangzhou in 1952, found that the Leica that had accompanied him in China over the last twenty-odd years was now beset with mechanical failures. As the Scovels' children recalled, Myra Scovel joked that her rudimentary Kodak Brownie took better photographs than her husband's far more expensive camera.[7] After an unsuccessful repair, the Leica was replaced with a new Kodak Signet, which became the family's primary camera for their mission in India.[8] The Lewises, leaving China for Thailand, made similar choices in regard to new photographic technology. After obtaining exit permits from Beijing for the entire family in 1952, the Lewises were photographed just before they boarded a commercial aircraft for their eastward journey. Their worn expressions reflect the stresses of abruptly leaving the country during anti-American protests, while slung under Ralph Lewis's arm is the well-used Rolleiflex he had brought to China in 1933, stored in its battered leather case.[9] The camera, like the enterprise it once documented, was fading into

obsolescence. The photograph itself (a Kodachrome slide) was made instead with Lewis's Kodak 35, a subtle indication that its form and products would become the standard for him and other missionary-photographers in the years to come.[10] Indeed, Lewis would produce far more color slides in Thailand than he did in China, where he and the Kodak 35 appeared in a photograph taken by his now-adult son, Harry, during a visit in the mid-1950s. The Lewises' Rolleiflex and the Scovels' Leica eventually vanished, discarded or simply misplaced over time.

Other missionaries decided not to return to Asia at all. Having dedicated years or decades to activities there, they now confronted the disappearance of institutions and communities in which they could operate. Harold and Jessie Mae Henke (apart from final trips to China that they undertook with their children in the late 1970s and 1980s) were among them. They, like many other middle-aged American missionaries, had anticipated a life spent in China predicated on the forms of missionary work, local familiarities, and national political climates with which they had engaged in the 1920s through the 1940s. Although the Henkes expressed a strong desire to return if possible, their medical mission and what they considered a normal life in China were largely erased along with the pre-1949 missionary enterprise.[11] Despite lengthy official correspondence urging the couple to consider new opportunities in Thailand, India, Iran, and Africa—specifically referencing Chinese communities in Southeast Asia—Jessie Mae and Harold ultimately concluded that familial ties and the challenges of language acquisition precluded any future return to missions.[12] After a month and a half of debate, the Henkes a submitted a brief but open-ended letter of resignation: "We hope that at some future time when and if it is possible to resume missionary work in China that we may again become missionaries of the Presbyterian Church."[13] The Henkes thereafter maintained medical practices in Lockport, Illinois, and Southern California (counting the Bickfords' grandchildren among their patients), before retiring on the east side of Los Angeles. Their latter days were spent surrounded by other elderly missionaries at Westminster Gardens, a retirement home founded by Frank M. S. Hsu, a Chinese businessman who received his early education at Presbyterian schools in North China.[14] The Henkes' films and photographs from China were joined over the decades by more US domestic images. The Cine-Kodak was retired and replaced by a smaller, more affordable 8 mm movie camera as the 16 mm format fell out of consumer favor in the 1950s and 1960s. Films of vacations and family gatherings, many produced by the Henkes' adult children, soon accompanied the aging mission films.[15] The *Chicago Tribune* scrapbooks that

were filled in the beginning with photographs of life in prewar and wartime China ended with color snapshots of family trips in the United States.

Similarly, whatever color slides missionaries made in the 1940s were soon joined by many more from post-China lives. Instead of representing churches, schools, and hospitals in an adopted country for transnational audiences, color slides from China joined realms of private display and imagination closer to the vacation images envisioned by Kodak commercial advertisements. They still maintained the ability to engage and awe audiences with technical magic not found in other forms of still photography, described by Darsie Alexander as "the scale of a slide projection, which made ordinary subjects bigger than life . . . the sharpness of a good slide glowing in the dark on an iridescent silver screen . . . [fostering] relationships, both visual and social."[16] But the meanings of these images had changed dramatically. Now mainly seen privately, if at all, by people for whom the missionary enterprise no longer existed, they were imbued with auras of nostalgia and loss. Being transported to that former world through slides did not carry the freshness of contemporary belonging and participation in China. Rather, as the Cold War redrew political, social, and religious lines across East and West, these feelings were replaced with a sense of dislocation and of looking through colorful, ultrarealistic lenses into times, places, and communities that were no longer. Part of this disruption was technological, as slides literally animated still images in the manner of a film and "the different frames captured a past moment that was taken *out of time*, like a photograph."[17] The slides and ways of seeing them metaphorically represented their viewers, makers, and contents. This visual technology reminded missionaries that though their lives and those of others in pre-1949 China once existed— undeniably relived in "lifelike" displays (in the words of Kodachrome advertisements)—these existences could never be fully recovered or returned to.[18] It also constructed a past in which idealized images superseded real challenges or made them painfully evident by reference to (or effacement of) living memory. It is not difficult to imagine the tenor of the stories, questions, and even disagreements as these color images of "old" China and the missionary enterprise crossed the screen in viewings by families and other close-knit groups.[19]

Traces of missionary imaging and images led far more fragile afterlives in the PRC itself. Across mainland China, Christian communities underwent tremendous internal and external pressure after 1949, with former denominational lines largely erased by the state-driven reforms of the Protestant Three-Self Patriotic Movement and the Chinese Patriotic Catholic

Figure E.1. Richard Henke preparing to screen his parents' 16 mm films from China using the family's Kodascope projector, July 29, 2013. Photograph by the author.

Association, the latter officially independent of the Vatican's ecclesiastical oversight.[20] This reorganization overlapped with violent campaigns to root out counterrevolutionaries and "rightist" intellectuals, as well as national traumas that accompanied the Great Leap Forward and the Cultural Revolution, during which even religious institutions sympathetic to the state were targeted for ostensibly harboring individuals with proforeign backgrounds or nonconformist sentiments.[21] Moreover, broad government oversight of educational and medical facilities across the nation (including the absorption of former missionary institutions) created a bloc of centralized state-provided public services that effectively wiped out competition from religious groups.[22] The Korean War also played a role in speeding the process of closing political ranks and missionary expulsion, further focusing state attention on ties between Chinese Christian communities and the United States and intensifying pressure to sever them in the service of national consolidation.[23]

In the meantime, public visual practices in the PRC were almost entirely relegated to government reportage and propaganda imaging. This occurred not only because of the general absence of camera-carrying Western individuals but also because popular photography in the former Republican era (with its connections to urban elites and commercial capitalism) was largely

decried as bourgeois culture, to be discarded in favor of revolutionary arts and a focus on state-sponsored visual production.[24] Thus, the kinds of images that missionaries had once produced, particularly in nonurban areas and communities, would not be seen outside of mainland China (or the state propaganda apparatus) for several decades after 1949.[25]

This breakdown of Christian community and the competing Communist state's supplanting of its Western cultural links extended not only to religious institutions' social identity and political allegiance but also to the symbolic structures and technologies formerly associated with foreign missionary activity that remained in evidence. Church buildings—gradually at first and then with increasing rapidity during the late 1950s and the 1960s—were occupied by work units (*danwei*) and largely stripped of their religious trappings.[26] Some were repurposed as warehouses, granaries, or meeting halls. Others were converted into movie theaters for screening state-sponsored films; after all, their existing architecture, with rows of front-facing pews and a prominent altar or preaching space, lent itself particularly well to both mass assembly and film projection.[27] This visible appropriation of religious buildings for political use (and in the case of churches-turned-theaters, the literal dissemination of political visions and messages in filmic form) highlighted state control over these former missionary or Chinese Christian spaces and their conversion from the sacred to the secular.

On a more private level, material objects like Bibles, religious icons, and church-oriented musical instruments were subject to destruction or confiscation, with unfortunate repercussions for their owners. One Protestant couple in Dali, Yunnan Province, Wu Yongsheng and Zhang Fengxiang, kept a small pump organ in their house—a gift from a US Army chaplain based in Yunnan during the Pacific War. The couple found it disassembled repeatedly by members of the CCP branch office overseeing the former missionary hospital at which they still worked.[28] The officials claimed that the pump organ, with its box-like wooden construction, concealed a wireless transmitter with which the accused Chinese Christians, Wu and Zhang, were communicating with Western enemies.[29] Although the specific reasons for these intrusions were decidedly tenuous, it was perhaps no accident that the investigators conflated the organ's literal ability to musically broadcast Christian hymns and the religious ideologies they represented with a hidden telegraphic link to now distant Western imperialism. For Chinese Christians, who by the late 1950s were reduced to meeting in underground groups or, otherwise, registering with government-sanctioned official churches, the suspicion of

Christian material objects and the radical conversion or closure of public worship spaces forced hard choices about making their religious practices and identities invisible.[30]

Under these circumstances, remaining visual materials that had been produced by missionaries and Chinese Christians were subject to various forms of censorship, resulting in fragmentation and loss. Some of this censorship took the form of the PRC government's top-down archival control over and associated restriction of public access to materials previously associated with the missionary enterprise.[31] In other cases, censorship was enacted on a private scale by Christian individuals and groups now under intense scrutiny from the state. Both these trajectories are challenging to track in the present day, but traces of the latter appear in the oral histories of people who lived through the decades following the missionaries' departure. As pressures increased for Chinese Protestants and Catholics—as well as for nonreligious individuals—to disavow their former (or presently suspected) partnerships with "imperialist" foreign institutions, images that represented such links were forced into invisibility.[32]

Although Liu Ju's husband, Li Qinghai, was well established in the PRC's new academia and committed to the CCP, her family—and their photographs—did not fully escape the ravages of the Cultural Revolution. At some point during the tumult of the mid-1960s, Red Guards in Wuhan searched Li and Liu's personal possessions, looking for evidence to fuel a struggle session against the family. One of the family's albums was carefully hidden, as it contained photographs made during Li's graduate education at Cornell University, his cross-country travels in the United States with members of the Works Progress Administration, and Liu's postwar work as a nurse in mission hospitals in Tianjin and Beijing.[33] This album was apparently not discovered, as no damage was done to it. A second album containing photographs from the family's life in the early PRC was not so fortunate. Prints were violently ripped out of the pages, either by the family prior to the search or by Red Guards themselves, only to be pasted back in later, some in shreds, when the threat of investigation was lifted. Some extant group photographs depict individuals with their faces scratched off the print with a sharp object. Was this literal defacement an act of revenge by external forces, or a private attempt to protect their identities? Although the album and its caretakers remain silent on this matter, it is not difficult to imagine what might have happened to the family (together with all of their visual materials) had the Red Guards uncovered the more damning images from Liu and Li's US-inflected past.

In similar circumstances, Chinese members of the former Presbyterian mission at Shunde reported quietly destroying any photographs that featured foreign colleagues and friends, to prevent them from being used by the authorities as evidence of subversive connections.[34] This destruction was often carried out by burning the images, simultaneously assuring their permanent disappearance and mirroring (whether on purpose or by coincidence) longstanding traditions in which paper money was burned at funerals or as part of ancestral worship to enrich the spirits of the deceased.[35] In any case, with the photographs incinerated, there was nothing left but dust and ashes to prove their owners' prior association with missionaries. These actions signaled a partial (in the case of hidden images) or complete existential break with the missionary enterprise, for reasons of security or ideological disavowal. At the same time, they represented the complicated, intimately felt meanings that Chinese Christians attached to visual material as traces of a different past. These images stood in for former relationships, community belonging, and other modern identities that now not only were supplanted by the state but also carried substantial risks to the possessors if publicly visible.

But times changed, and the images' meanings along with them. As the PRC and the United States reestablished diplomatic relations in the 1970s and transpacific travel to and from the mainland resumed, missionary images experienced various revivals in interest. Carrying decades-old photographic prints on their return visits to China, missionaries and their descendants retraced spaces formerly walked, searched for mission residences and structures (sometimes finding them repurposed to the point of unrecognizability or simply obliterated), and remapped landscapes that had undergone dramatic changes since their departure decades before.[36] In seeking out these connections, they were now tourists and passersthrough rather than long-term residents and members of a local community. But their visual materials enabled private forms of historical recovery. Aged images—exchanged in emotional reunions with Chinese friends and colleagues or displayed to strangers in searching for now-lost places and people—quietly helped to re-establish links to religious communities that had weathered the storms of the 1950s and 1960s. Cameras and video equipment, too, came along to document the return. Loaded with consumer color film or videotape, they sometimes replicated visual practices in the same spaces visualized by older lenses and devices.[37] Vernacular image-making, as before, served to bridge time, frame space, and script cross-cultural behaviors.[38]

On Jessie Mae Henke's final visit to China in 1987, during which she and Liu Ju met for the last time in life, she overheard a group of young bystanders asking aloud why these elderly foreigners were in the area. With equal parts jest and indignation, she stunned them by replying in Mandarin, "I was in China long before you were born!"[39] This encounter—with its bittersweet undertone, reference to a former embeddedness, and existential distance from Jessie Mae's first bewildered encounter with the country sixty years earlier—was not recorded visually. Yet, the sentiment of her retort was echoed in images made by others undertaking journeys of recovery and reunion in the same period. Children of the Bickford family, accompanying the Henkes on a prior trip in 1979, included in their color slides an image of an elderly Harold Henke chatting cheerily with a Mao suit–clad Chinese man of about the same age in Beijing.[40] Behind the two men, a sunlit pile of construction rubble in front of a multistoried building (possibly a hospital wing) gestures at yet another "new China"—that of the post-Mao era—coming into being. Although conversational rather than confrontational, the encounter and the slide that captured it harkened back to prior lives; the smiles and discussion could have easily taken place some fifty years earlier. In the fashion of inserting new slides into a projector tray of old ones, these experiences reanimated visual and historical narratives in a China that had also reinvented itself in the missionaries' thirty-to-forty-year absence.

In some ways, former missionary images became emblems of a quietly hoped-for future. Sino-US contacts across the last quarter of the twentieth century signaled new relationships, religious or otherwise, that could supersede, at the very least in cultural and institutional finesse, the failed missionary enterprise of the past. Together, the old images and the new ones made on return trips represented both recovery and dislocation, which were connected to the existential paradox of the indexical photograph in time.[41] In aiding viewers to remember former places and times and reconnect with older communities, images also heightened the strong sense of visible change. They reinforced the inability to truly recover the past other than in memory and imagination. No longer were these returnees people engaged in religious and humanitarian projects in China. The missionary modernity they had lived with, the institutions of which they were once an integral part, and the ethos behind their former experiences had passed away or evolved in ways unfamiliar to them. Many Chinese Christian communities now operated under state supervision and political pressures. Others were underground or unregistered groups with greater internal autonomy, indigenous cultural nuances, and theological fluidity than prior mission-organized

congregations.⁴² For every reconnection made, there were an equal number of fissures and changes to comprehend.

Now, in the third decade of the 2000s, another half century has passed since these trips took place. The majority of the participants (including growing numbers of their now elderly children) have passed on, and even the images from the trips have faded into obscurity in technology and meaning. So too, have collections of other color slides and films from the post-China missionary diaspora in Taiwan, Thailand, Japan, South Korea, India, and other places. They are visions and stories waiting to be rediscovered. Outside these frames, the China of Deng Xiaoping's "reform and opening-up" (*gaige kaifang*) has been replaced by other, newer versions—each less recognizable to former participants in the mission enterprise than the ones before. For these individuals, the pre-1949 missionary past, in many ways, is now just as foreign as the Chinese present.⁴³

On the other hand, the circulation of photographs and film that paralleled these renewed relationships across the late twentieth and early twenty-first centuries allowed Chinese Christian communities to reconstruct their own past in images. As in the Xingtai Grace Christian Church and numerous other religious, medical, and educational institutions with missionary roots across modern China, visual materials borrowed or reproduced from collections in the United States now serve as symbols of a recovered historical heritage. In some cases, they are a source of local pride. Rather than symbols of foreign oppression, they prefigure international cross-cultural connections, demonstrating these Christian communities' Sino-foreign contacts half a century or more before such connections revived from the 1980s through the 2000s.⁴⁴ In turn, a growing number of Chinese and international scholars studying missionary institutions (whether for their religious or secular dimensions) are giving greater attention to visual representations from the missionary enterprise.⁴⁵

Beyond religious or scholarly communities, missionary images now appear in numerous popular assemblages of "old photos" (*lao zhaopian*) in China and East Asia more broadly.⁴⁶ Whether in polished commercial publications, private collections and art galleries, or informal, sometimes haphazard displays on webpages and social media, they have captured the curiosity of new generations.⁴⁷ Their uses across these contexts represent both a remaking of memory (though to whom this memory belongs is an open question) and the creation of new vernacular ways of seeing history. At the same time, the new worlds in which these images exist are not immune to the vagaries of popular media trends, the souring of international relations (tainting the

visual content with foreignness yet again), or the slipperiness of authenticity—especially when packaged reality or manufactured nostalgia is involved in their presentation.[48] This leveraging of missionary images for new retellings is built on idealizations of the past and selective (or limited) contextualization of visual material in new narratives. Framing publications or texts often offer little discussion of the myriad complexities relating to missionary presence in China or antagonistic relationships to Chinese state power, then and now. Balancing between commemoration, appropriation, and critique is tricky and not without risks. After all, the ashes of burned photographs and the traumas of past conflicts still lie ghostly in many of the same places to which these images have returned, as well as in the new worlds through which they move.

Forgotten and recovered, contextualized and recontextualized, American missionary visual practices and materials in modern China continue to encompass deeply complicated resonances beyond the seemingly simple moment of raising a camera to the eye. The modern visions that enabled images' production, the peoples, times, and spaces that they represented, and the experiences colliding in the visual practices that produced them indelibly marked the identities of the two countries they drew together. Other perceptions and afterlives remain to be discovered in this visual medium, at once mysterious and illuminating. In their scriptural readings, missionaries and Chinese Christians alike meditated on the enigmatic verse: "Through faith we understand that the worlds were framed by the word of God, so that things which are seen were not made of things which do appear."[49] Something similar could be said of their images.

Acknowledgments

In completing this book during the global COVID-19 pandemic, I think often of friends and family whose presence is writ on these pages. As with the historical images and people whose stories appear on these pages, visual technologies and ways of seeing from afar bridge the distances of our time. Glowing screens and hopes for a better tomorrow—and that tomorrow together—connect us. No experience exists in true isolation, whether mental, physical, or spiritual. Neither did the creation of this book.

I cannot thank enough the many families who, in great trust and friendship, allowed me to work closely with the materials they preserved over the years. This book would not exist without my beloved friend Richard Henke, whose visit to the San Diego Chinese Historical Museum while I was working there as an undergraduate assistant planted the seed for my research in his parents' photographs and films. The rest of the work grew from that moment. His siblings, Robert Henke and Lois Henke Pearson (1937–2018), daughter Maria Henke Elswick, son-in-law Barry Elswick, and nephew David Henke aided my work with the Henke materials over the years. I count myself fortunate to have known Sophie Henke (1933–2013), Richard's wife, whose cheer and hospitality live on in my memory.

Harry Lewis, Cecile Lewis Bagwell (1935–2019), Charles Lewis, and Wendy Lewis Thompson gave generously of their father and mother's astounding collection of photographs, writings, and multimedia material, as well as their colorful memories and strong friendship. So too, did Carl and Faith Scovel, Tom Scovel, Jim Scovel, Anne Scovel Fitch, Judy Scovel Robinson, and Vicki Scovel Harris; their compassion, humor, and kindness over many years of research always made me feel never far from home. Clara Bickford Heer (1930–2015) and Ray Heer (1927–2015) shared photographs, mealtime conversations, and impromptu piano recitals in their Pasadena home, while also bringing me into contact with the Chinese Christian community in Xingtai. Their children, Gloria Lane, Carol Holsinger, and Grace Heer, continue their parents' tradition of care. Margaret Winfield Sullivan and her son, Charley Sullivan, entrusted me with their family's images and letters while also inspiring me with their stories and writing.

In Wuhan, Liu Ju (1917–2011)—whom I miss dearly—graciously shared her memories and personal photographs, while her son Li Weilai stood beside me and later spurred on my work from afar. In Xingtai, Dou Languang kindly introduced me to the historical legacies of his church community. In Taiwan, Archbishop Emeritus Joseph Ti-Kang's warm friendship and pastoral care (in my life as well as in the lives of my family over several decades) not only deepened my research but also demonstrated the tripartite fellowship of "faith, hope, and love." Teddy and Andrea Heinrichsohn, David and Gartha Angus, Mimi Hollister Gardner, Anne Lockwood Romasco (1933–2017), and other wonderful alumni of the pre-1950 Shanghai American School welcomed me to their group and their homes, listened with interest to my presentations, and contributed personal materials. This book and my journey as a historian exist because of these extraordinary individuals. My life is immeasurably richer for knowing them.

The Ricci Institute for Chinese-Western Cultural History at the University of San Francisco, the Passionist Historical Archives, and the Jesuit California Province Archives (formerly based at Santa Clara University, now at the Jesuit Archives and Research Center) made available vital sources on which this book is built. I am greatly indebted to Bro. Dan Peterson, SJ (Santa Clara University), Rev. Daniel Love (Rye Presbyterian Church, New York), Christopher Anderson (Yale Divinity School Library), David Miros and Ann Knake (Jesuit Archives and Research Center), Marcia Stein and Andrew Rea (Robert M. Myers Archives, Chicago Province of the Society of the Divine Word), and the Ricci Institute's truly incomparable staff: Fr. Antoni Ucerler,

SJ, Xiaoxin Wu, and Mark Mir. All these individuals hold a special place in my heart for their kindness and unwavering support (and in the case of Xiaoxin and Mark, for their shared interests in photography and classic cinema, respectively). Fr. Robert Carbonneau, CP, played a pivotal role in opening the Passionist China Collection for research. His personal care is a blessing, and reflects his dedication to ministry and scholarship. Jennifer Miko and Buck Bito at Movette Film Transfer in San Francisco skillfully digitized all the rare films examined in this book—permitting them to be widely viewed for the first time in decades—while sharing their extensive expertise in historical filmmaking technologies.

At the University of Michigan, Jay Cook taught me how to be a cultural historian while sharpening my scholarly and professional development. Penny Von Eschen demonstrated the importance of thinking seriously about global US experience and power. Pär Cassel strongly supported my interdisciplinary approaches to modern Chinese history and crucially launched wider public interest in my research. Sara Blair, with her characteristic brilliance and warmth, always encouraged me to make theories and practices of photography a central element in my studies. It is because of her that I am a historian of visual culture. Brandi Hughes showed me what it meant to be an empathetic scholar of transnational religion, while lively chats with Christian de Pee gave rise to the title of this book, among many other topics of interest. Hitomi Tonomura and Greg Parker were constant friends during and after my time at the Eisenberg Institute for Historical Studies. Over home-cooked meals and afternoon discussions, Jonathan Marwil led me to critically consider photography's connection to modern experience and to write in a way that was accessible to broader audiences.

Ernest P. Young, Nancy Bartlett, Michael Smith, Liangyu Fu, Carol Stepanchuk, and William Foreman each contributed to networks of support that made my project possible. Katie Lennard, Rachel Miller, Liz Harmon, Jacques Vest, and Pascal Massinon gave insightful comments on early drafts of this work. Amir Syed shared the thrill of photography with classic cameras while providing valuable advice in global historiography and the academic world. Jonathan and Kate Shaw graciously provided intellectual and spiritual nourishment and continue to transform lives with their educational and humanitarian work in Africa. Hajin Jun, Vivian Li, Hiroaki Matsusaka, Rie Kim, Anna Topolska, Fusheng Luo, Jaymin Kim, Nan Z. Da, Ananda Burra, Yoni Brack, Yaakov Herskovitz, Amanda Hendrix-Komoto, Marie Stango, Nevila Pahumi, and Roxana Maria Aras enriched my life in ways large and small.

Chief among friends who shaped my intellectual journey is Stephen Cox at the University of California, San Diego. Stephen encouraged my love for the humanities and was with me at every moment from my undergraduate years onward, always sympathizing with my struggles and cheering my successes. He taught me how to think, write, and teach as a historian, to appreciate the beauty of literature, and to "taste and see" the colorful histories of Christianity and the United States. This book is filled with the indelible marks of Stephen's deep friendship, generosity, and inspiration. No words can adequately express my tremendous gratitude to him.

Charlie Bright provided an unexpected opportunity to work on his grandfather's personal letters from wartime Hangzhou, a project that evolved from scholarly curiosity to an excellent coedited volume. Since then, he has walked beside me—sometimes literally, on neighborhood strolls—as I started faculty life and finished this book. Charlie gave generously of his time and energy to read the full book in multiple forms, provided crucial suggestions, and lightened many a day with his companionship and good humor. I am thankful for him, Susan Crowell, and their lovely family.

Paul Pickowicz, Li Huai, and Jeremy Brown nurtured my first explorations in modern Chinese history and made possible life-changing opportunities that merged my interests in visual and historical studies. Anthony Clark, Amanda Clark, Margaret Tillman, Jenny Huangfu Day, Maggie Greene, Daryl Ireland, Eugenio Menegon, Chloë Starr, Joseph Tse-Hei Lee, Christie Chui-Shan Chow, and Ronald Frank are the best colleague-friends one could ever wish for, and continue to inspire me with their amazing scholarship. They spurred on my work and freely contributed their time, resources, and expertise in bringing me into our community of scholars. Jennifer Lin and Carolyn Hsu-Balcer lent their enthusiastic support and interest, facilitating public engagements that I would not have previously thought possible. Dale and Sharon Lieu introduced me to the San Diego Chinese Historical Museum, setting in motion the events that led to my meeting with Richard Henke. I will always cherish their friendship and those of so many others whose paths crossed at Chinese Evangelical Church and Kairos Christian Church in San Diego.

At Albion College, Laura Brade, Chris Riedel, Marcy Sacks, Deborah Kanter, Wes Dick, and Carol Stout made the Department of History a home for me. Deborah provided helpful advice on publishing in the earlier stages of preparing this book. Laura, Chris, and Marcy gave priceless gifts of camaraderie and constant encouragement in teaching, research, and life. Beyond my department, Ron Mourad, Midori Yoshii, Elizabeth Palmer, Ashley

Feagin, Carrie Walling, and David Abbott opened new doors for interdisciplinary collaboration. My students urged me on with fresh ways of thinking as I introduced them to the sources and stories behind the book. Namara Swillum, Phillip Voglewede, Aislinn Meszaros, Noah Simmons, Mickey Benson, Chad Martin, and their peers made my first years as a "freshman professor" all the better. Ellen Wilch, Thom Wilch, and their relatives—Edgar T. Shields, Sr. (1927–2019), Peggy Shields Klein, Tom Shields, and Rick Shields—introduced me to their family's histories and photographs from late imperial China and colonial Korea.

I am grateful to the people who shepherded this book through its many stages. At Cornell University Press, Michael J. McGandy, Clare Jones, Emily Conroy-Krutz, David Engerman, Karen Hwa, Monica Achen, and Martyn Beeny provided vital support at every turn. Kathryn Deering read and copyedited earlier versions of the book with outstanding care, and kindly served as a sounding board on revisions. The Albion College Faculty Development Committee provided Hewlett-Mellon Large and Small Grants to aid production. I have benefitted from earlier publications of selected material, and wish to acknowledge these as follows:

Abridged portions of chapter 1 appeared in "'In Our Image': Visual Perception and American Protestant Missions in Interwar China," *UCLA Historical Journal* 23, no. 1 (2012): 43–61.

Some parts of chapters 1 and 3 appeared in "Imaging Missions, Visualizing Experience: American Presbyterian Photography, Filmmaking, and Chinese Christianity in Interwar Republican China," in *China's Christianity: From Mission to Indigenous Church*, ed. Anthony E. Clark (The Netherlands: Brill, 2017), 52–85. © Copyright 2017 by Koninklijke Brill NV, Leiden, The Netherlands.

Parts of chapter 2 appeared in "Cameras and Conversions: Crossing Boundaries in American Catholic Missionary Experience and Photography in Modern China," *U.S. Catholic Historian* 32, no. 2 (Spring 2016), 93–120. © 2016 by The Catholic University of America Press, Washington, D.C.

In considering further gifts of friendship that touched my life and this work, I am thankful for Ethan Yee's kindness, compassion, and brilliant historical expertise, which have been a true anchor over so many years. Tim Yu, Kristie Leong, and Michael Tang motivated me with their refreshing thoughts and humor, even while halfway across the country. Richard Yu at Contra Costa Gospel Church in Walnut Creek gave freely of his friendship

and spiritual guidance from my childhood onward, as well as opportunities to present my research to the East Bay's Chinese Christian communities. Leo Soong (1946–2021) shared delightful conversations and eye-opening family materials while also facilitating contact with scholars in China. Stephanie and Kevin Chen, Elizabeth and Daniel Eyler, Susan and Tomas Poloni, and their wonderful children blessed me and my family with their lively company.

Finally, my deepest gratitude goes to my family. My dad, Jimmy, and my mom, Patricia, encouraged me to embrace intellectual curiosity, the vibrant complexities of family history, and the art of storytelling. This book reflects their loving support in ways far too numerous to count. David, my brother, was always there for me, and I give thanks for his lifelong friendship. Our extended family in Taiwan—especially my aunt Wennie—nurtured my passions for all things photographic and historical from childhood on, while my mother-in-law, Jessica, ensured the timely completion of this book with her steadfast care over the challenging past months.

Jane and James remind me every day of life's joy, beauty, and wonder; I cannot imagine an existence without them. Above all, I owe everything to Jing, whose love and wisdom know no bounds. She has been the greatest inspiration to me since the day we met, the voice of reason in my obsessions, fellow adventurer in our journeys, and my best friend. This book is for her.

Notes

Introduction

1. Li Qinghai, photographic print, Beijing, 1948, Li/Liu Family Collection, Wuhan, China.

2. Liu Ju, personal interview by the author, May 22, 2011, Wuhan, China. The meeting with Liu was made possible by a chain of contacts via Li Weilai (Liu's son) and Richard P. Henke.

3. Richard P. Henke, personal interview by the author, May 2, 2010, Rolling Hills, California.

4. See also Susan Tucker, Katherine Ott, and Patricia Buckler, eds. *The Scrapbook in American Life* (Philadelphia: Temple University Press, 2006).

5. Identified as Ralph Charles Lewis, a medical missionary colleague and close friend of the Henkes who used a Rolleiflex Original (ca. 1929–1932) twin-lens-reflex camera with a Zeiss Tessar 75 mm f/3.8 lens.

6. Ralph C. Lewis, photograph, in Henke scrapbook album, HFC.

7. Liu Ju interview.

8. Robert C. Miller and Ellen M. Studley, "Peiping Religious Workers' Retreat, June 3–4, 1949," "Opening Worship Led by Bishop Chang; Hymn—O God Our Help in Ages Past," HFC; Isaac Watts, "O God, Our Help in Ages Past" (1719), no. 289, *The Hymnal of the Protestant Episcopal Church in the United States of America* (New York: Church Pension Fund, 1943).

9. Thomas Tweed, *Crossing and Dwelling: A Theory of Religion.* (Cambridge, Mass.: Harvard University Press, 2006), 54.

10. Carol C. Chin, *Modernity and National Identity in the United States and East Asia, 1895–1919* (Kent, Ohio: Kent State University Press, 2010), 103.

11. Lian Xi, *The Conversion of Missionaries: Liberalism in American Protestant Missions in China, 1907–1932* (University Park: Pennsylvania State University Press, 1997), 14–16, 21; David A. Hollinger,

Protestants Abroad: How Missionaries Tried to Change the World but Changed America (Princeton, N.J.: Princeton University Press, 2017), 9–10, 13.

12. Hollinger, *Protestants Abroad*, 8–11.

13. Daniel H. Bays, *A New History of Christianity in China* (Malden, Mass.: Wiley-Blackwell, 2011), 72, 94, 114–115.

14. Bays, *New History*, 92–124. For a view closer to Protestant missionaries' interwar perspectives, see also Kenneth Scott Latourette, *A History of Christian Missions in China* (New York: Macmillan, 1929).

15. Daniel H. Bays, "Foreign Missions and Indigenous Protestant Leaders in China, 1920–1955: Identity and Loyalty in an Age of Powerful Nationalism," in *Missions, Nationalism, and the End of Empire*, ed. Brian Stanley (Grand Rapids, Mich.: William B. Eerdmans, 2003), 144–147.

16. Ka-che Yip, "China and Christianity: Perspectives on Missions, Nationalism, and the State in the Republican Period, 1912–1949," in *Missions, Nationalism, and the End of Empire*, ed. Brian Stanley (Grand Rapids, Mich.: William B. Eerdmans, 2003), 132–140. See also Charles Bright and Joseph W. Ho, eds., *War and Occupation in China: The Letters of an American Missionary from Hangzhou, 1937–1938* (Bethlehem, Pa.: Lehigh University Press, 2017).

17. Bays, *New History*, 158–164; Yip, "China and Christianity," 140–143.

18. Timothy Brook, "Toward Independence: Christianity in China under the Japanese Occupation, 1937–1945," in *Christianity in China: From the Eighteenth Century to the Present*, ed. Daniel H. Bays (Stanford, Calif.: Stanford University Press, 1996), 317–337.

19. Hollinger, *Protestants Abroad*, 15–23.

20. Daniel H. Bays and Grant Wacker, "Introduction: The Many Faces of the Missionary Enterprise at Home," in *The Foreign Missionary Enterprise at Home*, ed. Daniel H. Bays and Grant Wacker (Tuscaloosa: University of Alabama Press, 1993), 1–3.

21. Ma Yunzeng, *Zhongguo sheyingshi, 1840–1937* (Beijing: Zhongguo sheying chubanshe, 1987), 16; Jean-Paul Wiest, "Understanding Mission and the Jesuits' Shifting Approaches toward China," in *Missionary Approaches and Linguistics in Mainland China and Taiwan*, ed. Ku Wei-ying (Leuven, Belgium: Ferdinand Verbiest Foundation; Leuven University Press, 2001), 45–47.

22. See Wu Hung, *Zooming In: Histories of Photography in China* (London: Reaktion, 2016); and Jeffery W. Cody and Frances Terpak, eds., *Brush and Shutter: Early Photography in China* (Los Angeles: Getty Research Institute, 2011).

23. Helmut Gernsheim, *A Concise History of Photography* (New York: Dover, 1986), 23–24; Mona Domash, *American Commodities in an Age of Empire* (New York: Routledge, 2006), 28–29.

24. Martha Sandweiss, *Print the Legend: Photography and the American West* (New Haven, Conn.: Yale University Press, 2002), 126–128.

25. I draw these references from oral history interviews, contemporary commercial advertisements and technical manuals, and close observations of photographic equipment that is preserved in family collections or that appears in missionary images or texts. For a history of Western photography in China prior to this period, see Terry Bennett, *History of Photography in China: Western Photographers, 1861–1879* (London: Bernard Quaritch, 2010).

26. Elizabeth Edwards and Janice Hart, "Introduction: Photographs as Objects," in *Photographs Objects Histories: On the Materiality of Images*, ed. Elizabeth Edwards and Janice Hart (New York: Routledge, 2004), 11–12.

27. *The Seventy-Ninth Annual Report of the Board of Foreign Missions of the Presbyterian Church in the United States of America* (New York: PC-USA Board of Foreign Missions, 1916), 146–147. The report notes: "One of the leading employees in the city book store . . . was first led to consider the claims of Christ by a conversation with a Christian photographer whom he met on the train, and is convinced that his mission lies in similar personal work."

28. See David Morgan, *Protestants and Pictures: Religion, Visual Culture, and the Age of American Mass Production* (New York: Oxford University Press, 1999); also Heather D. Curtis, *Holy Humanitarians: American Evangelicals and Global Aid* (Cambridge, Mass.: Harvard University Press, 2018), 22–24.

29. See Laura Wexler, *Tender Violence: Domestic Visions in an Age of U.S. Imperialism* (Chapel Hill: University of North Carolina Press, 2000); Emily Rosenberg, *Spreading the American Dream* (New York: Macmillan, 1982), 31.

30. Rosenberg, *Spreading the American Dream*, 8, 28–31.

31. Lian, *Conversion of Missionaries*, 11, 17–21; Michael G. Thompson, *For God and Globe: Christian Internationalism in the United States between the Great War and the Cold War* (Ithaca, N.Y.: Cornell University Press, 2015), 4–5. See also Heather D. Curtis, "Picturing Pain: Evangelicals and the Politics of Pictorial Humanitarianism in an Imperial Age," in *Humanitarian Photography: A History*, ed. Heide Fehrenbach and Davide Rodogno (New York: Cambridge University Press, 2015), 22–46.

32. See Curtis, *Holy Humanitarians*.

33. Ann Stoler, *Along the Archival Grain: Epistemic Anxieties and Colonial Common Sense* (Princeton, N.J.: Princeton University Press, 2010), 19–20.

34. William R. Hutchison, *Errand to the World: American Protestant Thought and Foreign Missions* (Chicago: University of Chicago Press, 1987), 4–5, 44–45.

35. See Derek Chang, *Citizens of a Christian Nation: Evangelical Missions and the Problem of Race in the Nineteenth Century* (Philadelphia: University of Pennsylvania Press, 2010); and Barbara Reeves-Ellington, Katherine Kish Sklar, and Connie A. Shemo, eds. *Competing Kingdoms: Women, Mission, Nation, and American Protestant Empire, 1812–1960* (Durham, N.C.: Duke University Press, 2010).

36. Jeffrey W. Cody and Frances Terpak, "Through a Foreign Glass: The Art and Science of Photography in Late Qing China," in *Brush and Shutter: Early Photography in China*, ed. Jeffrey W. Cody and Frances Terpak (Los Angeles: Getty Research Institute, 2011), 41–42, 53.

37. See William Shaefer, *Shadow Modernism: Photography, Writing, and Space in Shanghai, 1925–1937* (Durham, N.C.: Duke University Press, 2017).

38. Sandweiss, *Print the Legend*, 7.

39. See Joanna Sassoon, "Photographic Materiality in the Age of Digital Reproduction," in *Photographs Objects Histories: On the Materiality of Images*, ed. Elizabeth Edwards and Janice Hart (New York: Routledge, 2004), 186–202.

40. Bennett, *History of Photography in China*, 314.

41. "About," International Missionary Photography Archive, University of Southern California Digital Library, http://digitallibrary.usc.edu/cdm/about/collection/p15799coll123, accessed August 1, 2019.

42. Marshall McLuhan, *Understanding Media: The Extensions of Man* (Cambridge, Mass.: MIT Press, 1994), 8–12.

43. Roland Barthes, *Camera Lucida: Reflections on Photography*, trans. Richard Howard (New York: Hill and Wang, 1981), 76–77.

44. Barthes, *Camera Lucida*, 40.

45. Benedict Anderson, *Imagined Communities: Reflections on the Origin and Spread of Nationalism* (New York: Verso, 1991), 5–7.

46. Bays and Wacker, "Introduction," 1–3; see also Lian, *Conversion of Missionaries*, 7; and Hutchison, *Errand to the World*, 1–14.

47. Tweed, *Crossing and Dwelling*, 63–64.

48. Walter Benjamin, "The Work of Art in the Age of Mechanical Reproduction," in *Illuminations*, trans. Harry Zohn (New York: Harcourt, Brace and World, 1968), 224–225.

49. Bruno Latour, *Reassembling the Social: An Introduction to Actor-Network-Theory* (New York: Oxford University Press, 2005), 72.

50. Latour, *Reassembling the Social*, 79.

51. Jonathan Crary, *Techniques of the Observer: On Vision and Modernity in the Nineteenth Century* (Cambridge, Mass.: MIT Press, 1990), 8–9.

52. Edwards and Hart, "Introduction," 11.

53. Edwards and Hart, Introduction," 12.

54. Edwards and Hart, Introduction," 11.

55. W. J. T. Mitchell, "The Photographic Essay: Four Case Studies," in *Picture Theory: Essays on Verbal and Visual Representation* (Chicago: University of Chicago Press, 1985), 289.

56. Ryan Dunch, "Science, Religion, and the Classics in Christian Higher Education to 1920," in *China's Christian Colleges: Cross-Cultural Connections, 1900–1950*, ed. Daniel H. Bays and Ellen Widmer (Stanford, Calif.: Stanford University Press, 2009), 68–69.

57. See Jane Hunter, *The Gospel of Gentility: American Women Missionaries in Turn-of-the-Century China* (New Haven, Conn.: Yale University Press, 1989); also Chin, *Modernity and National Identity*, 81–103.

58. Susan Sontag, *On Photography* (New York: Farrar, Straus and Giroux, 1978), 13–15.

59. See Judith Liu, *Foreign Exchange: Counterculture behind the Walls of St. Hilda's School for Girls, 1929–1937* (Bethlehem, Pa.: Lehigh University Press, 2011); Jessie G. Lutz, ed., *Pioneer Chinese Christian Women: Gender, Christianity, and Social Mobility* (Bethlehem, Pa.: Lehigh University Press, 2010); Garrett L. Washington, ed., *Christianity and the Modern Woman in East Asia* (Leiden, The Netherlands: Brill, 2018); and Connie A. Shemo, *The Chinese Medical Ministries of Kang Cheng and Shi Meiyu, 1872–1937: On a Cross-Cultural Frontier of Gender, Race, and Nation* (Bethlehem, Pa.: Lehigh University Press, 2011).

60. Hollinger, *Protestants Abroad*, 7–8; Bays, *New History*, 79–80; Gail Hershatter, *Women and China's Revolutions* (Lanham, Md.: Rowman and Littlefield, 2018), 46–52. See also Cindy Yik-yi Chu, *The Chinese Sisters of the Precious Blood and the Evolution of the Catholic Church* (New York: Palgrave Macmillan, 2016); Ji Li, *God's Little Daughters: Catholic Women in Nineteenth-Century Manchuria* (Seattle: University of Washington Press, 2015); and Peter J. Conn, *Pearl S. Buck: A Cultural Biography* (Cambridge: Cambridge University Press, 1998).

61. See Laura Wexler, *Tender Violence: Domestic Visions in an Age of U.S. Imperialism* (Chapel Hill: University of North Carolina Press, 2000); also Harriet Riches, "Picture Taking and Picture Making: Gender Difference and the Historiography of Photography," in *Photography, History, Difference*, ed. Tanya Sheehan (Lebanon, N.H., Dartmouth College Press, 2015), 128–150.

62. See Motoe Sasaki, *Redemption and Revolution: American and Chinese New Women in the Early Twentieth Century* (Ithaca, N.Y.: Cornell University Press, 2016).

63. See Wexler, *Tender Violence*; also Jay Taylor, *The Generalissimo: Chiang Kai-shek and the Struggle for Modern China* (Cambridge, Mass.: Harvard University Press, 2009).

64. See Chloë Starr, *Chinese Theology: Text and Context* (New Haven, Conn.: Yale University Press, 2016).

65. See Wu, *Zooming In*, 219–249; also Sontag, *On Photography*, 71, 74–75.

66. J. Lorand Matory, "The Many Who Dance in Me: Afro-Atlantic Ontology and the Problem with 'Transnationalism,'" in *Transnational Transcendence: Essays on Religion and Globalization*, ed. Thomas J. Csordas (Berkeley: University of California Press, 2009), 238.

67. Author, personal email to Li Weilai, August 13, 2011.

68. Li Weilai, personal email to the author, August 29, 2011.

69. From the Nicene Creed, shared by Catholic and creedal Protestant churches: "I believe in one God, the Father Almighty, Maker of heaven and earth, and of all things visible

and invisible." For examples in English, Latin, and Chinese, see Andrew Ewbank Burn, *The Nicene Creed* (New York: Edwin S. Gorham, 1909), 2–3; Francis Xavier Lasance and Francis Augustine Walsh, *The New Roman Missal in Latin and English* (New York: Benziger Brothers, 1942), 765–766; *Gong dao shu* [Book of common prayer] (Shanghai: American Episcopal Church, 1932), 20.

1. New Lives, New Optics

1. John A. Jackle, *Common Houses in America's Small Towns: The Atlantic Seaboard to the Mississippi Valley* (Athens: University of Georgia Press, 1989), 157–162.

2. Dou Languang, interview with the author, June 7, 2011, Xingtai, China.

3. Li Gucheng, ed. *A Glossary of Political Terms of the People's Republic of China* (Hong Kong: Chinese University Press, 1995), 412–413.

4. Dou interview; *Statistical Atlas of Christian Missions: Containing a Directory of Missionary, a Classified Summary of Statistics, an Index of Mission Stations, and a Series of Specially Prepared Maps of Mission Fields* (Edinburgh, Scotland: World Missionary Conference, 1910), 121.

5. *Statistical Atlas*, 121. See also *A Pen Picture of Shuntehfu Station, Presbyterian Mission, North China* (n.p., 1934).

6. Wang Ye and An Wei, eds., *Xingtai shi jidu jiaotang yibai zhounian jinian yingji* [The commemorative photo album of the 100th anniversary of the Xingtai city Christian church] (Xingtai, China: Xingtai Christian Council, 2003), 8.

7. *The Seventy-Ninth Annual Report of the Board of Foreign Missions of the Presbyterian Church in the United States of America* (New York: PC-USA Board of Foreign Missions, 1916), 146–147.

8. Harold Eugene Henke and Jessie Mae Henke, "Shuntehfu Hospital Bulletin," December 17, 1934, HFC. See also Paul P. Wiant, *The Long Way Home* (Fuzhou, China: Bing Ung, 1930).

9. Wang Ye, personal email to the author, August 10, 2013.

10. Roland Barthes, *Camera Lucida: Reflections on Photography*, trans. Richard Howard (New York: Hill and Wang, 1987), 76–77.

11. Peter Zarrow, *China in War and Revolution, 1895–1949* (New York: Routledge, 2005), 183–187.

12. Soong Mei-ling, *General Chiang Kai-shek and the Communist Crisis* (Shanghai: China Weekly Review Press, 1935), 55–73.

13. Daniel Fleming, *Whither Bound Missions?* (New York: Association, 1925), 86–87.

14. William R. Hutchison, *Errand to the World: American Protestant Thought and Foreign Missions* (Chicago: University of Chicago Press, 1987), 139–140. See also Daniel H. Bays, *A New History of Christianity in China* (Malden, Mass.: Wiley-Blackwell, 2012), 106–107, 121–123.

15. Hutchison, *Errand to the World*, 13; Bays, *New History*, 121–123.

16. Ralph C. Lewis, letter to parents from Hengzhou, November 1, 1934, LFP. See also Hutchison, *Errand to the World*, 11–14.

17. "Modern Significance of the Missionary," *Chinese Recorder* 60, no. 7 (July 1929): 412.

18. Chloë Starr, *Chinese Theology: Text and Context* (New Haven, Conn.: Yale University Press, 2016), 44–47.

19. Starr, *Chinese Theology*, 44–47.

20. Starr, *Chinese Theology*, 44–47. "Many therefore of his disciples, when they had heard this, said, This is an hard saying; who can hear it?" John 6:60 (King James Version).

21. He Hanwei, *Jinghan tielu chuqi shilue* [A brief history of the early Beijing-Hankou Railway] (Hong Kong: Chinese University Press, 1979), 33; Zarrow, *China in War and Revolution*, 305–306.

22. Bays, *New History*, 69–70. See also Sean Hsiang-lin Lei, *Neither Donkey Nor Horse: Medicine in the Struggle over China's Modernity* (Chicago: University of Chicago Press, 2014), 128–129; Daniel H. Bays and Ellen Widmer, eds., *China's Christian Colleges: Cross-Cultural Connections, 1900–1950* (Stanford, Calif.: Stanford University Press, 2009); Charles Bright and Joseph W. Ho, eds., *War and Occupation in China: The Letters of an American Missionary from Hangzhou, 1937–1938* (Bethlehem, Pa.: Lehigh University Press, 2017), 80, 103.

23. Lian Xi, *The Conversion of Missionaries: Liberalism in American Protestant Missions in China, 1907–1932* (University Park: Pennsylvania State University Press, 1997), 160–161.

24. Stephen R. Halsey, *Quest for Power: European Imperialism and the Making of Chinese Statecraft* (Cambridge, Mass.: Harvard University Press, 2015), 248–249.

25. Halsey, *Quest for Power*, 249.

26. See Qiliang He, *Newspapers and the Journalistic Public in Republican China: 1917 as a Significant Year of Journalism* (New York: Routledge, 2019).

27. Lane Jeremy Harris, "The Post Office and State Formation in Modern China, 1896–1949" (PhD dissertation, University of Illinois at Urbana-Champaign, 2012), 270.

28. Kathleen L. Lodwick, "Introduction," in *The Chinese Recorder Index: A Guide to Christian Missions in Asia, 1867–1941*, ed. Kathleen L. Lodwick (Lanham, Md.: Rowman and Littlefield, 1986), xiii–xvi.

29. *Chinese Recorder* 68 (1937).

30. Lodwick, "Introduction," xii.

31. *Chinese Recorder* 60, no. 5 (May 1929): xvii; *Chinese Recorder and Educational Review* 72, no. 5 (May 1941): i, iv.

32. Leo Ou-fan Lee, *Shanghai Modern: The Flowering of a New Urban Culture in China, 1930–1945* (Cambridge, Mass.: Harvard University Press, 1999), 16–17.

33. Harry W. Lewis, interview with the author, July 23, 2013, Sacramento, California; also Margaret Sullivan, personal email to the author, October 8, 2014.

34. Ralph C. Lewis, letter from Peiping to Dr. E. A. Van Nuys, pastor of Calvary Presbyterian Church, San Francisco, November 4, 1933, LFP.

35. Jim Scovel and Carl Scovel, interview with the author, July 18, 2014, Walnut Creek, California.

36. Smaller denominations with less funding (e.g., those participating in nonmainline "faith-based" missions) were typically unable to supply their missionaries with such devices. Jim Bard, interview with the author, August 14, 2011, Sacramento, California. See also Ruth J. Bard, *In the Service of the King of Kings: My Testimony of God's Miraculous Grace and Power* (Erzhausen, West Germany: Leuchter-Verlag, 1963); and Lodwick, "Introduction," xiii.

37. "Radio Evangelism," in "Work and Workers," *Chinese Recorder* 67, no. 6 (June 1937): 400. See also Michael A. Krysto, *American Radio in China: International Encounters with Technology and Communications, 1919–41* (New York: Palgrave Macmillan, 2011).

38. Erich Stenger, *Die Geschichte der Kleinbildkamera bis zur Leica* (New York: Arno, 1979), 49–56, 63–65; Richard L. Simon, *Miniature Photography from One Amateur to Another* (New York: Simon and Schuster, 1937), 16. See also Werner Wurst, *Exakta Kleinbild-Fotografie* (Halle, Germany: Wilhelm Knapp Verlag, 1956); and Walther Heering, *The Rolleiflex-Book*, trans. John L. Baring (New York: Burleigh Brooks, 1935), 12.

39. Simon, *Miniature Photography*, 13, 148.

40. Simon, *Miniature Photography*, 17.

41. Stenger, *Die Geschichte der Kleinbildkamera bis zur Leica*, 64–65.

42. Simon, *Miniature Photography*, 12, 65–66.

43. C. E. Kenneth Mees, *Photography* (New York: Macmillan, 1937), 35.

44. Mees, *Photography*, 33–35.

45. *Chinese Recorder* 68, no. 12 (December 1937): i.

46. Mees, *Photography*, 57.

47. Roberta Taylor Lewis, photographic print, flipbook album, LFP. In this image made by Roberta, Ralph Lewis uses his Rolleiflex twin-lens-reflex to photograph the ocean at Beidaihe in the summer of 1934.

48. Harold Eugene Henke, personal letter to friends Ethel and Harlan Palmer, October 23, 1927, HFC.

49. Henke letter to Ethel and Harlan Palmer.

50. Henke letter to Ethel and Harlan Palmer. See also Harold Eugene Henke and Jessie Mae Henke, "Crossing from Japan to China on the Chozo Marie [*sic*], 10-2-27 with Dr. & Mrs. Turner," photographic print, "Photographs" album, HFC.

51. Henke letter to Ethel and Harlan Palmer.

52. Harold Eugene Henke and Jessie Mae Henke, "In the Inland Sea, a fishing junk sailing at full speed, 9-'27," "In the Inland Sea, typical fishing junk," photographic prints, "Photographs" album, HFC.

53. Henke letter to Ethel and Harlan Palmer.

54. Harold Eugene Henke and Jessie Mae Henke, "The wharf where we landed at Tangku, China," photographic print, October 2, 1927, HFC.

55. The still cameras used by the Henkes in China are no longer in the extant family collection, and are presumed lost. The descriptions here and elsewhere in the book are based on careful analysis of existing images.

56. Jessie Mae Henke, "Family History," 11, HFC.

57. Henke, "Family History," 11.

58. Henke and Henke, "The wharf where we landed at Tangku, China."

59. Jessie Mae Henke, "Substance of My Talk on China to Groups," 1, HFC.

60. Henke, "My Talk," 1.

61. Henke, "Family History," 11.

62. Henke letter to Ethel and Harlan Palmer; Henke, "Family History," 11.

63. Jessie Mae Henke, personal letter to friends, November 14, 1927, HFC.

64. Henke letter to Ethel and Harlan Palmer.

65. Jessie Mae Henke, personal letters to friends, November 14, 1927, December 4, 1927, HFC.

66. Harold Eugene Henke and Jessie Mae Henke, "General Scenes," photographic prints, HFC.

67. Henke letter to Ethel and Harlan Palmer.

68. Henke and Henke, "General Scenes"; Harold Eugene Henke and Jessie Mae Henke, "The Temple of Heaven . . . 1927," photographic print, HFC.

69. Harold Eugene Henke and Jessie Mae Henke, "The famous dragon screen in the Pei Hai," photographic print, HFC.

70. Commercial photographic prints, ca. 1927–1928, HFC. See also Hedda Morrison, *A Photographer in Old Peking* (Hong Kong: Oxford University Press, 1986), 1. A previous discussion of Morrison's work appears in Joseph W. Ho, "Images of Nation: Western Photographers in Wartime China," *Wittenberg University East Asian Studies Journal* 39 (2009): 32–44.

71. Harold Eugene Henke and Jessie Mae Henke, "Taken at the main cross streets 2 ½ blocks from here & called SSu-Pailou," photographic print, ca. 1927–1928, HFC.

72. Bays, *New History*, 112.

73. Richard P. Henke, interview with the author, July 26, 2011, Rolling Hills, California.

74. Harold and Jessie Mae Henke, uncategorized photographic print, HFC.

75. Hsi-Sheng Ch'i, *Warlord Politics in China, 1916–1928* (Stanford, Calif.: Stanford University Press, 1976), 226.

76. Henke, "Family History," 12. See also Arthur Waldron, *From War to Nationalism: China's Turning Point, 1924–1925* (Cambridge: Cambridge University Press, 2003), 263; and Lloyd Eastman, *The Nationalist Era in China, 1927–1949* (Cambridge: Cambridge University Press, 1991), 9.

77. Ch'i, *Warlord Politics in China*, 226.

78. Madeleine Yue Dong, "Defining Beiping: Urban Reconstruction and National Identity, 1928–1936," in *Remaking the Chinese City: Modernity and National Identity, 1900–1950*, ed. Joseph W. Esherick (Honolulu: University of Hawaii Press, 2002), 121, 123–125.

79. "The Car General Chang Rode In," commercial photographic print, Bickford Family Papers, Bentley Historical Library, University of Michigan, Ann Arbor.

80. Mayumi Itoh, *The Making of China's War with Japan: Zhou Enlai and Zhang Xueliang* (Singapore: Palgrave Macmillan, 2016), 63–66.

81. Jessie Mae Henke, personal letter, January 20, 1929, HFC.

82. *Report of Medical Work at Shuntehfu, Hopei, North China—American Presbyterian Mission* (n.p., 1931), 22, HFC.

83. "Talcott, James," in *The Cyclopedia of American Biography*, ed. James E. Homans (New York: Press Association Compilers, 1918), 164; *The Eighty-Third Annual Report of the Board of Foreign Missions of the Presbyterian Church in the United States of America* (New York: Presbyterian Board of Foreign Missions, 1920), 148–150.

84. *Report*, 1931, 1.

85. *Report*, 1931, 1; Jessie Mae Henke, "Occupational" film narration, HFC.

86. Henke, "My Talk," 3. For parallel antiforeign rumors from an earlier time, see Ida Pruitt, *A Daughter of Han: The Autobiography of a Chinese Working Woman* (Stanford, Calif.: Stanford University Press, 1967), 63.

87. Jessie Mae Henke, "Our Life in China in Early Years, 1927–1940," HFC.

88. Henke, "My Talk," 3; *Report*, 1931, 1.

89. *Report*, 1931, 22.

90. *Report*, 1931, 1; Henke, "Occupational" film narration.

91. Harold Eugene Henke and Jessie Mae Henke, "Medical Facilities—Shuntehfu," photographic prints, HFC. The address penciled on the backs of these photographs reads, "570–10451 Atterbury Butler Hall 400 W. 19th NY 10027."

92. Henke and Henke, "Medical Facilities—Shuntehfu"; Harold Eugene Henke and Jessie Mae Henke, "Grace Talcott Hospital," photographic print, HFC.

93. Henke and Henke, "General Scenes"; Harold Eugene Henke and Jessie Mae Henke "Drilling for water at Shuntehfu, China[,] May 1935," "The apparatus for drilling the well[,] May 1935," photographic prints, HFC.

94. Harold Eugene Henke and Jessie Mae Henke, "Medical Staff—Shuntehfu," photographic prints, HFC.

95. Henke and Henke, "Medical Staff—Shuntehfu"; Harold Eugene Henke and Jessie Mae Henke, "The Students," photographic print, HFC.

96. "Hebei Shunde fuying yiyuan fushi fusheng quanti huansong Wei fushizhang fanguo jinian" [Hebei Shunde Gospel Hospital class of nurses and nursing students, seeing off superintendent Witmer on her departure to her homeland], photographic print, 1931, HFC.

97. *Report*, 1931, 1.

98. "China Records and Notes," HFC.

99. *Report*, 1931, 5.

100. *Report of Medical Work, American Presbyterian Mission, Shuntehfu, Hopei, North China, 1939* (n.p., 1939), 8–9, HFC.

101. *Report*, 1939, 12.

102. See Larissa N. Heinrich, *The Afterlife of Images: Translating the Pathological Body between China and the West* (Durham, N.C.: Duke University Press, 2008).

103. Henke, "Occupational" film narration.

104. Harold Eugene Henke and Jessie Mae Henke, "Medical Practice," "Child Ear Growth," photographic prints, HFC. The author expresses his sincere thanks to Elliot Ho, DO (University of Chicago Medical Center) and Corinne Lieu Schmidt, MD (Phoenix Children's Hospital) for their assistance in describing these and other medical conditions.

105. Henke and Henke, "Medical Practice"; Harold Eugene Henke and Jessie Mae Henke, "Von Recklinghausen," photographic print, HFC.

106. Henke and Henke, "Medical Practice"; Harold Eugene Henke and Jessie Mae Henke, "Is this a tumor of the retina??," photographic print, HFC.

107. Ralph C. Lewis, "China Years: His Story of Those Years in the Life of Ralph Charles Lewis (Growing Up and His Life in China through the War Years)," unpublished personal memoirs, in the author's possession, 123.

108. Lewis, "China Years," 6, 61, 75.

109. Harry Lewis, Cecile Lewis Bagwell, Charles Lewis, and Wendy Lewis Thompson, interview with the author, July 4, 2011, Mt. Hermon, California. Harry, the eldest child, recalled his father saying to him as a young boy, "Don't come in when the red light goes on," alluding to the darkroom in their mission residence in China.

110. Lewis, "China Years," 95.

111. Ralph C. Lewis, personal letter to parents, October 18, 1933, LFP.

112. Ralph C. Lewis, letter to parents, December 17, 1933, LFP.

113. Ralph C. Lewis, untitled photographic print, December 1933, LFP. *Shangdi shengdian, tianshang rongguang gui zhu min, dishang ping'an guiyu ren.* Habakkuk 2:20, Psalm 19:1, and Luke 2:14 (Chinese Union Version).

114. Lewis to parents, December 17, 1933.

115. Lewis, "China Years," 123.

116. Ralph C. Lewis, "The Hengchow Pres. Church after the memorial service for Dr. C. F. Brown who was fatally injured in auto accident Sept. 23, 1934 in Oklahoma," photographic print, small notebook album, LFP. 1 Corinthians 13:13 (American Standard Version), "But now abideth faith, hope, love, these three; and the greatest of these is love."

117. Lewis, "The Hengchow Pres. Church after the memorial service for Dr. C. F. Brown who was fatally injured in auto accident Sept. 23, 1934 in Oklahoma."

118. Lewis, "The Hengchow Pres. Church after the memorial service for Dr. C. F. Brown who was fatally injured in auto accident Sept. 23, 1934 in Oklahoma."

119. Hebrews 11:1 (American Standard Version).

120. Lewis, "China Years," 99, 111.

121. Lewis, "China Years," 99.

122. Lewis, "China Years," 112.

123. James L. Watson, "The Structure of Chinese Funerary Rites: Elementary Forms, Ritual Sequence, and the Primacy of Performance," in *Death Ritual in Late Imperial and Modern China*, ed. Evelyn S. Rawski and James L. Watson (Berkeley: University of California Press, 1988), 12. Sun Yat-sen's Christian funeral rites featured a large photographic portrait of the deceased leader. See Frederic Wakeman, Jr., "Mao's Remains," in Rawski and Watson, *Death Ritual*, 257.

124. Lewis, "China Years," 111.
125. Lewis to parents, November 1, 1934.
126. Lewis, "China Years," 111.
127. Lewis to parents, November 1, 1934.
128. Lewis, "China Years," 112; also Lewis to parents, November 1, 1934.

2. Converting Visions

1. An earlier iteration of this chapter was published as "Cameras and Conversions: Crossing Boundaries in American Catholic Missionary Experience and Photography in Modern China," *U.S. Catholic Historian* 34, no. 2 (Spring 2016): 93–120.

2. For an oral history of George Tootell's day-to-day experiences and medical missions in Hunan, see *China Missionaries Oral History Project: George T. Tootell* (Claremont, Calif.: Claremont Graduate School Oral History Program, 1971).

3. Raphael Vance and Agatho Purtill, "Diary of Frs. Agatho and Raphael, C.P. (First Band of American C.P. Missionaries to China), Dec. 11, 1921 to March 9, 1922," February 9, 1922, 28, file 505.02_007, Missionary Administrative Correspondence, PCC. Chenzhou (Shenchow or Shenchowfu, as it appears in period sources), the previous name of the city now called Yuanling, is not to be confused with present-day Chenzhou, a different city located over two hundred and fifty miles southeast of the region discussed in this chapter.

4. Vance and Purtill, "Diary," February 7, 1922, 28.

5. Vance and Purtill, "Diary," February 15, 1922, 30. See Daniel H. Bays, *A New History of Christianity in China* (Malden, MA: Wiley-Blackwell, 2012), 113–114; and Ernest P. Young, *Ecclesiastical Colony: China's Catholic Church and the French Religious Protectorate* (New York: Oxford University Press, 2013), 121–147, 171–232.

6. Vance and Purtill, "Diary," March 1, 1922, 31.

7. Vance and Purtill, "Diary," March 2, 1922, 31.

8. Vance and Purtill, "Diary," March 3, 1922, 32.

9. George Tootell, coincidentally, was a close colleague and personal friend of Ralph C. Lewis. The latter worked in Hengzhou, Hunan Province, in the mid-1930s before joining the Shunde mission in North China.

10. Bays, *New History*, 113–115.

11. Raphael Vance, report typed on the *Oriental Limited*, Chicago to Seattle, December 20–22, 1921, 5, file 505.01_007.009, PCC.

12. Vance report, 5.

13. Vance and Purtill, "Diary," December 24–25, 1921, January 6, 1922, 8–9, 14.

14. Vance and Purtill, "Diary," December 27, 1921, 9.

15. Vance and Purtill, "Diary," December 31, 1921, 10. See also "Chinamen May Kiss," in "Sidelights of New York," *Gettysburg Times*, September 14, 1931, 3.

16. Vance and Purtill, "Diary," December 31, 1921, 10.

17. Vance and Purtill, "Diary," January 3, 1922, 11.

18. Ralph C. Lewis, letter to mother, September 16, 1933, LFP.

19. Theophane Maguire, *Hunan Harvest* (Milwaukee, Wis.: Bruce, 1946), 6.

20. Multiple mentions are made of the group sending telegrams to family and supporters in the United States. See Vance and Purtill, "Diary," December 27, 1921, 9.

21. Vance and Purtill, "Diary," December 27, 1921, 9.

22. Vance and Purtill, "Diary," January 10, 1922.

23. Vance and Purtill, "Diary," December 26, 1921, 9.

24. Vance and Purtill, "Diary," December 11, 1921, January 10, 1922, 1, 17.

25. Vance and Purtill, "Diary," January 7–8, 1922, January 10, 1922, January 13, 1922, 15–20.

26. Vance and Purtill, "Diary," January 22, 1922, January 24, 1922, 23–24.

27. Maguire, *Hunan Harvest*, 173.

28. Maguire, *Hunan Harvest*, 18.

29. Vance and Purtill, "Diary," February 14, 1922, 30. See David E. Mungello, *Drowning Girls in China: Female Infanticide since 1650* (Lanham, Md.: Rowman and Littlefield, 2008); and Henrietta Harrison, "A Penny for the Little Chinese: The French Holy Childhood Association in China, 1843–1951," *American Historical Review* 113, no. 1 (2008): 72–92.

30. Large-format cameras using sheet film or glass plates only allowed two photographs at a time (at most, if using a double-sided holder). The user had to preload film holders in a light-tight space and carry them before and after making photographs. Although standard practice, this was ill suited to the missionaries' working environment.

31. Timothy McDermott, scrapbook, "Sun. Feb 5, 1922," caption on print verso, file 800.08_004.003, PCC. The caption reads, "Sun. Feb 5, 1922. This is the front of our boat. I took this picture by means of my automatic self-timer. . . . Don't we look sweet."

32. Timothy McDermott, photograph annotation, verso, file 800.08_004.003, PCC.

33. McDermott scrapbook, "Changteh. Feb 7, 1922," caption on print verso, file 800.08_004.004, PCC.

34. Incidentally, McDermott's tripod was rendered unusable between the time this photograph was made and the time the Passionists arrived in Chenzhou. In a letter to his family dated March 9, 1922, McDermott reported, "I wish you would get me a screw for my tripod. I think you will be able to get it [as] I lost mine . . . the one which fastens the camera screw to the silver plate . . . also send me along a [shutter release] cable or two for my small camera." The reference to "my small camera" implies that McDermott had two cameras of different formats, further supporting his comment in the caption: "I am supposed to be the photographer." Timothy McDermott, letter to "Dad and Girls," March 9, 1922, file 602.290_004.015b, PCC.

35. McDermott scrapbook, files 800.08_004.004, 800.08_004.005, PCC.

36. Clement Seybold, letter to Silvan Latour, February 13, 1928, file 505.08b_009.001, PCC. In his letter to Latour, editor of the Passionists' magazine, the *Sign*, Seybold stated: "I am sorry that I haven't had any pictures to send with this letter . . . for the very good reason that I have no material either for taking or printing pictures. Films and chemicals deteriorate so rapidly in this damp climate and its [*sic*] so difficult to get them sent up to use from down river. It takes a year or more for the stuff to arrive so that it is often spoilt before reaching here."

37. Timothy McDermott, photograph annotation, verso, file 800.02_074.005, PCC.

38. Raphael Vance photographs, files 800.02_018.015, 800.02_018.17, PCC. Vance's handwriting on the back of the first photograph reads, "Paotsing Church upper front. Note the windows." The second reads, "Paotsing Church rear."

39. Maguire, *Hunan Harvest*, 77. For environmental effects on photographic equipment, see Walter Clark, "Cameras and Climates," *Popular Photography*, June 1946, 56–57, 170–180. Missionaries are among the photographers Clark listed who would "find their problems numerous and varied." Clark, "Cameras and Climates," 56, 174.

40. Kevin Murray, letter to Stanislaus Grennan, May 27, 1923, file 505.03_015.006, PCC. Murray reported: "It is extremely difficult to have good developing done here in Central China. It is necessary to send the films to Hankow, which requires a loss of a full month before pictures are returned to Yuanchow."

41. Cuthbert O'Gara, letter to Stanislaus Grennan, December 26, 1924, file 505.04_021. 005c, PCC.

42. Seybold letter to Latour. Seybold noted, "My best camera was stolen from me in Hungkiang about two years ago by bandit soldiers." The traveling photographer incident is mentioned in Arthur Benson, letter to Stanislaus Grennan, August 25, 1927, file 505.06_008.005a, PCC.

43. Raphael Vance, photograph, "Paotsing," with annotation (verso), file 800.02_016. 006, PCC.

44. Maguire, *Hunan Harvest*, 76. See also Donald S. Sutton, "Ethnicity and the Miao Frontier in the Eighteenth Century," in *Empire at the Margins: Culture, Ethnicity, and Frontier in Early Modern China*, ed. Pamela Kyle Crossley, Helen F. Siu, and Donald S. Sutton (Berkeley: University of California Press, 2006), 190–228.

45. "Et Verbum caro factum est, et habitvit en nobis" (The Word became flesh, and dwelt among us). Francis Xavier Lasance and Francis Augustine Walsh, *The New Roman Missal in Latin and English* (New York: Benziger Brothers, 1942), 795.

46. Theophane Maguire, letter to Silvan Latour, December 26, 1924, file 505.04_021. 005c, PCC.

47. Susan Sontag, *On Photography* (New York: Farrar, Straus and Giroux, 1977), 55.

48. Cuthbert O'Gara, letter to Stephen Sweeney, June 28, 1925, file 505.05_020.002b, PCC.

49. Sontag, *On Photography*, 55.

50. "Transubstantiation," in *The Catholic Encyclopedia: An International Work of Reference on the Constitution, Doctrine, Discipline, and History of the Catholic Church*, ed. Charles G. Herbermann, vol. 5 (New York: Encyclopedia Press, 1914), 579. See also Maguire, *Hunan Harvest*, 68.

51. Raphael Vance, "Paotsing Mission. On a visit from the prefect—also Frs. Theophane and Basil came on for the occasion. This is not all the Xtians, just the inmates of the Mission. Raphael [undated]," "With some of the Xtians at Paotsing Sept, 1923," captions on print verso, file 800.02_016.009, PCC.

52. Vance, "With some of the Xtians at Paotsing Sept, 1923." The pencil lines on the print were presumably done at the Passionist headquarters in New Jersey, after which the image was reproduced for publication in *Sign* magazine.

53. Raphael Vance, "My Altar Boys—Paotsing—left to right, 'Tsang John' 'Ho Joseph' 'Fu Paul' 'Lu Gabriel' & 'Su Patrick'[.] The Chinese always put family name first. Fr. Raphael," file 800.02_016.016, PCC. Although this image is not dated, another photograph of a nativity scene with nearly identical lighting, focus errors, and developing flaws in Vance's file is dated "Xmas 1924."

54. Most of the Passionists' cameras were box or folding models without focusing aids like an optical rangefinder.

55. Vance, "My Altar Boys," file 800.02_016.016, PCC. The author did a double take on encountering the name "Ho Joseph" scrawled in Vance's handwriting on the back of the photographic print.

56. Four of the five boys in this photograph later added their names to a September 26, 1925, letter reprinted in the January 1926 issue of the *Sign*. "Father Raphael Vance, C.P., and His Passionist (Chinese) Postulants," *Sign* 5, no. 6 (January 1926): 261, PCC.

57. Timothy McDermott, letter to "Dad and Girls," February 24, 1922, file 602.290_004. 012b, PCC.

58. Timothy McDermott, letter to "Dad and Girls," June 4, 1922, file 602.290_005.007a, PCC.

59. McDermott later became one of the best speakers of Hunanese dialect among this group of Passionists. See Murray letter to Grennan.

60. McDermott letter, June 4, 1922.

61. Given the lack of electricity in rural Hunan and the fact that there is no mention of electrically powered darkroom equipment in McDermott's correspondence, he was likely using a solar contact printing box. This required the photographer to place the negative on a sheet of light-sensitive paper, with the negative-paper combination held flat by a piece of glass in a wooden frame. This was then exposed to sunlight for a certain time and the paper print processed in the darkroom. McDermott would have had to produce test prints to determine the appropriate exposure, and restart the process if he made any mistakes or the sunlight changed. Repeated eighteen times for each photographed convert, this would have taken several hours, as McDermott noted.

62. McDermott letter, June 4, 1922.

63. Robert E. Carbonneau, "The Sign," *The Encyclopedia of American Catholic History*, ed. Michael Glazier and Thomas Shelley (Collegeville, Minn.: Liturgical Press, 1997), 1297.

64. Timothy McDermott, letter to family, "Palm Sunday," April 9, 1922, files 602.290_004.021b, 602.290_004.021c, PCC. McDermott did not translate the Protestant church's Chinese term (*Fuyin tang*). Either out of spite or by accident, by translating the indigenous name for the Catholic Church alone (rendering the Protestants' "Fu In Tang" incomprehensible to US readers), McDermott subtly undermined the opposing group's legitimacy.

65. O'Gara letter to Sweeney. The referenced "proselytizers" are presumably Chinese evangelists or medical staff who took the opportunity to speak about their Protestant faith to locals awaiting or undergoing treatment.

66. O'Gara letter to Sweeney.

67. "Fr. Silvan Latour, C.P., St. Paul of the Cross Province (1891–1933)," Passionist Historical Archives (online), https://passionistarchives.org/biography/father-silvan-latour-c-p-st-paul-of-the-cross-province-1891-1933/, accessed April 10, 2021.

68. Theophane Maguire, letter to Silvan Latour, October 19, 1924, 1, file 505.04_021.002, PCC.

69. Maguire October letter to Latour; file 800.08_003.056, PCC.

70. Maguire October letter to Latour.

71. O'Gara letter to Sweeney. The letter's first page is stamped in purple ink: "RETURN TO FR. SILVAN."

72. O'Gara letter to Sweeney.

73. O'Gara letter to Sweeney.

74. Glenn D. Kittler, *The Maryknoll Fathers* (Cleveland, Ohio: World, 1961), 107–126.

75. Kittler, *Maryknoll Fathers*, 55–57, 78–79, 114. Photography was also a key part of Maryknoll media from the very beginning of *The Field Afar*'s existence. The first group of Maryknoll missionaries—including their founder, Fr. James A. Walsh—photographed "in flash pictures" as they departed for China in 1919.

76. Edward J. Hickey, "The Society for the Propagation of the Faith: Its Foundation, Organization, and Success (1822–1922)" (PhD dissertation, Catholic University of America, 1922), 156–157. For a contemporary example of the US-based magazine, see *Catholic Missions* 2, no. 12 (December 1925); this issue included articles on Maryknoll and Passionist missions, as well as Benedictine (OSB) and Society of the Divine Word (SVD) projects in China. The article on the SVD references that order's media efforts, stating, "At Techny, Ill., the [SVD] Mission Press is publishing 150,000 copies of magazines each month, 100,000 calendars and almanacs each year besides thousands of leaflets and pamphlets." W. A. Ross, "Fifty Years for the Divine Word," *Catholic Missions* 2, no. 12 (December 1925): 10.

77. See Neil Harris, "Iconography and Intellectual History: The Halftone Effect," in *Cultural Excursions: Marketing Appetites and Cultural Tastes in Modern America* (Chicago: University of Chicago Press, 1990), 304–317.

78. O'Gara letter to Sweeney.

79. "Eucharistic Procession after the Consecration of Bishop Cuthbert O'Gara in Hankow [October 28] 1934," 16 mm film, PCC.

80. O'Gara letter to Sweeney.

81. Walter H. Mallory, *China: Land of Famine* (New York: American Geographical Society, 1928), 42–43, 56.

82. "Yiao Fan: A Cry of Distress," back cover, *Sign* 5, no. 6 (January 1926), PCC. The phonetically rendered title means "need food/rice," and was associated with beggars seeking alms.

83. "Yiao Fan."

84. Raphael Vance, "Father & son. Victims of famine. Baptized the boy Ambrose who died two days later. August 30, 1925," annotation (verso) on photograph by Theophane Maguire, file 800.02_016.021, PCC.

85. Theophane Maguire, letter to Stanislaus Grennan, March 19, 1926, file 505.06_ 021.007a-007b, PCC.

86. Maguire letter to Grennan. The scriptural reference is from Mark 12:41–44.

87. Basil Bauer, letter to Stanislaus Grennan, February 11, 1926, file 505.06_005.002b-002c, PCC.

88. See also Neil Harris, "Pictorial Perils: The Rise of American Illustration," in *Cultural Excursions*, 337–348.

89. Ann Stoler, *Along the Archival Grain: Epistemic Anxieties and Colonial Common Sense* (Princeton, N.J.: Princeton University Press, 2010), 1–3.

90. Benson letter to Grennan.

91. "Yiao Fan."

92. Cuthbert O'Gara, "Shenchowfu: The Passionist Prefecture in Hunan, China," *Sign* 10, no. 2 (September 1925): 54, PCC.

93. Photograph, with annotation (verso), file 800.01_039.004, PCC. The white "K"s inked above and on both sides of the group are crop boundaries.

94. File 800.02_016.022, PCC.

95. Paul Fu ("Fu Paulo") maintained a personal connection with the Baojing mission beyond his time as a postulant, and was photographed again over a decade later, on his wedding day in June 1939. See file 800.01_022.014, PCC.

96. Passionist scrapbook, file 800.08_002, PCC.

97. Photograph, with annotations (recto and verso), in Passionist scrapbook, file 800.08_ 002.028, PCC.

98. Photograph annotation, verso, file 800.08_002.020, PCC.

99. File 800.08_002.033, PCC.

100. Robert E. Carbonneau, "Life, Death, and Memory: Three Passionists in Hunan, China and the Shaping of an American Mission Perspective in the 1920s" (PhD dissertation, Georgetown University, 1992), 228–233.

101. Silvan Latour, "At the Rainbow's End," insert, *Sign* 8, no. 11 (June 1929): 672A–672B, PCC.

102. Seybold letter to Latour.

103. Photograph annotation, verso, file 800.08_002.020, PCC.

104. Roland Barthes, *Camera Lucida: Reflections on Photography*, trans. Richard Howard (New York: Hill and Wang, 1987), 77.

105. See Brant Pitre, *Jesus and the Last Supper* (Grand Rapids, Mich.: William B. Eerdmans, 2015), esp. 444–512.

106. "Sacrifice of the Mass," in Herbermann, *Catholic Encyclopedia*, 10:6.

107. Passionist scrapbook, files 800.08_002.035, 800.08_002.038, 800.08_002.040, PCC. For these images, the photographer advanced the film rapidly between exposures, resulting in

a flipbook-style impression of movement. The album itself is constructed as a photo-essay, starting with the coffins in the church and ending with their burial attended by a large crowd of Chinese Catholics and foreign missionaries.

108. Latour, "At the Rainbow's End," 672C–672D. The Society for the Propagation of the Faith took a more moderate approach to the murders, with the *Catholic Missions* editor writing: "Details are lacking as to the circumstances of [the three Passionists'] death and it may never be possible to prove them martyrs in the technical sense of the word, as having died for the Faith. Whatever the occasion may have been, we know, however, that these priests had the martyrs' spirit." H. A. Campo, "American Missions Receive Baptism of Blood," *Catholic Missions* 6, no. 7 (July 1929): 195. For contested definitions of the three priests' deaths as martyrdom, see Robert E. Carbonneau, "Images of Missionary Life: The Lives of Passionists: Walter Coveyou, Godfrey Holbein, Clement Seybold," *Passionist* 26 (1993): 27–28.

109. Barthes, *Camera Lucida*, 99–100.

110. Francis Flaherty, "For Christ in China!," in *Eyes East: On Chinese Pathways with the Passionist Missionaries* (Union City, N.J.: Passionist Fathers, n.d.), 72.

111. Carbonneau, "Life, Death, and Memory," 377. Schmitz's encounter with the photograph is drawn from a biographical account: Roger Mercurio and Rian Clancy, *Fr. Carl—Passionist* (Chicago: Passionist Missions, 1990), 2.

112. Barthes, *Camera Lucida*, 96.

113. H. A. Campo, "The Mission Intention," *Catholic Missions* 6, no. 7 (July 1929): 195.

114. Timothy McDermott, letter to Stanislaus Grennan, May 19, 1925, file 505.05_016.005a-005b, PCC.

115. Stephen R. Platt, *Provincial Patriots: The Hunanese and Modern China* (Cambridge, Mass.: Harvard University Press, 2007), 141–142, 194–199, 206–207. See also Mao Zedong, "Hunan jianshe de genben wenti—Hunan gonghe guo" [The fundamental issue of developing Hunan: The Republic of Hunan], in *Mao Zedong zaoqi wengao* [Mao Zedong's early writings], ed. CPC Central Committee Literature Research Center and the Hunan Province Party Committee (Changsha, China: Hunan renmin chubanshe, 2008), 505, 507–508.

116. Platt, *Provincial Patriots*, 183–184, 199–200; Rebecca E. Karl, *Mao Zedong and China in the Twentieth-Century World: A Concise History* (Durham, N.C.: Duke University Press, 2010), 18–31.

117. Bays, *New History*, 149–151; 158–160.

118. Platt, *Provincial Patriots*, 184–215. In yet another twist of fate, Mao was later interviewed by a US Passionist, Fr. Cormac Shanahan, CP, who traveled to Yan'an in May 1944 and wrote for the *Sign*. See also "Father Cormac Shanahan, C.P., St. Paul of the Cross Province (1899–1987)," Passionist Historical Archives (online), https://passionistarchives.org/biography/father-cormac-shanahan-c-p-st-paul-of-the-cross-province-1899-1987/, accessed April 10, 2021.

3. The Movie Camera and the Mission

1. Minutes of the Session of the Presbyterian Church at Rye, New York, December 18, 1930, Presbyterian Church Archives, Rye, New York.

2. Minutes, Session, December 18, 1930; Minutes of the Session of the Presbyterian Church at Rye, New York, May 7, 1928, Presbyterian Church Archives, Rye, New York.

3. "Rome, Timbuctoo, Main Street," Cine-Kodak advertisement (Rochester, N.Y.: Eastman Kodak, 1931).

4. Jessie Mae Henke, letter to Palmer and White families in California, March 15, 1931, 1; Jessie Mae Henke, "Occupational" film narration, HFC.

5. Henke letter to Palmer and White families, 3. See also Mary Brown Bullock, *An American Transplant: The Rockefeller Foundation and Peking Union Medical College* (Berkeley: University of California Press, 1980), 81–82.

6. Henke letter to Palmer and White families.

7. Jessie Mae Henke, letter to "Dear Friends in the Homeland," September 19, 1933, HFC.

8. Cine-Kodak advertisement, 1931.

9. Richard Henke, interview with the author, July 29, 2013, Rolling Hills, California.

10. Patricia R. Zimmermann, "Morphing History into Histories: From Amateur Film to the Archive of the Future," in *Mining the Home Movie: Excavations in Histories and Memories*, ed. Karen L. Ishizuka and Patricia R. Zimmermann (Berkeley: University of California Press, 2008), 275–276.

11. William Stott, *Documentary Expression and Thirties America* (Chicago: University of Chicago Press, 1986), 119–123.

12. Robert Sklar, *A World History of Film* (New York: Harry N. Abrams, 2002), 16, 28. See also Terry Lindvall, *The Silents of God: Selected Issues and Documents in Silent American Film and Religion, 1908–1925* (Lanham, Md.: Scarecrow, 2001), ix–xiii.

13. Eunice V. Johnson and Carol Lee Hamrin, *Timothy Richard's Vision: Education and Reform in China, 1880–1910* (Eugene, Oreg.: Wipf and Stock, 2014), 22–26.

14. Yoshino Sugawara, "Toward the Opposite Side of 'Vulgarity': The Birth of Cinema as a 'Healthful Entertainment' and the Shanghai YMCA," in *Early Film Culture in Hong Kong, Taiwan, and Republican China: Kaleidoscopic Histories*, ed. Emilie Yueh-yu Yeh (Ann Arbor: University of Michigan Press, 2018), 188–189.

15. "Missionaries and Moving Pictures," *Nickelodeon* 1, no. 1 (January 1909): 16. See also Lindvall, *Silents of God*, 4.

16. See Gospel of Matthew 9:27–30; Gospel of Mark, 8:22–25; Gospel of John 9:1–12.

17. Jessie Mae Henke, "Family History," 1–4, HFC; Joseph Henkels, *My China Memoirs, 1928–1951* (Dubuque, Iowa: Divine Word College, 1988), 1.

18. Julia Lovell, introduction to Lu Xun, *The Real Story of Ah-Q and Other Tales of China: The Complete Fiction of Lu Xun*, trans. Julia Lovell (London: Penguin Classics, 2009), 5.

19. Lovell, introduction, 5. Coincidentally, Lu's son, Zhou Haiying, became an accomplished documentary photographer. See Zhonghui Yang, "Zhou Haiying," trans. Sue Wang, *Photography of China*, August 11, 2013, https://photographyofchina.com/blog/zhou-haiying, accessed October 12, 2020.

20. Henkels, *My China Memoirs*, 1.

21. Anthony E. Clark, *China's Saints: Catholic Martyrdom during the Qing, 1644–1911* (Bethlehem, Pa.: Lehigh University Press, 2011), 52.

22. Clark, *China's Saints*, 1.

23. "Taking Films to Heathens: Eighty-Six Methodist Missionaries to Sail This Week," *New York Times*, June 27, 1920, 21.

24. Ernest A. Dench, *Motion Picture Education* (Cincinnati, Ohio: Standard, 1917), 154.

25. Lindvall, *Silents of God*, 5–7; also William Ernest Hocking et al., *Re-Thinking Missions: A Layman's Inquiry after One Hundred Years* (New York: Harper and Brothers, 1932), 190.

26. Dench, *Motion Picture Education*, 154–155.

27. Hocking et al., *Re-Thinking Missions*, 191.

28. Although differing in political aims, these missionary presentations echoed the work of mobile educational film teams in mid-1930s Jiangsu Province and also prefigured the Chinese Communist Party's mass rural film screenings in the 1960s. See Hongwei Thorn Chen, "Cinemas,

Highways, and the Making of Provincial Space: Mobile Screenings in Jiangsu, China, 1933–1937," *Wide Screen* 7, no. 1 (March 2018): 1–34; and Alan P. L. Liu, *Communications and National Integration in Communist China* (Berkeley: University of California Press, 1971), 165–166.

29. "Work in an Occupied City (excerpted from *The China Christian Advocate*, November 1940)," *Chinese Recorder* 72, no. 1 (January 1941): 50–51.

30. Patricia R. Zimmermann, *Reel Families: A Social History of Amateur Film* (Bloomington: Indiana University Press, 1995), 28–29.

31. "Work in an Occupied City," 50–51.

32. "Missionaries and the Cinema," *International Review of Educational Cinematography*, July 1932, 557.

33. "Missionaries and the Cinema," 557–558.

34. See also Bernard R. Hubbard, *Alaskan Odyssey* (Robert Hale, 1952).

35. "Missionaries and the Cinema," 558.

36. *American Annual of Photography* 41 (1927), advertisement no. 63; Cine-Kodak advertisement, 1931. One hundred and fifty dollars in 1927 was equivalent to about $2,242 in 2021 dollars, and $140 in 1931 was equivalent to about $2,303, both figures according to the US Bureau of Labor Statistics Consumer Price Index (CPI) inflation scale.

37. Harold Eugene Henke, letter to "Dearest Ones at Home," January 15, 1932, HFC.

38. Zimmermann, *Reel Families*, 29–30.

39. *Instructions for Use of the Cine-Kodak Model B f/1.9 Lens* (Rochester, N.Y.: Eastman Kodak, 1927), 19–20.

40. "The Latest Motion Picture Outfit for Amateurs," *Scientific American*, August 1923, 111; *Making the Most of Your Cine-Kodak Model B f/1.9* (Rochester, N.Y.: Eastman Kodak, 1928), 39.

41. *Instructions for Use of the Cine-Kodak*, 21–22.

42. *Making the Most of Your Cine-Kodak*, 42. See also Mona Domosh, *American Commodities in an Age of Empire* (New York: Routledge, 2006), 26, 28–30.

43. *Making the Most of Your Cine-Kodak*, 42.

44. These materials are lost and no longer accompany the Henke camera as it exists in 2021. This analysis is drawn from an identical Cine-Kodak B in the author's collection that included the original manuals and packing material.

45. *Making the Most of Your Cine-Kodak*, 39.

46. *Instructions for Use of the Cine-Kodak*, 25.

47. *Making the Most of Your Cine-Kodak*, 1.

48. *Making the Most of Your Cine-Kodak*, 5.

49. *Making the Most of Your Cine-Kodak*, 24–38.

50. *Making the Most of Your Cine-Kodak*, 26, 29.

51. Zimmermann, "Morphing History into Histories," 279–280.

52. Stott, *Documentary Expression and Thirties America*, 214–218.

53. Tan Ye and Yun Zhu, *Historical Dictionary of Chinese Cinema* (Lanham, Md.: Scarecrow, 2012), 108.

54. Henke letter to Palmer, White families.

55. Raimund E. Goerler, "Epilogue: Richard Evelyn Bird, 1928–1957," in *To the Pole: The Diary and Notebook of Richard E. Byrd, 1925–1927*, ed. Raimund E. Goerler (Columbus: Ohio State University Press, 1998), 121–124.

56. "Big Film 'With Byrd at the South Pole,' A Great Story beyond Human Imagination to Be Shown Here Starting on Saturday," *China Press*, September 25, 1930, 8.

57. "'With Byrd at the South Pole,' Paramount Super Picture Opens Today at the Capitol," *China Press*, September 27, 1930, 10.

58. *With Byrd at the South Pole* also played as a second-run feature at the Embassy Theatre in Shanghai on March 1, 1931. "Embassy Theatre," *China Press*, March 1, 1931, 6.

59. "'With Byrd at the South Pole,' Paramount Super Picture," 14.

60. Jessie Mae Henke, letter to cousins in Hollywood, March 20, 1932, HFC.

61. Harold Eugene Henke, letter to Paddock and Henke families, December 20, 1931, HFC.

62. Henke, "Occupational" film narration.

63. Henke letter to cousins in Hollywood.

64. Henke letter to Paddock and Henke families.

65. C. E. Kenneth Mees, *Photography* (New York: Macmillan, 1937), 144–145.

66. Sklar, *World History of Film*, 26–27, 29. See also Barry Salt, *Film Style and Technology: History and Analysis*, 3rd ed. (London: Starword, 2009), 39. The "actuality" films referenced here are *La Sortie de l'Usine Lumière à Lyon* (*Workers Leaving the Lumière Factory*) and *Le Débarquement du Congrès de Photographie à Lyon* (*Debarkation of Photographic Congress Members at Lyon*).

67. Frame-by-frame examination of the digitized footage reveals that some editing was done "in-camera." That is, the Henkes filmed part of a scene, switched off the camera, and repositioned it before continuing with a different angle (sometimes a close-up) or a new scene entirely. In other cases, they used scissors and paste to produce splices, visible as rough-cut film edges smeared with hand-applied paste.

68. *Instructions for Use of the Cine-Kodak*, 36.

69. Y. C. James Yen, *The Ting Hsien Experiment* (Ting Hsien, China: Chinese National Association of the Mass Education Movement, 1934), 20–21.

70. *Making the Most of Your Cine-Kodak*, 5.

71. Eugene N. Anderson, *The Foods of China* (New Haven, Conn.: Yale University Press, 1988), 144.

72. Henke letter to cousins in Hollywood.

73. See Donald Jordan, *China's Trial by Fire: The Shanghai War of 1932* (Ann Arbor: University of Michigan Press, 2001).

74. "16 mm films," typed contents list found in Henke film storage box, n.d., HFC; "[Reel] VI. fall 1932," HFC.

75. "16 mm films."

76. Harold Eugene Henke, letter to Ethel and Harlan Palmer, October 27, 1927, HFC.

77. Jessie Mae Henke, letter to family, February 1932, HFC.

78. See R. Dawson Hall, "America's Largest Shovel and Biggest Strip Mine," *Coal Age* 34, no. 12 (December 1929): 729–730.

79. Siegfried Giedion, *Mechanization Takes Command: A Contribution to Anonymous History* (New York: Oxford University Press, 1948), 141–142, 162–168.

80. Ralph C. Lewis, "China Years: His Story of Those Years in the Life of Ralph Charles Lewis (Growing Up and His Life in China through the War Years)," unpublished personal memoirs, in the author's possession, 110.

81. Paul G. Pickowicz, *China on Film: A Century of Exploration, Confrontation, and Controversy* (Lanham, Md.: Rowman and Littlefield, 2012), 46–47.

82. Giedion, *Mechanization Takes Command*, 165–166.

83. Stott, *Documentary Expression and Thirties America*, 214.

84. Liu Ju, interview with the author, May 22, 2011, Wuhan, China.

85. Liu interview. See also Yen, *The Ting Hsien Experiment*, 5–7, 20–22, 27–32. Dingxian, where Yen's community was located, is less than 125 miles north of Shunde. The Henkes and Chinese colleagues may have passed it while going to and from Baoding.

86. James C. Thomson Jr., *While China Faced West: American Reformers in Nationalist China, 1928–1937* (Cambridge, Mass.: Harvard University Press, 1969), 61–63.

87. Henke, "Occupational" film narration.

88. Frederic Wakeman, Jr., "Mao's Remains," in, *Death Ritual in Late Imperial and Modern China*, ed. Evelyn S. Rawski and James L. Watson (Berkeley: University of California Press, 1988), 257–258.

89. Marie-Claire Bergére, *Sun Yat-sen*, trans. Janet Lloyd (Stanford, Calif.: Stanford University Press, 1998), 26–27, 31–32.

90. Henke, "Occupational" film narration.

91. Henke, "Occupational" film narration.

92. Henke letter to "Dear Friends in the Homeland."

93. Harold Eugene Henke, *Shuntehfu Hospital Bulletin*, copy mailed to the "Whites, Palmer[s], & the Haskins," December 21, 1935, HFC.

94. These lengths are drawn from the three existing four-hundred-foot-capacity 16 mm reels in the Henke collection today. As most electrically driven consumer film projectors from the 1930s onward were equipped with a knob (usually labeled only with "Fast" and "Slow" directions) to vary projection speed by eye, these times are general estimates.

95. *Instructions for Use of the Cine-Kodak*, 34.

96. Daniel J. Fleming, *Whither Bound in Missions?* (New York: Association, 1925), 169.

97. Jessie Mae Henke, in *A Pen Picture of Shuntehfu Station, Presbyterian Mission, North China* (n.p., December 1934), 11, HFC.

98. Henke in *Pen Picture*, 10.

99. *Report of Medical Work at Shuntehfu, Hopei, North China—American Presbyterian Mission* (n.p., 1931), 21, HFC. According to the Shunde hospital's financial report for 1931, the expenses (in US dollars) for the entire facility and staff were $26,910.21, while the hospital's income, including appropriations from the mission board, charities, gifts and "sundry," as well as inpatient hospital fees, was $34,804.78.

100. Jessie Mae Henke, "Hospital" film narration, HFC.

101. Henke, "Hospital" film narration.

102. Henke, "Hospital" film narration.

103. Richard Henke interview.

104. *Report*, 1931, 1, 5, 17. See also Bullock, *An American Transplant*.

105. Robert and Richard Henke, interview with the author, June 29, 2012, Pasadena, California; Lewis, "China Years," 124.

106. Lewis, "China Years," 124.

107. See Robert J. Dicke, *Epidemiology of Kala Azar in China* (Washington, D.C.: Navy Department Bureau of Medicine and Surgery, 1946).

108. Henke, "Hospital" film narration. See Mrs. Howard Taylor (Geraldine Taylor), *Guinness of Honan* (Toronto: China Inland Mission Press, 1930), 317; and *Chung-hua I Hsüeh Tsa Chih Wai Wen Pan* [China medical journal] 37:1032.

109. *Report*, 1931, 4. See also "War Threat in the North," *North-China Herald and Supreme Court & Consular Gazette*, May 5, 1931, 148; "Wang Leaves for Tsangchow; Chang Completes Plans," *China Press*, July 21, 1931, 1; "China Nationalists Crush Rebel Army," *Washington Post*, August 4, 1931, 3. John Bickford also produced a detailed firsthand account of the "Siege of Shuntehfu" in a letter dated August 13, 1931, reproduced in "The Most Lovely People: A History of the Henke Family from the Letters of John Bickford, 1928–1948," 4–6, unpublished compilation of personal letters, in the author's possession. Bickford occasionally borrowed the Henkes' Cine-Kodak to make family movies of his own. See John Bickford, letter to family, April 4, 1932, and May 21, 1932, reproduced in "The Most Lovely People," 7–8.

110. *Report*, 1931, 4.

111. *Report*, 1931, 8.

112. Richard Henke interview.

113. Phil Billingsley, *Bandits in Republican China* (Stanford, Calif.: Stanford University Press, 1988), 150–153, 193–196.

114. Larissa N. Heinrich, *The Afterlife of Images: Translating the Pathological Body between China and the West* (Durham, N.C.: Duke University Press, 2008), 10–14.

115. Kathleen L. Lodwick, "Introduction," in *The Chinese Recorder Index: A Guide to Christian Missions in Asia, 1867–1941*, ed. Kathleen L. Lodwick (Lanham, Md.: Rowman and Littlefield, 1986), xiii. See also M. Avrum Ehrlich, *The Jewish-Chinese Nexus: A Meeting of Civilizations* (New York: Routledge, 2008), 29–30; and Liming Li, *Guoji gongchan zhuyi zhanshi Fu Lai* [Richard Frey, an international communist fighter] (Beijing: China Union Medical College Press, 2009).

116. Harold Eugene Henke, letter from "Presbyterian Mission, Peiping" to "Dear Ones in Hollywood," November 9, 1947, HFC.

117. Jessie Mae Henke and Harold Eugene Henke, *Shuntehfu Hospital Bulletin*, December 17, 1934, 1, HFC.

118. Henke and Henke, *Shuntehfu Hospital Bulletin*, December 17, 1934, 1–2.

119. Henke in *Pen Picture*, 10–11.

120. Henke in *Pen Picture*, 10.

121. Lillian K. Jenness in *Pen Picture*, 6–7.

122. See also Sue Gronewold, "New Life, New Faith, New Nation, New Women: Competing Models at the Door of Hope Mission in Shanghai," in *Competing Kingdoms: Women, Mission, Nation, and the American Protestant Empire, 1812–1960*, ed. Barbara Reeves-Ellington, Kathryn Kish Sklar, and Connie A. Shemo (Durham, N.C.: Duke University Press, 2009), 195–211.

123. *Pen Picture*, 1–3.

124. 1 Corinthians 13:12 (King James Version).

125. Roland Barthes, *Camera Lucida: Reflections on Photography*, trans. Richard Howard (New York: Hill and Wang, 1987), 45.

126. Harold Eugene Henke, letter to "Dear Friends," from "House No. 5, Presbyterian Mission, Peking China," October 25, 1937, HFC.

127. "16 mm films"; "[Reel] V. 1937," HFC.

128. Harold Eugene Henke, letter from the "Presbyterian Mission, Peiping, China," March 3, 1946, HFC.

129. *The Film Preservation Guide: The Basics for Archives, Libraries, and Museums* (San Francisco: National Film Preservation Foundation, 2004), 14–15.

130. Harold Eugene Henke, letter to "Dearest Ones at Home," December 20, 1931, HFC.

4. Chaos in Three Frames

1. Bernd Martin, "Das Deutsche Reich und Guomindang-China, 1927–1941," in *Von der Kolonialpolitik zur Kooperation: Studien zur Geschichte der deutsch-chinesischen Beziehungen* [From colonial policy to cooperation: Studies in the history of German-Chinese relations], ed. Hengyu Guo (Munich, Germany: Minerva Publikation, 1986), 325–375.

2. Richard Whelan, *Robert Capa: A Biography* (Lincoln: University of Nebraska Press, 1985), 211–214; Caroline Brothers, *War and Photography: A Cultural History* (London: Routledge, 1997), 178–185.

3. "Life's Cover," *Life*, May 16, 1938, 9.

4. "China Puts Japanese Army on the Run: A Unified Nation Reverses Its War Fortunes," *Life*, May 16, 1938, 11.

5. Edward J. Drea and Hans van de Ven, "An Overview of Major Military Campaigns during the Sino-Japanese War, 1937–1945," in *The Battle for China: Essays on the Military History of the Sino-Japanese War of 1937–1945*, ed. Mark Peattie, Edward J. Drea, and Hans van de Ven (Stanford, Calif.: Stanford University Press, 2011), 27–34.

6. Yang Tianshi, "Chiang Kai-shek and the Battles for Shanghai and Nanjing," in Peattie, Drea, and van de Ven, *The Battle for China*, 143–158.

7. "John G. Magee," in *Eyewitnesses to Massacre: American Missionaries Bear Witness to Japanese Atrocities in Nanjing*, ed. Zhang Kaiyuan (Armonk, N.Y.: M. E. Sharpe; New Haven, Conn.: Yale Divinity School Library, 2001), 166–227.

8. "These Atrocities Explain Jap Defeat," *Life*, May 16, 1938, 14.

9. Alan Brinkley, *The Publisher: Henry Luce and His American Century* (New York: Alfred A. Knopf, 2010), 13–39.

10. See Hattori Satoshi, "Japanese Operations from July to December 1937," with Edward J. Drea, trans. Daqing Yang, in Peattie, Drea, and van de Ven, *The Battle for China*, 159–180. For a contemporary summary of the Japanese invasion, see Harold John (H. J.) Timperley, *Japanese Terror in China* (New York: Modern Age, 1938), 61–62.

11. "These Atrocities Explain Jap Defeat."

12. Louise Kiehle Scovel, letter from Japanese-occupied Jining, Shandong to "George and Harriet," August 30, 1938, SFC. Scovel wrote, "I am sorry we cannot send you kodaks [*sic*], but films cannot be bought and even the [local] photographers are so short of materials that they have to charge enormous prices."

13. See Charles Bright and Joseph W. Ho, eds., *War and Occupation in China: The Letters of an American Missionary from Hangzhou, 1937–1938* (Bethlehem, Pa.: Lehigh University Press, 2017).

14. Edward V. Gulick, *Teaching in Wartime China: A Photo-Memoir, 1937–1939* (Amherst: University of Massachusetts Press, 1995), 5.

15. See Michael G. Thompson, *For God and Globe: Christian Internationalism in the United States between the Great War and the Cold War* (Ithaca, N.Y.: Cornell University Press, 2015).

16. Gulick, *Teaching in Wartime China*, 3–4.

17. Miner Searle Bates, first letter to US Consul in Nanjing, John M. Allison, May 6, 1938, reproduced in Zhang, *Eyewitnesses to Massacre*, 24.

18. Zhang Kaiyuan, "Introduction: Historical Background," in Zhang, *Eyewitnesses to Massacre*, xxi; and "Miner Searle Bates," in Zhang, *Eyewitnesses to Massacre*, 3.

19. Yang, "Chiang Kai-shek and the Battles for Shanghai and Nanjing," 157–158.

20. Timperley, *Japanese Terror*, 62.

21. Bates, first letter to Allison, May 6, 1938.

22. Bates, first letter to Allison, May 6, 1938.

23. Bates, first letter to Allison, May 6, 1938.

24. Miner Searle Bates, "Documents: Nanking Safety Zone, Number 48, Notes on the Present Situation, January 22, 1938, 9am," reproduced in *Documents on the Rape of Nanking*, ed. Timothy Brook (Ann Arbor: University of Michigan Press, 1999), 94.

25. Bates, first letter to Allison, May 6, 1938.

26. Miner Searle Bates, second letter to US Consul in Nanjing, John M. Allison, May 6, 1938, reproduced in Zhang, *Eyewitnesses to Massacre*, 25–26.

27. Bates, second letter to Allison, May 6, 1938.

28. Bates, second letter to Allison, May 6, 1938. See also Timothy Brook, *Collaboration: Japanese Agents and Local Elites in Wartime China* (Cambridge, Mass.: Harvard University Press, 2005), 32–61, 125–158, 221–239.

29. Bates, second letter to Allison, May 6, 1938. Yasui Kasuya is referenced in Minnie Vautrin's diary entry of February 21, 1938. Minnie Vautrin, *Terror in Minnie Vautrin's Nanjing: Diaries and Correspondence, 1937–38*, ed. Suping Lu (Chicago: University of Illinois Press, 2008), 171.

30. "The Camera Overseas: 136,000,000 People See This Picture of Shanghai's South Station," *Life*, October 4, 1937, 102.

31. "A Universal Cameraman Documents American History: 'The Panay Incident,'" *Life*, January 10, 1938, 11–17. See also "The Situation Confronted by the Conferences," in *American Far Eastern Policy and the Sino-Japanese War*, ed. Miriam S. Farley (New York: American Council Institute of Pacific Relations, 1938), 4–5.

32. "Immediate Choices before the United States," subsection "Public Opinion in United States," in Farley, *American Far Eastern Policy and the Sino-Japanese War*, 51–52.

33. Bates, second letter to Allison, May 6, 1938.

34. James H. McCallum, "Losses of Personal and Household Furniture Sustained by James H. McCallum at His Residence at 209 Peh Hsia Lu, Nanking, between December 11, 1937 and January 1, 1938," attached to US Consul R. L. Smyth, "Subject: Sino-Japanese Hostilities, 1937–1938, American Losses Resulting from, Reverend James H. McCallum, Claim of," August 23, 1938, reproduced in *A Mission under Duress: The Nanjing Massacre and Post-Massacre Social Conditions Documented by American Diplomats*, ed. Suping Lu (Lanham, Md.: University Press of America, 2010), 316–317.

35. Lewis S. C. Smythe, letter to US mission supporters, "Dear Friends in God's Country," from the University of Nanking, March 8, 1938, reproduced in Zhang, *Eyewitnesses to Massacre*, 25.

36. George A. Fitch, personal diary, December 30, 1937, reproduced in Zhang, *Eyewitnesses to Massacre*, 98.

37. Fitch, personal diary, "New Year's Day," reproduced in Zhang, *Eyewitnesses to Massacre*, 100–101.

38. Fitch, personal diary, "New Year's Day."

39. John Craig William Keating, *A Protestant Church in Communist China: Moore Memorial Church Shanghai* (Bethlehem, Pa.: Lehigh University Press, 2012), 104.

40. Fitch, personal diary, "New Year's Day." See also Joseph Kosek, *Acts of Conscience: Christian Nonviolence and Modern American Democracy* (New York: Columbia University Press, 2010).

41. John G. Magee, "Introduction of Magee's Film," n.d., reproduced in Zhang, *Eyewitnesses to Massacre*, 202.

42. Magee, "Introduction of Magee's Film," 201.

43. John G. Magee, "Film 2," scene 2, reproduced in Zhang, *Eyewitnesses to Massacre*, 203.

44. Military and documentary filmmaking in World War II further articulated these visual cues, and wartime and postwar Hollywood cinema appropriated them. See Patricia R. Zimmermann, *Reel Families: A Social History of Amateur Film* (Bloomington: Indiana University Press, 1995), 90–111.

45. John G. Magee, film stills from Nanjing film, reel 9, ca. 1938, RG 242, John G. Magee Family Papers, Special Collections, Yale Divinity School Library, New Haven, Connecticut, http://divinity-adhoc.library.yale.edu/Nanking/Magee_reel_9_clip.mp4, accessed May 9, 2016.

46. Magee, "Film 3," scenes 10–12; "Film 4," scene 1; "Film 11," scene 4; all reproduced in Zhang, *Eyewitnesses to Massacre*, 206–207, 224.

47. Magee, "Film 4," scene 5, 208. The medical descriptions likely originated with Dr. Robert O. Wilson, a Methodist doctor at the University of Nanking hospital. See "Robert O. Wilson," in Zhang, *Eyewitnesses to Massacre*, 391–410.

48. Magee, "Film 4," scene 9, 209–210.

49. Magee "Film 7," scene 6, reproduced in Zhang, *Eyewitnesses to Massacre*, 216.

50. Magee "Film 7," scene 6, 216.

51. Gary Evans, "The Nanking Atrocity: Still and Moving Images, 1937–1944," *Media and Communication* 1, no. 1 (2013): 57. This article unfortunately contains a number of factual errors, and the missionary context is almost entirely absent.

52. Zimmermann, *Reel Families*, 90–111.

53. Daqing Yang, "The Challenges of the Nanjing Massacre," in *The Nanjing Massacre in History and Historiography*, ed. Joshua A. Fogel (Berkeley: University of California Press, 2000), 140; Takashi Yoshida, "A Battle over History in Japan," in Fogel, *Nanjing Massacre*, 106–107. See also Kobayashi Yoshinori, *On War: Shin gōmanizumu sengen supesharu sensōron* (Tokyo: Gentōsha, 1998), 158–160.

54. Bates, Fitch, Magee, and Smythe appear in the docudrama *Nanking* (2007), played respectively by actors Graham Sibley, John Getz, Hugo Armstrong, and Stephen Dorff. In *John Rabe* (2009), Magee is a minor character portrayed by Shaun Lawton, while Smythe is played by Christian Rodska. The latter film features Robert O. Wilson in a more prominent cinematic role, played by Steve Buscemi.

55. Diana Lary, *The Chinese People at War: Human Suffering and Social Transformation, 1937–1945* (Cambridge: Cambridge University Press, 2010), 82–96. See also Pingchao Zhu, *Wartime Culture in Guilin, 1938–1944: A City at War* (Lanham, Md.: Lexington, 2015); Isabel Brown Crook and Christina Kelley Gilmartin, *Prosperity's Predicament: Identity, Reform, and Resistance in Rural Wartime China*, with Yu Xiji, ed. Gail Hershatter and Emily Honig (Lanham, Md.: Rowman and Littlefield, 2014).

56. Charles Hodge Corbett, *Shantung Christian University* (New York: United Board for Christian Colleges in China, 1955), 219–220. For a detailed overview of the regions of Free China up to 1943, see Hollington K. Tong, ed., *China Handbook, 1937–1943: A Comprehensive Survey of Major Developments in China in Six Years of War, Compiled by the Chinese Ministry of Information* (New York: Macmillan, 1943).

57. Corbett, *Shantung Christian University*, 237–241.

58. Gerald F. Winfield, *China: The Land and the People* (New York: William Sloane Associates, 1948), specifically 104–145, 255–275.

59. Winfield, *China*, 112–135.

60. Winfield, *China*, 215–218.

61. Hans van de Ven, *China at War: Triumph and Tragedy in the Emergence of New China* (Cambridge, Mass.: Harvard University Press, 2018), 123–126. See also Lary, *The Chinese People at War*, 87–89.

62. Winfield, *China*, 221. See also Yingjing Zhang and Zhiwei Xiao, eds., *Encyclopedia of Chinese Film* (New York: Routledge, 1998), 303–304.

63. See John Lossing Buck, *Chinese Farm Economy* (Chicago: University of Chicago Press, 1930); John Lossing Buck, *Land Utilization in China* (Chicago: University of Chicago Press, 1937). For Marion Yang's work, see Yuehtsen Juliette Chung, *Struggle for National Survival: Eugenics in Sino-Japanese Contexts* (New York: Routledge, 2002), 118–127.

64. Winfield photograph, typed verso description, WSFC.

65. Lary, *The Chinese People at War*, 90.

66. Joseph W. Ho, "Sha Fei: Communist Concepts of National Identity in Chinese Wartime Photographs," *San Diego Chinese Historical Society and Museum Newsletter*, Summer 2009, 13, 17; Fall 2009, 12, 17.

67. See also "Father Cormac Shanahan, C.P., St. Paul of the Cross Province (1899–1987)," Passionist Historical Archives, University of Scranton, Pennsylvania, https://passionistarchives.org/biography/father-cormac-shanahan-c-p-st-paul-of-the-cross-province-1899-1987, accessed May 7, 2021.

68. See Matthew D. Johnson, "Propaganda and Sovereignty in Wartime China: Morale Operations and Psychological Warfare under the Office of War Information," *Modern Asian Studies* 45, no. 2 (March 2011): 303–344.

69. Gerald F. Winfield, personal letter to sister Ruth Winfield Love from Chongqing, September 14, 1942, WSFC.

70. Winfield letter to sister.

71. Winfield letter to sister.

72. Gerald F. Winfield, personal letter to wife Louise Winfield and family from Chongqing, August 16, 1942, WSFC.

73. Winfield letter to wife and family. He also described at length his encounter with a baby animal, in the care of a colleague, that was "a cross between a racoon and a possum . . . the first panda" he had "ever seen." He, his family, and this panda would meet again at the Bronx Zoo in 1943. By coincidence, the future US Ambassador to China (1991–1995), J. Stapleton Roy, played with the same panda as a missionary child in wartime West China. Margaret Winfield Sullivan, *Fragments from a Mobile Life* (Santa Fe, N.M.: Red Mountain, 2019), 50; and Margaret Winfield Sullivan, personal email to the author, October 24, 2020.

74. "Statement of Dr. Gerald F. Winfield, Formerly with Office of War Information," *International Technical Cooperation Act of 1949 ("Point IV" Program), Hearings before the Committee on Foreign Affairs, House of Representatives, Eighty-First Congress, First Session on H.R. 5615*, October 5, 1949 (Washington: US Government Printing Office, 1950), 170.

75. "Statement of Dr. Gerald F. Winfield," 170–171.

76. "Statement of Dr. Gerald F. Winfield," 172.

77. Gerald F. Winfield, photographic print, West China, ca. 1942–1943, WSFC

78. Winfield, photographic print.

79. "Statement of Dr. Gerald F. Winfield," 172.

80. "Speaking of Pictures . . . Fable of Birds Tells War History to Chinese," *Life*, July 24, 1944, 12–14.

81. "Speaking of Pictures," 14.

82. "Speaking of Pictures, 13. See also Chang Jui-te, "An Imperial Envoy: Shen Zonglian in Tibet, 1943–1946," in *Negotiating China's Destiny in World War II*, ed. Hans van de Ven, Diana Lary, and Stephen R. Mackinnon (Stanford, Calif.: Stanford University Press, 2015), 52–69.

83. "Statement of L. G. Shreve, President, Counsel Services Inc., Baltimore, MD," *International Technical Cooperation Act of 1949 ("Point IV" Program, Hearings*, October 5, 1949, 163–170.

84. Alan P. L. Liu, *Communications and National Integration in Communist China* (Berkeley: University of California Press, 1971), 165–66.

85. Ralph C. Lewis, "China Years: His Story of Those Years in the Life of Ralph Charles Lewis (Growing Up and His Life in China through the War Years)," unpublished personal memoirs, in the author's possession, 139–140; also Roberta Lewis, personal letter to mother and family, July 17–18, 1937, LFP.

86. Lewis, "China Years," 140.

87. John Bickford, personal letters to family, July 29, 1937, August 14, 1937, reproduced in "The Most Lovely People: A History of the Henke Family from the Letters of John Bickford, 1928–1948," 14–15, unpublished compilation of personal letters, in the author's possession; Harold Eugene Henke, personal letter to friends from "House No. 5, Presbyterian Mission, Peking," October 25, 1937, HFC.

88. John Bickford, personal letters to family, August 14, 1937, August 17, 1937, August 25, 1937, August 30, 1937, reproduced in "The Most Lovely People," 14–22.

89. John Bickford, personal letter to family, August 25, 1937, reproduced in "The Most Lovely People," 18.

90. Lary, *The Chinese People at War*, 56–57.

91. Lewis, "China Years," 141.

92. Yang, "Chiang Kai-shek and the Battles for Shanghai and Nanjing," 145.

93. Lewis, "China Years," 141; Lewis, personal letter to mother and family.

94. Ralph C. Lewis, personal letter to mother-in-law Taylor and family, August 9, 1937, LFP; Harry Lewis, interview with the author, August 11, 2014, Mt. Hermon, California; Richard Henke, interview with the author, July 29, 2013, Rolling Hills, California.

95. Lewis letter to Taylor and family, LFP.

96. Sullivan, *Fragments from a Mobile Life*, 35–36.

97. Jessie Mae Henke and Harold Eugene Henke, letter to supporters, from "Presbyterian Mission, Peiping," December 15, 1937, HFC.

98. Henke and Henke, letter to supporters.

99. Liu Ju, interview with the author, May 22, 2011, Wuhan, China.

100. Joseph Henkels, *My China Memoirs, 1928–1951* (Dubuque, Iowa: Divine Word College, 1988), 80.

101. Joseph Ti-Kang (archbishop emeritus), interview with the author, June 9, 2012, Keelung, Taiwan.

102. Ti-Kang interview.

103. Henkels, *My China Memoirs*, 86–89, 90–91.

104. Harold Eugene Henke, personal letter to supporters, February 11, 1938, HFC.

105. H. E. Henke, personal letter to supporters.

106. Harold Eugene Henke, personal letter to Ethel and Harlan Palmer, February 15, 1938, HFC.

107. H. E. Henke, personal letter to supporters. The movies that the Henkes watched and documented in their letters were *The Prince and the Pauper, Shall We Dance?*, and *The Good Earth* (all released earlier in 1937).

108. H. E. Henke, personal letter to supporters.

109. Lewis, "China Years," 154.

110. Lewis, "China Years," 154.

111. *Report of Medical Work, American Presbyterian Mission, Shuntehfu, Hopei, North China 1939*, HFC.

112. Lewis, "China Years," 154.

113. Henke and Henke, letter to supporters.

114. Lewis, "China Years," 154.

115. Lewis, "China Years," 160. See also Yang Kuisong, "Nationalist and Communist Guerilla Warfare in North China," in Peattie, Drea, and van de Ven, *The Battle for China*, 308–327.

116. Lewis, "China Years," 160.

117. Richard E. Jenness, letter to supporters, from "American Presbyterian Mission, Shuntehfu, North China," July 11, 1938, included in "Extracts from China Letters," 2–4, received in the United States September 19, 1938, HFC.

118. One of the prints, somewhat underexposed, may have been a rejected test print by Lewis or the official photographer. If Lewis made the image, it makes sense that he kept even a poor copy, as fresh photographic paper was then difficult to obtain.

119. See Kazuo Tamayama, *Railwaymen in the War: Tales by Japanese Railway Soldiers in Burma and Thailand, 1941–47* (New York: Palgrave Macmillan, 2005), 1–3. Also Hattori, "Japanese Operations from July to December 1937," 161–162.

120. Jessie Mae Henke, "Family History," 16, HFC. Robert Henke and Richard Henke, interview with the author, June 29, 2012, Pasadena, California.

121. Jessie Mae Henke, "Substance of My Talk on China to Groups," 9, HFC.

122. These are identifiable by the presence of medical staff who were only in Shunde in 1939 and by direct comparison with contemporary photographs made by Ralph Lewis and featured in the 1939 hospital report.

123. Winfield, *China*, 119–220.

124. *Report*, 1939, 3.

125. *Report*, 1939, 10.

126. Frederick G. Scovel and Myra Scovel, photographic prints, SFC. The verso stamp reads "Jining Kenpeitai [Military Police]" (*Sainei Kenpeitai*), and the censor examined it on March 18, 1939.

127. Myra Scovel, *The Chinese Ginger Jars* (New York: Harper and Brothers, 1962), 74.

128. Scovel, *Chinese Ginger Jars*, 74; see also Louise Kiehle Scovel, letter to "Ada and All" in San Diego, June 4, 1938, SFC.

129. Scovel, *Chinese Ginger Jars*, 75–76, 82–83.

130. Scovel letter to "Ada and All." Also Carl Scovel, interview with the author, February 26, 2012, Jamaica Plain, Massachusetts.

131. Louise Kiehle Scovel, personal letter to Frederick G. Scovel from Cortland, New York, May 8, 1932, SFC; also Jim Scovel, Carl Scovel, and Anne Scovel Fitch, interview with the author, July 18, 2014, Walnut Creek, California.

132. Scovel, *Chinese Ginger Jars*, 76.

133. Richard L. Simon, *Miniature Photography from One Amateur to Another* (New York: Simon and Schuster, 1937), 127.

134. Frederick G. Scovel, Kodachrome 35 mm color slides, ca. 1940–1941, SFC.

135. Lewis, "China Years," 164.

136. Scovel, *Chinese Ginger Jars*, 97–98.

137. Lewis, "China Years," 154, 164.

138. Lewis, "China Years," 169; Scovel, *Chinese Ginger Jars*, 99.

139. Frederick G. Scovel, Kodachrome 35 mm color slides, ca. 1941–1942, SFC.

140. Lewis, "China Years," 176–177.

141. Scovel, *Chinese Ginger Jars*, 105.

142. Scovel, *Chinese Ginger Jars*, 158. According to Myra Scovel's personal diary, located in the SFC, the recovery took place on May 13, 1947.

143. Carl Scovel, "The China Trip," 6–7, shared in personal email to author, April 29, 2016; also Jim Scovel, "Jim's China Trip April 2016," 1–2, shared by Vicki Scovel Harris in personal email to author, May 21, 2016.

144. C. Scovel, "The China Trip," 6–7; also J. Scovel, "Jim's China Trip April 2016," 1–2.

145. Langdon Gilkey, *Shantung Compound: The Story of Men and Women under Pressure* (San Francisco: Harper Collins, 1966), 10; also Greg Leck, *Captives of Empire: The Japanese Internment of Allied Civilians in China, 1941–1945* (Bangor, Maine: Shandy, 2006).

146. Lewis, "China Years," 180–201; Scovel, *Chinese Ginger Jars*, 105–142. Eric Liddell and his prewar life would later become the focus of the acclaimed 1981 film *Chariots of Fire*.

147. Scovel, *Chinese Ginger Jars*, 115.

148. Sylvie Pénichon, *Twentieth Century Color Photographs: Identification and Care* (Los Angeles: Getty Conservation Institute, 2013), 163–164, 182.

149. Pénichon, *Twentieth Century Color Photographs*, 163.

150. Scovel, *Chinese Ginger Jars*, 144. Myra Scovel went into labor as the family's repatriation ship, the MV *Gripsholm*, was landing in New York on December 1, 1943. She gave birth to daughter Victoria (Vicki) Scovel within an hour after disembarking. See Lucy Greenbaum,

"Babies Make News on Gripsholm; One Waits to Be Born in the U.S.," *New York Times*, December 2, 1943, 24.

151. Carl Scovel, interviews with the author, February 26, 2012 and June 2, 2013, Jamaica Plain, Massachusetts.

152. Scovel, *Chinese Ginger Jars*, 144; Exodus 23:20 (King James Version). The Scovels left China with several hundred other foreigners aboard the Japanese repatriation ship *Teia Maru*, and waited in Goa to be picked up by the *Gripsholm*. Ralph Lewis also traveled with them on both legs of the voyage.

153. See Barry O'Toole, "What Civilization Owes to China," *China Monthly* 1, no. 1 (December 1939): 7–10. See also Paul Yu-Pin, "Bishop Yu-Pin Speaks: U.S. Can Stop Japan's Aggression by Stopping Sending War Materials to Tokio," *China Monthly* 1, no. 1 (December 1939): 5–6.

5. Memento Mori

1. William J. Klement letter to Bernard Rosecrans Hubbard, December 22, 1949, 5600 California Province Archives, Bernard Rosecrans Hubbard, SJ, Correspondence, box 6, letter from Klement with individual descriptions of photographs [actually the film screenplay, mislabeled] from China, JARC. These materials were formerly held at the Jesuit California Province Archives, Santa Clara University, Santa Clara, California.

2. "Missionaries and the Cinema," *International Review of Educational Cinematography*, July 1932, 557–558.

3. Klement letter to Hubbard.

4. William J. Klement, "William J. Klement, 1906–1994," 1305 ChiM, China Mission Personnel, William Klement, SJ, box 24, Personnel Documents, JARC.

5. David Strand, *An Unfinished Republic: Leading by Word and Deed in Modern China* (Berkeley: University of California Press, 2011), 236.

6. Frederic Wakeman, Jr., "Cleanup," in *Dilemmas of Victory: The Early Years of the People's Republic of China*, ed. Jeremy Brown and Paul G. Pickowicz (Cambridge, Mass.: Harvard University Press, 2007), 31, 40–43, 52–57. See also Paul P. Mariani, *Church Militant: Bishop Kung and Catholic Resistance in Communist Shanghai* (Cambridge, Mass.: Harvard University Press, 2011), 27–108.

7. See also Daniel H. Bays, *A New History of Christianity in China* (Malden, Mass.: Wiley-Blackwell, 2011), 159–175; Oi Ki Ling, *The Changing Role of British Protestant Missionaries in China, 1945–1952* (London: Associated University Presses, 1999), 110–112.

8. "Father William J. Klement, S.J., Obituary," 1305 ChiM, China Mission Personnel, William Klement, SJ, box 24, Personnel Documents, JARC.

9. See Creighton Lacy, "The Missionary Exodus from China," *Pacific Affairs* 28, no. 4 (December 1955): 301–314.

10. See Mao Zedong, "Farewell, Leighton Stuart" [Biele, Situleideng], in *The Selected Works of Mao Tse-tung*, vol. 4 (Beijing: Foreign Languages, 1966), 433–440.

11. Bays, *New History*, 146–160.

12. Joyce Mao, *Asia First: China and the Making of Modern American Conservatism* (Chicago: University of Chicago Press, 2015), 21–25, 54–59.

13. Ling, *The Changing Role*, 121–122.

14. Clarence Burton Day, *Hangchow University: A Brief History* (New York: United Board for Christian Colleges, 1955), 154–155.

15. Day, *Hangchow University*, 155. The quote is from 1 Corinthians 15:57–58 (King James Version).

16. Susan Sontag, *On Photography* (New York: Farrar, Straus and Giroux, 1978), 15.

17. Sontag, *On Photography*, 15.

18. Roland Barthes, *Camera Lucida: Reflections on Photography*, trans. Richard Howard (New York: Hill and Wang, 1981), 77, 85, 88–89.

19. Barthes, *Camera Lucida*, 77.

20. Peter Zarrow, *China in War and Revolution, 1895–1949* (New York: Routledge, 2005), 338.

21. William Hung San Francisco Opera House speech transcript, in W. H. Dobson, "Quarterly Letter #21," December 15, 1946, 3, HFC. See also Sigmund Tobias, *Strange Haven: A Jewish Childhood in Wartime Shanghai* (Chicago: University of Illinois Press, 1999).

22. Dobson, "Quarterly Letter #21," 3.

23. Dobson, "Quarterly Letter #21," 3.

24. Richard Henke, phone interview with the author, August 23, 2016. Henke remembered the young American missionaries having an upbeat attitude, which he found easy to relate to as a twelve-year-old. The new arrivals lived at Beijing's other Presbyterian compound on Gulouxi Road, not far from the Drum Tower.

25. Chih Tsang, *China's Postwar Markets* (New York: Institute of Pacific Relations, 1945), vi, 112.

26. Tsang, *China's Postwar Markets*, 112–113, 119–120.

27. Harold Eugene Henke, letter to "Dear Ones in Hollywood," December 21, 1945, HFC; Harold Eugene Henke letter to "Dear Friends in the USA," March 3, 1946, HFC.

28. Frederick Scovel, letter to Myra Scovel, April 10, 1946, S. "Before you leave please bring me half a dozen of Plus-X 35 mm films, with 36 exposures if available[,] otherwise 18 (put on list!)."

29. Kalton C. Lahue and Joseph A. Bailey, *Glass, Brass, and Chrome: The American 35mm Miniature Camera* (Norman: University of Oklahoma Press, 1972), 212–215.

30. Lewis Kodachrome slide collection, 1947–1952, LFP. Focusing the Kodak 35 involved turning an uncomfortably geared thumbwheel to merge two halves of an optically split image in a tiny viewfinder, compared to judging focus on the Rolleiflex's large ground glass focusing screen.

31. Harold Eugene Henke letter to "Dearest Ones at Home," July 20, 1947, HFC.

32. Claudia Deveaux and George Bernard Wong, *Bamboo Swaying in the Wind: A Survivor's Story of Faith in Imprisonment in Communist China* (Chicago: Loyola, 2000), 3, 13–31, 48–49, 55–56. See also Amanda C. R. Clark, *China's Last Jesuit: Charles J. McCarthy and the End of the Mission in Catholic Shanghai* (Singapore: Palgrave Macmillan, 2017), 8, 39; and Joseph Tse-hei Lee, "Faith and Defiance: Christian Prisoners in Maoist China," *Review of Religion and Chinese Society* 4, no. 2 (2017): 167–192.

33. Deveaux and Wong, *Bamboo Swaying in the Wind*, 49.

34. Zarrow, *China in War and Revolution*, 24–25.

35. Harold Eugene Henke, letter to "Judy, Eth, and Mildred," March 3, 1946, HFC.

36. H. E. Henke letter to "Dear Friends in the USA."

37. Henke letter to "Judy, Eth, and Mildred."

38. Henke added in the March 3 letter, "Mrs. [Lillian] Jenness upon her return here from Weihsien [Internment Camp] wrote the leader of one of the groups who had been [in Shunde]

and received back here the Xray machine, and several boxes of laboratory and operating room equipment, and some drugs. Much of this is unusable now and an Xray mechanic is coming this week to test the Xray machine." Henke letter to "Judy, Eth, and Mildred." The identity of the "group" that looted the hospital is again not mentioned (see chapter 4); its political affiliation was not clearly known to the missionaries.

39. Harold Eugene Henke, letter to "Dearest Ones in Lockport and Eu Claire," October 6, 1946, HFC.

40. Lillian Jenness, "The Entrance into Glory of Richard E. Jenness," reprinted by E. Roger Jones, June 13, 1941, LFP. Richard Jenness died after a sudden illness on April 16, 1941, and was buried in the garden of the Hung Tao Laymen's Bible School in Shunde. His obituary included a comment by an attending Chinese doctor, who "was so impressed with the expression of his face in death that he insisted that a picture be taken. 'You must take his picture as a testimony . . . [as] that is how a Christian ought to look!'"

41. Harold Eugene Henke, letter to mother, December 16, 1946, HFC. See also Harold Eugene Henke, letter to "Dear Ones in [Lockport] and Eu Claire," March 16, 1947, HFC.

42. Suzanne Pepper, *Civil War in China: The Political Struggle, 1945–1949* (New York: Rowman and Littlefield, 1999), 203–206, 305–307.

43. Liu Ju, interview with the author, May 22, 2011, Wuhan, China; photograph albums, Li/Liu Family Collection.

44. Joseph Henkels, *My China Memoirs, 1928–1951* (Dubuque, Iowa: Divine Word College, 1988), 165–176. See also Tingfu F. Tsiang, *China National Relief and Rehabilitation Administration: C.N.R.R.A. What Does It Do? How Does It Do It?* (Shanghai: International, 1946).

45. Henkels, *My China Memoirs*, 169.

46. Henkels, *My China Memoirs*, 169–170; Joseph Henkels, "Agenda Missionarii 1943," Personnel Files Collection on Reverend Joseph Henkels, SVD, File—Journal, 1935–1951, US.ILTECPA 001.02.00007-3-01.05, Robert M. Myers Archives, Chicago Province of the Society of the Divine Word, Techny, Illinois.

47. See also Terry Lautz, *John Birch: A Life* (New York: Oxford University Press, 2016); "Barrett, David D[ean]," in David Shavit, *The United States in Asia: A Historical Dictionary* (New York: Greenwood, 1990), 29–30; David D. Barrett, *Dixie Mission: The United States Army Observer Group in Yenan, 1944* (Berkeley: Center for Chinese Studies, University of California, 1970); and John N. Hart, *The Making of an Army 'Old China Hand:' A Memoir of Colonel David D. Barrett* (Berkeley: Center for Chinese Studies, University of California, 1985).

48. Myra Scovel, *The Chinese Ginger Jars* (New York: Harper and Brothers, 1962), 147–149. Frederick Scovel, personal diary, August 12–16, 1946, SFC.

49. F. Scovel personal diary, August 15, 1946, September 19, 1946. At this time, Myra Scovel and their children were still living in Rochester, New York. It would be several more months before they saw each other again.

50. H. E. Henke letter to "Dear Friends in the USA."

51. Harold Eugene Henke and Jessie Mae Henke, letter to "Dear Friends in the United States," January 20, 1948, HFC.

52. Henke and Henke letter to "Dear Friends in the United States."

53. Harold Eugene Henke, letter to "Dear Ones in Hollywood," November 9, 1947, HFC.

54. Harold Eugene Henke, letter to "Dearest Ones in Eau Claire and Lockport," January 5, 1947, HFC; Harold Eugene Henke, letter to "Dearest Ones at Home," June 1, 1947, HFC. See also Robert Shaffer, "A Rape in Beijing, December 1946: GIs, Nationalist Protests, and American Foreign Policy," *Pacific Historical Review* 69, no. 1 (February 2000): 31–64.

55. William Summers, "The Chaplain Speaks," *North China Marine*, January 25, 1947, 8, quoted in Shaffer, "A Rape in Beijing," 44.

56. Jessie Mae Henke, letter to "Dear Friends in the USA," April 30, 1947, HFC.

57. See John Useem and Ruth Useem, "The Interfaces of a Binational Third Culture: A Study of the American Community in India," *Journal of Social Issues* 23 (1967): 130–143.

58. Jessie Mae Henke and Roberta Lewis were involved in the administration of the Peking American School while in the city, with Henke working as secretary of the board of managers. See Jessie Mae Henke, "Annual Report, 1947–1948, to the Presbyterian Board of Foreign Missions," 2, HFC.

59. "Photography Club," *The Columbian 1949* (Shanghai: Shanghai American School, 1950), 66; David Angus, phone interview with the author, August 20, 2016.

60. Harry Lewis, phone interview with the author, August 17, 2016. Lewis does not remember what type of camera he used, other than that it was a basic model. It may have been a box or folding camera that his mother Roberta previously used before the war. See Lewis scrapbook album 1948–1949, LFP.

61. Theodor Heinrichsohn, interviews with the author, October 28–29, 2013, Leverkusen, Germany.

62. Carl Scovel, interview with the author, June 3, 2015, Jamaica Plain, Massachusetts.

63. Angus phone interview.

64. Lewis phone interview; Heinrichsohn interview, October 28, 2013.

65. Cecile Lewis Bagwell, Charles Lewis, and Wendy Lewis Thompson, interview with the author, July 4, 2011, Mt. Hermon, California; Thomas Scovel, interview with the author, January 16, 2015, Walnut Creek, California.

66. J. M. Henke letter to "Dear Friends in the USA." In regard to rampant inflation, Jessie Mae added in the postscript, "We had hoped to have this printed and mailed from Peiping. But at a cost of 270,000 dollars for the printing of over 11 cents (1,100 dollars Chinese) per letter for postage, we thought you would understand why we have accepted the offer of a friend in Chicago to mail it for us." See also Odd Arne Westad, *Decisive Encounters: The Chinese Civil War, 1946–1950* (Stanford, Calif.: Stanford University Press, 2003), 182–185.

67. Harold Eugene Henke, letter to "Dearest Ones in Lockport and Eau Claire," January 27, 1947, HFC. Five more cases of attempted suicide followed in the days to come, according to a letter written by Harold to his family on February 8, 1948, recalling the suicide cases of 1947 (totaling eight) and fearing for the worst. The week before, Henke and two other doctors operated on "bad firecracker injuries in little children—one [with] three fingers blown off and the other a hug[e] explosive wound of one side of the face that took . . . 2 hours to clean and repair." Harold Eugene Henke, letter to mother, January 19, 1947, HFC.

68. Westad, *Decisive Encounters*, 160–161. The breakdown in negotiations was no secret to the officers involved; one of them in Marshall's postwar mission admitted to his family after arriving in China in 1947 that his work was "destined to fail." Mary Dodge Wang, interview with the author, February 17, 2014, Denver, Colorado.

69. Harold Eugene Henke, letter to "Dearest Ones in Lockport and Eau Claire," April 2, 1947, HFC. "US forces are rapidly withdrawing from Peking and we have had . . . dinners with [friends] who are leaving [and] are about to do so."

70. This footage, shot with the Cine-Kodak, unfortunately cannot be located and is presumed to no longer exist (though the Henke children remember it well). Harold Eugene Henke, letter to "Dearest Ones in Lockport and Eau Claire," August 5, 1947, HFC; also Richard Henke, phone interview with the author, August 22, 2016.

71. Henke letter to "Dearest Ones at Home." "We continue to be peaceful and quiet here tho[ugh] civil war is on in various parts of the country and there is much fighting going on in Shantung and Manchuria, tho from here we have little reliable and up to date information. At any rate we are very peaceful in Peking and one would not know that there is strife all about us."

72. Harold Eugene Henke and Jessie Mae Henke, letters to family, May 25, 1947, June 1, 1947, HFC.

73. Lloyd Eastman, "Nationalist China during the Nanjing Decade, 1927–1937," in *The Cambridge History of China*, vol. 13: *Republican China 1912–1949, Part 2*, ed. John K. Fairbank and Albert Feuerwerker (Cambridge: Cambridge University Press, 2002), 148.

74. J. M. Henke, letter to "Dear Friends in the USA." By January of the following year, however, Harold reported, "We here in Peking are quite peaceful but all about us civil war rages . . . one has a feeling that we are more or less sitting on top of [a] volcano which may decide to blow up one of these days." Harold Eugene Henke, letter to "Dearest Ones in Hollywood, Lockport and Eu Claire and Pinckneyville and Washington," January 18, 1948, HFC.

75. Derk Bodde, *Peking Diary: A Year of Revolution* (New York: Henry Schuman, 1950), 68–70, entries December 14 and December 15, 1948; 103–104, entry February 3, 1949.

76. *Ageless China*, dir. Bernard Rosecrans Hubbard, n.d., ca. 1949–1950, 16 mm color film with sound narration, JARC (digital copies also held at the Ricci Institute for Chinese-Western Cultural History, University of San Francisco); M. R. Kenney, US Army Advisory Group, "Invitational Travel Orders, Father Bernard Hubbard," April 22, 1947, 5600 California Province Archive, Bernard Rosecrans Hubbard, SJ, Correspondence, box 6, Military Correspondence, 1945–1950, JARC.

77. *Ageless China*. In a strange twist of fate, on April 7, three weeks before Hubbard filmed Tien, the cardinal met Harold Henke for dinner. As Henke wrote, "Monday . . . I was invited to dinner by [a] Cardinal of the Catholic church, T'ien. I had met him a week before on an inspection tour with the International Relief Comm[ittee]. He is very pleasant to meet and we had a dandy dinner." Harold Eugene Henke, letter to "Dearest Ones in Lockport and Eu Claire," April 9, 1947, HFC.

78. Deveaux and Wong, *Bamboo Swaying in the Wind*, 56.

79. *Ageless China*; Kenney, "Invitational Travel Orders."

80. Bernard Rosecrans Hubbard, letter to Harold J. Bock, National Broadcasting Company, Inc., July 21, 1949, 5600 California Province Archive, Bernard Rosecrans Hubbard, SJ, Correspondence, box 6, Commercial and Personal Correspondence, 1949–1950, JARC.

81. Caprice Murray Scarborough and Deanna M. Kingston, *The Legacy of the "Glacier Priest," Bernard R. Hubbard, S.J.* (Santa Clara, Calif.: Santa Clara University, Department of Anthropology and Sociology, 2001), 60. In 1931, Hubbard was reportedly the United States' highest-paid lecturer, earning about $2,000 per appearance (the equivalent of over $35,500 in 2021).

82. A. D. Spearman, "Father Bernard Hubbard, 1888–1962," *Woodstock Letters* 94, no. 4 (November 1965): 471. See also "A Colorful Discussion," *Popular Photography* 19, no. 2 (August 1946): 105.

83. Hubbard was no stranger to product placement, having included in his Alaskan expedition films similar commercial references, among them Purina Dog Chow and the American Can Company. See *Alaska's Silver Millions*, dir. Bernard Rosecrans Hubbard (Carousel Films, 1936), https://archive.org/details/AlaskasS1936, accessed August 15, 2016.

84. American Bolex Company, advertisement in *Popular Photography*, May 1948, 9.

85. Bernard Rosecrans Hubbard, letter to Joseph King, March 18, 1947, 5600 California Province Archive, Bernard Rosecrans Hubbard, SJ, Provincial Curia Files, box 3, Correspondence, 1947, JARC.

86. Klement letter to Hubbard.

87. Calvert Alexander, letter to Bernard Hubbard, October 3, 1947, 5600 California Province Archive, Bernard Rosecrans Hubbard, SJ, Provincial Curia Files, box 3, Correspondence, 1947, JARC; also Bernard Rosecrans Hubbard, letter to Joseph King, October 12, 1947, 5600 California Province Archive, Bernard Rosecrans Hubbard, SJ, Provincial Curia Files, box 3, Correspondence, 1947, JARC.

88. Klement letter to Hubbard.

89. Klement letter to Hubbard.

90. See also Bays, *New History*, 150–151.

91. Klement letter to Hubbard.

92. Klement letter to Hubbard. See also Peng Deng, *China's Crisis and Revolution through American Lenses, 1944–1949* (Lanham, Md.: University Press of America, 1994), 56–58.

93. The phrase with *hao nan* ("good men") was intended to co-opt existing antimilitary proverbs, such as one that the author's paternal grandfather shared: *hao tie bu dang ding, hao nan bu dang bing* (good iron does not make nails; good men do not make soldiers). See Diana Lary, *The Chinese People at War: Human Suffering and Social Transformation, 1937–1945* (Cambridge: Cambridge University Press, 2010), 52–53.

94. Klement letter to Hubbard.

95. Klement letter to Hubbard. Dowd continued his career in Taiwan after 1952, working extensively with youth and prison ministries until the 1970s. Dowd's successful work was facilitated by his Chinese language fluency, which Klement also reported in his film narrative.

96. Klement letter to Hubbard. The "Fr. Fahy" named here—later Monsignor Fahy—was Eugene Fahy, SJ, who was later imprisoned in the PRC alongside several other US and Chinese Catholic priests (at least one of whom, Fr. Matthew Su, SJ, died after being tortured). See *International Fides Service*, February 9, 1952, no. 297, NE 49, June 14, 1952, no. 315, NE 188–189; *Life*, September 8, 1952, 126–146.

97. Klement letter to Hubbard. The aforementioned grave belonged to Fr. William O'Leary, SJ, who died in Yangzhou from cerebral meningitis at the age of thirty-four. Deveaux and Wong, *Bamboo Swaying in the Wind*, 57–58.

98. Jay Taylor, *The Generalissimo: Chiang Kai-shek and the Struggle for Modern China* (Cambridge, Mass.: Harvard University Press, 2009), 585–587.

99. This camera-carrying Chinese priest may be "Father Chang" from Klement's screenplay.

100. See Wu Hung, *Remaking Beijing: Tiananmen Square and the Creation of a Political Space* (Chicago: University of Chicago Press, 2004).

101. Bernard Rosecrans Hubbard, *Ageless China* film, JARC.

102. An almost identical description appears in *A Guide to Catholic Shanghai* (Shanghai: Tou-se-we, 1937), vii.

103. Hubbard, *Ageless China*; Klement letter to Hubbard.

104. Hubbard, *Ageless China*.

105. Mariani, *Church Militant*, 16–17.

106. Matt. 14:1–3, 6–10 (King James Version).

107. Jeremy Clarke, "Our Lady of China: Marian Devotion and the Jesuits," *Studies in the Spirituality of Jesuits* 41, no. 3 (Autumn 2009): 18–41.

108. Mariani, *Church Militant*, 16.

109. Klement letter to Hubbard; *Ageless China.*

110. Bays, *New History*, 169–175.

111. Mariani, *Church Militant*, 27–32, 42–45, 52–53.

112. Mariani, *Church Militant*, 148–156, 215–216.

113. Hubbard, *Ageless China.*

114. Lian Xi, *Redeemed by Fire: The Rise of Popular Christianity in Modern China* (New Haven, Conn.: Yale University Press, 2010), 115–118, 200–201.

115. See Wallace C. Merwin, *Adventures in Unity: The Church of Christ in China* (Grand Rapids, Mich.: William B. Eerdmans, 1974); and "'Patriotic Gifts' for Pummeling," *Living Church*, January 25, 1959, 9.

116. Jessie Mae Henke, letter to Palmer and White families in California, March 15, 1931, HFC.

117. Jessie Mae Henke, "Family History," 19, HFC.

118. Cai Yanxin, *Chinese Architecture* (New York: Cambridge University Press, 2011), 44–47. See also Xinian Fu, "Architecture Technology: Lecture 4 Ceremonial Buildings in Ancient China," in Yongxiang Lu, ed. *A History of Chinese Science and Technology*, vol. 3 (Shanghai: Shanghai Jiao Tong University Press, 2015), 103–106; Norman J. Girardot, *The Victorian Translation of China: James Legge's Oriental Pilgrimage* (Berkeley: University of California Press, 2002), 86–89.

119. Westad, *Decisive Encounters*, 221–224.

120. Bodde, *Peking Diary*, 12–13, entry September 12, 1948.

121. Bodde, *Peking Diary*, 13, entry September 12, 1948.

122. Harold Eugene Henke, letters to "Dear Ones at Home," August 5, 1948, October 14, 1948, October 28, 1948, December 7, 1948, December 19, 1948, HFC; Westad, *Decisive Encounters*, 222–224.

123. Henke letters to "Dear Ones at Home," August 5, 1948, October 14, 1948. Harry Lewis, interviews with the author, August 11, 2014, October 31, 2016, Sacramento, California. Ralph Lewis was rotating with Henke and another Presbyterian doctor, William Cochrane, to handle heavy medical duties in the Baoding hospital from 1946 to 1948.

124. Harold Eugene Henke, letter to "Dear Ones in the USA," October 31, 1948, HFC. The film's contents match Henke's letter description exactly. Wendy and Charles Lewis, the two younger Lewis children, also appear in this film.

125. Jessie Mae Henke and Harold Eugene Henke, letter to "Dear Friends," November 15, 1948, HFC.

126. Robert Henke and Richard Henke, letter to "Nai Nai [grandmother], Uncle Sam, Aunt Dodo, Anne, and Tim," n.d. [after December 11, 1948, in Lockport, Illinois], written on USS *General H. W. Butner* letterhead, HFC.

127. Ralph C. Lewis and Roberta Lewis, "Summary of Life of Ralph and Roberta Lewis as Missionaries," n.d., LFP; Harold Eugene Henke, letter to "Dear Friends," Lockport, Illinois, October 1949, HFC.

128. Photographer unknown, photographic print, HFC. The Chinese caption reads: "Beiping Douw Hospital Senior Nurses Training School student body commemorating Principal Elizabeth Sarah Perkins [*Pan Ailan*] and Mrs. Jessie Mae Henke [*Hengqi furen*] on their departure to [their] home country, 37th year [of the Republic of China], eleventh month, twelfth day [November 12, 1948]." Elizabeth Perkins also appears in Beijing Municipal Committee's Historical Data Research Council, *Beijing wenshi ziliao jingxuan* [Selected Beijing cultural and historical resources] (Beijing: Beijing Publishing House, 2006), 231–233. The Henkes are not mentioned.

129. Henke and Henke letter to "Dear Friends." "It has seemed to many of us that missions could possibly be carried on in such a place as Peking with its large numbers of foreigners, foreign consulates, and where the publicity and public opinion would make it difficult to maintain an

'iron curtain'. Our medical work is more encouraging that ever. We have the finest group of young doctors we have ever known, and they are all Christians."

130. Henke and Henke letter to "Dear Friends." As this letter was written before Jessie Mae and Lois left for Shanghai on November 27, 1948, the conclusion was written in the plural, assuming that Jessie Mae and Harold would stay together in Beijing and continue their medical missionary work in tandem.

131. Westad, *Decisive Encounters*, 224, 226–227.

132. Harold Eugene Henke, letter to mother, February 3, 1949, HFC. Henke had been a member of the Beijing Rotary Club (composed of foreign and Chinese men) since 1947 and renewed his membership in the club on June 30, 1948, half a year before the Communist takeover. Derk Bodde was also in the crowd on the same day Henke encountered the parade, and unlike Henke, made numerous photographs of it. See Bodde, *Peking Diary*, 103–104, entry February 3, 1949.

133. Henke letter to mother, February 3, 1949, HFC.

134. A sentiment echoed in Henke and Henke letter to "Dear Friends."

135. Lewis and Lewis, "Summary of Life of Ralph and Roberta Lewis as Missionaries."

136. Wendy Lewis and Charles Lewis, interview with the author, July 4, 2011, Mt. Hermon, California.

137. Wendy Lewis and Charles Lewis interview; Bays, *New History*, 163.

138. Scovel, *Chinese Ginger Jars*, 164–167. See also Thomas Scovel, *The Year China Changed: Memories of Remarkable Events and Extraordinary People* (Mustang, Okla.: Tate, 2012), 335–336. See also Jonas Jonson, *Lutheran Missions in a Time of Revolution: The China Experience, 1944–1951* (Uppsala, Sweden: Tvåväga Förlags, 1972), 109–110.

139. Scovel, *Chinese Ginger Jars*, 164–167; Scovel, *The Year China Changed*, 340. Louise Scovel passed away in Guangzhou and was buried in the British Cemetery on Shameen Island. Her gravesite has since been lost. Thomas Scovel, interview with the author, July 6, 2012, Walnut Creek, California.

140. Westad, *Decisive Encounters*, 284–286.

141. Scovel, *Chinese Ginger Jars*, 174–175; Scovel, *The Year China Changed*, 345.

142. Scovel, *The Year China Changed*, 347–348; Thomas Scovel, phone interview with the author, April 22, 2021.

143. Scovel, *The Year China Changed*, 347–349; Scovel, *Chinese Ginger Jars*, 176; Myra Scovel, diary 1949–1951, March 3, 1949, SFC. See also Charles Hodge Corbett, *Lingnan University, A Short History Based Primarily on the Records of the University's American Trustees* (New York: Trustees of Lingnan University, 1963), 161.

144. Scovel, *The Year China Changed*, 354; Scovel, *Chinese Ginger Jars*, 176–177.

145. Bays, *New History*, 162–164.

146. Scovel, *The Year China Changed*, 352–357; Scovel, *Chinese Ginger Jars*, 181–184.

147. Scovel, *Chinese Ginger Jars*, 178–180.

148. Thomas Scovel, phone interview with the author, April 22, 2021; Scovel, *The Year China Changed*, 355–356.

149. Robert C. Miller and Ellen M. Studley, "Peiping Religious Workers' Retreat, June 3–4, 1949," HFC. "Dr. Harold E. Henke, Chinese Medical Association Life Membership Card, no. 1528, Issued March 15, 1947," HFC.

150. Harold Eugene Henke, typed diary entries, June 3, 1949, HFC.

151. Bays, *New History*, 159–163. See also Wu Yaozong (Y. T. Wu), *Shehui fuyin* [The social gospel] (Shanghai: Association, 1936); *Shen Tilan jinian wenji* [Shen Tilan memorial *festschrift*] (Shanghai: Shanghai Political Consultative Conference Literature and Historical Resources

Editorial Department, November 1999); Zhao Zichen (T. C. Chao), *Jidujiao zhexue* [Christian philosophy] (Suzhou, China: Literature Department of the Church of Christ in China, 1925); and Xu Yihua, "Pu Huaren: chu ren jiaohui de shenqi renwu" ["Pu Huaren: A Christian turned legendary revolutionary"], in *Jidujiao yu jindai wenhua* [Christianity and modern culture], ed. Zhu Weizheng (Shanghai: Shanghai People's Press, 1994), 269–287.

152. Miller and Studley, "Peiping Religious Workers' Retreat," 1, 3–4.

153. Miller and Studley, "Peiping Religious Workers' Retreat," 4.

154. Miller and Studley, "Peiping Religious Workers' Retreat," 4.

155. Robert C. Miller, endnote commentary on Miller and Studley, "Peiping Religious Workers' Retreat," HFC.

156. Harold Eugene Henke, typed diary entries, June 8, 1949, August 2, 1949, HFC.

157. Harold Eugene Henke, typed diary entries, September 23, 1949, September 27–29, 1949, HFC. Richard Henke, phone conversations with the author, August 2, 2016, November 10, 2016. Richard Henke has since gifted the stamps to the British Library's Philatelic Department.

158. Sontag, *On Photography*, 15.

159. Miller and Studley, "Peiping Religious Workers' Retreat," 1. The notes state that "Opening Worship [was] led by Bishop Chang; Hymn—O God Our Help in Ages Past." For the English lyrics, see Isaac Watts (1719), "O God, Our Help in Ages Past," no. 289, *The Hymnal of the Protestant Episcopal Church in the United States of America* (New York: Church Pension Fund, 1943). For the Chinese lyrics employed in this period, see "Qiangu baozhang ge," no. 21, *Pu tian song zang* [Hymns of universal praise], ed. Union Hymnal Committee (Shanghai: Christian Literature Society for China, 1947), 23.

Epilogue

1. "China Reserve Personnel" board pamphlet, March 13, 1951, HFC.

2. Including the author's paternal grandparents and their family, Chinese Catholics from Chaozhou and Ningbo who immigrated to Taiwan during this time. See also Dominic Meng-Hsuan Yang, *The Great Exodus from China: Trauma, Memory, and Identity in Modern Taiwan* (Cambridge: Cambridge University Press, 2020).

3. William J. Klement letter to Bernard Rosecrans Hubbard, December 22, 1949, 5600 California Province Archives, Bernard Rosecrans Hubbard, SJ, Correspondence, box 6, letter from Klement with individual descriptions of photographs [actually the film screenplay, mislabeled] from China, 1949, JARC. See also Beverley Hooper, *China Stands Up: Ending the Western Presence, 1948–1950* (Crows Nest, Australia: Allen and Unwin, 1986), 38–45.

4. *Minutes of the General Assembly of the Presbyterian Church in the United States of America* (New York: Presbyterian Board of Publication, 1956), 125.

5. Jonathan D. Spence, "Li Zhensheng: Photography for a Time of Troubles," in *Red-Color News Soldier*, Li Zhensheng, with Robert Pledge (London: Phaidon, 2003), 11–15.

6. Joseph Henkels, "Agenda Missionarii 1943," Personnel Files Collection on Reverend Joseph Henkels, SVD, File—Journal, 1935–1951, US.ILTECPA 001.02.00007–3–01.05, 44, 111, Robert M. Myers Archives, Chicago Province of the Society of the Divine Word, Techny, Illinois.

7. Fotoprint Service "Memo of Cost," receipt made out to Fr. Joseph Henkels, SVD, in Henkels, "Agenda Missionarii 1943." Jim Scovel and Carl Scovel, interview with the author, July 18, 2014, Walnut Creek, California.

8. Frederick Scovel, letter to Myra Scott Scovel, n.d. (ca. 1954), SFC.

9. Paul Hsiao, phone interview with the author, April 18, 2011.

10. Harry Lewis, "Refreshments at Bang Peyin," 35 mm Kodachrome slide, February 1955, LFP; Harry Lewis, personal email to the author, May 16, 2015; Frederick and Myra Scovel in Agra, India, 35 mm Kodachrome slide, ca. 1957, SFC.

11. Harold Eugene Henke to Lloyd S. Ruland, Secretary of the Board of Foreign Missions of the Presbyterian Church in the United States of America (PCUSA), April 11, 1951, HFC.

12. Harold Eugene Henke, letter to Lloyd S. Ruland, April 29, 1951, HFC.

13. Harold Eugene Henke and Jessie Mae Henke, letter to Lloyd S. Ruland, June 7, 1951, HFC; also E. M. Dodd, letters to Harold Eugene Henke from the Medical Department of the Board of Foreign Missions of the PCUSA, November 26, 1951, December 4, 1951, HFC.

14. Hollington K. Tong, *Free China's Role in the Asian Crisis: Collection of Speeches March–November 1957* (Washington D.C.: Chinese Embassy, 1958), 158–159.

15. Richard P. Henke, interview with the author, November 12, 2013, Rolling Hills, California.

16. Darsie Alexander, "Slideshow," in *Slideshow: Projected Images in Contemporary Art*, ed. Darsie Alexander (University Park: Pennsylvania State University Press, 2005), 3.

17. Alexander, "Slideshow," 5.

18. See also John-Paul Spiro and Peter Augustine Lawler, "*Mad Men*'s Selective Nostalgia and Uncertain Progress," in *Mad Men: The Death and Redemption of American Democracy*, ed. Sara MacDonald and Andrew Moore (Lanham, Md.: Lexington, 2016), 49–50.

19. Spiro and Lawler, "*Mad Men*'s Selective Nostalgia," 3.

20. Daniel H. Bays, *A New History of Christianity in China* (Malden, Mass.: Wiley-Blackwell, 2011), 160–166, 169–176.

21. Lian Xi, *Redeemed by Fire: The Rise of Popular Christianity in Modern China* (New Haven, Conn.: Yale University Press, 2010), 197–198, 200.

22. Mary Brown Bullock, *An American Transplant: The Rockefeller Foundation and Peking Union Medical College* (Berkeley: University of California Press, 1980), 206–208, 211–217; Bays, *New History*, 163.

23. Bays, *New History*, 162–163.

24. Wu Hung, *Zooming In: Histories of Photography in China* (Chicago: Reaktion, 2016), 124–125, 143–152, 156–157.

25. Wu, *Zooming In*, 189–218.

26. Bays, *New History*, 176. See also John Craig William Keating, *A Protestant Church in Communist China: Moore Memorial Church, 1949–1989* (Bethlehem, Pa.: Lehigh University Press, 2013), 174–175.

27. Huan Hsu, *The Porcelain Thief: Searching the Middle Kingdom for Buried China* (New York: Crown, 2015), 315.

28. Wu Xiaoyu, personal email to the author, February 3, 2017.

29. Email correspondence between author and Wu Xiaoyu.

30. Bays, *New History*, 176–177.

31. Shen Hong, interview by the author, May 28, 2012, Hangzhou, China.

32. Laura Wexler, "Chinese Family Photographs and American Collective Memory," *Trans-Asia Photography Review* 1, no. 1 (Fall 2010), http://hdl.handle.net/2027/spo.7977573.0001.102. Accessed November 28, 2020.

33. Li Weilai, interview by the author, May 22, 2011, Wuhan, China.

34. Dou Languang, interview with the author, June 7, 2011, Xingtai, China.

35. Susan Naquin, "Funerals in North China," *Death Ritual in Late Imperial and Modern China*, ed. Evelyn S. Rawski and James L. Watson (Berkeley: University of California Press, 1988), 39–40, 59, 61.

36. Clara Bickford Heer, interview with the author, July 25, 2011, Pasadena, California; Thomas Scovel, interview with the author, July 13, 2012, Walnut Creek, California.

37. Robert E. Carbonneau, interview with the author, January 20, 2015, San Francisco, California.

38. Thomas Scovel interview, July 13, 2012.

39. Sophie D. Henke, interview with the author, July 25, 2011, Rolling Hills, California; Richard P. Henke, phone interview with the author, December 1, 2020.

40. Photographer unknown, Kodachrome slide, December 1979, Bickford Family Papers, Bentley Historical Library, University of Michigan, Ann Arbor.

41. Roland Barthes, *Camera Lucida: Reflections on Photography*, trans. Richard Howard (New York: Hill and Wang, 1981), 96.

42. Bays, *New History*, 187–199.

43. Bays, *New History*, 199–201.

44. Wang Ye and An Wei, eds., *Xingtai shi jidu jiaotang yibai zhounian jinian yingji* [The commemorative photo album of the 100th anniversary of the Xingtai city Christian church] (Xingtai, China: Xingtai Christian Council, 2003), 8.

45. See Shen Hong, *Tiancheng jiyi* [Memories of the heavenly city] (Jinan, China: Shandong renmin chubanshe, 2010); Shen Hong, *Xihu baixiang* [One hundred views of West Lake] (Jinan, China: Shandong renmin chubanshe, 2010); Cheng Ma, *Meiguo jingtou li de Zhongguo fengjing* [China's traditions from inside an American camera] (Beijing: Zhongguo wenshi chubanshe, 2011); Joseph Tse-hei Lee and Christie Chui-Shan Chow, *Context and Horizon: Visualizing Chinese-Western Cultural Encounters in Chaoshan* [*Chujing yu shiye: Chaoshan Zhongwai jiaoliu de guangying jiyi*] (Beijing: SDX, 2017).

46. Wu, *Zooming In*, 219–225.

47. See Gu Zuoyi, *The Memory of Our Country and Families: Scenes of Chinese Social Life during 150 Years* [*Guojia chunqiu: 150 nian Zhongguo shehui shenghuo changjing*] (Guangzhou, China: Anno Domini, 2011); also Feng Keli, *Gushi fengwu* [Local scenes from the past] (Jinan, China: Shandong huabao chubanshe, 2008).

48. Wu, *Zooming In*, 225; Susan Sontag, *On Photography* (New York: Farrar, Straus and Giroux, 1978), 71–72, 74–75.

49. Hebrews 11:1, 3 (King James Version).

Glossary of Chinese Terms

All terms are given in traditional characters and in order of first appearance in the text.

Term	Pinyin	Wade-Giles	Alt. Terms / Postal Romanization (PO)
Introduction			
武漢大學	Wuhan daxue	Wu-han ta-hsüeh	
武漢	Wuhan	Wu-han	Formerly Hankou, Hanyang, Wuchang
劉犟	Liu Ju	Liu Chü	
李慶海	Li Qinghai	Li Ch'ing-hai	
武漢測量製圖學院	Wuhan celiang zhitu xueyuan	Wu-han ts'e-liang chih-t'u hsüeh-yüan	Wuhan Institute of Surveying and Cartography
順德	Shunde	Shun-teh	Shunteh (PO), Shuntehfu
石家莊	Shijiazhuang	Shih-chia-chuang	Shihkiachwang (PO)
河北	Hebei	Ho-pei	Hopeh (PO)
北京	Beijing	Pei-ching	Peking (PO)
義和團運動	Yihetuan yundong	I-ho-t'uan yün-tung	Boxer Uprising

(*Continued*)

Term	Pinyin	Wade-Giles	Alt. Terms / Postal Romanization (PO)
Introduction			
辛亥革命	Xinhai geming	Hsin-hai ko-ming	1911 Revolution
五四運動	Wusi yundong	Wu-ssu yün-tung	May Fourth Movement
非基督教運動	Fei jidujiao yundong	Fei chi-tu-chiao yün-tung	Anti-Christian Movement
國共內戰	Guogong neizhan	Kuo-kung nei-chan	Chinese Civil War
抗日戰爭	Kangri zhanzheng	K'ang-jih chan-cheng	Second Sino-Japanese War
中華民國	Zhonghua minguo	Chung-hua min-kuo	Republic of China (ROC)
中國共產黨	Zhongguo gongchandang	Chung-kuo kung-ch'an-tang	Chinese Communist Party (CCP)
中國國民黨	Zhongguo guomindang	Chung-kuo kuo-min-tang	Kuomintang (KMT), Guomindang (GMD), Chinese Nationalist Party (CNP)
中華人民共和國	Zhonghua renmin gongheguo	Chung-hua jen-min kung-ho-kuo	People's Republic of China (PRC)
台灣	Taiwan	T'ai-wan	
湘西	Xiangxi	Hsiang-hsi	West Hunan
揚州	Yangzhou	Yang-chou	Yangchow (PO)
李維來	Li Weilai	Li Wei-lai	
Chapter 1			
新華南路	Xinhua nanlu	Hsin-hua nan-lu	
新西街	Xinxi jie	Hsin-hsi chieh	
邢台	Xingtai	Hsing-tai	Formerly Shunde or Shundefu
實事求是	shi shi qiu shi	shih shih ch'iu shih	seek truth from facts
邢台基督教懷恩堂	Xingtai jidujiao huai'en tang	Hsing-tai chi-tu-chiao huai-en t'ang	Xingtai Grace Christian Church
王燁	Wang Ye	Wang Yeh	
新生活運動	Xin shenghuo yundong	Hsin sheng-huo yün-tung	New Life Movement
蔣介石	Jiang Jieshi	Chiang Chieh-shih	Chiang Kai-shek
宋美齡	Song Meiling	Sung Mei-ling	Soong Mei-ling
京漢鐵路	Jinghan tielu	Ching-han tieh-lu	Beijing-Hankou Railway
南京十年	Nanjing shi nian	Nan-ching shih nien	Nanjing Decade
天津	Tianjin	T'ien-chin	Tientsin (PO)
上海	Shanghai	Shanghai	Shanghai (PO)
湖南	Hunan	Hunan	Hunan (PO)

Term	Pinyin	Wade-Giles	Alt. Terms / Postal Romanization (PO)
Chapter 1			
山東	Shandong	Shantung	Shantung (PO)
四川	Sichuan	Ssu-ch'uan	Szechwan (PO)
廣東	Guangdong	Kuang-tung	Kwangtung (PO)
塘沽	Tanggu	Tang-ku	Tangku (PO)
海河	Haihe	Hai-ho	Hai River
陽江	Yangjiang	Yang-chiang	Yeungkong (PO)
紫禁城	Zijincheng	Tzu-chin-ch'eng	Forbidden City
天壇	Tiantan	T'ien-t'an	Temple of Heaven
北海公園	Beihai gongyuan	Pei-hai kung-yüan	Beihai Park
九龍壁	Jiulongbi	Chiu-lung-pi	Nine-Dragon Screen
東交民巷	Dong jiaomin xiang	Tung chiao-min hsiang	Legation Quarter
牌樓	pailou	p'ai-lou	
北伐	Beifa	Pei-fa	Northern Expedition
南口	Nankou	Nan-k'ou	Nankow (PO)
張作霖	Zhang Zuolin	Chang Tso-lin	
奉軍	Fengjun	Feng-chün	Fengtian Army
張學良	Zhang Xueliang	Chang Hsüeh-liang	
北平	Beiping	Pei-p'ing	Peiping (PO)
保定	Baoding	Pao-ting	Paoting (PO), Paotingfu
福音醫院	Fuyin yiyuan	Fu-yin i-yüan	Gospel Hospital
北京協和醫學院	Beijing xiehe yixueyuan	Pei-ching hsieh-ho i-hsüeh-yüan	Peking Union Medical College (PUMC)
洋鬼子	yang guizi	yang kuei-tzu	foreign devils
北平華北工程學校	Beiping huabei gongcheng xuexiao	Pei-ping hua-pei kung-ch'eng hsüeh-hsiao	
美國基督教長老會	Meiguo jidujiao zhanglaohui	Mei-kuo chi-tu-chiao chang-lao-hui	American Presbyterian Church
衡州	Hengzhou	Heng-chou	Hengchow (PO)
信, 望, 愛	xin, wang, ai	hsin, wang, ai	faith, hope, love
Chapter 2			
常德	Changde	Chang-teh	Changteh (PO)
廣德醫院	Guangde yiyuan	Kuang-teh i-yüan	Presbyterian Mission Hospital, Kuangteh

(Continued)

Term	Pinyin	Wade-Giles	Alt. Terms / Postal Romanization (PO)
Chapter 2			
苦難會	Kunan hui	K'u-nan hui	Passionists, Congregation of the Passion of Jesus Christ
湘西	Xiangxi	Hsiang-hsi	West Hunan
長沙	Changsha	Ch'ang-sha	Changsha (PO)
辰州 / 沅陵	Chenzhou / Yuanling	Ch'en-chou / Yüan-ling	Shenchow (PO), Shenchowfu Yüanling (PO)
沅江	Yuanjiang	Yüan-chiang	Yuan River
漢陽	Hanyang	Han-yang	Hanyang (PO)
漢口	Hankou	Han-k'ou	Hankow (PO)
保靖	Baojing	Pao-ching	Paoking (PO), Paotsing
辰谿	Chenxi	Ch'en-hsi	Chenki (PO)
沅州	Yuanzhou	Yüan-chou	Yuanchow (PO), Yuanchowfu
福音堂	Fuyin tang	Fu-yin t'ang	Protestant church
天主堂	Tianzhu tang	T'ien-chu t'ang	Catholic church
瑪利諾外方傳教會	Malinuo waifang chuanjiao hui	Ma-li-no wai-fang ch'uan-chiao hui	Maryknoll Society, Catholic Foreign Mission Society of America (CFMSA)
要飯	yao fan	yao fan	
花橋	Huaqiao	Hua-ch'iao	
譚延闓	Tan Yankai	T'an Yen-k'ai	
湖南共和國	Hunan gonghe guo	Hu-nan kung-ho kuo	Republic of Hunan
大公報	Da gong bao	Da kung pao	
毛澤東	Mao Zedong	Mao Tse-tung	
Chapter 3			
山西	Shanxi	Shan-hsi	Shansi (PO)
商務印書館	Shangwu yinshuguan	Shang-wu yin-shu-kuan	Commercial Press
魯迅	Lu Xun	Lu Hsün	
聖言會	Shengyan hui	Sheng-yen hui	Society of the Divine Word (SVD)
巨野教案	Juye jiao'an	Chü-yeh chiao-an	Juye Incident
熱鬧	renao	jen-ao	
江西路	Jiangxi lu	Chiang-hsi lu	Kiangse Road (PO)

Term	Pinyin	Wade-Giles	Alt. Terms / Postal Romanization (PO)
Chapter 3			
華北電影公司	Huabei dianying gongsi	Hua-pei tien-ying kung-ssu	North China Film Company
羅明佑	Luo Mingyou	Lo Ming-yu	
光陸大戲院	Guanglu daxiyuan	Kuang-lu ta-hsi-yüan	Capitol Theatre
紙紮	zhiza	chih-tsa	
晏陽初	Yan Yangchu	Yen Yang-ch'u	Y. C. James Yen
一二八事變	Yi erba shibian	I erh-pa shih-pien	Shanghai Incident
桃花泣血記	Taohua qixue ji	T'ao-hua ch'i-hsüeh chi	*Peach Blossom Weeps Tears of Blood*
聯華影業公司	Lianhua yingye gongsi	Lien-hua ying-yeh kung-ssu	United Photoplay Service
卜萬蒼	Bu Wancang	Pu Wan-ts'ang	Richard Poh
江西	Jiangxi	Chiang-hsi	Kiangsi (PO)
孫中山	Sun Zhongshan	Sun Chung-shan	Sun Yat-sen
國父	guofu	kuo-fu	Father of the Nation
重男輕女	zhongnan qingnü	chung-nan ch'ing-nü	
石友三	Shi Yousan	Shih You-san	
土匪	tu fei	t'u-fei	bandit(s)
衛生展覽會	weisheng zhanlan hui	wei-sheng chan-lan hui	
餃子	jiaozi	chiao-tzu	
中華基督教會	Zhonghua Jidu jiaohui	Chung-hua Chi-tu chiao-hui	Church of Christ in China
Chapter 4			
南京	Nanjing	Nan-ching	Nanking (PO)
蘆溝橋事變	Lugouqiao shibian	Lu-kou-chiao shih-pien	Marco Polo Bridge Incident
金陵大學	Jinling daxue	Chin-ling ta-hsüeh	University of Nanking
中華路	Zhonghua lu	Chung-hua lu	
申報	Shen bao	Shen pao	*Shanghai News*
王海升	Wang Haisheng	Wang Hai-sheng	H. S. Wong
南京鼓樓	Nanjing gulou	Nan-ching ku-lou	Drum Tower of Nanjing
下關	Xiaguan	Hsia-kuan	
鍋巴	guo ba	kuo pa	

(Continued)

Term	Pinyin	Wade-Giles	Alt. Terms / Postal Romanization (PO)
Chapter 4			
重慶	Chongqing	Ch'ung-ch'ing	Chungking (PO)
成都	Chengdu	Ch'eng-tu	Chengtu (PO)
昆明	Kunming	K'un-ming	Formerly Yunnanfu
桂林	Guilin	Kuei-lin	Kweilin (PO)
中華民國自由地區	Zhonghua minguo ziyou diqu	Chung-hua min-kuo tzu-yu ti-ch'ü	Free China
齊魯大學	Qilu daxue	Ch'i-lu ta-hsüeh	Cheeloo University
華西聯合大學	Huaxi lianhe daxue	Hua-hsi lien-ho ta-hsüeh	West China Union University
長江 / 揚子江	Chang jiang / Yangzi jiang	Ch'ang chiang / Yang-tzu chiang	Yangtze River
大路	Da lu	Ta lu	*The Big Road*
沈西苓	Shen Xiling	Shen Hsi-ling	
中央電影公司	Zhongyang dianying gongsi	Chung-yang tien-ying kung-ssu	Central Film Studio
楊崇瑞	Yang Chongrui	Yang Ch'ung-jui	Marion Yang
國立第一助產學校	Guoli di yi zhuchan xuexiao	Kuo-li ti-i chu-ch'an hsüeh-hsiao	First National Midwifery School
延安	Yan'an	Yen-an	Yenan (PO)
聯合國影聞宣傳處	Lianheguo yingwen xuanchuan chu	Lien-ho-kuo ying-wen hsüan-ch'uan ch'u	United Nations Filmstrip Propagation Department
中華民國教育部	Zhonghua minguo jiaoyubu	Chung-hua min-kuo chiao-yü-pu	Ministry of Education
優良的放影隊是電影教育的優良學校	youliang de fangyingdui shi dianying jiaoyu de youliang xuexiao	yu-liang te fang-ying-tui shih tien-ying chiao-yü te yu-liang hsüeh-hsiao	an excellent projection team is an excellent school of film education
中國農村復興聯合委員會	Zhongguo nongcun fuxing lianhe weiyuanhui	Chung-kuo nung-ch'un fu-hsing wei-yüan-hui	Sino-American Joint Commission on Rural Reconstruction
北戴河	Beidaihe	Pei-tai-ho	Pehtaiho (PO)
香港	Xianggang	Hsiang-kang	Hong Kong
秦皇島	Qinhuangdao	Ch'in-huang-tao	Chinwangtao (PO)
狄剛	Di Gang	Ti Kang	Joseph Ti-Kang
太原	Taiyuan	T'ai-yüan	Taiyüan (PO)
八路軍	Balu jun	Pa-lu chün	Eighth Route Army
濟寧	Jining	Chi-ning	Tsining (PO)
泰山	Taishan	T'ai-shan	Taishan (PO)

Term	Pinyin	Wade-Giles	Alt. Terms / Postal Romanization (PO)
Chapter 4			
濟寧市博物館	Jining shi bowuguan	Chi-ning shih po-wu-kuan	Jining Museum
濰縣集中營	Weixian jizhongying	Wei-hsien chi-chung-ying	Weihsien Internment Camp
Chapter 5			
耶穌會加州省	Yesu hui jiazhou sheng	Yeh-su hui chia-chou sheng	California Province of the Society of Jesus
江蘇	Jiangsu	Chiang-su	Kiangsu (PO)
公安局	Gong'an ju	Kung-an chü	Public Security Bureau
中國大陸	Zhongguo dalu	Chung-kuo ta-lu	mainland China
之江大學	Zhijiang daxue	Chih-chiang ta-hsüeh	Hangchow Christian College
浙江	Zhejiang	Che-chiang	Chekiang (PO)
杭州	Hangzhou	Hang-chou	Hangchow (PO)
洪業	Hong Ye	Hung Yeh	William Hung
章植	Zhang Zhi	Tsang Chih	
二條胡同	Er tiao hutong	Erh t'iao hu-tung	
天津中央醫院	Tianjin zhongyang yiyuan	T'ien-chin chung-yang i-yüan	Tientsin Central Hospital
中國善後救濟總署	Zhongguo shanhou jiuji zongshu	Chung-kuo shan-hou chiu-chi tsung-shu	United Nations Relief and Rehabilitation Administration
徐州	Xuzhou	Hsü-chou	Süchow (PO)
新鄉	Xinxiang	Hsin-hsiang	Sinsiang (PO)
懷遠	Huaiyuan	Huai-yüan	Hwaiyüan (PO)
安徽	Anhui	An-hui	Anhwei (PO)
民望醫院	Minwang yiyuan	Min-wang i-yüan	Hope Hospital
道濟醫院	Daoji yiyuan	Tao-chi i-yüan	Douw Hospital
北京大學	Beijing daxue	Pei-ch'ing ta-hsüeh	Peking University
福建	Fujian	Fu-chien	Fukien (PO)
煤山	Meishan	Mei-shan	Coal Hill
萬壽山	Wanshou shan	Wan-shou shan	Longevity Hill
昆明湖	Kunming hu	K'un-ming hu	Kunming Lake
頤和園	Yiheyuan	I-ho-yüan	Summer Palace
中國人民解放軍	Zhongguo renmin jiefang jun	Chung-kuo jen-min chieh-fang chün	People's Liberation Army (PLA)

(Continued)

Term	Pinyin	Wade-Giles	Alt. Terms / Postal Romanization (PO)
Chapter 5			
北堂 / 救世主堂	Beitang / Jiushi zhutang	Pei-tang / Chiu-shih chu-tang	North Church / Church of the Saviour
田耕莘	Tian Gengxin	T'ien Keng-hsin	Thomas Tien Ken-sin
拯望會	Zhengwang hui	Cheng-wang hui	Society of the Helpers of the Holy Souls
大運河	Da yunhe	Ta yün-ho	Grand Canal
好男兒絕不逃避兵	hao nan'er jue bu taobi bing	hao nan-erh chüeh bu t'ao-pi ping	good men never desert the army
瘦西湖	Shou xihu	Shou hsi-hu	Slender West Lake
天安門	Tian'anmen	T'ien-an-men	
徐家匯	Xujiahui	Hsu-chia-hui	Siccawei (PO)
佘山	Sheshan	She-shan	Zose
佘山聖母大殿	Sheshan shengmu dadian	She-shan sheng-mu ta-tien	Basilica of Our Lady of Sheshan
龔品梅	Gong Pinmei	Kung P'in-mei	Ignatius Kung Pin-Mei
圜丘壇	Huan qiu tan	Huan ch'iu t'an	Circular Mound Altar
王明道	Wang Mingdao	Wang Ming-tao	
基督徒會堂	Jidutu huitang	Chi-tu-t'u hui-tang	Christian Tabernacle
天	tian	t'ien	heaven
林彪	Lin Biao	Lin Piao	
聶榮臻	Nie Rongzhen	Nieh Jung-chen	
青島	Qingdao	Ch'ing-tao	Tsingtao (PO)
傅作義	Fu Zuoyi	Fu Tso-i	
傅東菊	Fu Dongju	Fu Tung-chü	
夏葛醫學院	Xiage yixueyuan	Hsia-ko i-hsüeh-yüan	Hackett Medical Center
嶺南大學	Lingnan daxue	Ling-nan ta-hsüeh	Lingnan University
蚌埠	Bengbu	Peng-pu	Pengpu (PO)
趙紫宸	Zhao Zichen	Chao Tzu-ch'en	T. C. Chao
吳耀宗	Wu Yaozong	Wu Yao-tsung	Y. T. Wu
沈體蘭	Shen Tilan	Shen T'i-lan	T. L. Shen
浦化人	Pu Huaren	P'u Hua-jen	H. J. Pu
三自愛國運動	Sanzi aiguo yundong	San-tzu ai-kuo yün-tung	Three-Self Patriotic Movement
初期教會	chuqi jiaohui	ch'u-ch'i chiao-hui	early church

Term	Pinyin	Wade-Giles	Alt. Terms / Postal Romanization (PO)
Chapter 5			
新華通訊社	Xinhua tongxunshe	Hsin-hua t'ung-hsün-she	New China News Agency
外僑出境証	waiqiao chujing zheng	wai-ch'iao ch'u-ching cheng	
朱德	Zhu De	Chu Te	Chu Teh
Epilogue			
文化大革命	Wenhua dageming	Wen-hua ta-ko-ming	Cultural Revolution
改革開放	Gaige kaifang	Kai-ko k'ai-fang	reform and opening-up
中國天主教愛國會	Zhongguo tianzhujiao aiguo hui	Chung-kuo t'ien-chu-chiao ai-kuo hui	Chinese Patriotic Catholic Association
鎮壓反革命	Zhenya fangeming	Chen-ya fan-ko-ming	Campaign to Suppress Counterrevolutionaries
反右運動	Fanyou yundong	Fan-yu yün-tung	Anti-Rightist Movement
大躍進	Da yue jin	Ta-yüe-chin	Great Leap Forward
單位	danwei	tan-wei	work unit
大理	Dali	Ta-li	Tali (PO)
雲南	Yunnan	Yün-nan	Yunnan (PO)
吳永生	Wu Yongsheng	Wu Yung-sheng	
張鳳祥	Zhang Fengxiang	Chang Feng-hsiang	
紅衛兵	Hong weibing	Hung wei-ping	Red Guards

Index